THE SOCIETY OF PUBLICATION DESIGNERS 39TH PUBLICATION DESIGN ANNUAL

CONTENTS

THE COMPETITION

This year we divided the competition
into three parts.

1. NEWSSTAND
Magazines typically sold on newsstands.
That's it.
We judged each magazine against
magazines of similar circulations.

2. NON-NEWSSTAND
This included corporate, educational,
institutional, controlled circulation,
annual reports, trade, business-to-
business magazines - titles not typically
sold on the newsstand and single
subject publications.

3. NEW MEDIA
Same as the 38th Annual except the
categories were simplified a bit.

WHY?
Well, it's to be more inclusive.
There are over 60,000 different titles in
the U.S. alone, and we wanted to see
more of them.

COVER

Jacket Creative Direction:
Robert Priest & **Deb Bishop**

Cover Photograph:
Stephen Lewis

Styling:
Anna Beckman

PEOPLE, PLACES &
EVENTS OF THE YEAR

Abu Abbas
Abu Musab al-Zarqawi
Abu Sayyaf
Afghanistan
Ahmed Chalabi
Al Jazeera
al-Qaeda
Al Sharpton
Alan Bates
Alex Rodriguez
American Chopper
Andre 3000
Andrew Fastow
Andrew Jarecki
Angels in America
Ariel Sharon
Arnold Schwarzenegger
Art Carney
Art Cooper
Barry Bonds
Baz Luhrman
Ben Affleck
Ben Curtis
Beyoncé
Big Boi
Bill Frist
Bill Murray
Bob Hope
Botox
Britney Spears
Buddy Hackett
California Wildfires
Carol Mosley Braun
Carol Shields
Carson Kressley
Catherine Martin
Charles Bronson
Charles Taylor
Christina Aguilera
Clint Eastwood
Coldplay
Colin Powell
Columbia Space Shuttle
Condoleezza Rice
Dan Brown
Daniel Libeskind
Daniel Patrick Moynihan
David Beckham
David Bloom
David Brinkley
David Kay
David Kelly
Dennis Kozlowski
Dennis Kucinich
Dick Cheney
Dick Gephardt
Dixie Chicks
Dominique de Villepin
Donald Carty
Donald Regan
Donald Rumsfeld
Dr. Phil McGraw
Eduard Shevardnadze
Edward P. Jones
Elia Kazan
Elizabeth Smart
Enron
European heat wave
Evan Marriot
Florida Marlins
Frank Gehry

Frank Keating
Frank Quattrone
Fred Rogers
Funny Cide
Gen. John P. Abizaid
Gen. Richard Myers
George Tenet
George W. Bush
Gerald Boyd
Gerhard Schröder
Gray Davis
Gregory Hines
Gregory Peck
Guantanamo Bay
Hairspray
Halliburton
Hamas
Hamid Karzai
Hans Blix
Harvey Pekar
Harvey Weinstein
Hey Ya!
Hilary Rodham Clinton
Howard Dean
Howell Raines
Hugh Jackman
Hurricane Isabel
I Pod
ImClone
Islamic Jihad
J. M. Coetzee
J.K. Rowling
Jack Black
Jacques Chirac
Jason Williams
Jay Garner
Jayson Blair
Jeffrey Skelling
Jennifer Lopez
Jessica Lynch
Jessica Simpson
Joe Millionaire
John Allen Muhammad
John Ashcroft
John Edwards
John Kerry
John Ritter
Johnny Cash
Johnny Depp
Joseph Lieberman
Kenneth Lay
Khalid Shaikh Mohammed
Kim Jong Il
Kobe Bryant
Kofi Annan
Lance Armstrong
Last Flight of the Concorde
Lee Boyd Malvo
Leni Riefenstahl
Lord of the Rings:
The Return of the King
Lost in Translation
Madonna
Mahmoud Abbas
Mark Geragos
Mars Exploration Rover
Martha Stewart
Master and Commander
Maurice Gibb
Michael Jackson
Michael Kelly
Missy Elliot
Monica Ali
Muammar al-Qaddafi

Muhammed Saeed al-Sahaf
(Baghdad Bob)
Mystic River
Naomi Watts
Netflix
New England Patriots
New Jersey Devils
Nicole Kidman
Nina Simone
Noel Redding
North Korea
Operation Iraqi Freedom
Orlando Bloom
Osama bin Laden
Outkast
Paris Hilton
Paul Bremer
Paul Simon
Paul Wolfowitz
Peter Arnett
Peter Jackson
Phil Spector
Queer Eye For The Straight Guy
Quentin Tarantino
Rev. Paul Shanley
Richard Grasso
Richard Perle
Ricky Gervais
Riyadh
R. Kelly
Robert Mugabe
Rod Stewart
Roger Federer
Russ Limbaugh
Ryan Seacrest
Saddam Hussein
Sammy Sosa
Samuel Waksal
San Antonio Spurs
SARS
Scarlett Johansson
Scott Peterson
Sean Penn
Serena Williams
Sheik Abdel Majid al-Khoei
Silvio Berlusconi
Sir Edmund Hillary
Sofia Coppola
Stephen Case
Steve Jobs
Strom Thurmond
Syracuse University
Tariq Aziz
The Atkins Diet
The Blackout
The Da Vinci Code
The OC
The Office
The South Beach Diet
The White Stripes
Tommy Franks
Tom Ford
Tony Blair
Tyco International
Ugg Boots
Viggo Mortensen
Warren Spahn
Warren Zevon
Wesley Clark
Will Ferrell
WMD
Yasir Arafat
21 Grams
50 Cent

THE HERB LUBALIN AWARD &
THE MAGAZINE OF THE YEAR

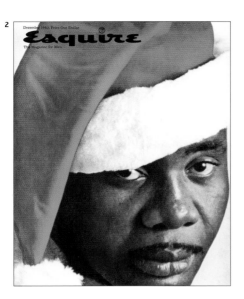

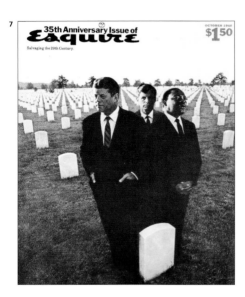

George Lois is often referred to as a legend, but he is more than that. He is an artist with a conceptual mind who has inspired three generations of designers and editors.

George Lois grew up in New York City, the Bronx to be exact. It was his love of drawing which led his teachers to steer him to The High School of Music and Art and then to Pratt. The talented Lois left Pratt early to begin his career at Doyle Dane Bernbach, the leading ad agency of the 1960s.

Harold Hayes, the venerable Editor in Chief of Esquire, was a fan of the ad campaigns put together by Lois and his young agency. In 1962, he called George and asked him if he would help him out with a few covers. The famous Floyd Patterson, alone in the boxing ring cover soon followed and Esquire circulation soared.

Lois' passion for current events and celebrity gave him the fuel that informed every cover he created. He sold his ideas to the editors with wit and brassy charm, much to the chagrin of Esquire's advertising sales department.

Harold Hayes appreciated Lois' direct approach to finding cover solutions, and he understood their success. Their relationship was a match made in art director heaven.

We honor George Lois.

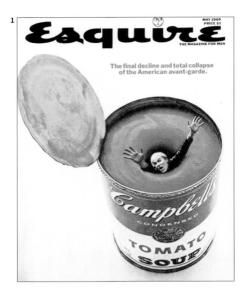

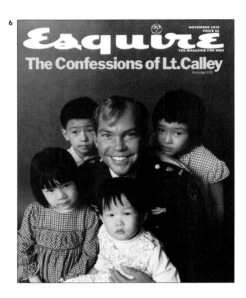

HERB LUBALIN was an advertising art director in the 40's and then worked with Sudler and Hennessey for 20 years. He was the recipient of numerous medals and awards, and in 1962 named Art Director of the Year by the National Society of Art Directors. He was a publication designer of great originality designing **Eros** in the early 60s, and the legendary **Avant Garde** late in the same decade. He started the International Typeface Corporation (ITC) in 1970 with Aaron Burns and worked extensively with Tom Carnase and Alan Peckolick. He founded **U & lc** in 1973. He was regarded as one of America's greatest typographers. His fonts include Avantgarde Gothic (with Carnase, Gschwind, Gürtler, Mengelt), Ronda, Lubalin Graph, Serif Gothic (with Tony DiSpigna). Herb Lubalin died in 1981.

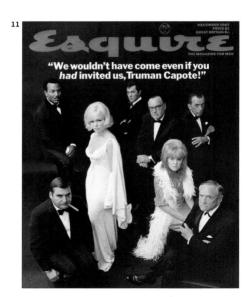

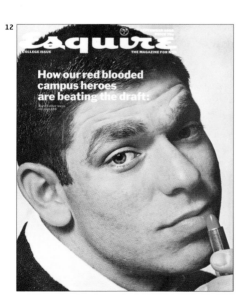

1: The Warhol cover became the supreme statement of Esquire's celebration of pop culture in the 60's. **2**: In the turbulent racial climate of 1963, Sonny Liston was perfect for the part of the black Santa. Liston the fighter was known as the meanest man in the world. **3**: Ali as the martyr to principle. He was the iconic symbol of non-violent protest in those troubled times. **4**: The Nixon composite shot was a satire of the 1960 TV debates. It was said that Nixon lost to Kennedy by a 5 o'clock shadow. **5**: The first cover Lois did for Esquire showed Floyd Patterson KO'd by Sonny Liston in the heavyweight championship. **6**: Lt. Calley was awaiting trial. The kids he posed with were like the children he was accused of murdering at My Lai. **7**: The three

3
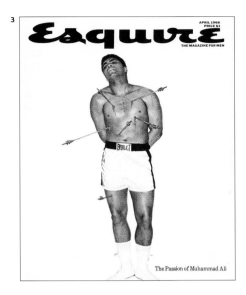
The Passion of Muhammad Ali

4
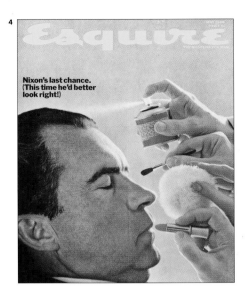
Nixon's last chance. (This time he'd better look right!)

5
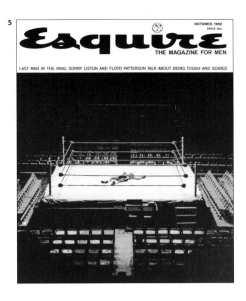
LAST MAN IN THE RING: SONNY LISTON AND FLOYD PATTERSON TALK ABOUT BEING TOUGH AND SCARED

8
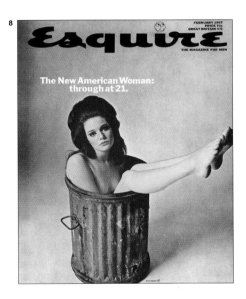
The New American Woman: through at 21.

9
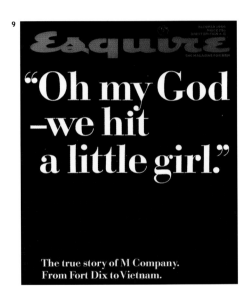
"Oh my God –we hit a little girl."

The true story of M Company. From Fort Dix to Vietnam.

10
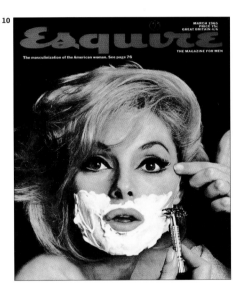
The masculinization of the American woman. See page 76

13
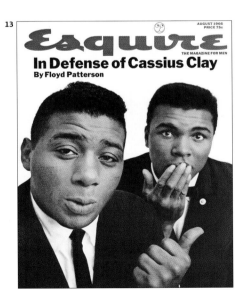
In Defense of Cassius Clay
By Floyd Patterson

14
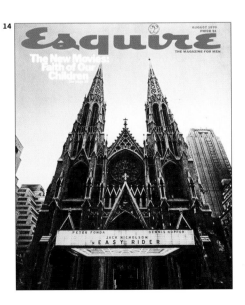
The New Movies: Faith of Our Children

PETER FONDA JACK NICHOLSON DENNIS HOPPER
"EASY RIDER"

15

Back to College Issue

The Kids VS The Pigs
Freshman Orientation Package

martyred leaders watch over a dream like epitaph, the murder of American goodness. **8:** In 1966 the ad people at Esquire wanted to return to pinups. 'I wanted an anti-pinup image. A beautiful ingenue dumped in a trash can'. **9:** A horrified GI's reaction as he comes upon the body of a dead Vietnamese child. The cover screamed that something was wrong. **10:** No American actress would pose in this 'manly' act, so we asked Italian actress Virna Lisi. It was a play on the liberation of women from traditional roles. **11:** Truman Capote threw a masked ball in 1966....inviting 'some 540' of his closest friends. Those who didn't make the cut were pretty swell, too. **12:** The college student's attitude toward the Vietnam war: any way to stay out of it was acceptable. **13:** Patterson was defeated by Ali, but stood by him when he was convicted as a draft dodger. **14:** Cult movies like Easy Rider became religion for the young in the 60's; so, the entrance to St. Patrick's Cathedral needed a marquee. The Church didn't like that. **15:** The scorn for cops during the anti-war years prompted this cover to be considered an insult to the animal kingdom.

SPECIAL ISSUE

MARTHA STEWART

kids

BACKYARD BIRTHDAY

BOATS TO BUILD

FREE!
"how now"
a 16-page pullout
just for kids

EASY OUTFITS

fun summer
activities
for *parents*
and kids

SILLY SHELLS

FLOWERS THAT POP!

COOL TREATS

A SUPPLEMENT TO
MARTHA STEWART LIVING
www.marthastewart.com

001
Publication **Martha Stewart Kids**
Creative Director **Gael Towey**
Design Director **Deb Bishop**
Editor-in-Chief **Margaret Roach**
Art Directors **Jennifer Wagner, Brooke Reynolds,
Jennifer Dahl**
Illustrators **Calef Brown, Greg Clarke, Lane Smith,
David Sheldon, Ross Macdonald**

Photo Editors **Stacie McCormick, Jamie Bass Perrotta**
Photographers **William Abranowicz, Sang An, Christopher
Baker, Frank Heckers, Gentl + Hyers, Stephen Lewis, Tosca
Radigonda, Victor Schrager, Philip Newton**
Stylists **Jodi Levine, Ayesha Patel, Tara Bench, Anna Beckman,
Shannon Carter, Sarah Conroy, Charlyne Mattox**
Publisher **Martha Stewart Living Omnimedia**
Issues **Winter/Spring 2003, Fall 2003, Holiday 2003**

001

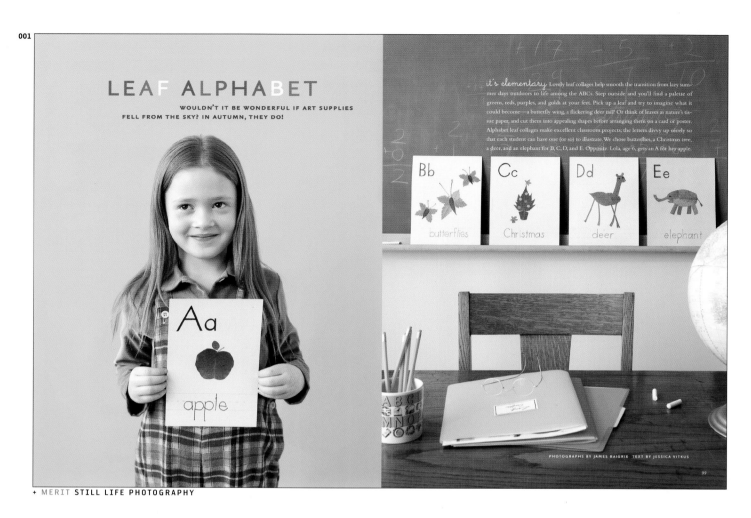

LEAF ALPHABET

WOULDN'T IT BE WONDERFUL IF ART SUPPLIES FELL FROM THE SKY? IN AUTUMN, THEY DO!

it's elementary Lovely leaf collages help smooth the transition from lazy summer days outdoors to life among the ABCs. Step outside and you'll find a palette of greens, reds, purples, and golds at your feet. Pick up a leaf and try to imagine what it could become—a butterfly wing, a flickering deer tail? Or think of leaves as nature's tissue paper, and cut them into appealing shapes before arranging them on a card or poster. Alphabet leaf collages make excellent classroom projects; the letters divvy up nicely so that each student can have one (or so) to illustrate. We chose butterflies, a Christmas tree, a deer, and an elephant for B, C, D, and E. Opposite: Lola, age 6, gets an A for her apple.

Bb butterflies Cc Christmas Dd deer Ee elephant

PHOTOGRAPHS BY JAMES BAIGRIE TEXT BY JESSICA VITKUS

99

+ MERIT **STILL LIFE PHOTOGRAPHY**

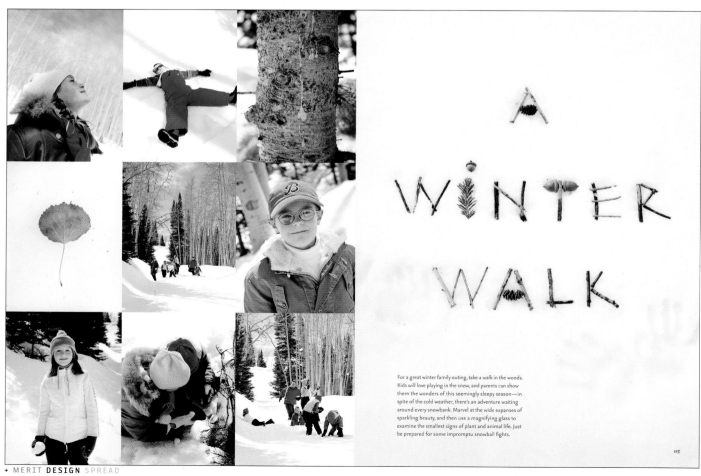

A WINTER WALK

For a great winter family outing, take a walk in the woods. Kids will love playing in the snow, and parents can show them the wonders of this seemingly sleepy season—in spite of the cold weather, there's an adventure waiting around every snowbank. Marvel at the wide expanses of sparkling beauty, and then use a magnifying glass to examine the smallest signs of plant and animal life. Just be prepared for some impromptu snowball fights.

115

+ MERIT **DESIGN** SPREAD

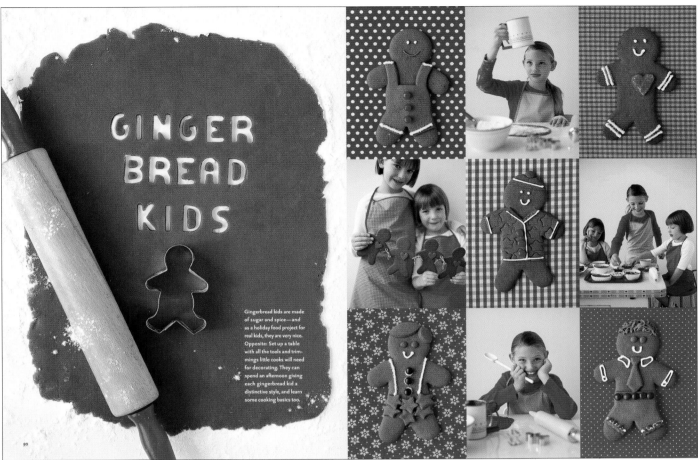

Gingerbread kids are made of sugar and spice—and as a holiday food project for real kids, they are very nice. Opposite: Set up a table with all the tools and trimmings little cooks will need for decorating. They can spend an afternoon giving each gingerbread kid a distinctive style, and learn some cooking basics too.

+ MERIT **DESIGN** ENTIRE STORY

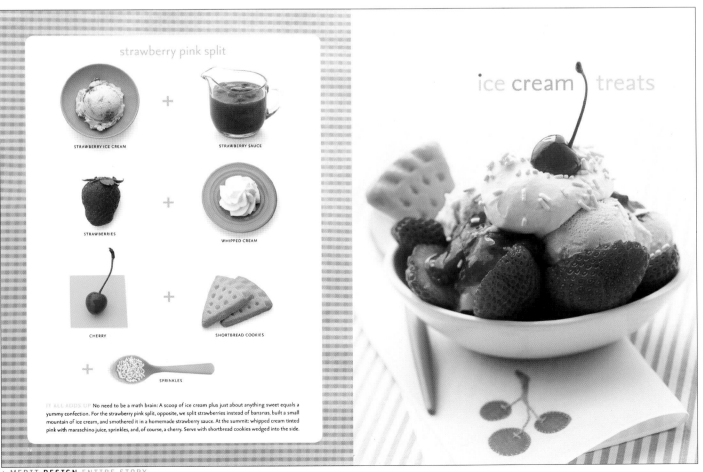

IT ALL ADDS UP No need to be a math brain: A scoop of ice cream plus just about anything sweet equals a yummy confection. For the strawberry pink split, opposite, we split strawberries instead of bananas, built a small mountain of ice cream, and smothered it in a homemade strawberry sauce. At the summit: whipped cream tinted pink with maraschino juice, sprinkles, and, of course, a cherry. Serve with shortbread cookies wedged into the side.

+ MERIT **DESIGN** ENTIRE STORY

002

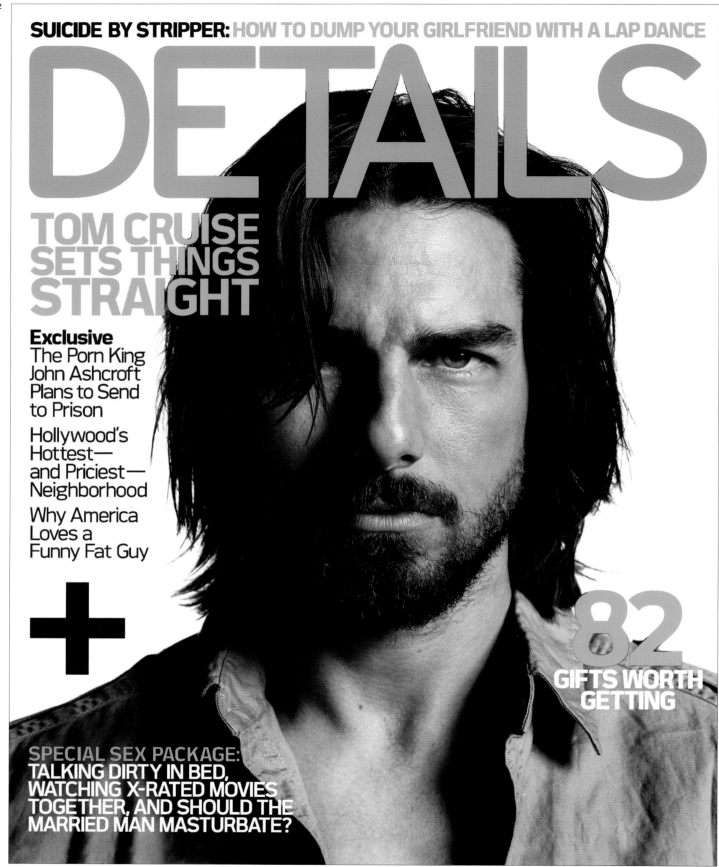

SUICIDE BY STRIPPER: HOW TO DUMP YOUR GIRLFRIEND WITH A LAP DANCE

DETAILS

TOM CRUISE SETS THINGS STRAIGHT

Exclusive
The Porn King
John Ashcroft
Plans to Send
to Prison

Hollywood's
Hottest—
and Priciest—
Neighborhood

Why America
Loves a
Funny Fat Guy

+

82
GIFTS WORTH
GETTING

SPECIAL SEX PACKAGE:
TALKING DIRTY IN BED,
WATCHING X-RATED MOVIES
TOGETHER, AND SHOULD THE
MARRIED MAN MASTURBATE?

002
Publication **Details**
Design Director **Rockwell Harwood**
Editor-in-Chief **Daniel Peres**
Publisher **Condé Nast Publications Inc.**
Issues **October 2003, November 2003, December 2003**

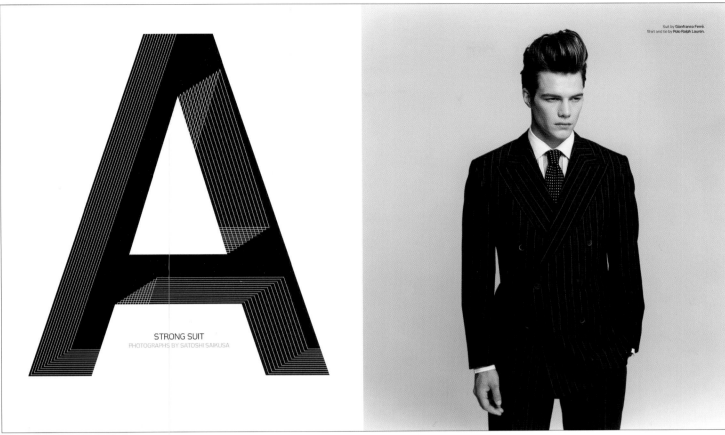

STRONG SUIT
PHOTOGRAPHS BY SATOSHI SAIKUSA

Suit by Gianfranco Ferré.
Shirt and tie by Polo Ralph Lauren.

+ MERIT DESIGN SPREAD

+ MERIT STILL LIFE PHOTOGRAPHY

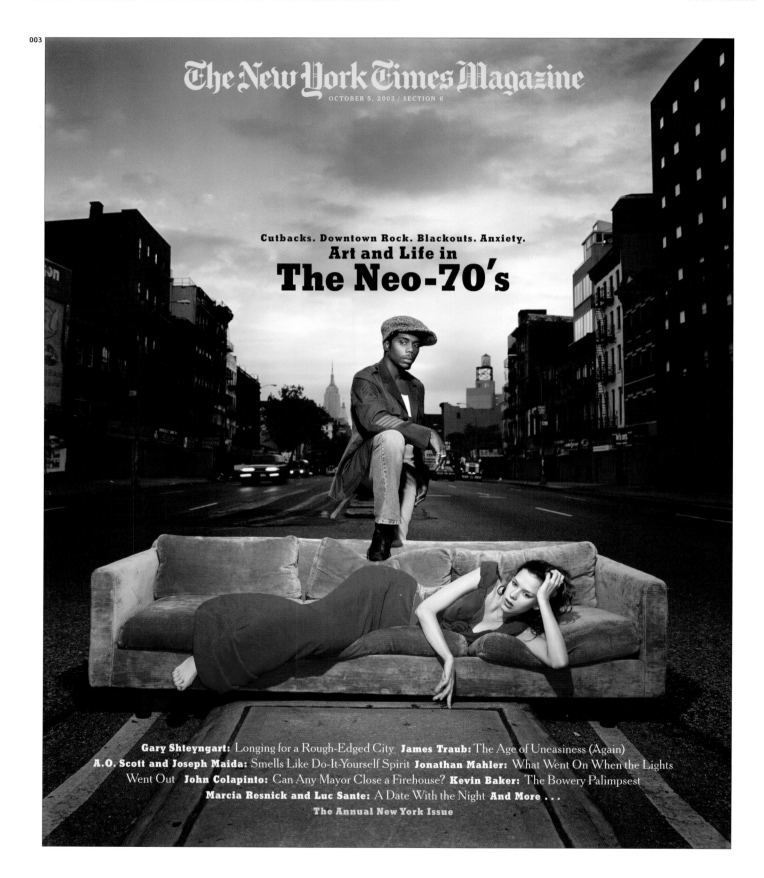

003
Publication **The New York Times Magazine**
Art Director **Janet Froelich**
Editor-in-Chief **Gerald Marzorati**
Designers **Janet Froelich, Joele Cuyler, Catherine Gilmore-Barnes, Nancy Harris, Jeff Glendenning, Kristina DiMatteo, Corliss Williams**
Photo Editors **Kathy Ryan, Jody Quon, Kira Pollack, Evan Kriss, Cavan Farrell**
Publisher **The New York Times**
Issues **October 5, 2003, November 9, 2003, November 30, 2003**

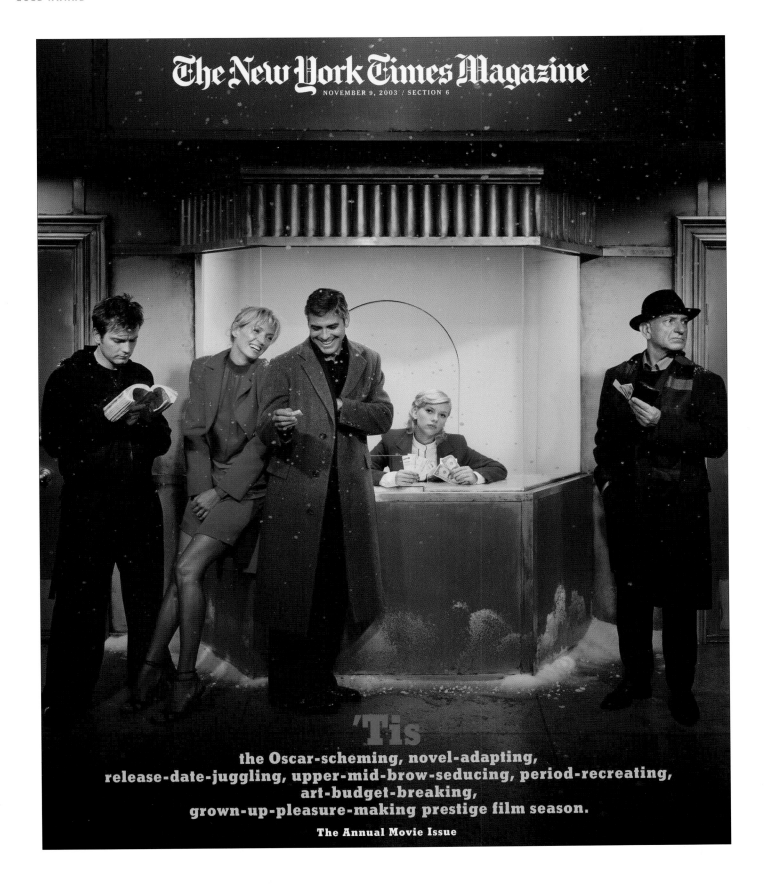

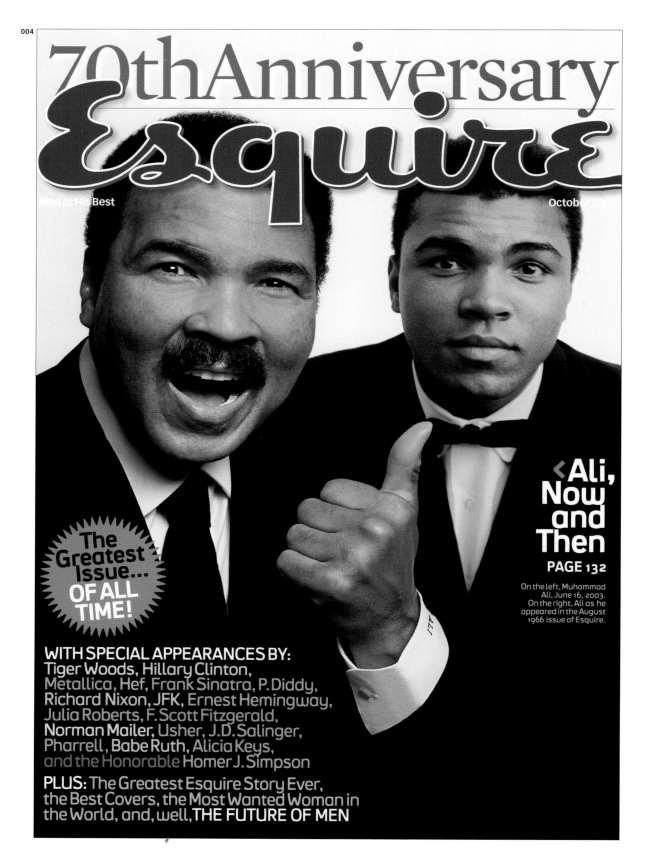

004

70thAnniversary

Esquire

Man at His Best

October 2003

< Ali, Now and Then
PAGE 132

On the left, Muhammad Ali, June 16, 2003. On the right, Ali as he appeared in the August 1966 issue of Esquire.

The Greatest Issue... OF ALL TIME!

WITH SPECIAL APPEARANCES BY:
Tiger Woods, Hillary Clinton, Metallica, Hef, Frank Sinatra, P. Diddy, Richard Nixon, JFK, Ernest Hemingway, Julia Roberts, F. Scott Fitzgerald, Norman Mailer, Usher, J.D. Salinger, Pharrell, Babe Ruth, Alicia Keys, and the Honorable Homer J. Simpson

PLUS: The Greatest Esquire Story Ever, the Best Covers, the Most Wanted Woman in the World, and, well, **THE FUTURE OF MEN**

004
Publication **Esquire**
Design Director **John Korpics**
Editor-in-Chief **David Granger**
Designers **Chris Martinez, Dragos Lemnei, Kim Forsberg**
Illustrator **C.F. Payne**
Photo Editors **Nancy Jo Iacoi, David Carthas, Adivije Sheji**
Photographers **Platon, Matt Mahurin, Sam Jones, Neil Leifer**
Publisher **The Hearst Corporation-Magazines Division**
Issues **May 2003, July 2003, October 2003**

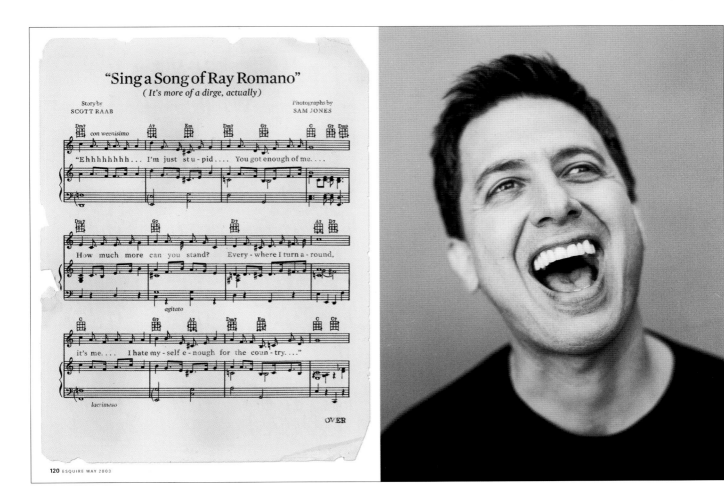

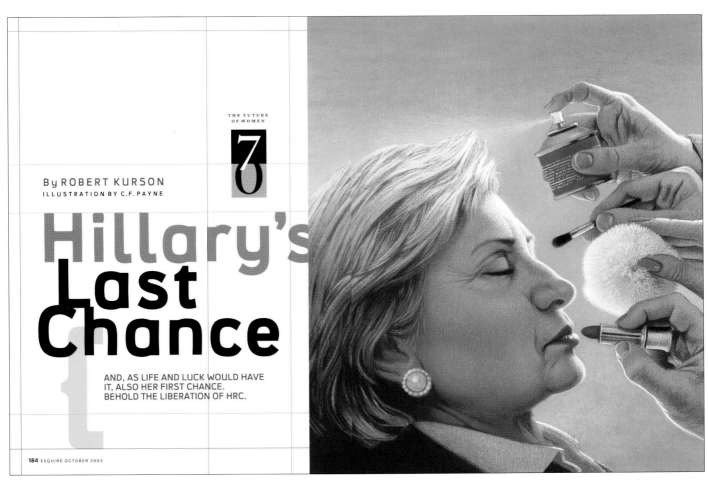

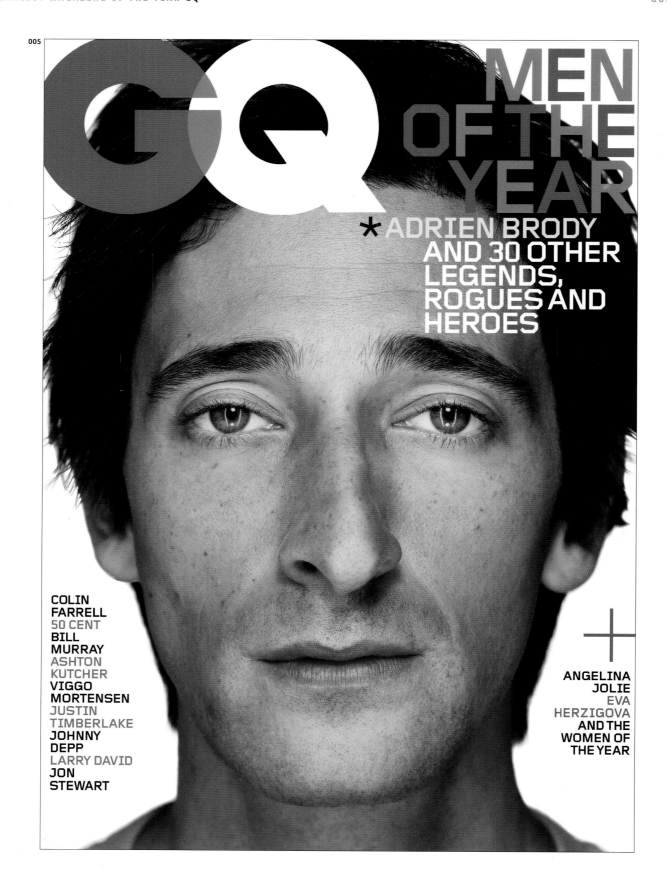

005

GQ MEN OF THE YEAR

*ADRIEN BRODY AND 30 OTHER LEGENDS, ROGUES AND HEROES

COLIN FARRELL
50 CENT
BILL MURRAY
ASHTON KUTCHER
VIGGO MORTENSEN
JUSTIN TIMBERLAKE
JOHNNY DEPP
LARRY DAVID
JON STEWART

+ ANGELINA JOLIE EVA HERZIGOVA AND THE WOMEN OF THE YEAR

005
Publication **GQ**
Design Director **Fred Woodward**
Editor-in-Chief **Jim Nelson**
Designers **Paul Martinez, Matthew Lenning, Ken DeLago, Sara Viñas, Gillian Goodman, Hudd Byard**
Illustrators **John Cuneo, Christoph Niemann, Eddie Guy, Istvan Banyai, Mark Ulriksen**
Photo Editors **Jennifer Crandall, Bradley Young, Catherine Talese,**

Kristen Schaefer, Michael Norseng
Photographers **Mark Seliger, Michael Thompson, Peggy Sirota, Dan Winters, Martin Schoeller, Norman Jean Roy, Jeff Riedel, Tom Schierlitz, John Midgley, Frederike Helwig, Anders Overgaard, Tony Duran, Michael Elins**
Creative Director **Jim Moore**
Fashion Director **Madeline Weeks**
Publisher **Condé Nast Publications Inc.**
Issues **March 2003, September 2003, November 2003**

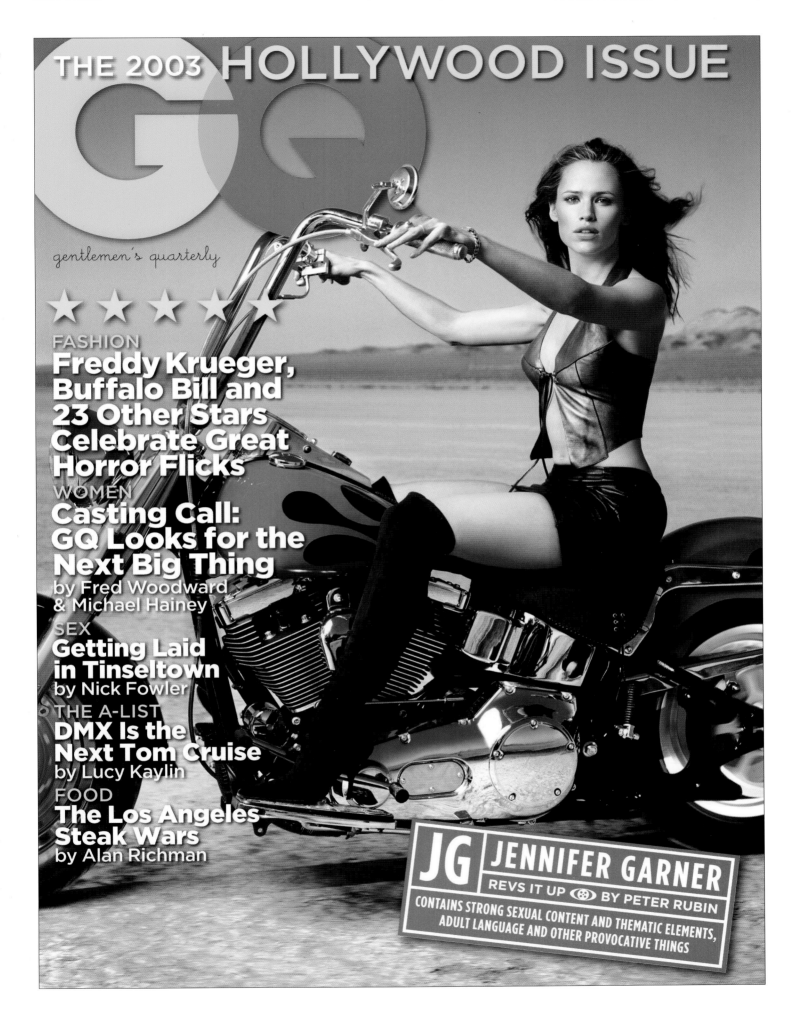

THE 2003 HOLLYWOOD ISSUE

GQ

gentlemen's quarterly

★ ★ ★ ★ ★

FASHION
**Freddy Krueger,
Buffalo Bill and
23 Other Stars
Celebrate Great
Horror Flicks**

WOMEN
**Casting Call:
GQ Looks for the
Next Big Thing**
by Fred Woodward
& Michael Hainey

SEX
**Getting Laid
in Tinseltown**
by Nick Fowler

THE A-LIST
**DMX Is the
Next Tom Cruise**
by Lucy Kaylin

FOOD
**The Los Angeles
Steak Wars**
by Alan Richman

JG **JENNIFER GARNER**
REVS IT UP BY PETER RUBIN
CONTAINS STRONG SEXUAL CONTENT AND THEMATIC ELEMENTS,
ADULT LANGUAGE AND OTHER PROVOCATIVE THINGS

006

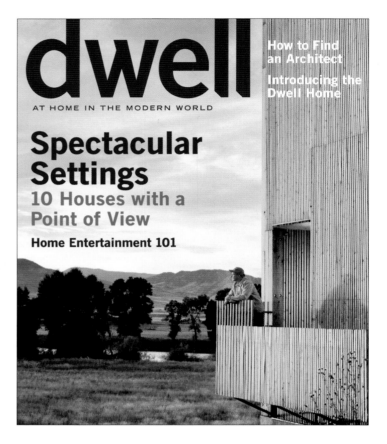

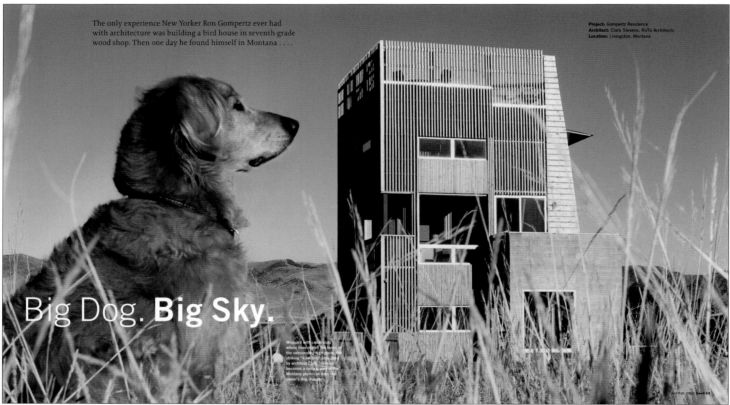

006
Publication **dwell**
Creative Director **Jeanette Hodge Abbink**
Editor-in-Chief **Allison Arieff**
Designers **Jeanette Hodge Abbink, Shawn Hazen, Craig Bromley**
Photo Editors **Maren Levinson, Aya Brackett**
Publisher **Dwell LLC**
Issues **January/February 2003, March/April 2003, July/August 2003**

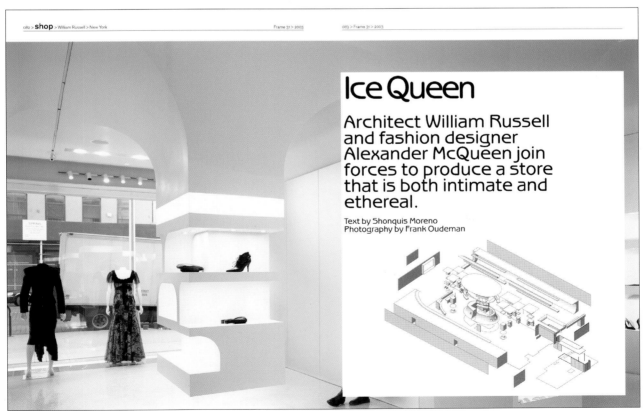

007
Publication **FRAMƎ Magazine**
Art Director **Coma New York/Amsterdam**
Editor-in-Chief **Robert Thiemann**
Designers **Cornelia Blatter, Marcel Hermans**
Photo Editors **Billy Nolan, Charlotte Vaudrey**
Publisher **Frame Publishers**
Issues **March/April 2003, July/August 2003, September/October 2003**

008

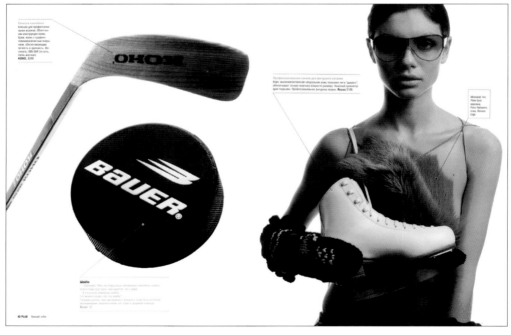

008
Publication **New Trends Plus Magazine**
Art Director **Anton Ioukhnovets**
Editor-in-Chief **Oleg Dyachenko**
Designer **Anton Ioukhnovets**
Photo Editor **Anton Ioukhnovets**
Photographers **Sean Hunt, Julia Saponova, Sergei Gavrilov, Andrei Bronnikov, Mihail Korolev, Lev Melihov, Jabagh Kaghado, Anna Beck, Ernesto Gonzales**
Publisher **Plus Publication LLC**
Issues **January/February 2003, March 2003, April 2003**

POL OXYGEN

DESIGN ART ARCHITECTURE

NEW WAVE

NICK KNIGHT UBERCOOL ONLINE
DAVID ADJAYE THE YOUNG BRITISH ARCHITECT
SEAN GODSELL THE BIG MAN

ISSUE FIVE
Australia: AU$17.50
Canada: CN$18.00
South Korea: 17,000 Won
New Zealand: NZ$19.50
UK: £7.50
USA: US$12.00

ISSN 1447-5170

9 771447 517703

009
Publication **POL Oxygen**
Art Director **Marcus Piper**
Editor-in-Chief **Jan Mackey**
Illustrator **Jaime Hayon**
Photographers **Martin van der Wal, Lyndon Douglas, Matthew Sleeth, Nick Knight**
Publisher **POL Publications**
Issues **Issue 4, 2003, Issue 5, 2003, June/July 2003**

010

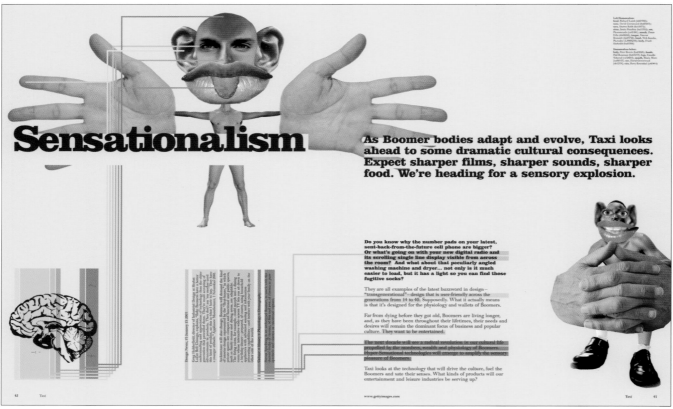

010
Publication **Taxi**
Creative Director **Lewis Blackwell**
Editor-in-Chief **John O'Reilly**
Design Director **Chris Ashworth**
Art Director **Dan Moscrop**
Designers **Paul Penson, Paul Reed**
Studio **Getty Images Creative Studio**
Publisher **Getty Images**
Issues **January 2003, March 2003, November 2003**

THE GOLD AND SILVER AWARDS

011

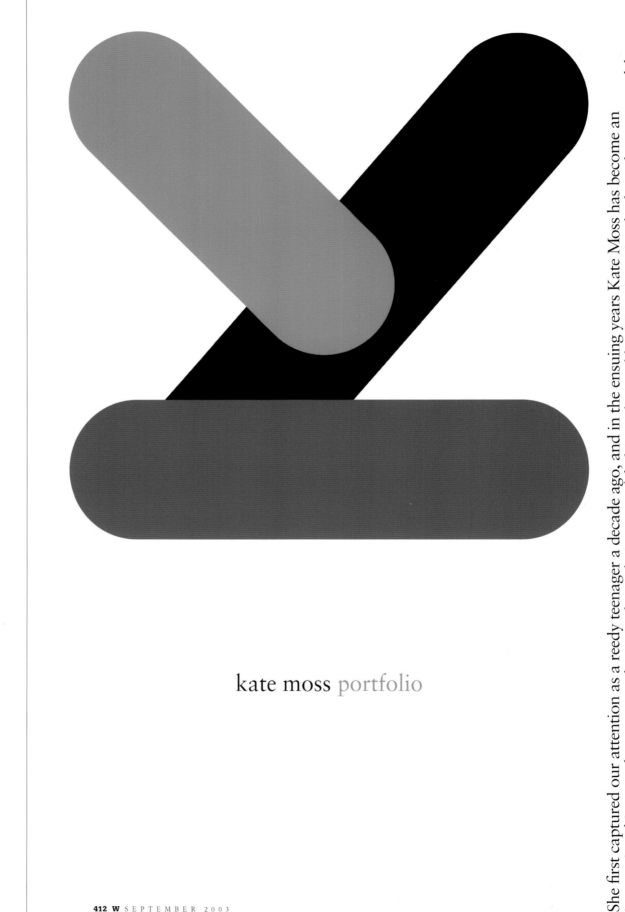

kate moss portfolio

She first captured our attention as a reedy teenager a decade ago, and in the ensuing years Kate Moss has become an international icon and a muse to photographers, designers and fashion editors alike. Here, in a visual ode to the supermodel, W unleashes a host of the world's most accomplished photographers and artists on Kate, with results ranging from spectacular nudes to cheeky games of dress-up, from classic fashion shots to subversive commentary on pop culture.

011
Publication **W Magazine**
(credits on next spread)

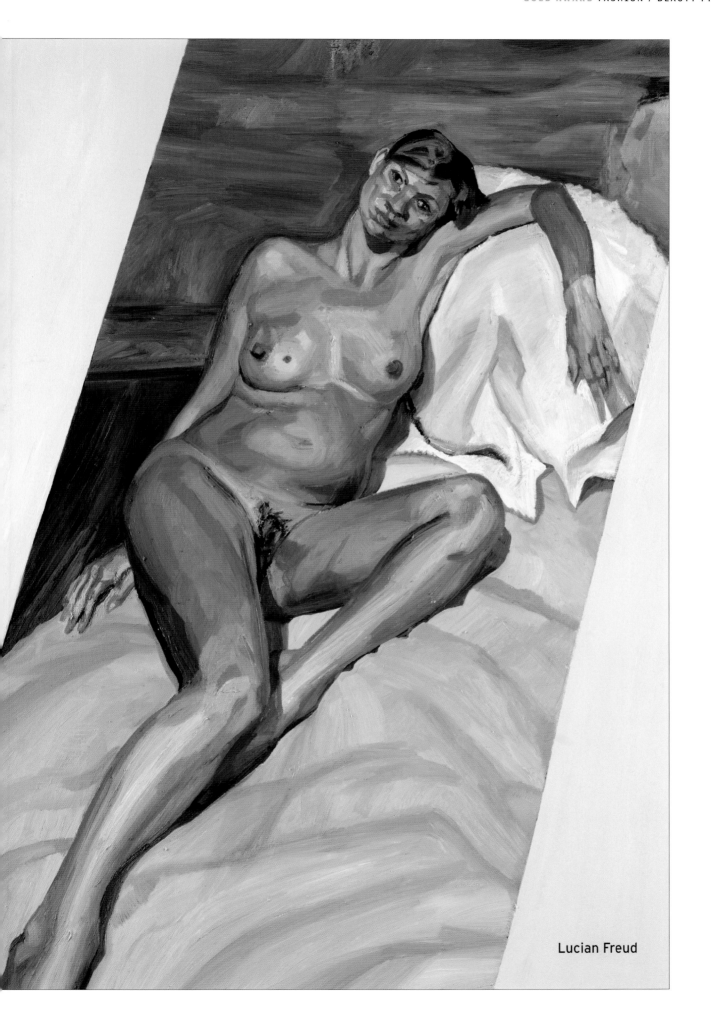

Lucian Freud

011

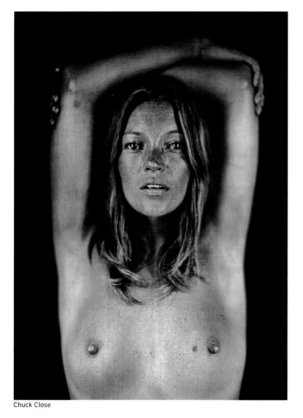

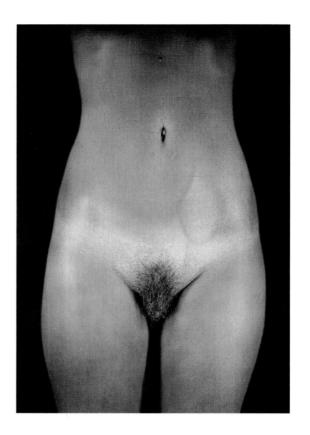

Chuck Close

416 W SEPTEMBER 2003

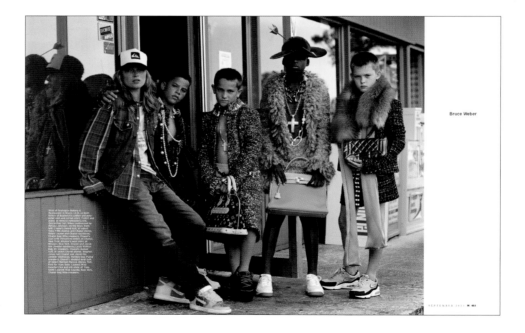

Bruce Weber

011
Publication **W Magazine**
Creative Director **Dennis Freedman**
Editor-in-Chief **Patrick McCarthy**
Design Director **Edward Leida**
Art Director **Kirby Rodriguez**
Designers **Edward Leida, Angela Panichi, Shanna Greenberg**
Photographers **Chuck Close, Bruce Weber, Inez Van Lamsweerde** & **Vinoodh Matadin, Juergen Teller, Lisa Yuskavage, Mario Sorrenti,**
Steven Klein, Richard Prince, Tom Sachs, Nick Knight, Michael Thompson, David Sims, Craig McDean, Mert Alas & **Marcus Piggott**
Painters **Lucian Freud, Takashi Murakami, Alex Katz**
Publisher **Fairchild Publications**
Issue **September 2003**

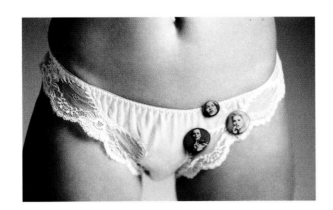

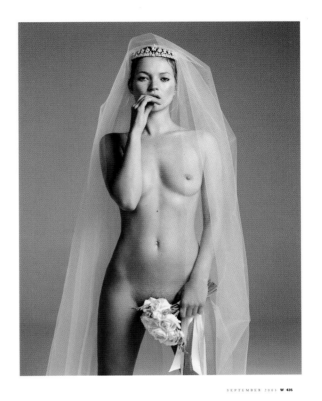

Inez van Lamsweerde & Vinoodh Matadin
Agent Provocateur's white silk and lace thong, at Agent Provocateur, New York.
Opposite: Vera Wang's tulle veil, at Vera Wang, New York. Harry Winston tiara.

SEPTEMBER 2003 **W** 435

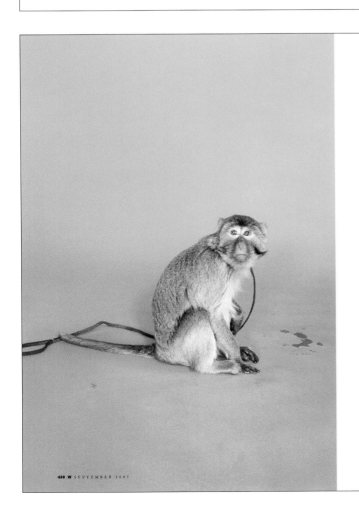

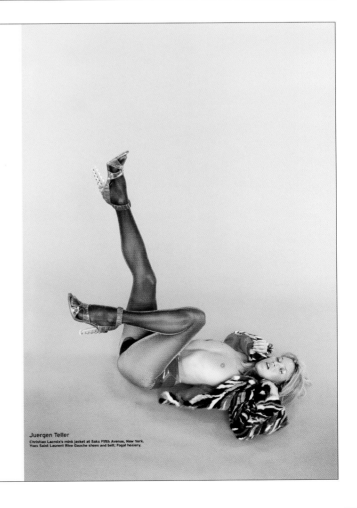

Juergen Teller
Christian Lacroix's mink jacket at Saks Fifth Avenue, New York.
Yves Saint Laurent Rive Gauche shoes and belt; Fogal hosiery.

428 **W** SEPTEMBER 2003

012

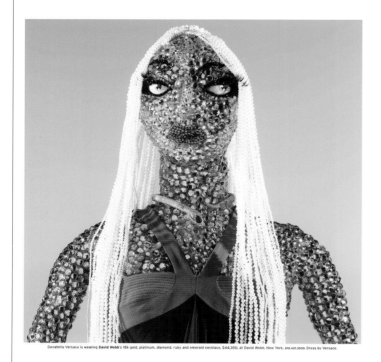

Donatella Versace is wearing David Webb's 18k gold, platinum, diamond, ruby and emerald necklace, $44,350, at David Webb, New York, 212.421.3030. Dress by Versace.

guys & dolls

The models—pop culture icons re-created by stylist Jane How and photographer Mario Sorrenti in deli meats, candy and Band-Aids—are fake, but the jewelry they're wearing is oh so real.

Photographs By Mario Sorrenti
Styled By Jane How

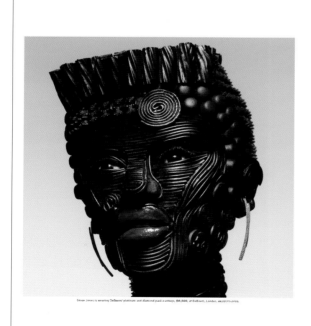

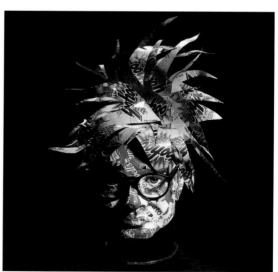

012
Publication **W Jewelry**
Creative Director **Dennis Freedman**
Editor-in-Chief **Patrick McCarthy**
Design Director **Edward Leida**
Art Director **Kirby Rodriguez**
Designers **Edward Leida, Angela Panichi, Shanna Greenberg**
Photographer **Mario Sorrenti**
Publisher **Fairchild Publications**
Issue **April 2003**

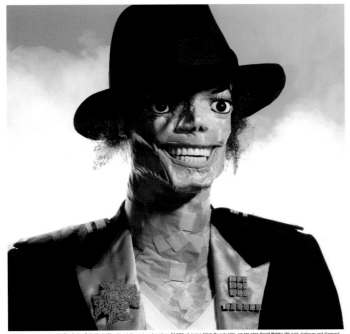

Michael Jackson is wearing **Bez Ambar Collection**'s 18k gold and diamond pavé earrings, $3,580, at James Elliot, Beverly Hills, 310.278.2557; **David Webb**'s 18k gold, platinum and diamond brooch, $25,500, at David Webb, New York, 212.421.3030; and **Bulgari**'s platinum and diamond brooches, $9,000 and $13,000, at Bulgari, New York, 800.BULGARI.

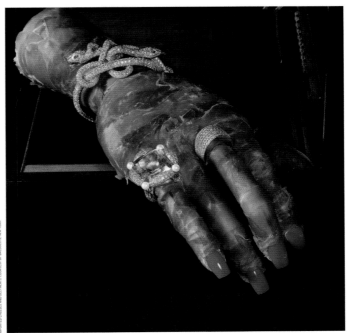

Thing, of "The Addams Family" fame, is wearing **Boucheron**'s white gold and diamond bracelet, price available upon request, at Boucheron, Paris, 331.42.44.42.44; **Gioia**'s white gold, diamond, kunzite and pink tourmaline ring, price available upon request, at Gioia, New York, 212.223.3146, and Bergdorf Goodman, New York, 212.753.7300; and **Piaget**'s 18k white gold and diamond ring, $12,500, at Piaget, New York and Palm Beach, 800.399.4526.

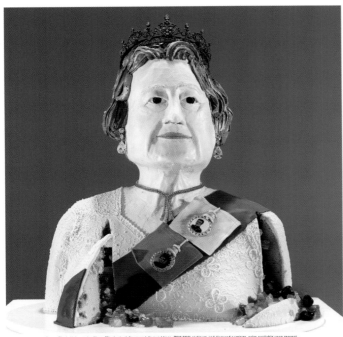

Queen Elizabeth is wearing **Harry Winston**'s platinum and diamond tiara, $120,000; platinum and diamond earrings, price available upon request, and 24k gold, platinum, pink and white diamond necklace, $275,000, all at Harry Winston, New York, 800.988.4110.

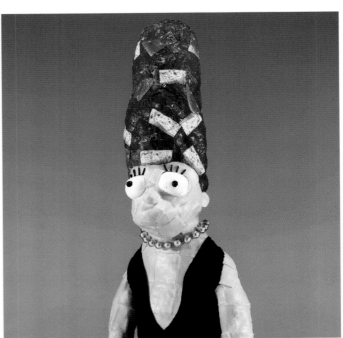

Marge Simpson in Paloma Picasso for Tiffany & Co.'s 18k gold necklace, $9,675, at Tiffany & Co., New York. 800.526.0649. Dress by Balenciaga.

013

VISUAL AND PERFORMING ARTS VOL 7 : NO 1

2wice

animal

013
Publication **2wice**
Designers **Abbott Miller, Jeremy Hoffman**
Editor-in-Chief **Patsy Tarr**
Photo Editor **Abbott Miller**
Photographers **Christian Witkin, Martin Schoeller, Joseph Mulligan**
Studio **Pentagram Design, Inc.**
Publisher **2wice Arts Foundation**
Client **2wice Arts Foundation**
Issue **2003**

CLOVEN
KINGDOM

PAUL TAYLOR DANCE COMPANY
Photography by Christian Witkin

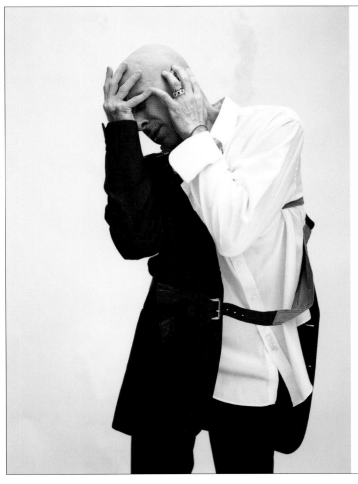

BROKEN
MAN

STEPHEN PETRONIO DANCE COMPANY
Photography by Christian Witkin

014

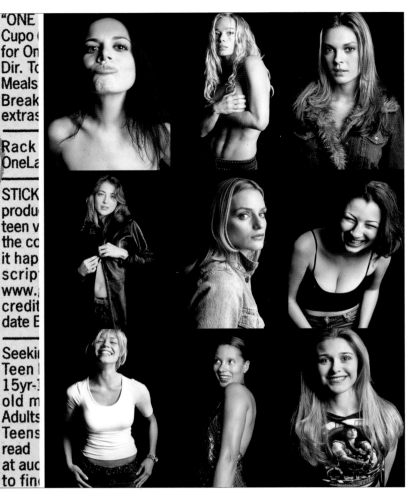

GQ GOES IN SEARCH OF THE NEXT BIG THING
Photographs by Fred Woodward
Interviews by Michael Hainey

CASTING CALL

WE'RE LOOKING TO DISCOVER THE NEXT BIG STAR. Wanted: Female Actors 18-25 to play strong, sultry, uninhibited lead. Open call Nov. 7 & 8. Don't miss out on this incredible casting opportunity. Please call 310-314-4403 or 212-286-7835 for details.

SPEND MORE THAN FIVE MINUTES IN LOS ANGELES AND YOU SEE THEM. The hopefuls. The believers. The would-be, could-be starlets. They are the soul of the town, the obsession of the business. They come from everywhere and nowhere, driven by the dream that they are just a break away from being discovered, a day away from stardom.

WE WANTED TO KNOW THEIR STORIES. To find them, we placed the ad above in an L.A. paper. These are the women we discovered. Keep an eye out. Maybe you'll see them. Maybe you won't.

+ MERIT PORTRAIT PHOTOGRAPHY

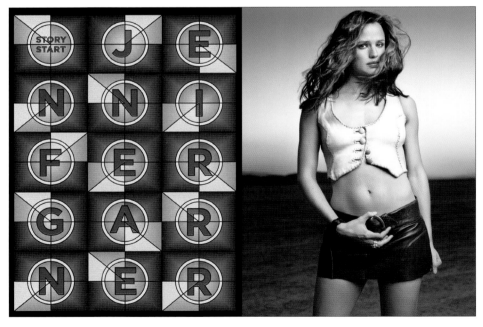

STORY START

JENNIFER GARNER

014
Publication **GQ**
Design Director **Fred Woodward**
Editor-in-Chief **Jim Nelson**
Designers **Paul Martinez, Matthew Lenning, Ken DeLago, Gillian Goodman**
Photo Editors **Jennifer Crandall, Catherine Talese, Kristen Schaefer, Michael Norseng**
Photographers **Mark Seliger, Dan Winters, Tony Duran, Jeff Riedel, James White, Lorenzo Agius, Norman Jean Roy, Martin Schoeller**
Creative Director **Jim Moore**
Publisher **Condé Nast Publications Inc.**
Issue **March 2003**

015
Publication **Vibe**
Design Director **Florian Bachleda**
Editor-in-Chief **Emil Wilbekin**
Photo Editors **George Pitts, Dora Somosi**
Photographers **Dan Winters, Christian Witkin, Sacha Waldman, Geoffrey deBoismenu, John Peng, Dah Len, David LaChapelle, Jonathan Mannion**
Publisher **Vibe/Spin Ventures**
Issue **September 2003**

profilin'

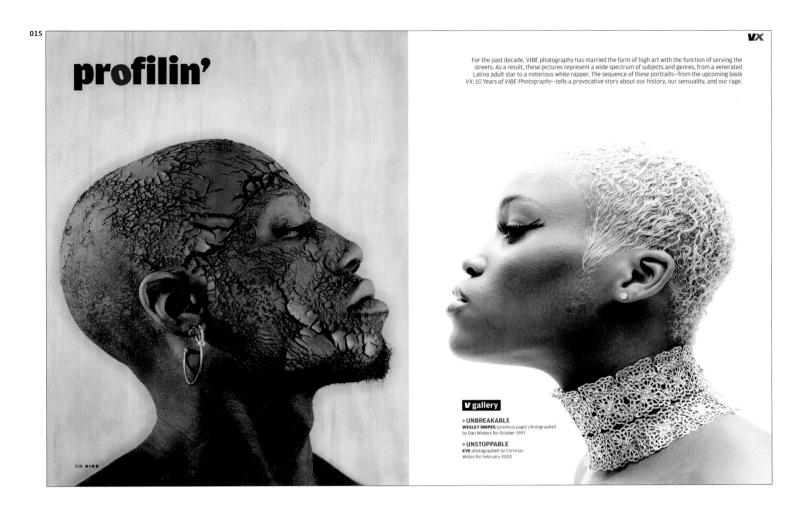

For the past decade, VIBE photography has married the form of high art with the function of serving the streets. As a result, these pictures represent a wide spectrum of subjects and genres, from a venerated Latina adult star to a notorious white rapper. The sequence of these portraits—from the upcoming book *VX: 10 Years of VIBE Photography*—tells a provocative story about our history, our sensuality, and our rage.

V gallery

> UNBREAKABLE
WESLEY SNIPES (previous page) photographed by Dan Winters for October 1993

> UNSTOPPABLE
EVE photographed by Christian Witkin for February 2000

238 VIBE

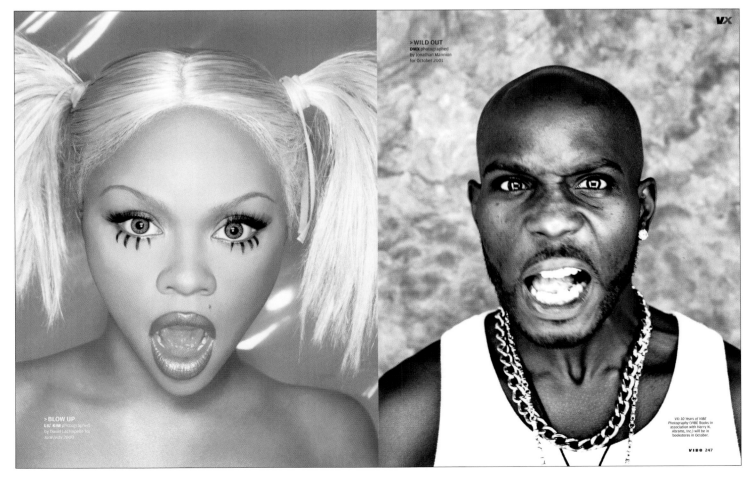

> WILD OUT
DMX photographed by Jonathan Mannion for October 2001

> BLOW UP
LIL' KIM photographed by David LaChapelle for June/July 2000

VX: 10 Years of VIBE Photography (VIBE Books in association with Harry N. Abrams, Inc.) will be in bookstores in October.

VIBE 247

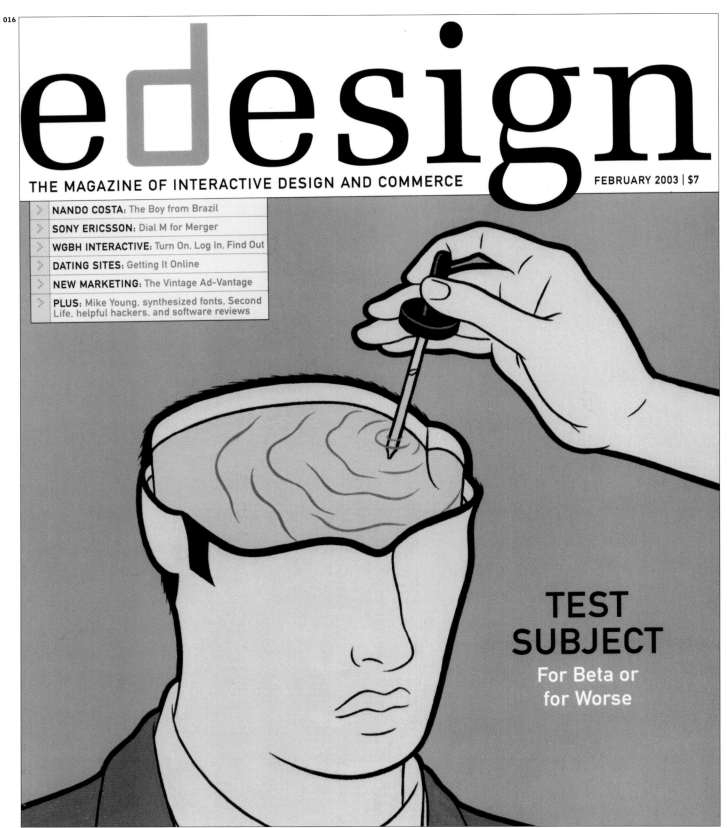

edesign

THE MAGAZINE OF INTERACTIVE DESIGN AND COMMERCE

FEBRUARY 2003 | $7

> NANDO COSTA: The Boy from Brazil
> SONY ERICSSON: Dial M for Merger
> WGBH INTERACTIVE: Turn On, Log In, Find Out
> DATING SITES: Getting It Online
> NEW MARKETING: The Vintage Ad-Vantage
> PLUS: Mike Young, synthesized fonts, Second Life, helpful hackers, and software reviews

TEST SUBJECT

For Beta or for Worse

+ MERIT DESIGN COVER

016
Publication **eDesign**
Art Director **Anke Stohlmann**
Editor-in-Chief **Alanna Stang**
Designers **Anke Stohlmann, Liza Larsson-Alvarez**
Illustrators **Paul Davis, Nick Dewar, Charles S. Anderson, Felix Sockwell, Martin O'Neill**
Photographer **Martyn Goodacre**
Publisher **eDesign Communications Inc.**
Issue **February 2003**

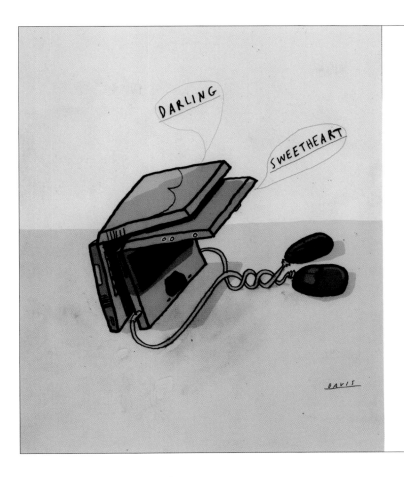

ILLUSTRATION BY PAUL DAVIS

DESIGN GETS PERSONAL | BY DARCY COSPER

Lonelyhearts are fishing for love online, so it's up to the matchmakers to bait an attractive hook[up].

IN THE OFFLINE WORLD, PERSONAL ADS get mocked, ridiculed regularly as a last resort of the undesirable and desperate. Print publications generally banish these notices to the back pages, where they vie for attention with the real estate listings, used-car descriptions, and "adult entertainment" offerings. Online, however, the personal ad appears to be a horse of a different color. In the comfort and privacy of their own homes, users are flinging themselves onto online dating sites without much hesitation and with hardly a blush. Web marketing ingenuity has turned the personals into a hip, new—and, for purveyors, very lucrative—fixture of the mating game. In the first quarter of 2002, the online personals industry was singing silly love songs to the tune of $53.1 million in revenue.

There are dozens of dating Web sites boasting millions of members and thousands of matches. Each has its own mark of distinction, whether it's the interface, dating philosophy, member services, or target market. There's the glam-cute Somebodylikesyou.com, a 21st-century update of passing notes to someone you have a crush on in high school, or eHarmony.com, which emphasizes long-term relationships and a Byzantine process of matching personalities. With style options that stretch from the suburban, LiteFM-flavored Kiss.com to the spunky yet sophisticated Matchmaker.com, and with community options ranging from BlackPlanetLove.com to the personals section of gay and lesbian site PlanetOut, online dating sites are increasingly using design to attract the attention of their perceived target audiences.

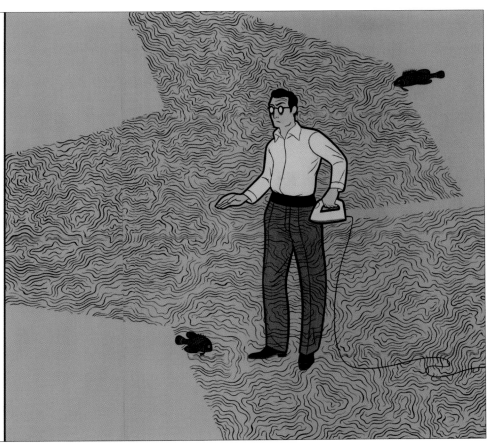

ILLUSTRATION BY NICK DEWAR

BETAVILLE | BY MARK FRAUENFELDER

Where buggy software is as desirable as good tech support, and designers wait in line for the privilege of working with incomplete programs.

THINGS COME IN SEVENS: dwarves, stages of grief, brides for brothers, jewels of wisdom, habits of highly effective people, deadly sins, even castaways on Gilligan's Island. (Rumor has it that each of the castaways can be uniquely matched to one of the deadly sins.)

There are also seven cycles of software development: concept, prototype, alpha, beta, gold, revision, and retirement. Each phase serves an important role in identifying and improving the functionality of a program. The concept stage begins when somebody comes up with a new idea for an application. The prototype demonstrates the concept's core ideas. At the alpha stage, most, but not all, of the features of the program have been determined. Developers test the alpha release in-house, mercilessly squashing any bugs they find and simultaneously adding any extra features they dream up.

Once an application's feature set is decided, the programmers write the beta release—the version meant for use by selected members of a product's user base. Sometimes, a beta release with limited functionality is offered to the general public. Game publishers, for example, might release a demo with a time stamp that renders a program useless after a certain grace period. The software companies that develop the tools found in interactive designers' belts, however, choose very carefully the clients and dedicated users who will be hitting the beta software with their procedural hammers and scanning for flaws, glitches, and improvement potential.

After those changes are implemented, it's a smooth ride to the gold release, the version that is shipped to retailers. Of course, once the product is released commercially, a slew of new bugs surface. These are exterminated in subsequent revisions. The final stage, retirement, means an application has become obsolete.

017

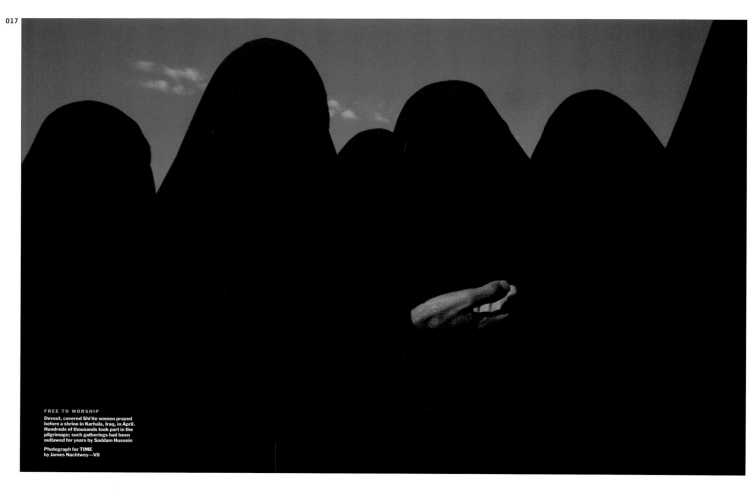

FREE TO WORSHIP
Devout, covered Shi'ite women prayed
before a shrine in Karbala, Iraq, in April.
Hundreds of thousands took part in the
pilgrimage; such gatherings had been
outlawed for years by Saddam Hussein

**Photograph for TIME
by James Nachtwey—VII**

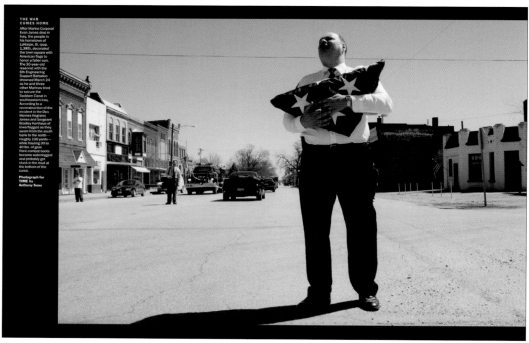

**THE WAR
COMES HOME**
After Marine Corporal
Evan James died in
Iraq, the people in
his hometown of
LaHarpe, Ill. (pop.
1,385), decorated
the town square with
American flags to
honor a fallen son.
The 20-year-old
reservist with the
6th Engineering
Support Battalion
drowned March 24
as he and three
other Marines tried
to secure the
Saddam Canal in
southeastern Iraq.
According to a
reconstruction of the
incident in the Des
Moines Register,
James and Sergeant
Bradley Korthaus of
Iowa flagged as they
swam from the south
bank to the north—
roughly 100 yards—
while hauling 30 to
40 lbs. of gear.
Their combat boots
became waterlogged
and probably got
stuck in the mud at
the bottom of the
canal.

**Photograph for
TIME by
Anthony Suau**

017
Publication **Time**
Art Director **Arthur Hochstein**
Editor-in-Chief **James Kelly**
Photographers **James Nachtwey, Christopher Morris, Yuri Kozyrev, Robert Nickelsberg, Brooks Kraft, Stephanie Sinclair, Anthony Suau, Steve Liss**
Deputy Art Director **Cynthia A. Hoffman**
Director of Photography **Michele Stephenson**
Picture Editor **Maryanne Golon**
Publisher **Time Inc.**
Issue **December 22, 2003**

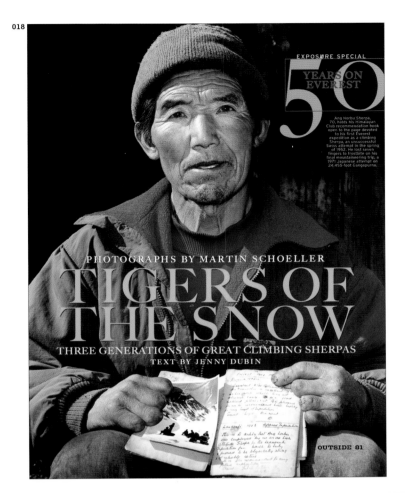

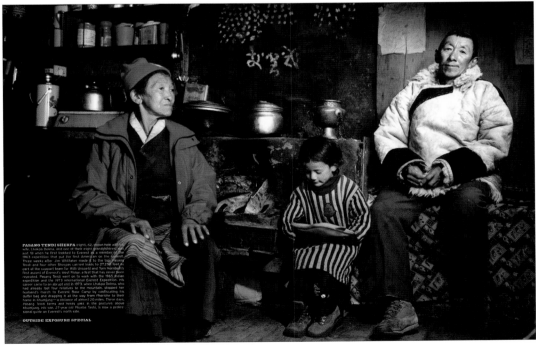

018
Publication **Outside**
Creative Director **Hannah McCaughey**
Editor-in-Chief **Hal Espen**
Designer **Hannah McCaughey**
Photo Editor **Rob Haggart**
Photographer **Martin Schoeller**
Associate Photo Editor **Quentin Nardi**
Publisher **Mariah Media, Inc.**
Issue **April 2003**

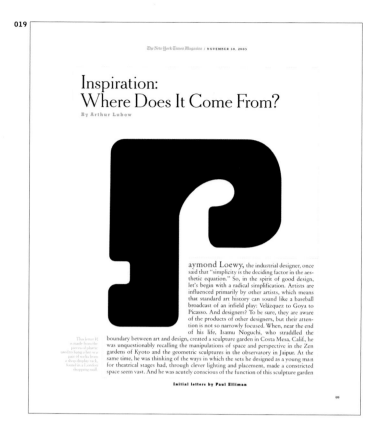

019
Publication **The New York Times Magazine**
Art Director **Janet Froelich**
Editor-in-Chief **Gerald Marzorati**
Designer **Janet Froelich**
Photo Editors **Kathy Ryan, Jody Quon**
Publisher **The New York Times**
Issue **November 30, 2003**

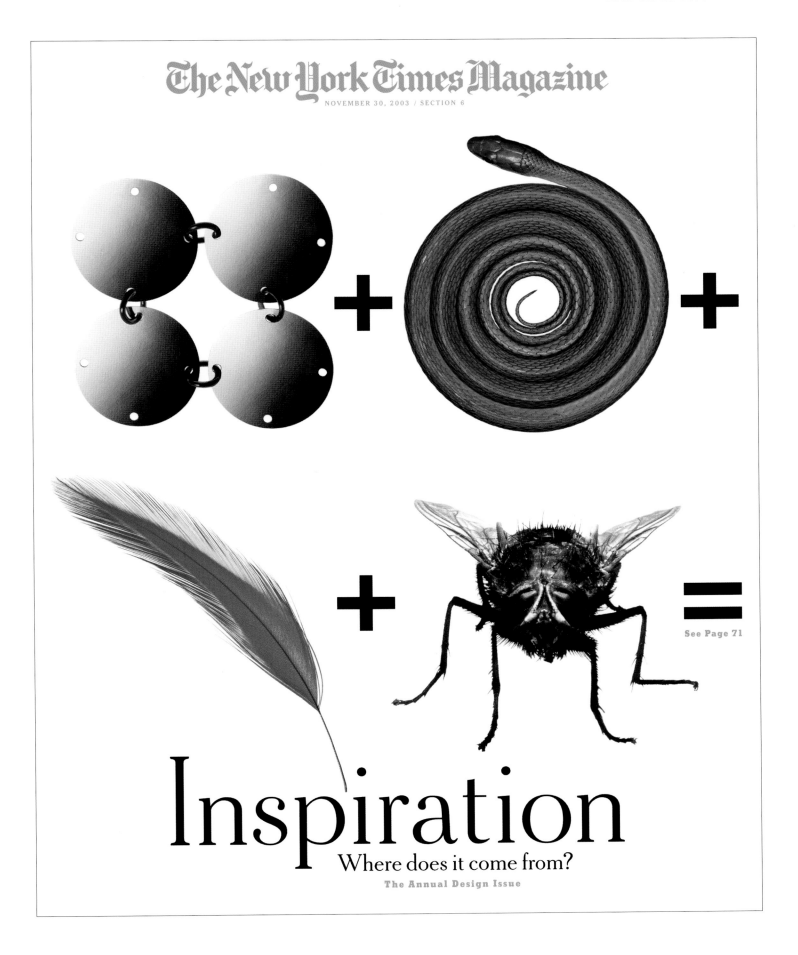

The New York Times Magazine

NOVEMBER 30, 2003 / SECTION 6

See Page 71

Inspiration

Where does it come from?

The Annual Design Issue

020

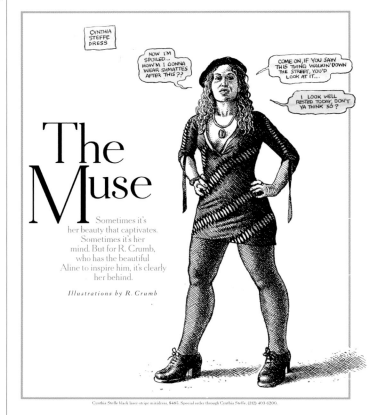

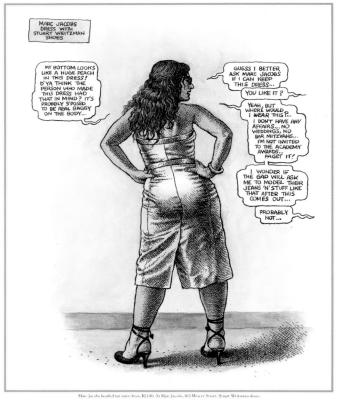

020
Publication **The New York Times Magazine**
Art Director **Janet Froelich**
Editor-in-Chief **Gerald Marzorati**
Designer **Joele Cuyler**
Illustrator **R. Crumb**
Style Editor **Andy Port**
Publisher **The New York Times**
Issue **March 30, 2003**

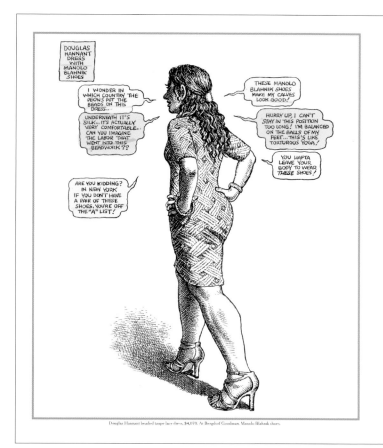

Douglas Hannant beaded taupe lace dress, $4,070. At Bergdorf Goodman. Manolo Blahnik shoes.

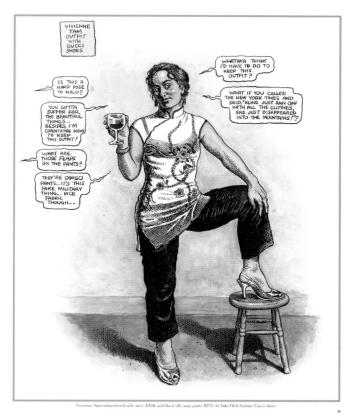

Vivienne Tam embroidered tulle tunic, $308, and black silk cargo pants, $273. At Saks Fifth Avenue. Gucci shoes.

021

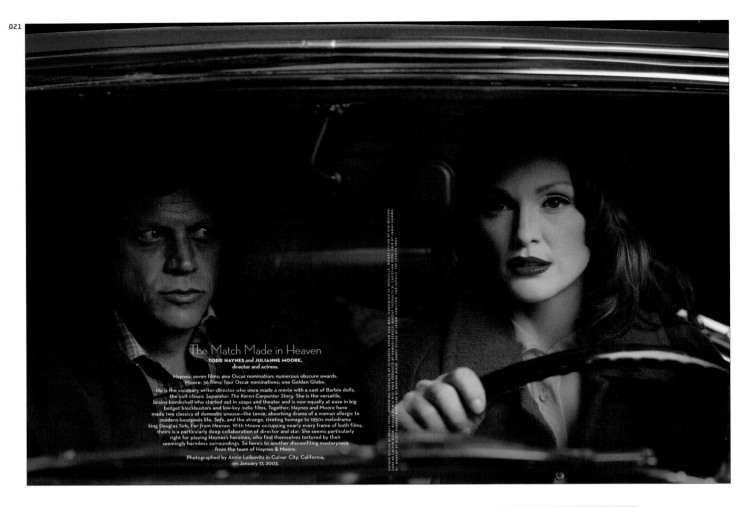

The Match Made in Heaven
TODD HAYNES and JULIANNE MOORE,
director and actress.

Haynes: seven films; one Oscar nomination; numerous obscure awards.
Moore: 36 films; four Oscar nominations; one Golden Globe.

He is the visionary writer-director who once made a movie with a cast of Barbie dolls,
the cult classic Superstar: The Karen Carpenter Story. She is the versatile,
brainy bombshell who started out in soaps and theater and is now equally at ease in big-
budget blockbusters and low-key indie films. Together, Haynes and Moore have
made two classics of domestic unease—the tense, absorbing drama of a woman allergic to
modern bourgeois life, Safe, and the strange, riveting homage to 1950s melodrama
king Douglas Sirk, Far from Heaven. With Moore occupying nearly every frame of both films,
theirs is a particularly deep collaboration of director and star. She seems particularly
right for playing Haynes's heroines, who find themselves tortured by their
seemingly harmless surroundings. So here's to another discomfiting masterpiece
from the team of Haynes & Moore.

Photographed by Annie Leibovitz in Culver City, California,
on January 17, 2003.

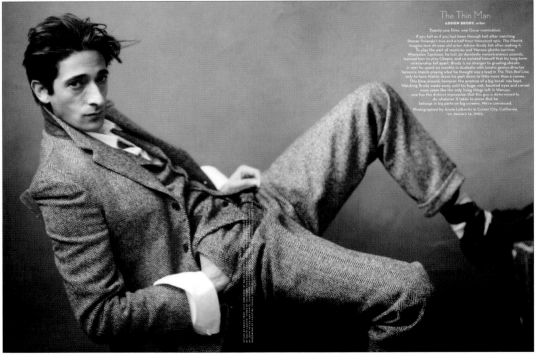

The Thin Man
ADRIEN BRODY, actor.

Twenty-one films, one Oscar nomination.

If you felt as if you had been through hell after watching
Roman Polanski's two-and-a-half-hour Holocaust epic, The Pianist,
imagine how 29-year-old actor Adrien Brody felt after making it.
To play the part of musician and Warsaw-ghetto survivor
Władysław Szpilman, he lost 30 decidedly nonexistent pounds,
learned how to play Chopin, and so isolated himself that his long-term
relationship fell apart. Brody is no stranger to grueling shoots:
in 1997 he spent six months in Australia with lunatic-genius director
Terrence Malick playing what he thought was a lead in The Thin Red Line,
only to have Malick shave his part down to little more than a cameo.
This time around, however, the promise of a big break was kept.
Watching Brody waste away, until his huge, wet, haunted eyes and cornet
nose seem like the only living things left in Warsaw,
one has the distinct impression that this guy is determined to
do whatever it takes to prove that he
belongs in big parts on big screens. We're convinced.

Photographed by Annie Leibovitz in Culver City, California,
on January 14, 2003.

021
Publication **Vanity Fair**
Design Director **David Harris**
Editor-in-Chief **Graydon Carter**
Art Director **Julie Weiss**
Designers **Chris Israel, Chris Mueller**
Photo Director **Susan White**
Photographers **Annie Leibovitz, Bruce Weber, Jim Rakete,**

Peggy Sirota, Julian Broad, Firooz Zahedi, Brigitte Lacombe,
Mark Seliger, Sam Jones, David LaChapelle, Michel Comte,
Jason Schmidt, Peter Lindbergh
Photo Editor **Lisa Berman**
Photo Producers **Ron Beinner, Sarah Czeladnicki, Kathryn MacLeod**
Publisher **The Condé Nast Publications Inc.**
Issue **April 2003**

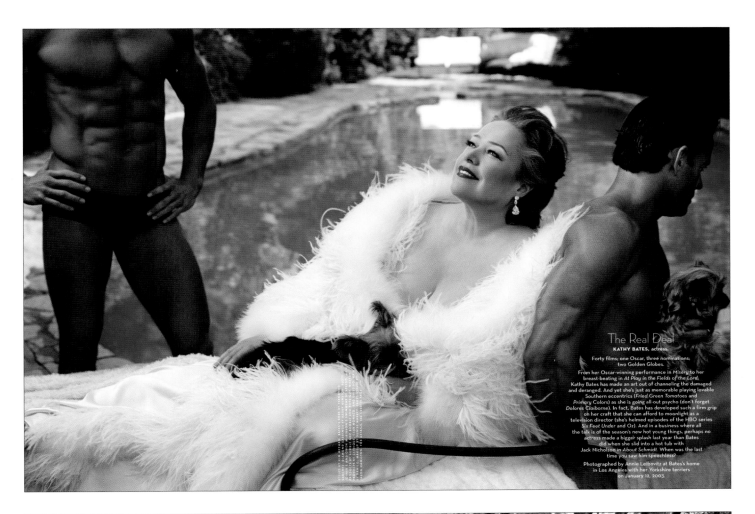

The Real Deal
KATHY BATES, actress.

Forty films; one Oscar, three nominations;
two Golden Globes.

From her Oscar-winning performance in *Misery* to her
breast-beating in *At Play in the Fields of the Lord*,
Kathy Bates has made an art out of channeling the damaged
and deranged. And yet she's just as memorable playing lovable
Southern eccentrics (*Fried Green Tomatoes* and
Primary Colors) as she is going all-out psycho (don't forget
Dolores Claiborne). In fact, Bates has developed such a firm grip
on her craft that she can afford to moonlight as a
television director (she's helmed episodes of the HBO series
Six Feet Under and *Oz*). And in a business where all
the talk is of the season's new hot young things, perhaps no
actress made a bigger splash last year than Bates
did when she slid into a hot tub with
Jack Nicholson in *About Schmidt*. When was the last
time you saw him speechless?

Photographed by Annie Leibovitz at Bates's home
in Los Angeles with her Yorkshire terriers
on January 12, 2003.

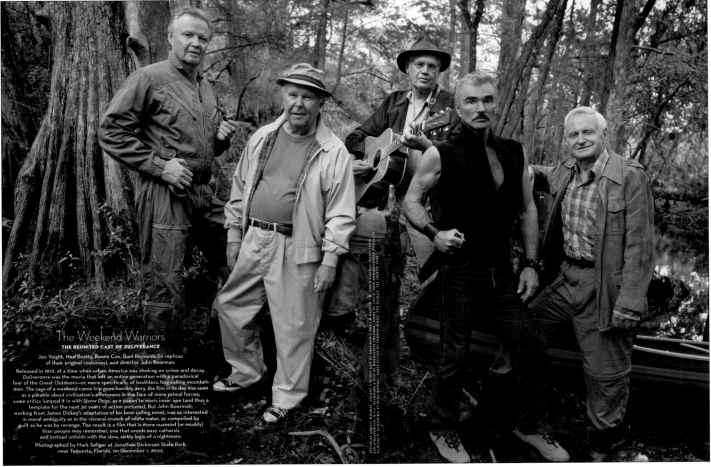

The Weekend Warriors
THE REUNITED CAST OF *DELIVERANCE*

Jon Voight, Ned Beatty, Ronny Cox, Burt Reynolds (in replicas
of their original costumes), and director John Boorman.

Released in 1972, at a time when urban America was choking on crime and decay,
Deliverance was the movie that left an entire generation with a paradoxical
fear of the Great Outdoors—or, more specifically, of toothless, hog-calling mountain
men. The saga of a weekend canoe trip gone horribly awry, the film in its day was seen
as a parable about civilization's effeteness in the face of more primal forces;
some critics lumped it in with *Straw Dogs*, as a paean to man's inner ape (and thus a
template for the next 30 years of action pictures). But John Boorman,
working from James Dickey's adaptation of his best-selling novel, was as interested
in moral ambiguity as in the visceral crunch of white water, as compelled by
guilt as he was by revenge. The result is a film that is more nuanced (or muddy)
than people may remember, one that avoids easy catharsis
and instead unfolds with the slow, sickly logic of a nightmare.

Photographed by Mark Seliger at Jonathan Dickinson State Park,
near Tequesta, Florida, on December 1, 2002.

022

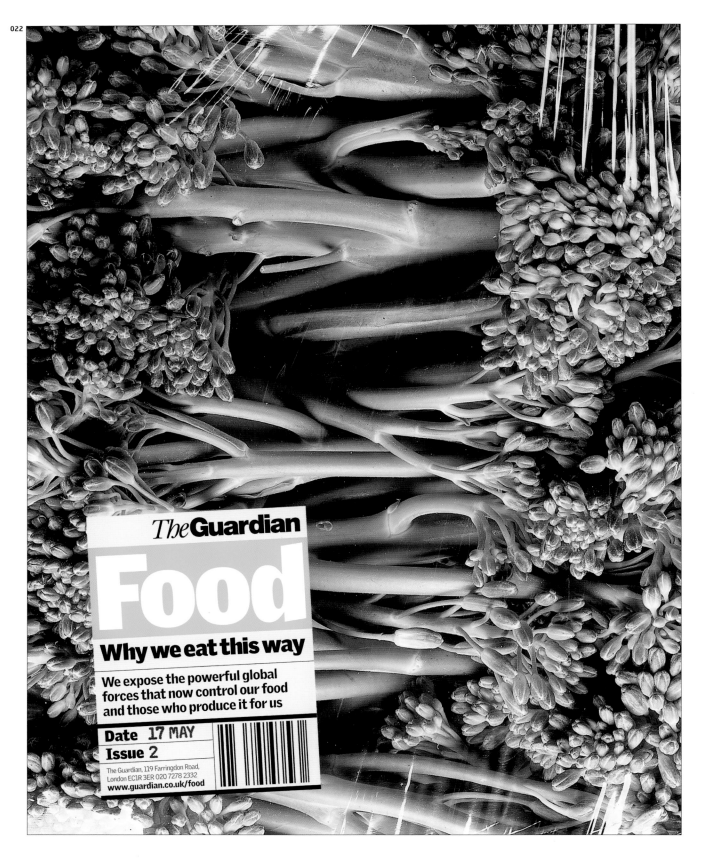

022
Publication **The Guardian**
Creative Director **Mark Porter**
Designer **Richard Turley**
Photographer **Colin Campbell**
Publisher **Guardian Newspapers Limited**
Issue **May 17, 2003**

023
Publication **Martha Stewart Kids**
Creative Director **Gael Towey**
Editor-in-Chief **Margaret Roach**
Design Director **Deb Bishop**
Photo Editors **Stacie McCormick, Jamie Bass Perrotta**
Photographer **Stephen Lewis**
Stylist **Anna Beckman**
Publisher **Martha Stewart Living Omnimedia**
Issue **Fall 2003**

023

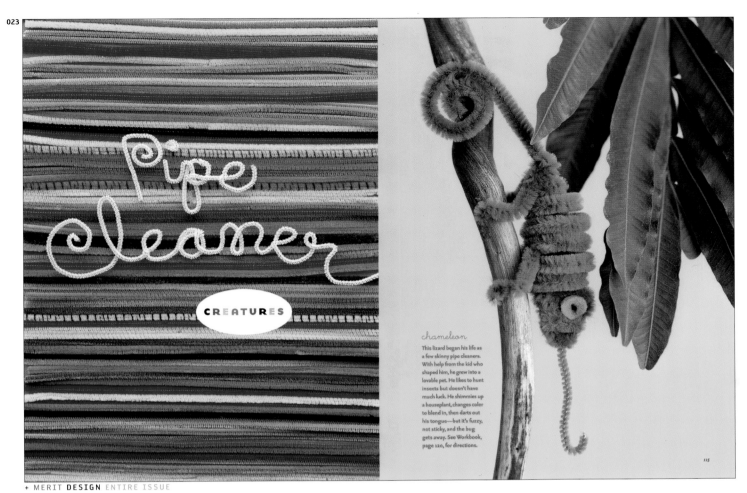

CREATURES

chameleon

This lizard began his life as a few skinny pipe cleaners. With help from the kid who shaped him, he grew into a lovable pet. He likes to hunt insects but doesn't have much luck. He shimmies up a houseplant, changes color to blend in, then darts out his tongue—but it's fuzzy, not sticky, and the bug gets away. See Workbook, page 120, for directions.

115

+ MERIT **DESIGN** ENTIRE ISSUE

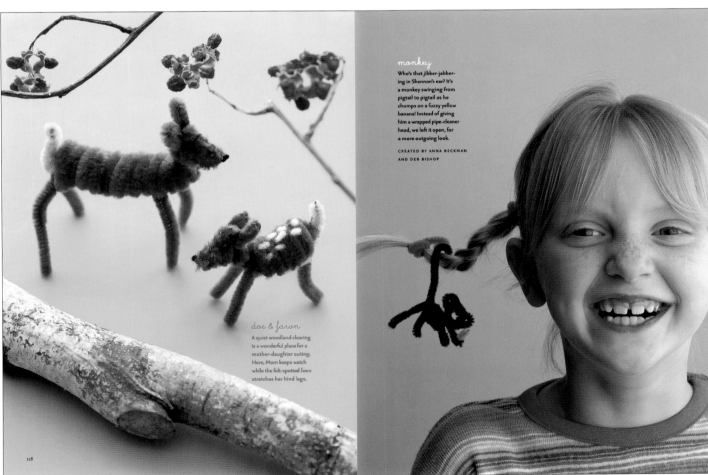

monkey

Who's that jibber-jabbering in Shannon's ear? It's a monkey swinging from pigtail to pigtail as he chomps on a fuzzy yellow banana! Instead of giving him a wrapped pipe-cleaner head, we left it open, for a more outgoing look.

CREATED BY ANNA BECKMAN AND DEB BISHOP

doe & fawn

A quiet woodland clearing is a wonderful place for a mother-daughter outing. Here, Mom keeps watch while the felt-spotted fawn stretches her hind legs.

118

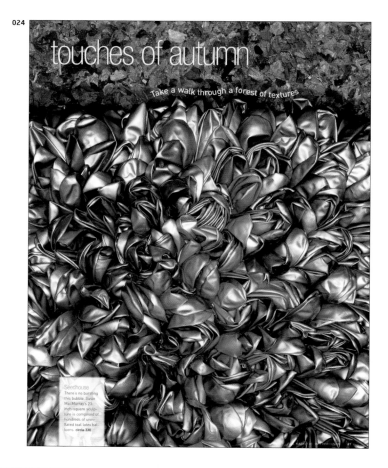

024
Publication **Interior Design Magazine**
Art Director **Claudia P. Marulanda**
Editor-in-Chief **Cynthia Allen**
Designer **Claudia P. Marulanda**
Photographer **Laura Johansen**
Publisher **Reed Business Information**
Issue **Fall Market 2003**

025
Publication **Comcast High-Speed Internet**
Creative Director **Melanie McLaughlin**
Editor-in-Chief **Neil McManus**
Design Director **Cindy Rosen**
Designers **Jill McLaughlin, Salve Retuta,
Phuong Tran, Shawn Berven**
Publisher **Comcast**
Online Address **http://www.comcast.net**

026

DR. ROBERT J.
FREEMAN PUTS
THE LATEST
ACCOUNTING
SCANDAL IN
PERSPECTIVE

—

HOW THE
PROFESSION WILL
BE IMPACTED

=

BAILOUT

026
Publication **Rawls Exchange**
Creative Director **Artie Limmer**
Design Director **Alyson Keeling Cameron**
Designer **Alyson Keeling Cameron**
Photographer **Melissa Goodlett**
Publisher **Texas Tech University**
Issue **Spring 2003**

027
Publication **El Mundo Metropoli**
Design Director **Carmelo Caderot**
Editor-in-Chief **Miguel Angel Mellado**
Art Director **Rodrigo Sanchez**
Designer **Rodrigo Sanchez**
Photo Editor **Rodrigo Sanchez**
Photographer **Angel Becerril**
Publisher **Unidad Editorial S.A.**
Issue **November 14, 2003**

028

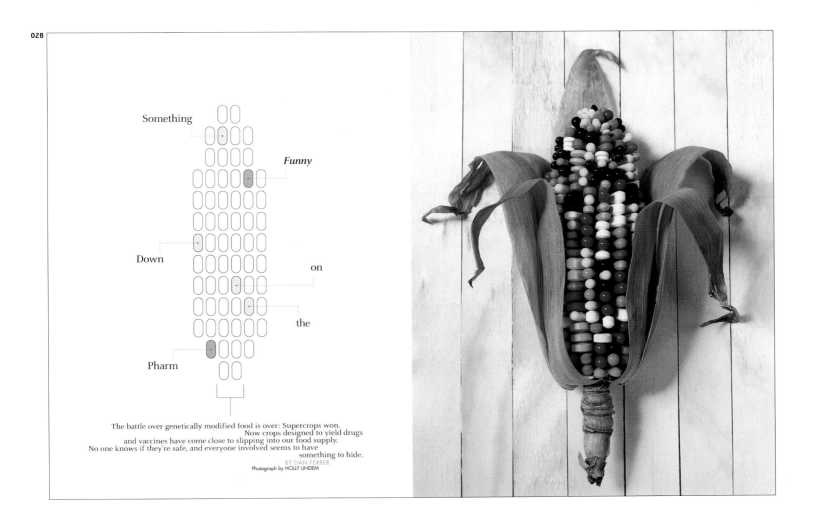

Something

Funny

Down on

the

Pharm

The battle over genetically modified food is over: Supercrops won.
Now crops designed to yield drugs
and vaccines have come close to slipping into our food supply.
No one knows if they're safe, and everyone involved seems to have
something to hide.
BY DAN FERBER
Photograph by HOLLY LINDEM

028
Publication **Popular Science**
Design Director **Dirk Barnett**
Editor-in-Chief **Scott Mowbray**
Art Director **Hylah Hill**
Designers **Hylah Hill, Dirk Barnett**
Photo Editor **Kris Lamanna**
Photographer **Holly Linden**
Publisher **Time4Media**
Issue **April 2003**

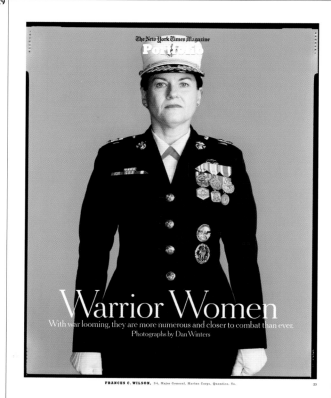

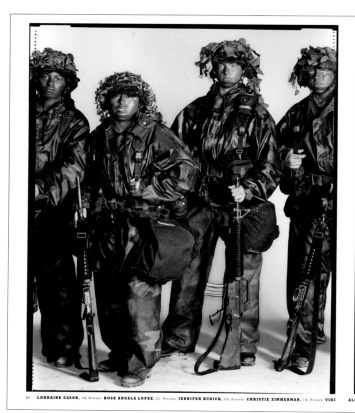
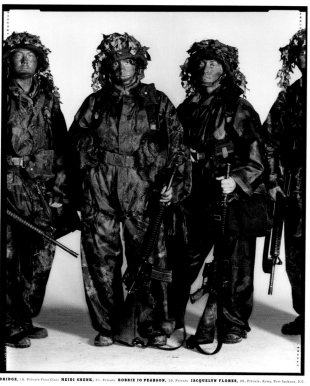

029
Publication **The New York Times Magazine**
Art Director **Janet Froelich**
Editor-in-Chief **Gerald Marzorati**
Designer **Joele Cuyler**
Photo Editor **Kathy Ryan**
Photographer **Dan Winters**
Publisher **The New York Times**
Issue **February 16, 2003**

030
Publication **The New York Times Magazine**
Art Director **Janet Froelich**
Editor-in-Chief **Gerald Marzorati**
Designer **Jeff Glendenning**
Illustrator **Tomer Hanuka**
Publisher **The New York Times**
Issue **April 27, 2003**

John Malkovich Won't Let Himself Be By Lynn Hirschberg

The New York Times Magazine

APRIL 27, 2003 / SECTION 6

Escape
From North
Korea

By Michael Paterniti

Putting the West Together Again By Timothy Garton Ash No Way to Run an Empire By Niall Ferguson

031

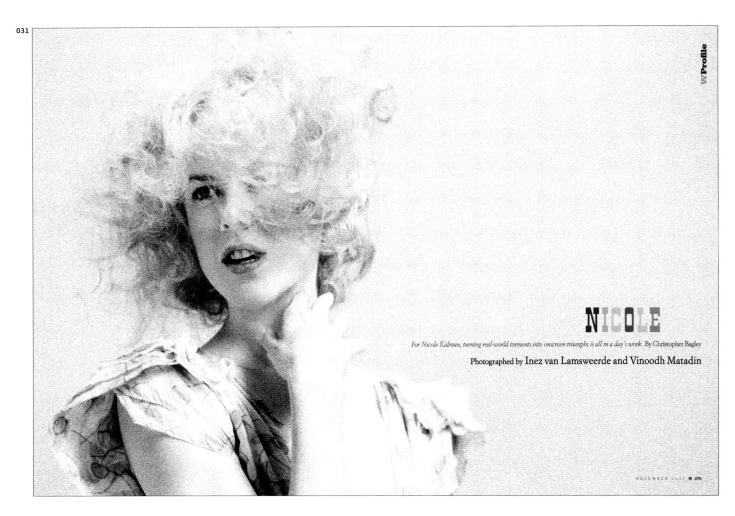

NICOLE

For Nicole Kidman, turning real-world torments into onscreen triumphs is all in a day's work. By Christopher Bagley

Photographed by Inez van Lamsweerde and Vinoodh Matadin

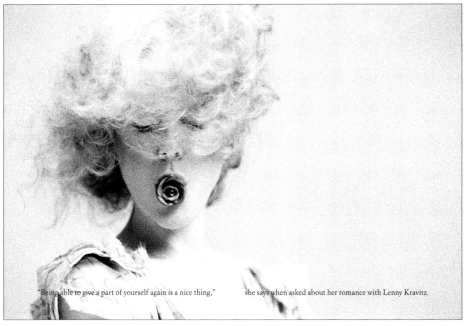

"Being able to give a part of yourself again is a nice thing," she says when asked about her romance with Lenny Kravitz.

031
Publication **W Magazine**
Creative Director **Dennis Freedman**
Editor-in-Chief **Patrick McCarthy**
Design Director **Edward Leida**
Art Director **Kirby Rodriguez**
Designers **Edward Leida, Angela Panichi, Shanna Greenberg**
Photographers **Inez Van Kamsweerde** & **Vinoodh Matadin**
Publisher **Fairchild Publications**
Issue **December 2003**

032
Publication **W Magazine**
Creative Director **Dennis Freedman**
Editor-in-Chief **Patrick McCarthy**
Design Director **Edward Leida**
Art Director **Kirby Rodriguez**
Designers **Edward Leida, Angela Panichi, Shanna Greenberg**
Photographer **Philip Lorca Dicorcia**
Publisher **Fairchild Publications**
Issue **November 2003**

032

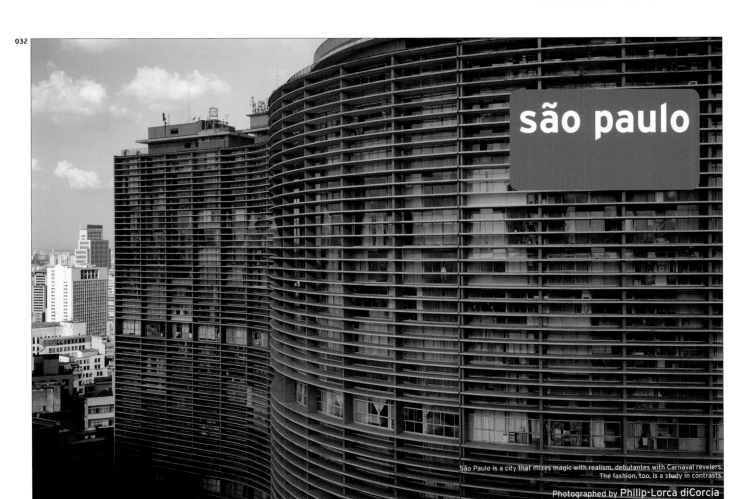

são paulo

São Paulo is a city that mixes magic with realism, debutantes with Carnaval revelers. The fashion, too, is a study in contrasts.

Photographed by **Philip-Lorca diCorcia**

Reem Acra's silk satin bridal gown, at Reem Acra, New York, 212.308.8760, www.reemacra.com. Sposabella crown; Agatha necklace; Portolano gloves. **Ralph Lauren Childrenswear**'s wool suit and cotton shirt, at Ralph Lauren nationwide, www.polo.com. Tommy Hilfiger tie.

This feature styled by Joe Zee. Hair by Kevin Ryan for Aveda; makeup by Dick Page/Jed Root. Models: Carolina Nunes, Patricia Sgai, Juliana Rinaldi, Gledes Romano, Paulo Henrique Barbosa, Juliana De Faria, Alan Lliezer, Nuri Choo, Tatiana Augusto, Fabio Escorel, Cassiano Santos and Thais Castilho. Casting by Jennifer Vendetti; local casting coordinator: Anna Luiza; production by Superstudio; location consultant: Lorez Ackerman; location scouting by Primeira Agencia de Locacao. Fashion assistants: Suzanne Karotkin and Shana Novak.

Special thanks to Chico Loendes, Cadu Alvez and Lucas Lenci at Superstudio. While in São Paulo, the crew stayed at the Unique Hotel. Please see "Personal Shopper," page 242, for information.

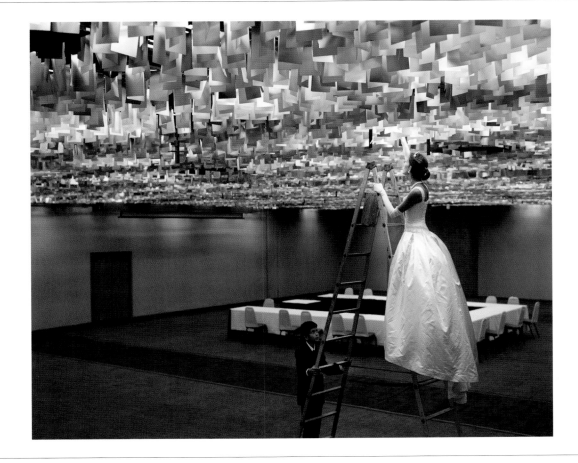

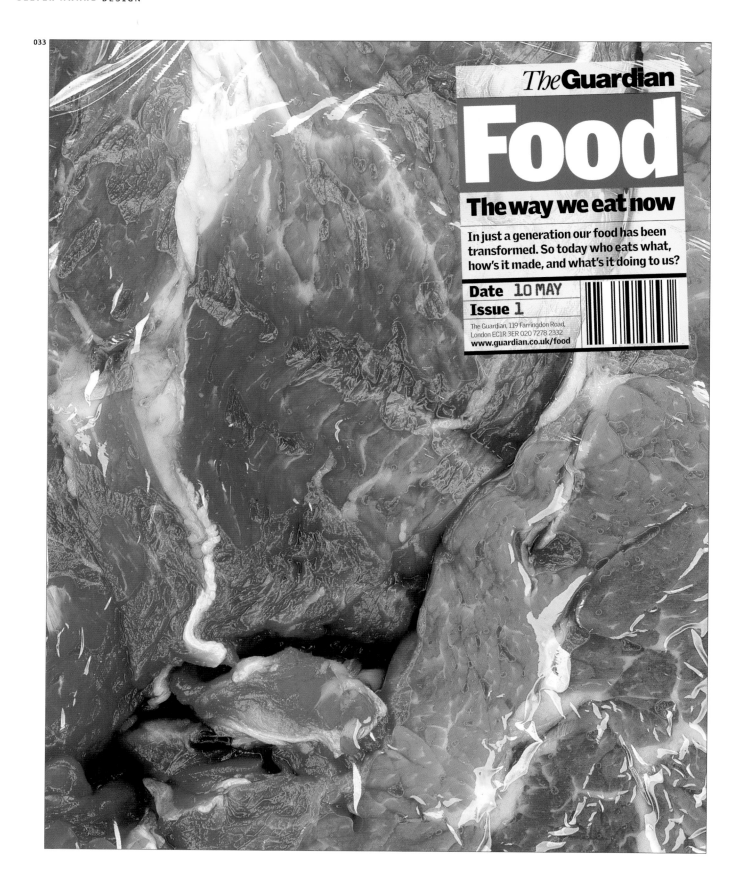

033
Publication **The Guardian**
Creative Director **Mark Porter**
Designer **Richard Turley**
Photographer **Colin Campbell**
Publisher **Guardian Newspapers Limited**
Issue **May 10, 2003**

034
Publication **Time**
Design Director **Arthur Hochstein**
Editor-in-Chief **James Kelly**
Designer **Arthur Hochstein**
Illustrator **Roberto Parada**
Publisher **Time Inc.**
Issue **April 21, 2003**

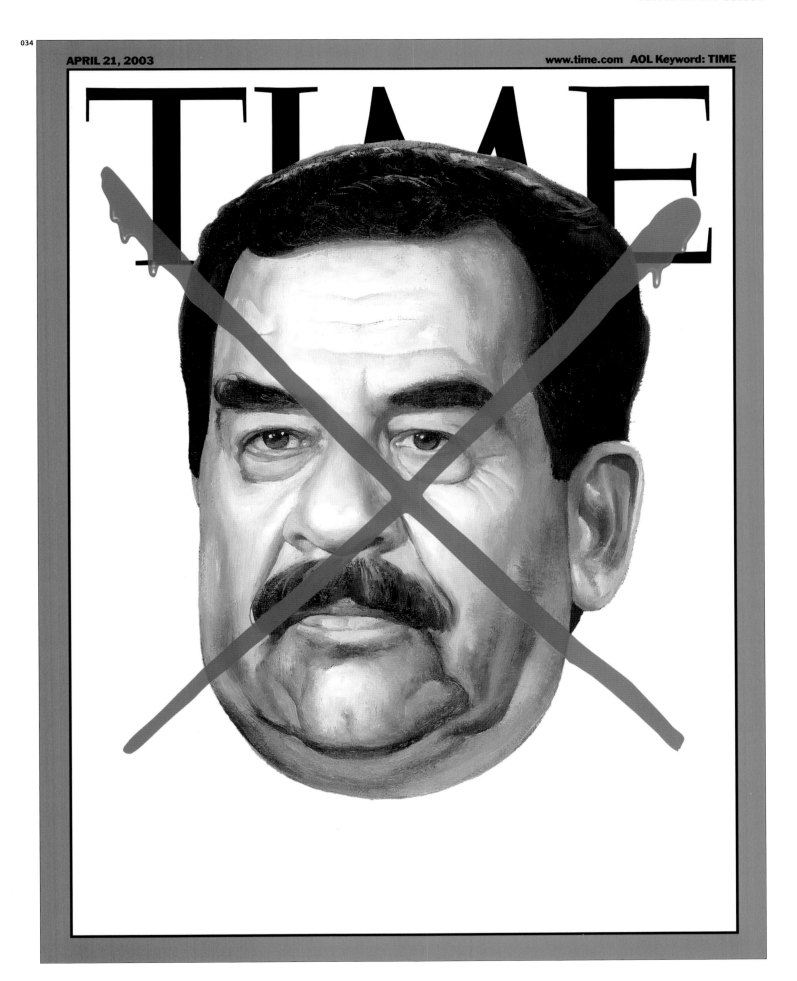

APRIL 21, 2003

www.time.com AOL Keyword: **TIME**

035

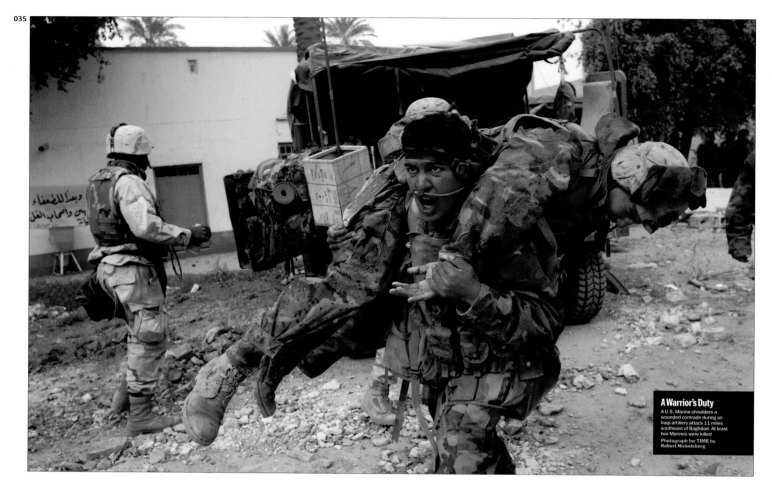

A Warrior's Duty
A U.S. Marine shoulders a wounded comrade during an Iraqi artillery attack 11 miles southeast of Baghdad. At least two Marines were killed
Photograph for TIME by Robert Nickelsberg

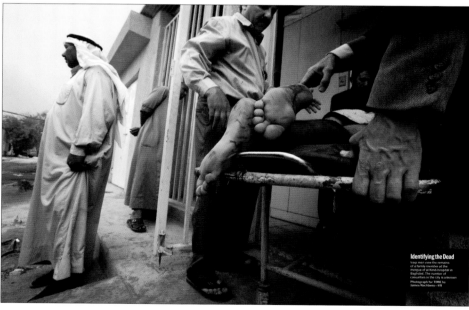

Identifying the Dead
Iraqi men view the remains of a family member at the morgue of al Kindi hospital in Baghdad. The number of casualties in the city is unknown
Photograph for TIME by James Nachtwey—VII

035
Publication **Time**
Art Director **Arthur Hochstein**
Editor-in-Chief **James Kelly**
Photographers **James Nachtwey, Yuri Kozyrev, Robert Nickelsberg, Thomas Dworzak, Yunghi Kim**
Deputy Art Director **Cynthia A. Hoffman**
Director of Photography **Michele Stephenson**
Picture Editor **Maryanne Golon**
Deputy Picture Editor **Hillary Raskin**
Associate Picture Editor **Alice Gabriner**
Publisher **Time Inc.**
Issue **April 21, 2003**

036
Publication **Time**
Art Director **Arthur Hochstein**
Editor-in-Chief **James Kelly**
Photographers **James Nachtwey, Yuri Kozyrev, Robert Nickelsberg, Benjamin Lowy**
Senior Art Director **Thomas M. Miller**
Director of Photography **Michele Stephenson**
Picture Editor **Maryanne Golon**
Deputy Picture Editor **Hillary Raskin**
Associate Picture Editor **Alice Gabriner**
Publisher **Time Inc.**
Issue **April 14, 2003**

036

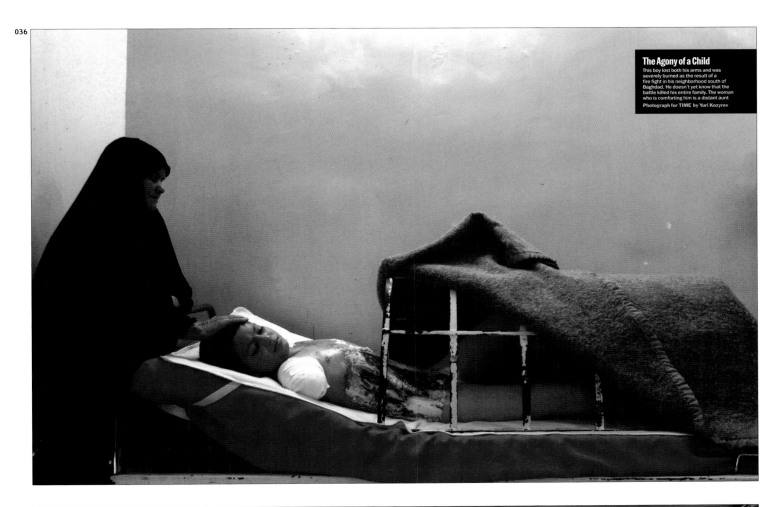

The Agony of a Child
This boy lost both his arms and was severely burned as the result of a fire fight in his neighborhood south of Baghdad. He doesn't yet know that the battle killed his entire family. The woman who is comforting him is a distant aunt
Photograph for TIME by Yuri Kozyrev

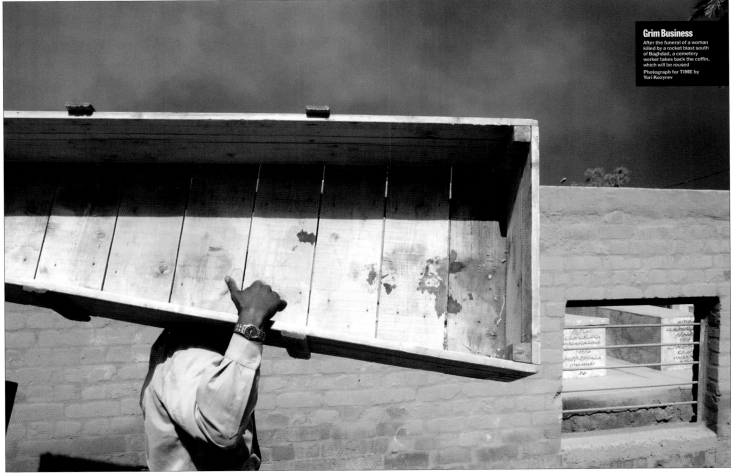

Grim Business
After the funeral of a woman killed by a rocket blast south of Baghdad, a cemetery worker takes back the coffin, which will be reused
Photograph for TIME by Yuri Kozyrev

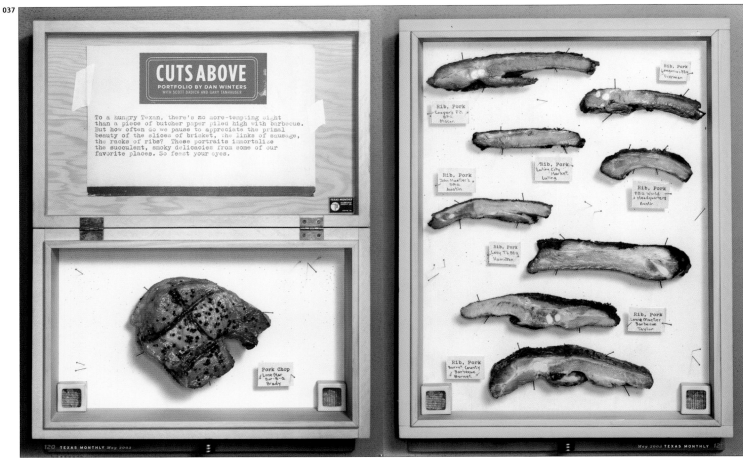

+ MERIT STILL LIFE PHOTOGRAPHY ENTIRE STORY

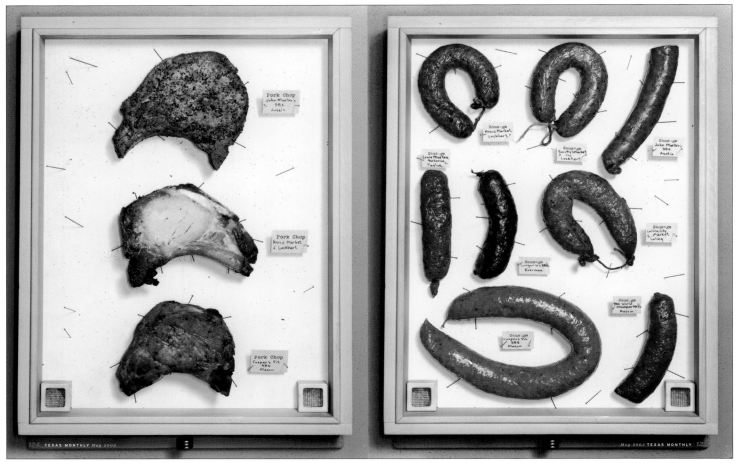

037 Publication **Texas Monthly** (credits on next spread)

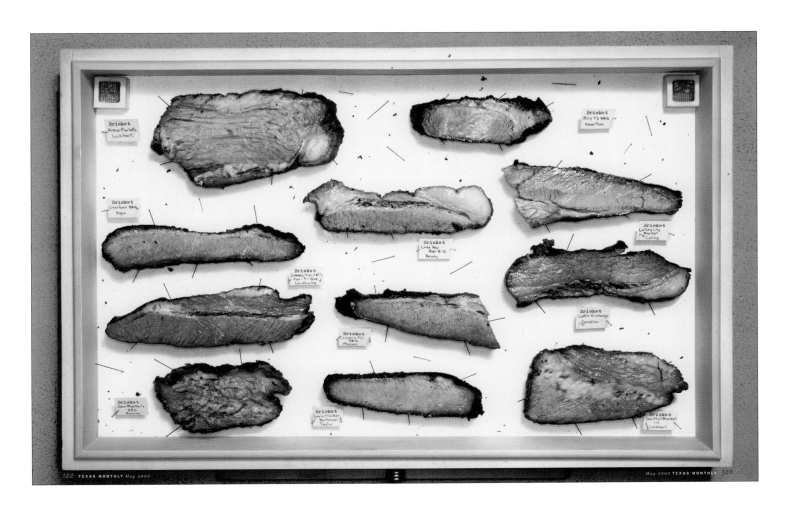

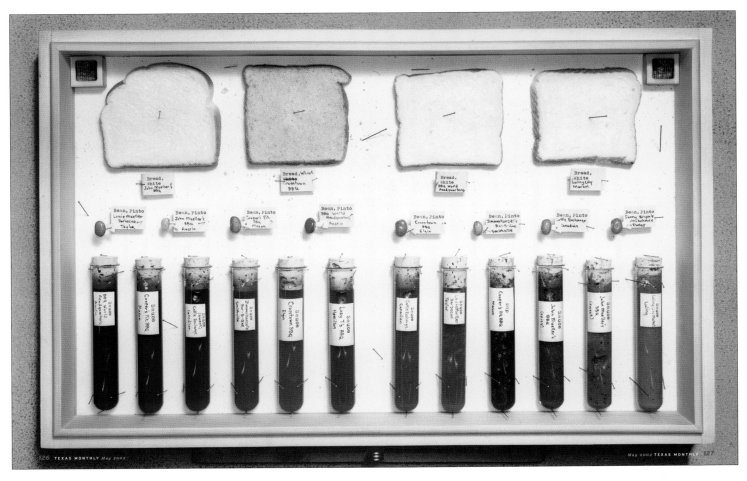

038

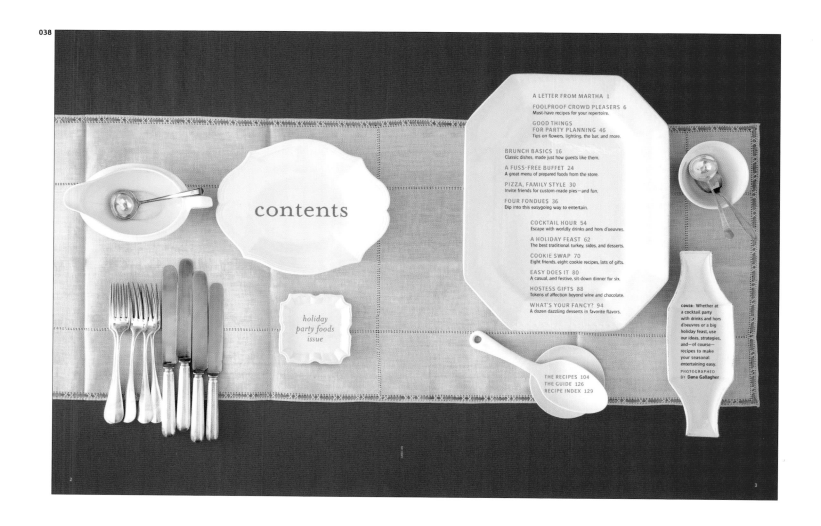

A LETTER FROM MARTHA 1

FOOLPROOF CROWD PLEASERS 6
Must-have recipes for your repertoire.

GOOD THINGS
FOR PARTY PLANNING 46
Tips on flowers, lighting, the bar, and more.

BRUNCH BASICS 16
Classic dishes, made just how guests like them.

A FUSS-FREE BUFFET 24
A great menu of prepared foods from the store.

PIZZA, FAMILY STYLE 30
Invite friends for custom-made pies—and fun.

FOUR FONDUES 36
Dip into this easygoing way to entertain.

COCKTAIL HOUR 54
Escape with worldly drinks and hors d'oeuvres.

A HOLIDAY FEAST 62
The best traditional turkey, sides, and desserts.

COOKIE SWAP 70
Eight friends, eight cookie recipes, lots of gifts.

EASY DOES IT 80
A casual, and festive, sit-down dinner for six.

HOSTESS GIFTS 88
Tokens of affection beyond wine and chocolate.

WHAT'S YOUR FANCY? 94
A dozen dazzling desserts in favorite flavors.

contents

holiday
party foods
issue

COVER: Whether at
a cocktail party
with drinks and hors
d'oeuvres or a big
holiday feast, use
our ideas, strategies,
and—of course—
recipes to make
your seasonal
entertaining easy.
PHOTOGRAPHED
BY Dana Gallagher

THE RECIPES 104
THE GUIDE 126
RECIPE INDEX 129

037
Publication **Texas Monthly**
Art Director **Scott Dadich**
Editor-in-Chief **Evan Smith**
Designers **Scott Dadich, TJ Tucker**
Photo Editor **Scott Dadich**
Photographers **Dan Winters, Scott Dadich**
Publisher **Emmis Communications Corp.**
Issue **May 2003**

038
Publication **Martha Stewart Holiday**
Creative Director **Eric Pike**
Editor-in-Chief **Margaret Roach**
Art Director **Jill Groeber**
Photo Editors **Stacie McCormick, Beth Krzyzkowski**
Photographer **Dana Gallagher**
Publisher **Martha Stewart Omnimedia**
Issue **Holiday 2003**

039
Publication **Teen Vogue**
Art Director **Lina Kutsovskaya**
Editor-in-Chief **Amy Astley**
Designers **James Casey, Jason Engdahl,
Holly Stevenson, Emily Wardwell**
Photo Editor **Lucy Lee**
Photographers **Thomas Schenk, Tom Munro,
Carter Smith, Magnus Unnar, Corinne Day,
Raymond Meier**
Associate Photo Editor **Brody Baker**
Assistant Photo Editor **Jillian Johnson**
Publisher **Condé Nast Publications Inc.**
Issue **April/May 2003**

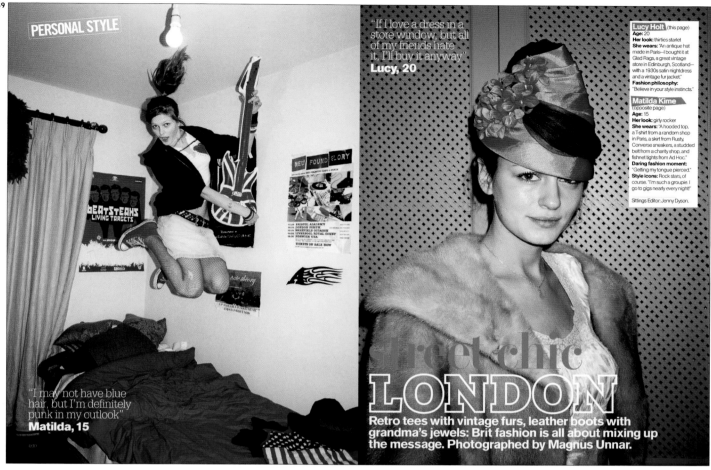

PERSONAL STYLE

"If I love a dress in a store window, but all of my friends hate it, I'll buy it anyway."
Lucy, 20

"I may not have blue hair, but I'm definitely punk in my outlook"
Matilda, 15

street chic
LONDON
Retro tees with vintage furs, leather boots with grandma's jewels: Brit fashion is all about mixing up the message. Photographed by Magnus Unnar.

Lucy Holt (this page)
Age: 20
Her look: thirties starlet
She wears: "An antique hat made in Paris—I bought it at Glad Rags, a great vintage store in Edinburgh, Scotland— with a 1930s satin nightdress and a vintage fur jacket."
Fashion philosophy: "Believe in your style instincts."

Matilda Kime (opposite page)
Age: 15
Her look: girly rocker
She wears: "A hooded top, a T-shirt from a random shop in Paris, a skirt from Rusty, Converse sneakers, a studded belt from a charity shop, and fishnet tights from Ad Hoc."
Daring fashion moment: "Getting my tongue pierced."
Style icons: Rock stars, of course. "I'm such a groupie. I go to gigs nearly every night!"

Sittings Editor: Jenny Dyson.

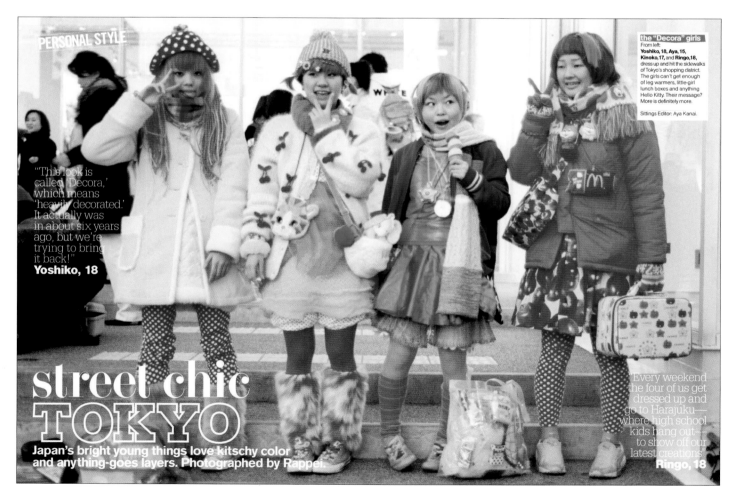

PERSONAL STYLE

"This look is called 'Decora,' which means 'heavily decorated.' It actually was in about six years ago, but we're trying to bring it back!"
Yoshiko, 18

street chic
TOKYO
Japan's bright young things love kitschy color and anything-goes layers. Photographed by Rappei.

the "Decora" girls
From left:
Yoshiko, 18, Aya, 15, Kinoko, 17, and **Ringo, 18,** dress up and hit the sidewalks of Tokyo's shopping district. The girls can't get enough of leg warmers, little-girl lunch boxes and anything Hello Kitty. Their message? More is definitely more.

Sittings Editor: Aya Kanai.

"Every weekend the four of us get dressed up and go to Harajuku— where high school kids hang out— to show off our latest creations"
Ringo, 18

040

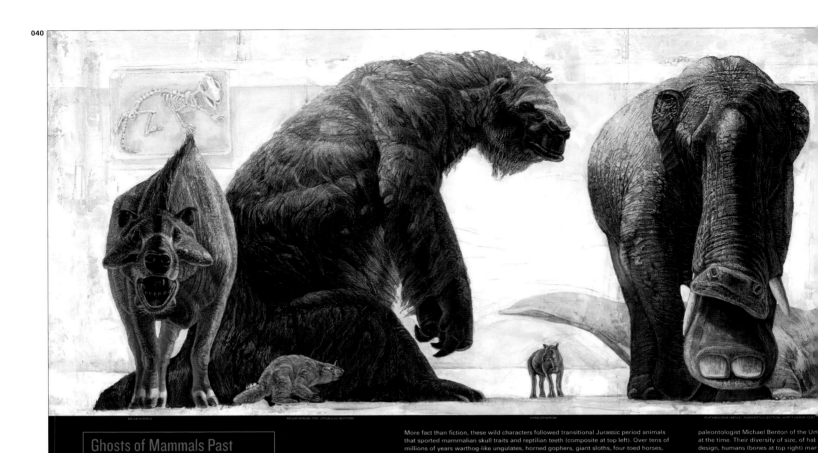

Ghosts of Mammals Past

More fact than fiction, these wild characters followed transitional Jurassic period animals that sported mammalian skull traits and reptilian teeth (composite at top left). Over tens of millions of years warthog-like ungulates, horned gophers, giant sloths, four-toed horses, elephant relatives with toothed shovels for jaws, legged whales, and leaf-nosed bats made their debuts and, ultimately, their exits. "In its day, each was highly successful," says

paleontologist Michael Benton of the Uni at the time. Their diversity of size, of hal design, humans (bones at top right) mar assemblage. If you want a full picture o go way back from here."

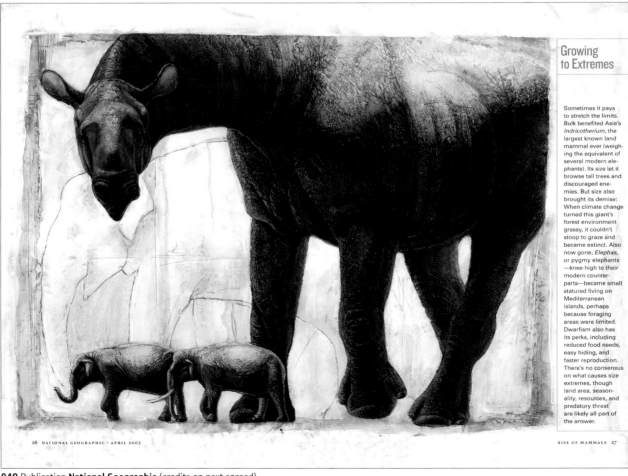

Growing to Extremes

Sometimes it pays to stretch the limits. Bulk benefited Asia's *Indricotherium*, the largest known land mammal ever (weighing the equivalent of several modern elephants). Its size let it browse tall trees and discouraged enemies. But size also brought its demise: When climate change turned this giant's forest environment grassy, it couldn't stoop to graze and became extinct. Also now gone, *Elephas*, or pygmy elephants —knee-high to their modern counterparts—became small statured living on Mediterranean islands, perhaps because foraging areas were limited. Dwarfism also has its perks, including reduced food needs, easy hiding, and faster reproduction. There's no consensus on what causes size extremes, though land area, seasonality, resources, and predatory threat are likely all part of the answer.

26 NATIONAL GEOGRAPHIC · APRIL 2003

RISE OF MAMMALS 27

040 Publication **National Geographic** (credits on next spread)

Southern Living

Which came first? The egg. Monotremes, or egg-laying mammals like the spiny anteater *Zaglossus*, bottom right—a snouted worm-eater—preceded placental mammals. So might have marsupials like Australia's rhino-size *Zygomaturus*, right, and lionlike *Thylacoleo*, far right. Marsupials, which carry their developing young in a pouch, once thrived worldwide. But for reasons still in debate, placentals ended up on northern continents while marsupials and monotremes took over the south—eventually enjoying geographic isolation there. Climate change and human hunters later drove many to extinction. Still, says paleontologist Steve Wroe of the University of Sydney, "Australia isn't intrinsically barren ground for placentals. Now everything from cats to camels runs riot."

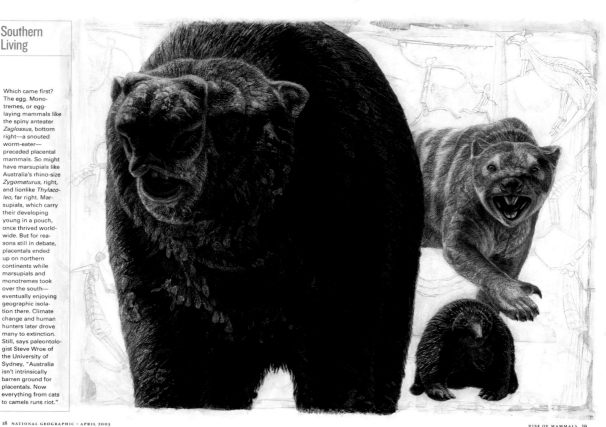

Perfect Teeth

"If there's a good mode of life," says Michael Benton, "evolution will hone different groups to fill it." That's known as convergence. Take the saber-tooth trait. The catlike *Barbourofelis*, right, of Eurasia and North America got its daggers for downing big, thick-skinned prey. Filling the same niche in South America, the marsupial *Thylacosmilus*, bottom right, evolved similar weapons and lost teeth it didn't use. "These guys were specialized to kill fast, eat their fill, and go," says Steve Wroe. In contrast, *Megistotherium*, top, had more generalized teeth—to pierce, crush, and scrape bones clean—though it was distinct in another way. "It was bloody big," says Wroe. But neither bite nor bulk saves specialists when their habitat changes faster than they can adjust. Wroe adds, "They were first to bite the dust."

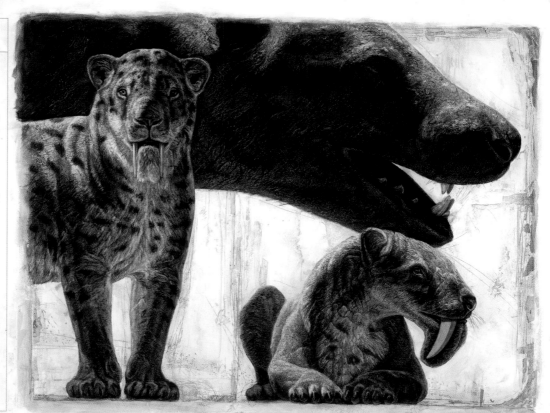

041

‹040
Publication **National Geographic**
Art Directors **Chris Sloan, David Whitmore,**
Connie Phelps, Kristin Hannah
Editor-in-Chief **Willam L. Allen**
Illustrator **Kennis and Kennis**
Researcher **Ellie Boettinger**
Publisher **National Geographic Society**
Issue **April 2003**

041
Publication **City Magazine**
Creative Director **Fabrice Frere**
Editor-in-Chief **John F. McDonald**
Art Director **Adriana Jacoud**
Photo Editor **Piera Gelardi**
Photographer **Martyn Thompson**
Publisher **City Publishing L.L.C.**
Issue **Fall 2003**

in the beginning …

Deerskin leaf with stitching, $18, by **Sandy Vohr**, Moss.

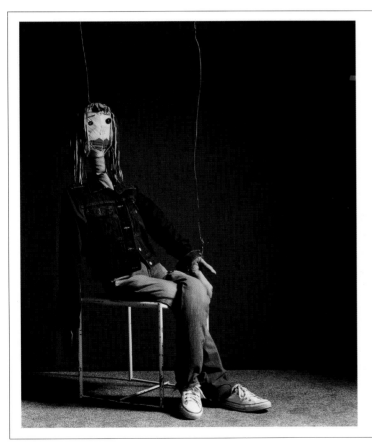

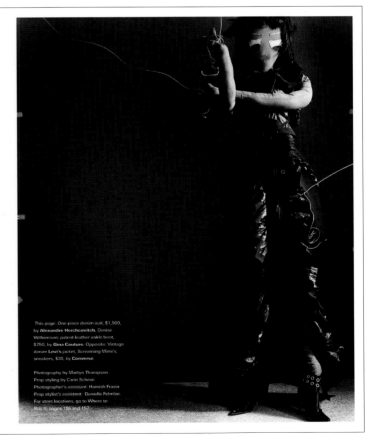

This page: One-piece denim suit, $1,500,
by **Alexandre Herchcovitch**, Denise
Williamson; patent leather ankle boot,
$750, by **Gina Couture**. Opposite: Vintage
denim **Levi's** jacket, Screaming Mimi's;
sneakers, $30, by **Converse**.

Photography by Martyn Thompson.
Prop styling by Carin Scheve.
Photographer's assistant: Hamish Fraser.
Prop stylist's assistant: Danielle Felmlee.
For store locations, go to Where to
Buy it, pages 156 and 157.

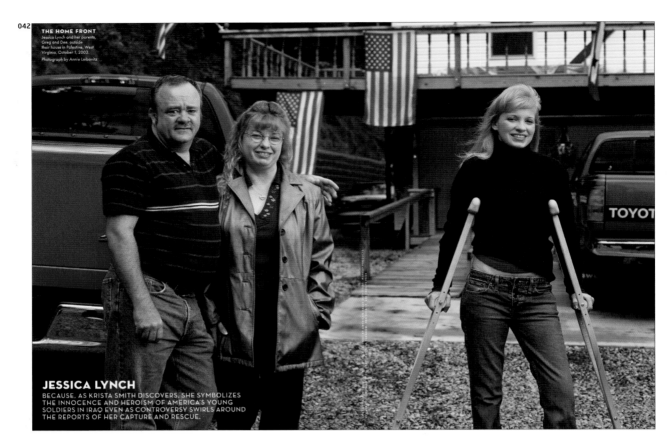

042

THE HOME FRONT
Jessica Lynch and her parents, Greg and Dee, outside their house in Palestine, West Virginia, October 1, 2003.
Photograph by Annie Leibovitz

JESSICA LYNCH
BECAUSE, AS KRISTA SMITH DISCOVERS, SHE SYMBOLIZES THE INNOCENCE AND HEROISM OF AMERICA'S YOUNG SOLDIERS IN IRAQ EVEN AS CONTROVERSY SWIRLS AROUND THE REPORTS OF HER CAPTURE AND RESCUE.

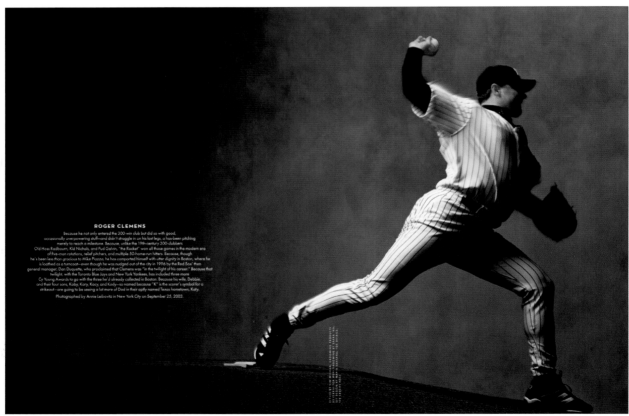

ROGER CLEMENS
because he not only entered the 300-win club but did so with good, occasionally overpowering stuff—and didn't struggle in on his last legs, a has-been pitching merely to reach a milestone. Because, unlike the 19th-century 300-clubbers Old Hoss Radbourn, Kid Nichols, and Pud Galvin, "the Rocket" won all those games in the modern era of five-man rotations, relief pitchers, and multiple 50-home-run hitters. Because, though he's been less than gracious to Mike Piazza, he has comported himself with utter dignity in Boston, where he is loathed as a turncoat—even though he was nudged out of the city in 1996 by the Red Sox' then general manager, Dan Duquette, who proclaimed that Clemens was "in the twilight of his career." Because that twilight, with the Toronto Blue Jays and New York Yankees, has included three more Cy Young Awards to go with the three he'd already collected in Boston. Because his wife, Debbie, and their four sons, Koby, Kory, Kacy, and Kody—so named because "K" is the scorer's symbol for a strikeout—are going to be seeing a lot more of Dad in their aptly named Texas hometown, Katy.
Photographed by Annie Leibovitz in New York City on September 25, 2003.

042
Publication **Vanity Fair**
Design Director **David Harris**
Editor-in-Chief **Graydon Carter**
Art Director **Julie Weiss**
Designer **Chris Mueller**
Photo Editor **Lisa Berman**
Photographers **Annie Leibovitz, Jonas Karlsson,**
Helmut Newton, Mark Seliger, Art Streiber
Photo Director **Susan White**
Photo Producers **Ron Beinner,**
Sarah Czeladnicki, SunHee Grinnell,
Kathryn MacLeod, Richard Villani
Publisher **Condé Nast Publications Inc.**
Issue **December 2003**

043

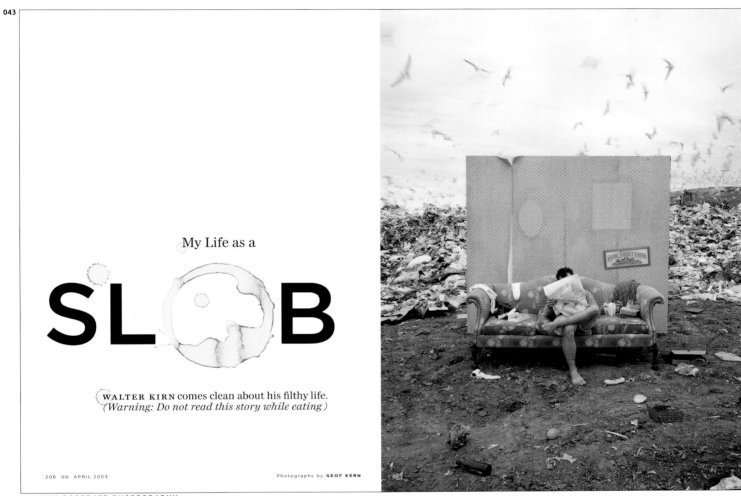

My Life as a

SL⬤B

WALTER KIRN comes clean about his filthy life.
(Warning: Do not read this story while eating)

206 GQ APRIL 2003

Photographs by **GEOF KERN**

+ MERIT **PORTRAIT PHOTOGRAPHY**

043
Publication **GQ**
Design Director **Fred Woodward**
Editor-in-Chief **Jim Nelson**
Designer **Ken DeLago**
Photo Editor **Jennifer Crandall**
Photographer **Geof Kern**
Publisher **Condé Nast Publications Inc.**
Issue **April 2003**

044

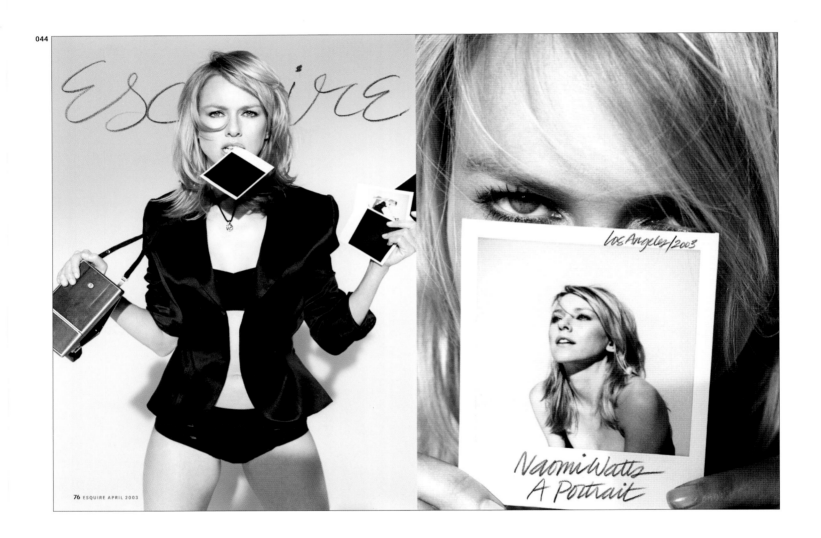

044
Publication **Esquire**
Design Director **John Korpics**
Editor-in-Chief **David Granger**
Photo Editor **Nancy Jo Iacoi**
Photographer **Sheryl Nields**
Publisher **The Hearst Corporation-Magazines Division**
Issue **April 2003**

045

045
Publication **Esquire**
Design Director **John Korpics**
Editor-in-Chief **David Granger**
Photo Editor **Nancy Jo Iacoi**
Photographer **Bill Jacobson**
Publisher **The Hearst Corporation-Magazines Division**
Issue **July 2003**

046

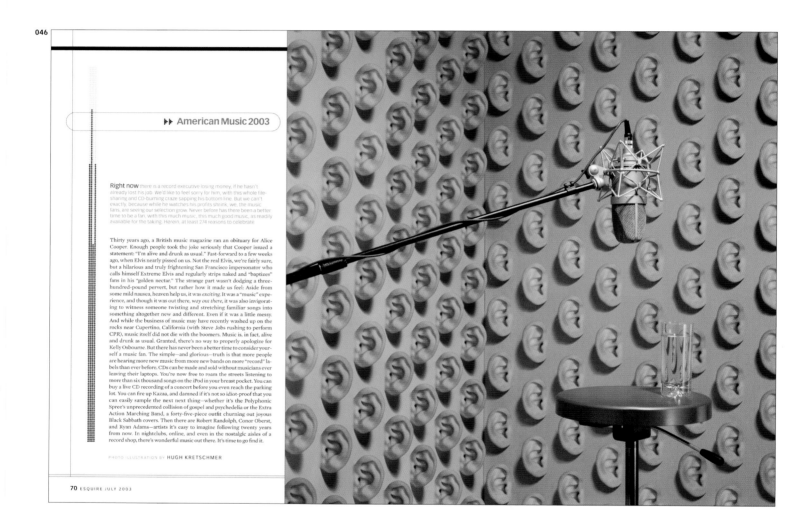

⏭ American Music 2003

Right now there is a record executive losing money, if he hasn't already lost his job. We'd like to feel sorry for him, with this whole file-sharing and CD-burning craze sapping his bottom line. But we can't exactly, because while he watches his profits shrink, we, the music fans, are seeing our selection grow. Never before has there been a better time to be a fan, with this much music, this much good music, as readily available for the taking. Herein, at least 274 reasons to celebrate.

Thirty years ago, a British music magazine ran an obituary for Alice Cooper. Enough people took the joke seriously that Cooper issued a statement: "I'm alive and drunk as usual." Fast-forward to a few weeks ago, when Elvis nearly pissed on us. Not the real Elvis, we're fairly sure, but a hilarious and truly frightening San Francisco impersonator who calls himself Extreme Elvis and regularly strips naked and "baptizes" fans in his "golden nectar." The strange part wasn't dodging a three-hundred-pound pervert, but rather how it made us feel: Aside from some mild nausea, heaven help us, it was *exciting*. It was a "music" experience, and though it was out there, *way out there*, it was also invigorating to witness someone twisting and stretching familiar songs into something altogether new and different. Even if it was a little messy. And while the business of music may have recently washed up on the rocks near Cupertino, California (with Steve Jobs rushing to perform CPR), music itself did not die with the boomers. Music is, in fact, alive and drunk as usual. Granted, there's no way to properly apologize for Kelly Osbourne. But there has never been a better time to consider yourself a music fan. The simple—and glorious—truth is that more people are hearing more new music from more new bands on more "record" labels than ever before. CDs can be made and sold without musicians ever leaving their laptops. You're now free to roam the streets listening to more than six thousand songs on the iPod in your breast pocket. You can buy a live CD recording of a concert before you even reach the parking lot. You can fire up Kazaa, and damned if it's not so idiot-proof that you can easily sample the next next thing—whether it's the Polyphonic Spree's unprecedented collision of gospel and psychedelia or the Extra Action Marching Band, a forty-five-piece outfit churning out joyous Black Sabbath covers. Then there are Robert Randolph, Conor Oberst, and Ryan Adams—artists it's easy to imagine following twenty years from now. In nightclubs, online, and even in the nostalgic aisles of a record shop, there's wonderful music out there. It's time to go find it.

PHOTO-ILLUSTRATION BY **HUGH KRETSCHMER**

70 ESQUIRE JULY 2003

046
Publication **Esquire**
Design Director **John Korpics**
Editor-in-Chief **David Granger**
Designer **Chris Martinez**
Illustrator **Hugh Kretschmer**
Publisher **The Hearst Corporation-Magazines Division**
Issue **July 2003**

047

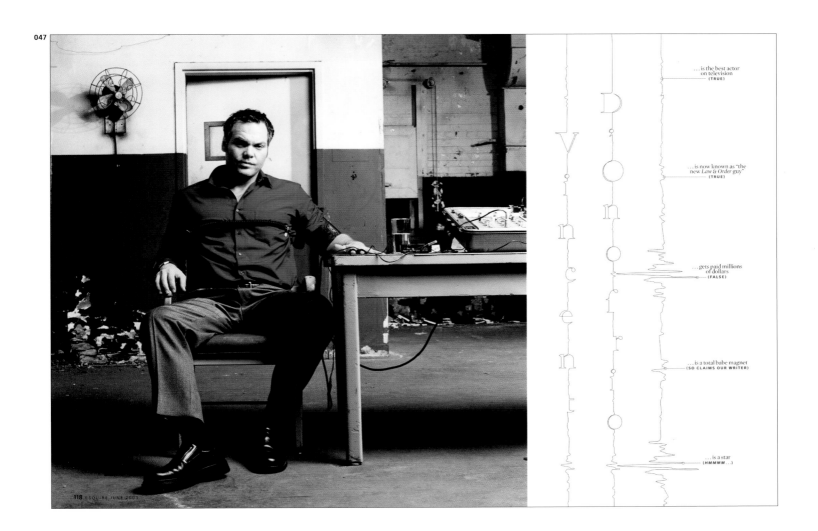

047
Publication **Esquire**
Design Director **John Korpics**
Editor-in-Chief **David Granger**
Designer **Chris Martinez**
Photo Editor **David Carthas**
Photographer **Gregg Segal**
Publisher **The Hearst Corporation-Magazines Division**
Issue **June 2003**

048

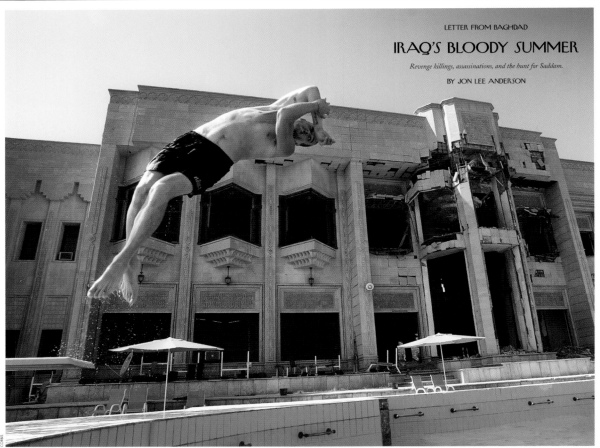

LETTER FROM BAGHDAD

IRAQ'S BLOODY SUMMER

Revenge killings, assassinations, and the hunt for Saddam.

BY JON LEE ANDERSON

One morning a few days before Qusay and Uday Hussein were killed in Mosul, I had an appointment with the Imam of the Abu Hanifa Mosque in Adhamiya, a traditionally pro-Baathist, predominantly Sunni Muslim neighborhood in the northwestern part of Baghdad. Saddam Hussein made his final public appearance outside the mosque on April 9th, and for several days afterward his fedayeen and Baathist militias fought the Americans in Adhamiya, staging a kind of last stand before melting away. I was travelling with Sabah, my driver, and Salih, a translator. As we began negotiating Adhamiya's narrow streets, I thought I heard a few gunshots, which would have been unusual when Saddam was running the city but was not now. A Humvee was blocking a side road, and an American soldier sat behind some sandbags in front of a building that Salih thought was the Adhamiya police station. A couple of blocks farther on, several more shots rang out, and two men in civilian clothes trotted toward us, firing pistols. At that moment, a blue van pulled in front of our car, and the two men with the guns broke into a run.

I yelled at Sabah to get us out of there, quickly, but we were stuck in traffic, behind the blue van. I looked back and saw that the men with guns were about thirty feet away, standing abreast, with their legs wide apart, arms outstretched and hands pressed together, pointing their weapons in our direction. Salih and I ducked below our seats and I heard the bangs of the pistols, but nothing hit us. Some car horns blared. The blue van sped down a side street and Sabah followed it. The van turned to the right, and Sabah turned right also, and suddenly we were in a dead-end lane. The driver of the van threw open his door, leaped out, and ran off in a crouch. Sabah jerked our car into reverse and pulled back into the street and then put the car into forward and accelerated—a cumbersome process that seemed to take forever. The two men with the guns had reappeared in their shooting stance. This time, with no other vehicles in sight, they were obviously aiming at us. But they paused. They didn't shoot, and in a few seconds we had got out of their line of fire.

Salih tried to calm me as we made our way to the mosque, which was only a

A soldier in the 2nd Battalion of the U.S. Army's 3rd Artillery Regiment dives into the pool at battalion headquarters in Uday Hussein's former palace, which includes his "love shack." Photograph by Benjamin Lowy.

THE NEW YORKER, AUGUST 11, 2003 43

048
Publication **The New Yorker**
Visuals Editor **Elisabeth Biondi**
Editor-in-Chief **David Remnick**
Photo Editors **Natasha Lunn, Elizabeth Culbert**
Photographer **Benjamin Lowy**
Publisher **Condé Nast Publications Inc.**
Issue **August 11, 2003**

049
Publication **The New Yorker**
Design Director **Françoise Mouly**
Editor-in-Chief **David Remnick**
Illustrator **Anita Kunz**
Publisher **Condé Nast Publications Inc.**
Issue **October 13, 2003**

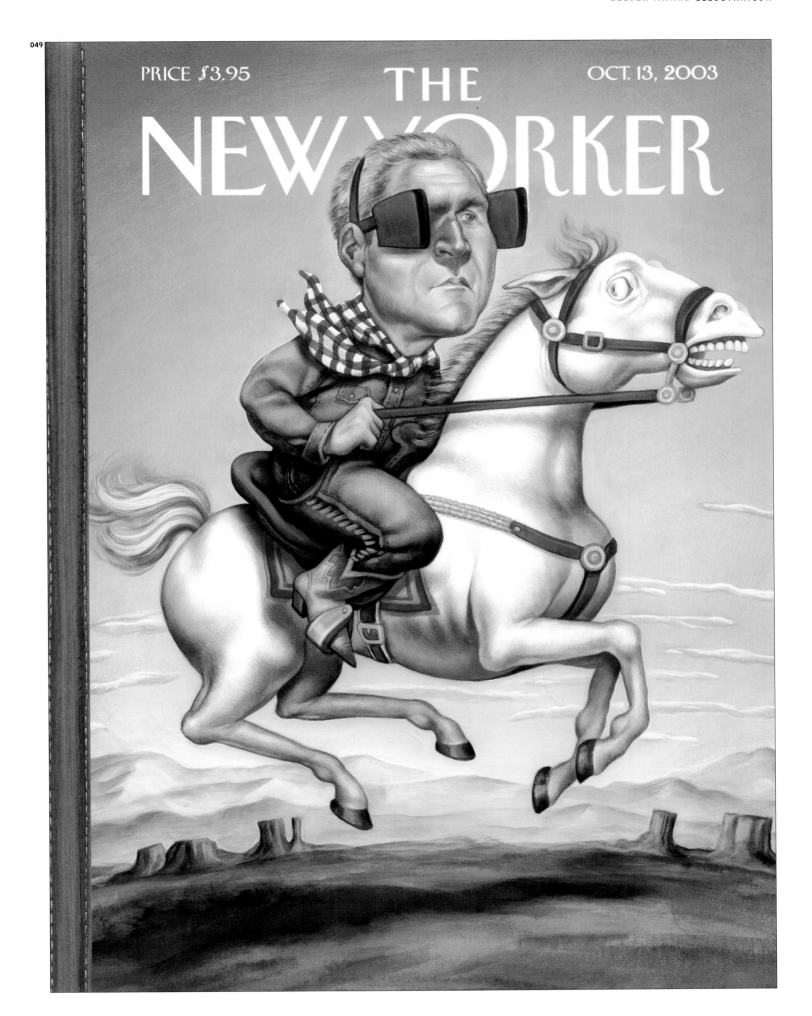

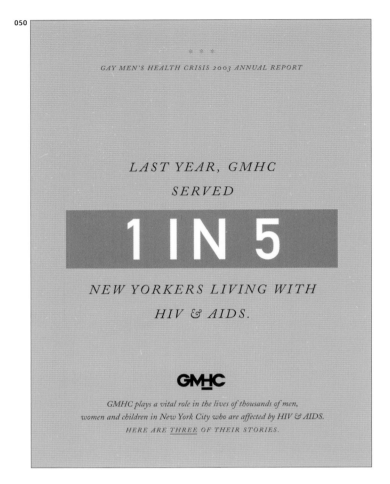

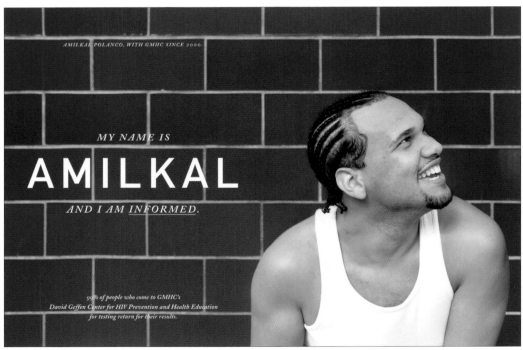

050
Publication **Gay Men's Health Crisis 2003 Annual Report**
Creative Director **Craig Bailey**
Designer **Craig Bailey**
Photographer **John Arsenault**
Printer **JCI Graphics**
Studio **BaileyCo-NYC**
Client **Gay Men's Health Crisis**
Issue **2003**

051
Publication **Aspirina**
Design Director **Carmelo Caderot**
Editor-in-Chief **Jose Luis de la Serna**
Art Director **Rodrigo Sanchez**
Designers **Rodrigo Sanchez, Manuel DeMiguel, Carmelo Caderot**
Illustrator **Raúl Arias**
Studio/Publisher **Khaos, SL**
Client **Bayer Espana**
Issue **2003**

051

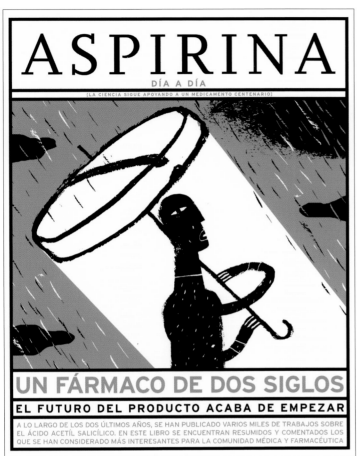

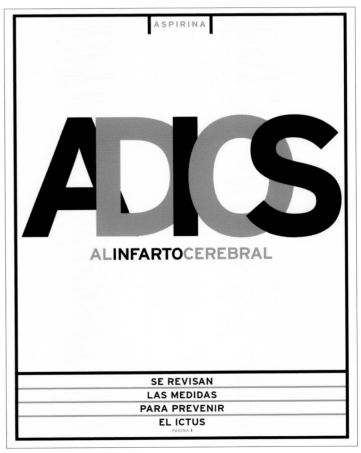

052

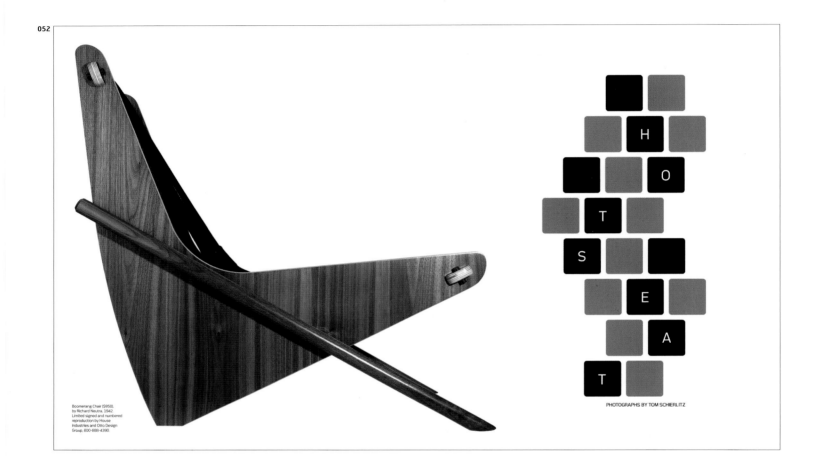

Boomerang Chair (S950),
by Richard Neutra, 1942.
Limited signed and numbered
reproduction by House
Industries and Otto Design
Group, 800-888-4390.

PHOTOGRAPHS BY TOM SCHIERLITZ

052
Publication **Details**
Design Director **Rockwell Harwood**
Editor-in-Chief **Daniel Peres**
Photo Editor **Judith Packett**
Publisher **Condé Nast Publications Inc.**
Issue **September 2003**

053

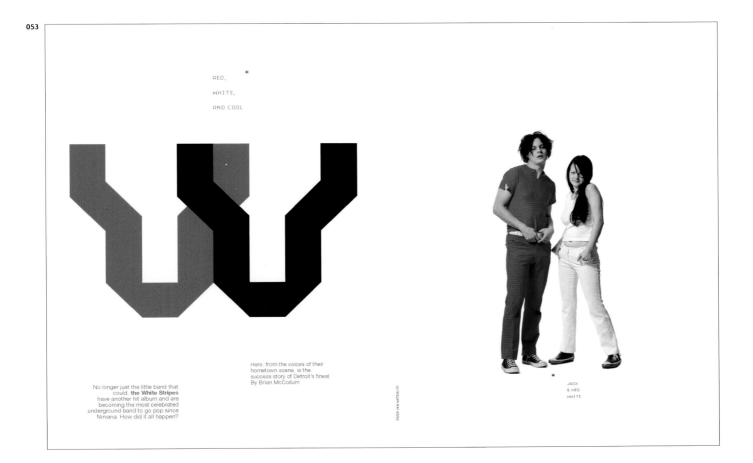

RED, *
WHITE,
AND COOL

No longer just the little band that could, **the White Stripes** have another hit album and are becoming the most celebrated underground band to go pop since Nirvana. How did it all happen?

Here, from the voices of their hometown scene, is the success story of Detroit's finest By Brian McCollum

PIETER VAN HATTEM/CPi

*
JACK
& MEG
WHITE

053
Publication **Spin**
Design Director **Arem Duplessis**
Editor-in-Chief **Sia Michel**
Art Director **Brandon Kavulla**
Designer **Arem Duplessis**
Photo Editor **Cory Jacobs**
Photographer **Pieter Van Hattem**
Publisher **Vibe/Spin Ventures LLC**
Issue **September 2003**

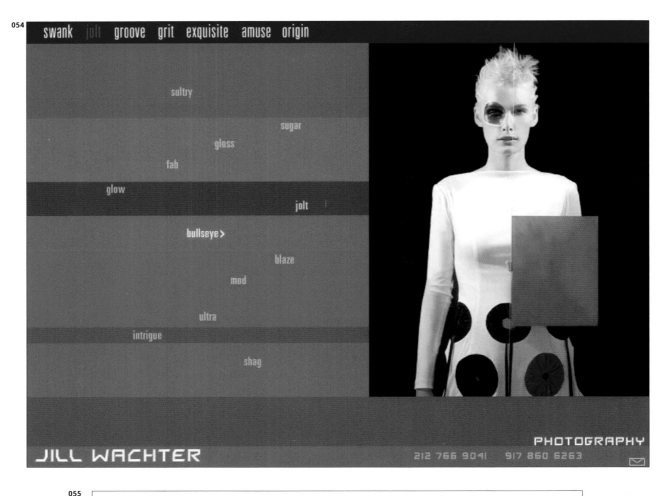

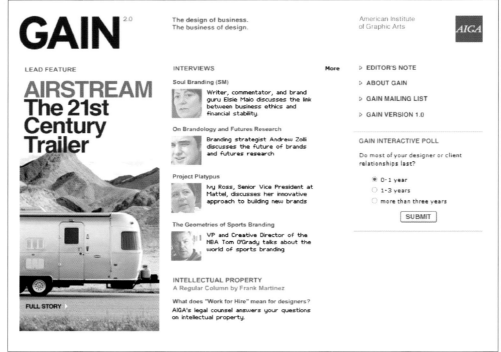

054
Publication **Jill Wachter Photography**
Creative Director **Deb Unger**
Designer **Deb Unger**
Photographer **Jill Wachter**
Studio **Deb Unger Studio**
Online Address **www.jillwachter.com**

055
Publication **Gain 2.0**
Art Director **Khoi Vinh**
Designers **Gicheol Lee, Khoi Vinh**
Information Architect **Christopher Fahey**
Design Technologists **Sharon Denning, Gicheol Lee**
Studio **Behavior**
Publisher **American Institute of Graphic Arts**

056
Publication **Surface Magazine**
Creative Director **Riley Johndonnell**
Design Director **Richard Smith**
Photo Editor **Victoria Leonard**
Photographer **Isabelle Bonjean**
Studio **Apostrophe Photo Agency**
Publisher **Surface Publishing, L.L.C.**
Issue **No 42**

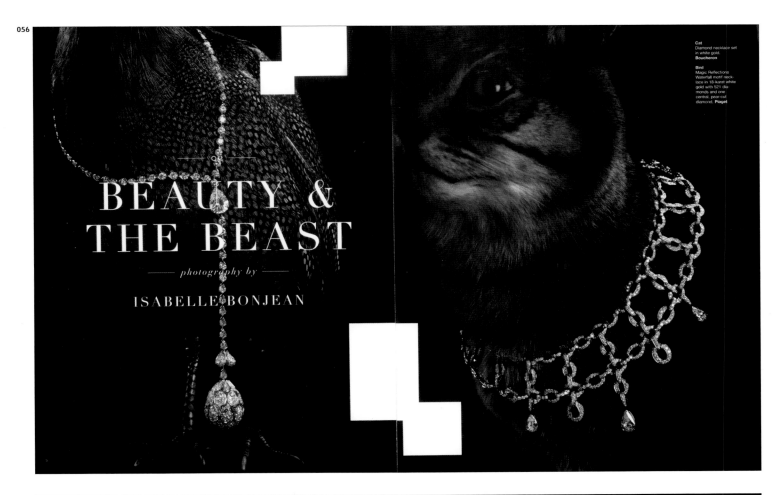

BEAUTY & THE BEAST

photography by

ISABELLE BONJEAN

Cat
Diamond necklace set in white gold. **Boucheron**

Bird
Magic Reflections Waterfall motif necklace in 18-karat white gold with 521 diamonds and one central, pear-cut diamond. **Piaget**

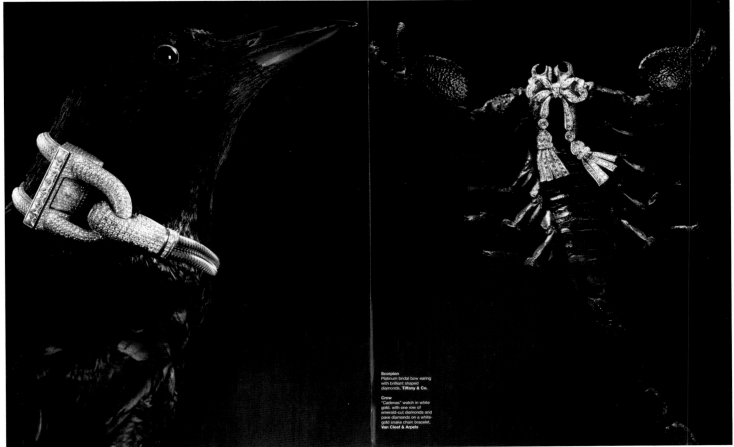

Scorpion
Platinum bridal bow earring with brilliant shaped diamonds. **Tiffany & Co.**

Crow
"Cadenas" watch in white gold, with one row of emerald-cut diamonds and pavé diamonds on a white-gold snake chain bracelet. **Van Cleef & Arpels**

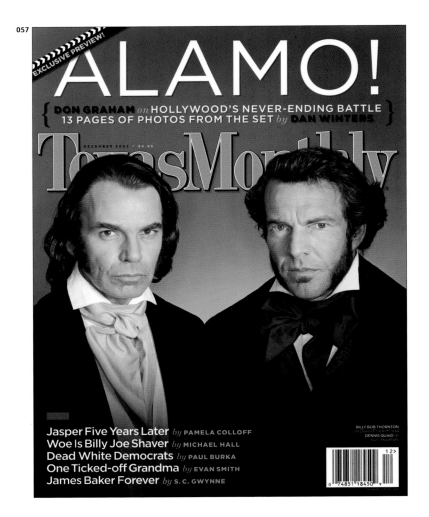

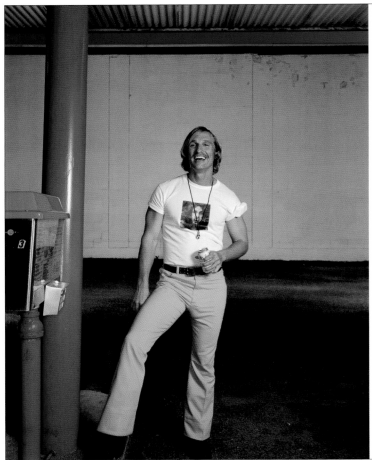

058

$10 €9.50 **SEPTEMBER 2003**

Art
+Auction

GROSSE TYEDE-LANDSCHAFT, GERHARD RICHTER, 1971

057
Publication **Texas Monthly**
Art Director **Scott Dadich**
Designers **Scott Dadich, TJ Tucker**
Illustrators **Mark Hooper, Christian Clayton, Chip Wass, Eddie Guy**
Photo Editor **Scott Dadich**
Photographers **Dan Winters, Wyatt McSpadden, Artie Limmer,
Judy Walgren, Peter Yang, Kenny Braun, Sarah Wilson**
Publisher **Emmis Communications Corp.**
Issues **May 2003, October 2003, December 2003**

058
Publication **Art + Auction**
Creative Director **Stephen Wolstenholme**
Art Directors **Miranda Dempster, Tom Phillips**
Designer **Phoebe J. Flynn**
Photo Editor **Adam Beinash**
Publisher **LTB Art**
Issues **July 2003, September 2003, October 2003**

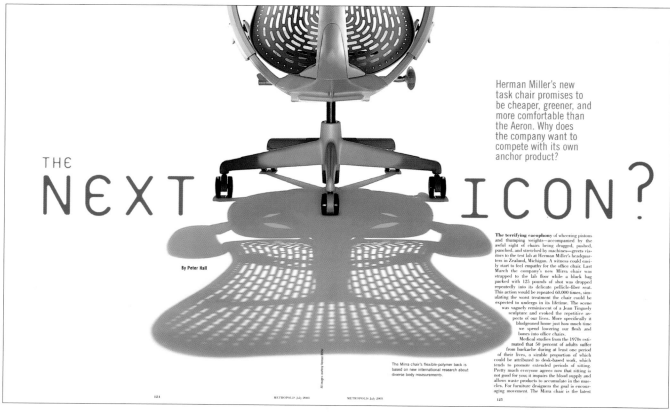

059
Publication **Step inside design**
Art Directors **Michael Ulrich, Robert Valentine**
Designers **Kathie Alexander, Brandon Jameson, Judy Minn**
Publisher **Dynamic Graphics Group**
Issues **January/February 2003, September/October 2003, November/December 2003**

060
Publication **Metropolis**
Art Director **Criswell Lappin**
Designers **Damian Chadwick, DJ Stout (Oct 03)**
Photo Editor **Sara Barrett**
Photographers **Chris Wahl, Tim Davis, Kristine Larsen, Robert Polidori, Sean Hemmerle, John Edwards Linden, David Allee, Frank Oudeman, Graham MacIndoe, Ross Muir**
Publisher **Bellerophon Publications**
Issues **June 2003, July 2003, October 2003**

061

KEEP IT TOGETHER
Layering slices of mozzarella cheese on each piece of bread and layering peppers and spreads in the middle will help seal sandwiches once pressed.

STORE-BOUGHT PESTO

STORE-BOUGHT TAPENADE

ROASTED RED PEPPERS

FRESH MOZZARELLA

BETWEEN THE BREAD

pressed mozzarella sandwiches

SERVES 4 ■ PREP TIME: 10 MINUTES ■ TOTAL TIME: 30 MINUTES

1 Cut ¾ pound **fresh mozzarella** into ¼-inch-thick slices. Drain a 12-ounce jar of **roasted red peppers**; pat dry. **2** Lightly brush 8 thick slices **sandwich bread** with **olive oil**; turn slices oiled sides down. Top half the bread with half the cheese; season with **coarse salt** and **ground pepper**. Spread **pesto** or tapenade over cheese, then top with peppers and remaining cheese and bread. **3** Heat a large grill pan or skillet over medium heat. Place sandwiches in pan (work in batches, if needed); weight with a heavy skillet. Cook over medium-low, pressing down firmly with skillet, until bread is golden and cheese is melted, 6 to 8 minutes per side. Serve warm.

64

061
Publication **Everyday Food**
Creative Directors **Gael Towey, Eric Pike**
Design Director **Scot Schy**
Art Directors **Michele Outland, William van Roden**
Publisher **Martha Stewart Omnimedia**
Issues **4, 5, 6**

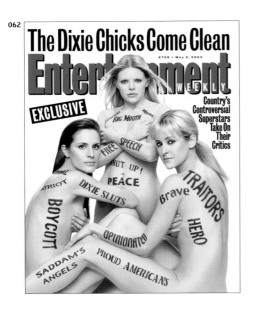

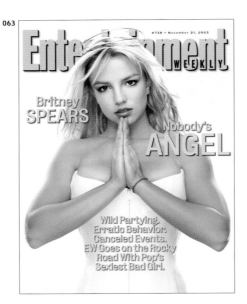

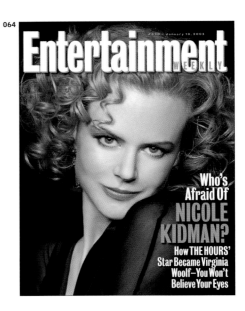

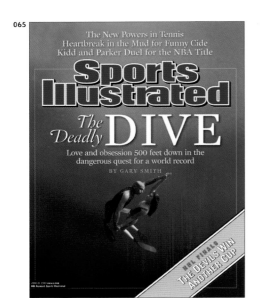

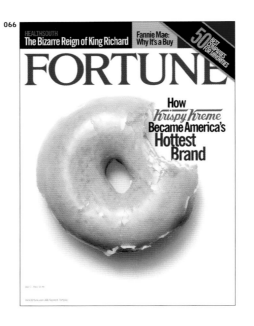

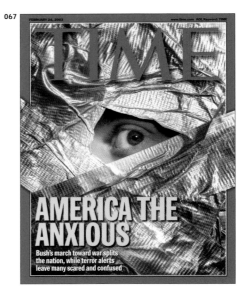

062
Publication **Entertainment Weekly**
Design Director **Geraldine Hessler**
Designer **Geraldine Hessler**
Photo Editor **Fiona McDonagh**
Photographer **James White**
Publisher **Time Inc.**
Issue **May 2, 2003**

063
Publication **Entertainment Weekly**
Design Director **Geraldine Hessler**
Designer **Geraldine Hessler**
Photo Editor **Fiona McDonagh**
Photographer **Martin Schoeller**
Publisher **Time Inc.**
Issue **November 21, 2003**

064
Publication **Entertainment Weekly**
Design Director **Geraldine Hessler**
Designer **Geraldine Hessler**
Photo Editor **Sarah Rozen**
Photographer **James White**
Publisher **Time Inc.**
Issue **January 10, 2003**

065
Publication **Sports Illustrated**
Creative Director **Steve Hoffman**
Art Director **Edward Truscio**
Designers **Chris Hercik, Edward Truscio**
Photographer **Jennifer S. Hayes**
Publisher **Time Inc.**
Issue **June 16, 2003**

066
Publication **Fortune**
Design Director **Blake Taylor**
Art Director **Blake Taylor**
Photo Editor **Michele McNally**
Photographer **Tom Schierlitz**
Publisher **Time Inc.**
Issue **July 1, 2003**

067
Publication **Time**
Design Director **Arthur Hochstein**
Designer **Arthur Hochstein**
Illustrator **Arthur Hochstein**
Photographer **Gregory Heisler**
Publisher **Time Inc.**
Issue **February 24, 2003**

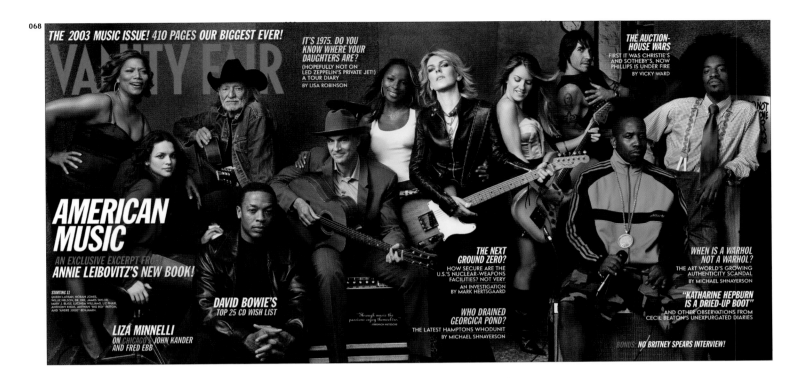

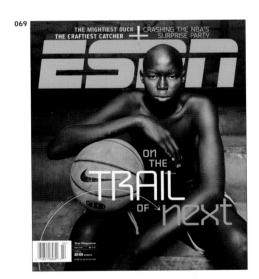

068
Publication **Vanity Fair**
Design Director **David Harris**
Art Director **Julie Weiss**
Designer **Chris Mueller**
Photo Editor **Lisa Berman**
Photographer **Annie Leibovitz**
Photo Director **Susan White**
Publisher **Condé Nast Publications Inc.**
Issue **November 2003**

069
Publication **ESPN The Magazine**
Design Director **Peter Yates**
Art Director **Peter Yates**
Designers **Peter Yates, Siung Tjia**
Photographer **Sarah A. Friedman**
Director of Photograhy **Nik Kleinberg**
Publisher **ESPN, Inc.**
Issue **May 26, 2003**

070
Publication **Gourmet**
Creative Director **Diana LaGuardia**
Art Director **Erika Oliveira**
Photo Editor **Helen Cannavale**
Photographer **Sang An**
Publisher **Condé Nast Publications Inc.**
Issue **April 2003**

071
Publication **The Washington Post Magazine**
Art Director **J Porter**
Designer **J Porter**
Illustrator **Ted Giesel**
Photo Editors **Keith Jenkins, Jennifer Beeson**
Production Manager **Leslie Garcia**
Publisher **The Washington Post Co.**
Issue **May 11, 2003**

072

073

074

075

076

077
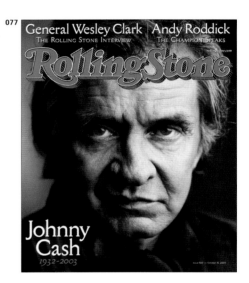

072
Publication **Rolling Stone**
Art Director **Andy Cowles**
Designer **Andy Cowles**
Photo Editor **Jodi Peckman**
Photographer **Max Vadukul**
Publisher **Wenner Media**
Issue **June 26, 2003**

075
Publication **The New York Times Book Review**
Art Director **Steve Heller**
Designer **Steve Heller**
Illustrator **Paul Davis**
Publisher **The New York Times**
Issue **November 16, 2003**

073
Publication **Rolling Stone**
Art Director **Andy Cowles**
Designer **Andy Cowles**
Publisher **Wenner Media**
Issue **May 15, 2003**

076
Publication **The New York Times Book Review**
Art Director **Steve Heller**
Designer **Steve Heller**
Illustrator **Stephen Savage**
Publisher **The New York Times**
Issue **June 8, 2003**

074
Publication **Rolling Stone**
Art Director **Andy Cowles**
Designer **Andy Cowles**
Photo Editor **Jodi Peckman**
Photographer **Albert Watson**
Publisher **Wenner Media**
Issue **April 3, 2003**

077
Publication **Rolling Stone**
Art Director **Andy Cowles**
Designer **Andy Cowles**
Photographer **Mark Seliger**
Publisher **Wenner Media**
Issue **October 16, 2003**

078

Issue 932 >> October 2, 2003
rollingstone.com

Rolling Stone

Britney

On Justin, That Kiss And Being Alone

David Bowie John Mayer Bill Murray

Martin Scorsese's History of the Blues

The 2003 Hot List

Viggo Mortensen Scarlett Johansson Ryan Adams Brand New Obie Trice Aimee Mullins

Special Report

America's Dirty War The Deadly Cost of Radioactive Tank Busters

078
Publication **Rolling Stone**
Art Director **Andy Cowles**
Designer **Andy Cowles**
Photographer **Matthew Rolston**
Publisher **Wenner Media**
Issue **October 2, 2003**

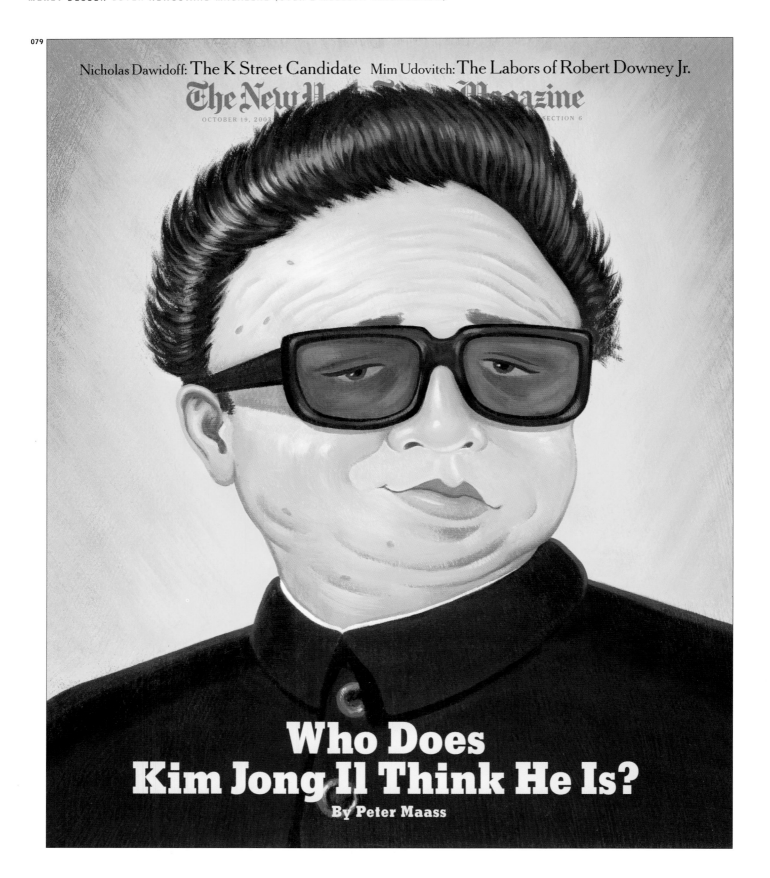

079
Publication **The New York Times Magazine**
Art Director **Janet Froelich**
Designer **Jeff Glendenning**
Illustrator **David M. Brinley**
Publisher **The New York Times**
Issue **October 19, 2003**

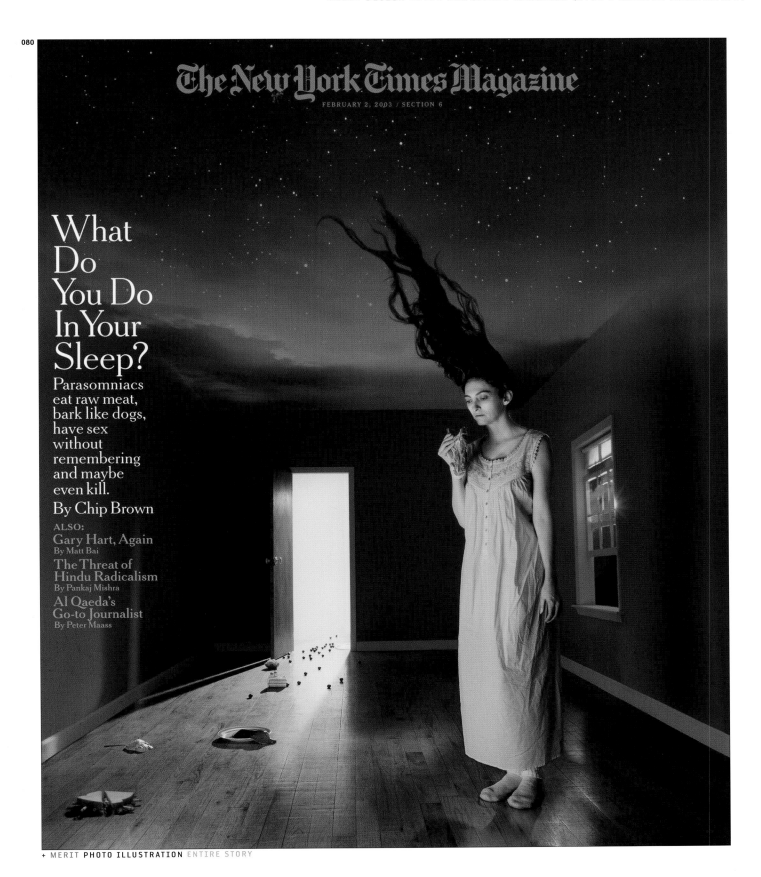

The New York Times Magazine

FEBRUARY 2, 2003 / SECTION 6

What
Do
You Do
In Your
Sleep?

Parasomniacs
eat raw meat,
bark like dogs,
have sex
without
remembering
and maybe
even kill.
By Chip Brown

ALSO:
Gary Hart, Again
By Matt Bai
The Threat of
Hindu Radicalism
By Pankaj Mishra
Al Qaeda's
Go-to Journalist
By Peter Maass

+ MERIT PHOTO ILLUSTRATION ENTIRE STORY

080
Publication **The New York Times Magazine**
Art Director **Janet Froelich**
Designer **Joele Cuyler**
Photo Editor **Kathy Ryan**
Photographer **Josef Astor**
Publisher **The New York Times**
Issue **February 2, 2003**

081

The New York Times Magazine

A Saddam
Family
Album
Found by Bruno Stevens

His Own
Private
C.I.A.
By Matt Bai

Making
Traffic
Disappear
By Randy Kennedy

(Artificial)
Turf Wars
By Jonathan Dee

The Road
From
Gideon to
Padilla
By Anthony Lewis

Couture
Ad
Absurdum
By Jonathan Reynolds

Autopilot
Can the Next War Be Fought
With No Soldiers at All?
By Matthew Brzezinski

Plus
The Taking of Baghdad,
One Kill at a Time
By Peter Maass

082

083

084

081
Publication **The New York Times Magazine**
Art Director **Janet Froelich**
Designer **Nancy Harris**
Photo Editor **Kathy Ryan**
Photographer **Thomas Hannich**
Publisher **The New York Times**
Issue **April 20, 2003**

082
Publication **The New York Times Magazine**
Art Director **Janet Froelich**
Designer **Kristina DiMatteo**
Photo Editor **Kathy Ryan**
Photographer **Rodney Smith**
Publisher **The New York Times**
Issue **December 14, 2003**

083
Publication **The New York Times Magazine**
Art Director **Janet Froelich**
Designer **Nancy Harris**
Publisher **The New York Times**
Issue **January 5, 2003**

084
Publication **The New York Times Magazine**
Art Director **Janet Froelich**
Designer **Catherine Gilmore-Barnes**
Photo Editor **Kathy Ryan**
Photographer **Paul Graham**
Publisher **The New York Times**
Issue **October 12, 2003**

085

086

087

088

089

085
Publication **Los Angeles Times**
Creative Director **Joseph Hutchinson**
Design Director **Lisa Clausen**
Art Director **Paul Gonzales**
Designer **Paul Gonzales**
Illustrator **Paul Gonzales**
Publisher **Tribune Company**
Issue **March 9, 2003**

087
Publication **The New York Times**
Art Director **Rodrigo Honeywell**
Designer **Rodrigo Honeywell**
Illustrator **Mika Grondahl**
Publisher **The New York Times**
Issue **December 9, 2003**

086
Publication **Los Angeles Times**
Creative Director **Joseph Hutchinson**
Design Director **Lisa Clausen**
Designer **Steven E. Banks**
Photo Editor **Kirk McKoy**
Publisher **Tribune Company**
Issue **December 21, 2003**

088
Publication **Los Angeles Times**
Creative Director **Joseph Hutchinson**
Design Director **Lisa Clausen**
Art Director **Carol Kaufman**
Designer **Carol Kaufman**
Illustrator **Edel Rodriguez**
Publisher **Tribune Company**
Issue **June 8, 2003**

089
Publication **Entertainment Weekly**
Design Director **Geraldine Hessler**
Art Director **John Walker**
Designers **John Walker, Jennifer Procopio, Lee Berresford, Jennie Chang, Sean Bumgarner, Sara Osten, Bhairavi Patel, Dian-Aziza Ooka**
Illustrators **Gary Taxali, Harry Campbell, Jonathon Rosen, Thomas Fuchs, Zohar Lazar, Robert De Michiell, David Hughes, Justin Wood, Tim Bower, David Cowles, Jody Hewgill**
Photo Editors **Fiona McDonagh, Audrey Landreth, Michele Romero, Richard Maltz, Suzanne Regan, Freyda Tavin, Jef Castro, Carrie Levitt, Melissa Roque**
Photographers **Jeff Riedel, Ethan Hill, Robert Maxwell, Christian Witkin, Gavin Bond, Judson Baker, Julian Broad, Martin Schoeller, Steve Road, Michael O'Neill, Michael Thompson, Catherine Lender, Ethan Hill, Danielle Levitt, Andrew Hetherington**
Publisher **Time, Inc.**
Issue **December 26, 2003**

090

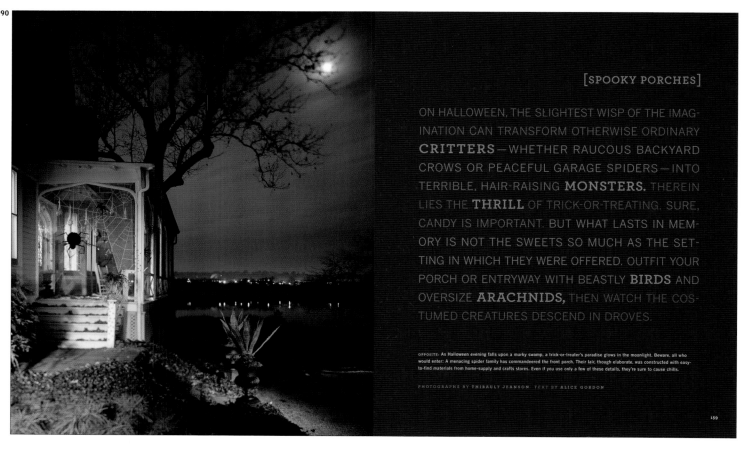

[SPOOKY PORCHES]

ON HALLOWEEN, THE SLIGHTEST WISP OF THE IMAG-
INATION CAN TRANSFORM OTHERWISE ORDINARY
CRITTERS—WHETHER RAUCOUS BACKYARD
CROWS OR PEACEFUL GARAGE SPIDERS—INTO
TERRIBLE, HAIR-RAISING MONSTERS. THEREIN
LIES THE THRILL OF TRICK-OR-TREATING. SURE,
CANDY IS IMPORTANT. BUT WHAT LASTS IN MEM-
ORY IS NOT THE SWEETS SO MUCH AS THE SET-
TING IN WHICH THEY WERE OFFERED. OUTFIT YOUR
PORCH OR ENTRYWAY WITH BEASTLY BIRDS AND
OVERSIZE ARACHNIDS, THEN WATCH THE COS-
TUMED CREATURES DESCEND IN DROVES.

OPPOSITE: As Halloween evening falls upon a murky swamp, a trick-or-treater's paradise glows in the moonlight. Beware, all who
would enter: A menacing spider family has commandeered the front porch. Their lair, though elaborate, was constructed with easy-
to-find materials from home-supply and crafts stores. Even if you use only a few of these details, they're sure to cause chills.

PHOTOGRAPHS BY THIBAULT JEANSON TEXT BY ALICE GORDON

159

090
Publication **Martha Stewart Living**
Creative Director **Eric Pike**
Design Director **Barbara de Wilde**
Art Director **James Dunlinson**
Designers **Mary Jane Callister, Yu Mei Tam
Compton, Jill Groeber, Alanna Jacobs, Angela
Gubler, Amber Blakesley, Alice Lynn McMichael,
Lilian Hough, Brooke H. Reynolds,
Esther Bridavsky, Asya Palatova**
Photo Editors **Stacie McCormick, Beth Krzyzkowski**
Photographers **David Prince, Gentl & Hyers,
Antonis Achilleos, Charles Schiller, Mark
Williams, Natasha Milne, Bill Batten, Dana
Gallagher, Lisa Romerein, William Abranowicz,
Victor Schrager, Victoria Pearson,
Thibault Jeanson, Earl Carter**
Publisher **Martha Stewart Living Omnimedia**
Issue **October 2003**

091
Publication **Martha Stewart Living**
Creative Director **Eric Pike**
Design Director **Barbara de Wilde**
Art Director **James Dunlinson**
Designers **Mary Jane Callister, Yu Mei Tam
Compton, Jill Groeber, Alanna Jacobs, Angela
Gubler, Amber Blakesley, Alice Lynn McMichael,
Cheryl Molnar, Brooke H. Reynolds, Scot Schy**
Photo Editors **Stacie McCormick, Beth Krzyzkowski**
Photographers **Charles Schiller, Andrew Bordwin,
Sivan Lewin, Sang An, John Kernick, James Baigrie,
Minh & Wass, Lisa Romerein, David Prince,
Francesco Mosto, Stephen Lewis, Christopher
Baker, Maria Robledo, William Abranowicz,
William Meppem**
Publisher **Martha Stewart Living Omnimedia**
Issue **April 2003**

092
Publication **Martha Stewart Holiday**
Creative Director **Eric Pike**
Art Directors **James Dunlinson, Jill Groeber**
Photo Editors **Stacie McCormick, Beth Krzyzkowski**
Photographers **Richard Gerhard Jung, Sang An,
Quentin Bacon, Anna Williams, Dana Gallagher,
Earl Carter**
Style Editor **Ayesha Patel**
Food Editor **Susan Sugarman**
Publisher **Martha Stewart Omnimedia**
Issue **Holiday 2003**

091

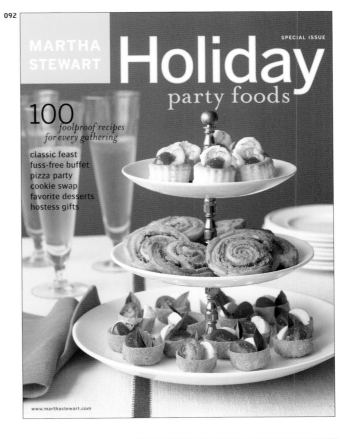

092

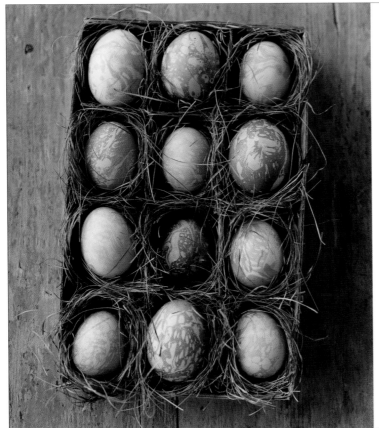

marbleizing eggs

If the earth hatched from a giant egg, as the ancient Persians believed, it might have resembled one of these in our dreamy dozen. We used a simple dyeing technique to create the intricate swirls of color: earthy brown twisting over baby blue, soft beige afloat on buttery yellow. Every Easter egg made this way is one of a kind–all are enchanting.

OPPOSITE: Nestle each egg in its own bed of grass. Using cardboard dividers, create twelve compartments in a shallow box or an empty shirt carton, then fashion a snug nest of dried grass inside each square. Save the lid for storage.

PHOTOGRAPHS BY CHRISTOPHER BAKER TEXT BY MEGAN KAPLAN

177

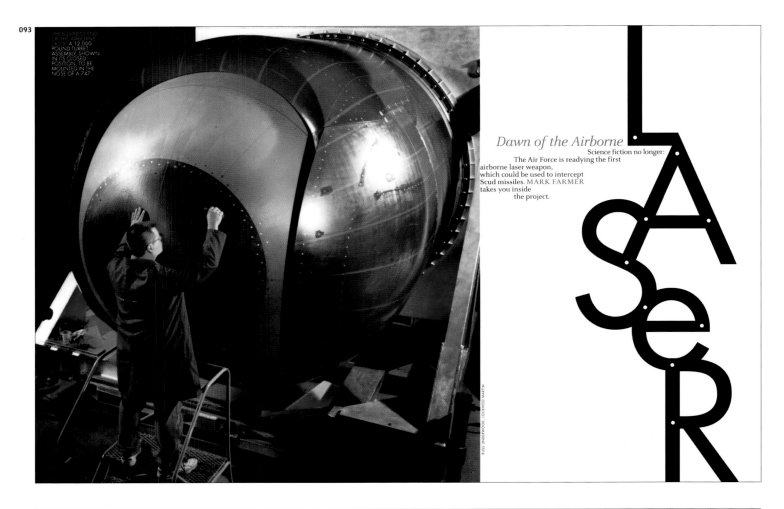

THE BUSINESS END OF THE AIRBORNE LASER: A 12,000-POUND TURRET ASSEMBLY, SHOWN IN ITS CLOSED POSITION, TO BE MOUNTED IN THE NOSE OF A 747.

Dawn of the Airborne
Science fiction no longer:
The Air Force is readying the first
airborne laser weapon,
which could be used to intercept
Scud missiles. MARK FARMER
takes you inside
the project.

LASER

RUSS UNDERWOOD, LOCKHEED MARTIN

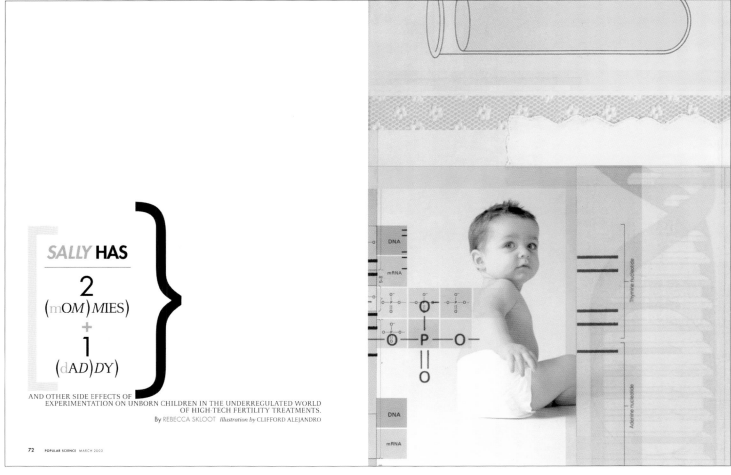

SALLY HAS

$$2 \; (mOM)MIES)$$
$$+$$
$$1 \; (dAD)DY)$$

AND OTHER SIDE EFFECTS OF
EXPERIMENTATION ON UNBORN CHILDREN IN THE UNDERREGULATED WORLD
OF HIGH-TECH FERTILITY TREATMENTS.
By REBECCA SKLOOT *Illustration by* CLIFFORD ALEJANDRO

094

095

096

093
Publication **Popular Science**
Design Director **Dirk Barnett**
Art Directors **Dirk Barnett, Hylah Hill, Josh Mckible, Neil Russo**
Designers **Dirk Barnett, Hylah Hill, Josh Mckible, Neil Russo**
Photo Editor **Kris Lamanna**
Photographer **John B. Carnett**
Publisher **Time4Media**
Issue **March 2003**

094
Publication **Field & Stream**
Art Directors **Tom Brown, Todd Albertson**
Designers **Erin Whelan, Carol Rheuban**
Illustrators **John Rice, Steve Sanford, Jack Unruh, Randall Watson, Lon Tweeten**
Photo Editors **Daniella Nilva, Amy Berkley**
Photographers **Dusan Smetana, Brent Humphreys, Holly Lindem, JP Greenwood, Svend Lindbaek**
Publisher **Time4Media**
Issue **October 2003**

095
Publication **Real Simple**
Creative Director **Robert Newman**
Art Director **Eva Spring**
Designers **Eva Spring, Monica Ewing**
Photo Editor **Jean Herr**
Photographer **David Prince**
Publisher **Time Inc.**
Issue **October 2003**

096
Publication **Real Simple**
Creative Director **Robert Newman**
Art Director **Ellene Standke**
Designer **Ellene Standke**
Photo Editor **Jean Herr**
Photographer **Wendell Webber**
Publisher **Time Inc.**
Issue **October 2003**

097
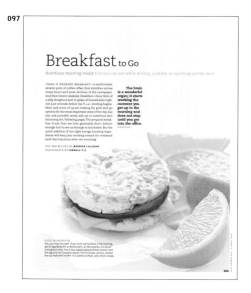

98

99

100
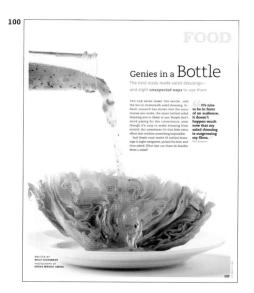

101

102

097
Publication **Real Simple**
Creative Director **Robert Newman**
Art Director **Leslie Long**
Designer **Leslie Long**
Photo Editors **Jean Herr, Deborah Kozloff**
Photographer **Formula Z/S**
Publisher **Time Inc.**
Issue **September 2003**

98
Publication **Real Simple**
Creative Director **Robert Newman**
Art Director **Leslie Long**
Designer **Leslie Long**
Photo Editor **Jean Herr**
Photographer **David White**
Publisher **Time Inc.**
Issue **June/July 2003**

99
Publication **Real Simple**
Creative Director **Robert Newman**
Art Director **Ellene Standke**
Designer **Ellene Standke**
Photo Editor **Jean Herr**
Photographer **Roland Bello**
Publisher **Time Inc.**
Issue **October 2003**

100
Publication **Real Simple**
Creative Director **Robert Newman**
Art Director **Leslie Long**
Designer **Leslie Long**
Photo Editor **Naomi Nista**
Photographer **Dasha Wright**
Publisher **Time Inc.**
Issue **June/July 2003**

101
Publication **Real Simple**
Creative Director **Robert Newman**
Art Director **Leslie Long**
Designers **Leslie Long, Monica Ewing**
Photo Editor **Naomi Nista**
Photographer **Mark Weiss**
Publisher **Time Inc.**
Issue **September 2003**

102
Publication **Rolling Stone**
Art Director **Andy Cowles**
Designer **Kory Kennedy**
Publisher **Wenner Media**
Issue **October 16, 2003**

your body

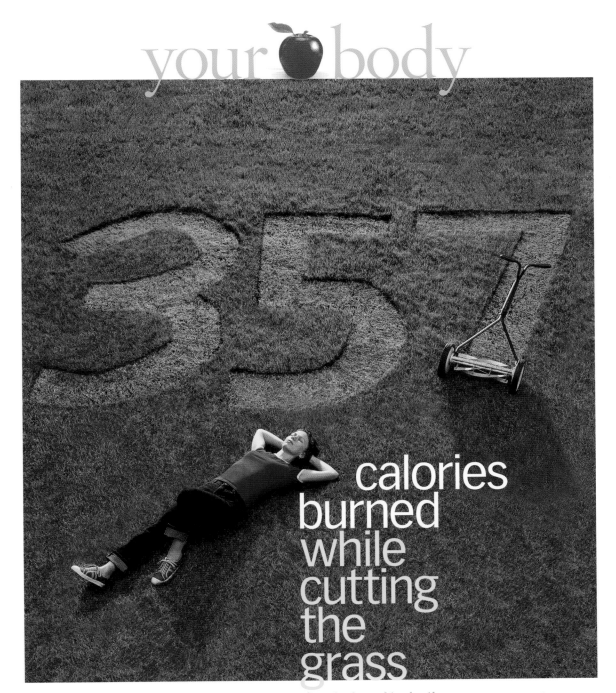

357 calories burned while cutting the grass

If you're bored to death by gym machines, try a lawn mower. A 135-pound woman pushing a nonpowered model will burn about 357 calories an hour and tone her arms. Even using a power cutter will work off 292 calories. And think of what you'll save on the gardener! ›

PHOTOGRAPH BY FREDRIK BRODEN

STYLIST: JULIE WHITMIRE. APPLE, FOODPIX.

2003 MAY 201

103
Publication **O, The Oprah Magazine**
Design Director **Carla Frank**
Designer **Albert Toy**
Photo Editor **Karen Frank**
Photographer **Fredrik Broden**
Publisher **The Hearst Corporation-Magazines Division**
Issue **May 2003**

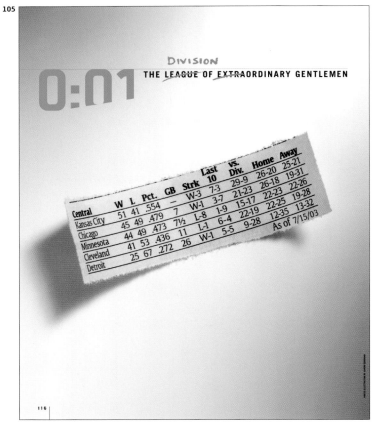

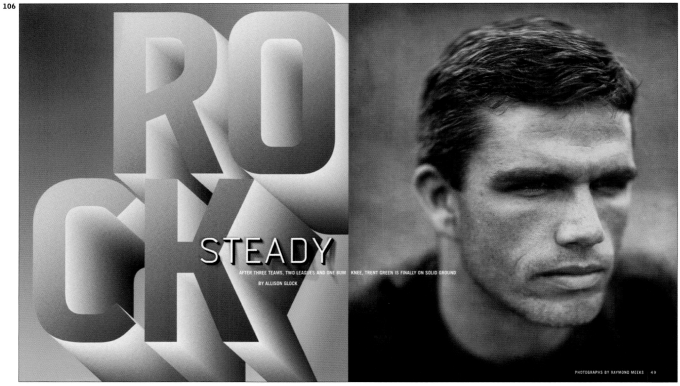

104
Publication **O, The Oprah Magazine**
Design Director **Carla Frank**
Designer **Erika Oliveira**
Photo Editor **Karen Frank**
Publisher **The Hearst Corporation-Magazines**
Division
Issue **February 2003**

105
Publication **ESPN The Magazine**
Design Director **Peter Yates**
Art Director **Kathie Scrobanovich**
Photo Editor **John Toolan**
Photographer **Aaron Goodman**
Director of Photograhy **Nik Kleinberg**
Publisher **ESPN, Inc.**
Issue **August 4, 2003**

106
Publication **ESPN The Magazine**
Design Director **Peter Yates**
Art Director **Siung Tjia**
Photo Editor **Jim Surber**
Photographer **Raymond Meeks**
Director of Photograhy **Nik Kleinberg**
Publisher **ESPN, Inc.**
Issue **November 10, 2003**

107

VANITY FAIR
NOVEMBER 2003

Here's the download: Elvis Costello fell for Diana Krall, and Def Jam
reunited, while the Donnas hopped into the female-rocker ring with
Avril Lavigne and a recharged Marianne Faithfull. Clive Davis is back to prove
he was never really gone, Perry Farrell brought back Lollapalooza,
and it's time to put Coldplay, Queens of the Stone Age, and the Dixie Chicks
on the playlist. Earphones, everyone...

PHOTOGRAPH BY JAMES WORRELL

▶Portraits by Annie Leibovitz, Bruce Weber, and Mark Seliger,
with Julian Broad, Karin Catt, Walter Chin, Danny Clinch, Olaf Heine,
Jonas Karlsson, Rankin, Norman Jean Roy, and Gasper Tringale

107
Publication **Vanity Fair**
Design Director **David Harris**
Art Director **Julie Weiss**
Designer **Chris Mueller**
Photo Editor **Lisa Berman**
Photographer **James Worrell**
Photo Director **Susan White**
Publisher **Condé Nast Publications Inc.**
Issue **November 2003**

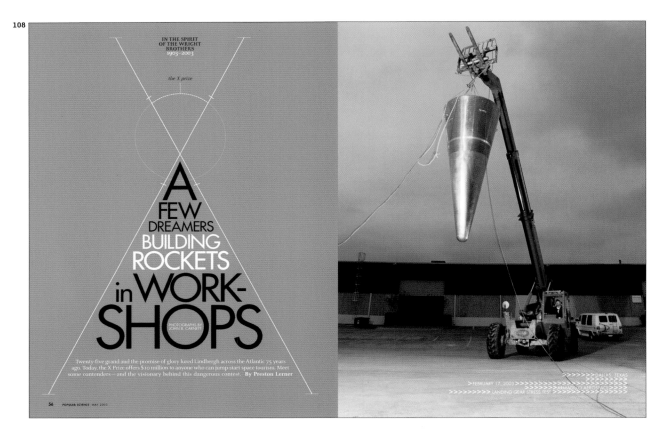

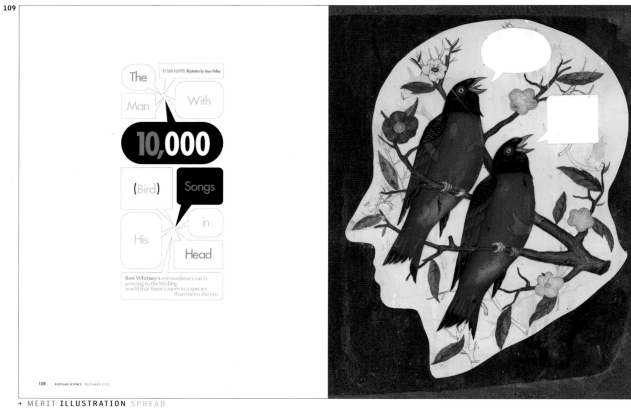

+ MERIT ILLUSTRATION SPREAD

108
Publication **Popular Science**
Design Director **Dirk Barnett**
Art Director **Hylah Hill**
Designers **Hylah Hill, Dirk Barnett**
Photo Editor **Kris Lamanna**
Photographer **John B. Carnett**
Publisher **Time4Media**
Issue **May 2003**

109
Publication **Popular Science**
Design Director **Dirk Barnett**
Designer **Dirk Barnett**
Illustrator **Jason Holley**
Publisher **Time4Media**
Issue **December 2003**

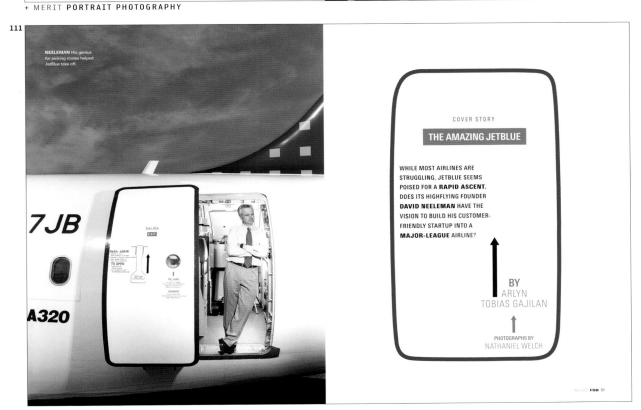

+ MERIT PORTRAIT PHOTOGRAPHY

110
Publication **Popular Science**
Design Director **Dirk Barnett**
Designer **Dirk Barnett**
Photo Editor **Kristine LaManna**
Photographer **Chris Buck**
Publisher **Time4Media**
Issue **September 2003**

111
Publication **FSB: Fortune Small Business**
Art Director **Scott A. Davis**
Designer **Grace Bonwon Koo**
Publisher **Time Inc.**
Issue **May 2003**

112

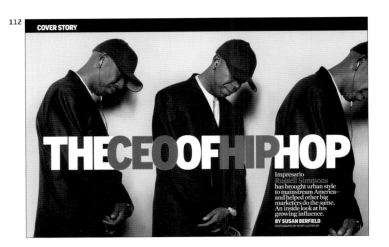

113

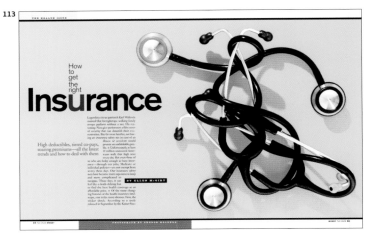

114

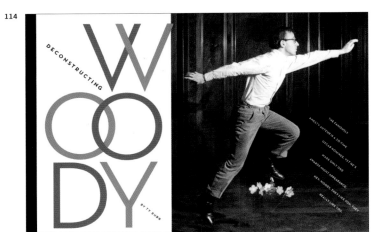

115

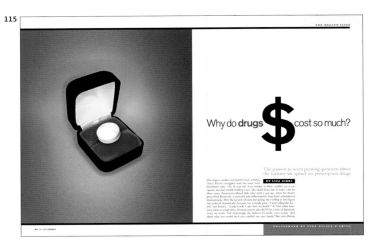

116

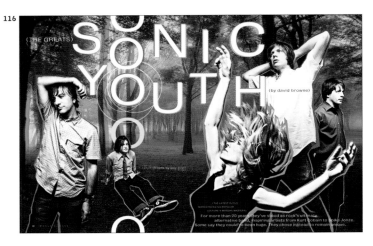

117

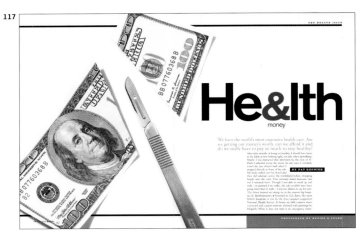

112
Publication **BusinessWeek**
Design Director **Malcolm Frouman**
Art Director **Jay Petrow**
Photo Editor **Anne D'Aprix**
Photographer **Henry Leutwyler**
Consulting Creative Director **Mary Jane Fahey**
Consulting Creative Director **David O'Connor**
Publisher **The McGraw-Hill Companies, Inc.**
Issue **October 27, 2003**

115
Publication **Money Magazine**
Art Director **Syndi Becker**
Designer **MaryAnn Salvato**
Photo Editors **Jane Clark, Betsy Keating**
Photographer **Pier Nicola D'Amico**
Publisher **Time Inc.**
Issue **Fall 2003**

113
Publication **Money Magazine**
Art Director **Syndi Becker**
Designer **David McKenna**
Photo Editors **Jane Clark, Betsy Keating**
Photographer **Gregor Halenda**
Publisher **Time Inc.**
Issue **Fall 2003**

116
Publication **Entertainment Weekly**
Design Director **Geraldine Hessler**
Designer **Geraldine Hessler**
Photographer **Amy Guip**
Publisher **Time Inc.**
Issue **March 7, 2003**

114
Publication **Entertainment Weekly**
Design Director **Geraldine Hessler**
Art Director **Jennifer Procopio**
Photo Editor **Freyda Tavin**
Publisher **Time Inc.**
Issue **March 21, 2003**

117
Publication **Money Magazine**
Art Director **Syndi Becker**
Designer **MaryAnn Salvato**
Photo Editors **Jane Clark, Betsy Keating**
Photographer **Davies & Starr**
Publisher **Time Inc.**
Issue **Fall 2003**

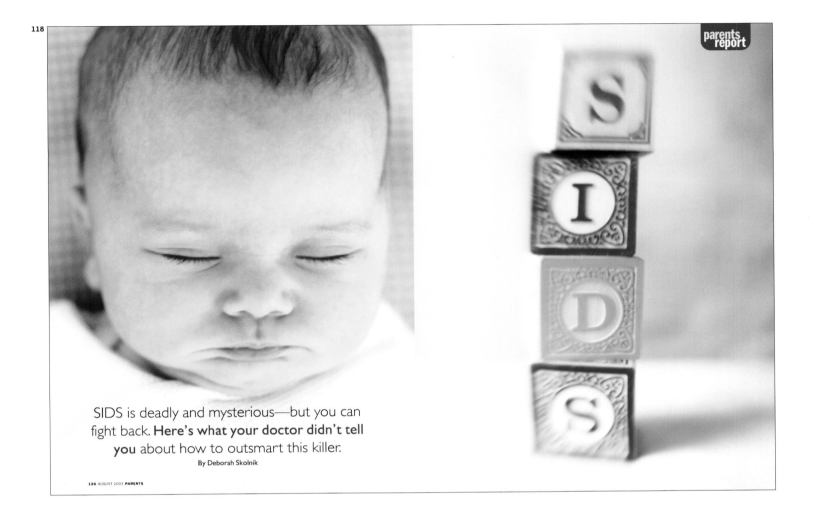

SIDS is deadly and mysterious—but you can fight back. **Here's what your doctor didn't tell you** about how to outsmart this killer.

By Deborah Skolnik

126 AUGUST 2003 **PARENTS**

118
Publication **Parents Magazine**
Creative Director **Jeffrey Saks**
Art Director **Andrea Amadio**
Designer **Mairead Liberace**
Photo Editor **Clare Lissaman**
Photographers **Anna Palma, Arwin Keawgumnurdpong**
Publisher **Gruner & Jahr**
Issue **August 2003**

119

120

121
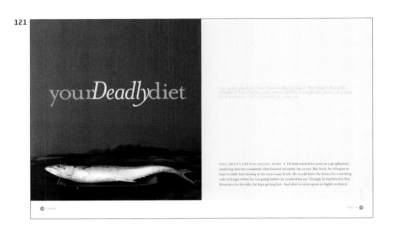

122
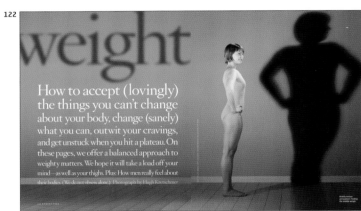

123
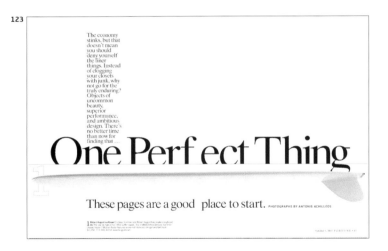

124
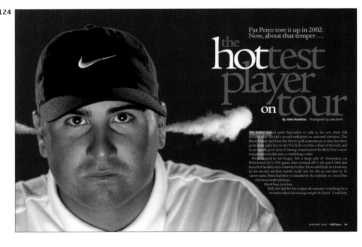

119
Publication **Chicago Tribune Magazine**
Art Director **David Syrek**
Photographer **Jack Perno**
Publisher **Chicago Tribune Company**
Issue **September 7, 2003**

120
Publication **O, The Oprah Magazine**
Design Director **Carla Frank**
Designer **Kristin Fitzpatrick**
Photo Editor **Karen Frank**
Photographer **Gentl & Hyers**
Publisher **The Hearst Corporation-Magazines Division**
Issue **May 2003**

121
Publication **Health Magazine**
Design Director **Paul Carstensen**
Designer **Kevin de Miranda**
Photo Editor **Angie Kelly**
Photographer **Sang An**
Publisher **Time Inc.**
Issue **June 2003**

122
Publication **O, The Oprah Magazine**
Design Director **Carla Frank**
Designer **Albert Toy**
Photo Editor **Karen Frank**
Photographer **Hugh Kretschmer**
Publisher **The Hearst Corporation-Magazines Division**
Issue **August 2003**

123
Publication **Fortune**
Design Director **Blake Taylor**
Art Director **Tony Mikolajczyk**
Photo Editor **Michele McNally**
Photographer **Antonis Achillos**
Publisher **Time Inc.**
Issue **October 6, 2003**

124
Publication **Golf Digest**
Design Director **Dan Josephs**
Art Director **Tim Oliver**
Designer **Matthew B. Cooley**
Photo Editors **Matthew M. Ginella, Christian Looss**
Photographer **Joey Terrill**
Publisher **Golf Digest Companies**
Issue **January 2003**

125

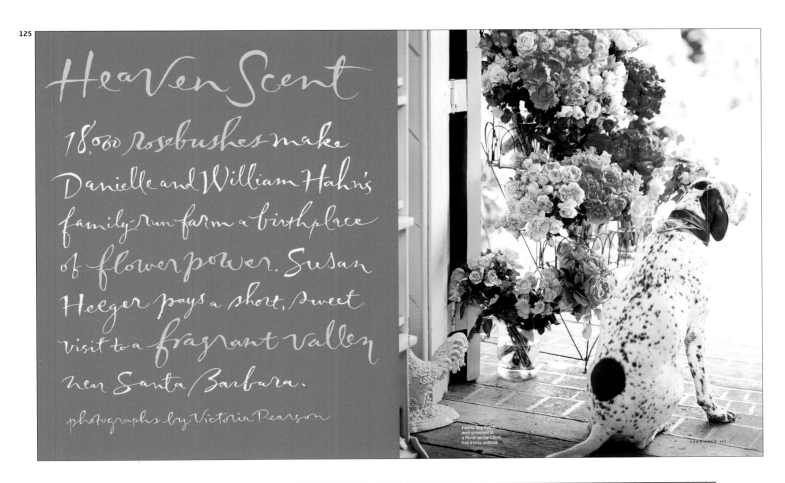

Heaven Scent

18,000 rosebushes make Danielle and William Hahn's family-run farm a birthplace of flower power. Susan Heeger pays a short, sweet visit to a fragrant valley near Santa Barbara.

photographs by Victoria Pearson

Family dog Patch, well groomed in a floral neckerchief, has a rosy outlook

126

age: You're 22. (Will you ever get a job you really like?) You're 32. (If only you'd known then what you know now.) You're 50. (Wait a minute… that can't be right.) This month we take a look at the Ages of Woman— the good, the bad, and the…no, honey, you can't wear Lycra anymore. Forty may be the new 30, but getting older still has an image problem. Why, we asked ourselves, should everyone be selling youth? Why not commission a few ads for maturity? Which we did. So read. Reap wisdom. Live joyously. You're only (fill in the blank) once.

125
Publication **O, The Oprah Magazine**
Design Director **Carla Frank**
Designer **Albert Toy**
Photo Editor **Karen Frank**
Lettering: **Lilly Lee**
Publisher **The Hearst Corporation-Magazines Division**
Issue **July 2003**

126
Publication **O, The Oprah Magazine**
Design Director **Carla Frank**
Designer **Kristin Fitzpatrick**
Publisher **The Hearst Corporation-Magazines Division**
Issue **October 2003**

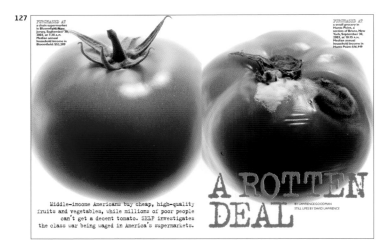

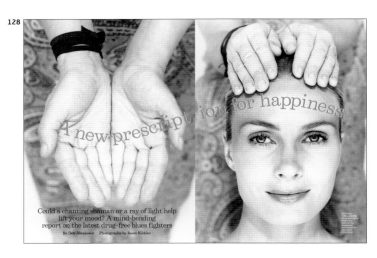

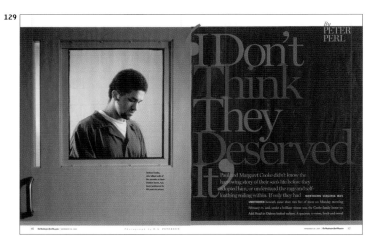

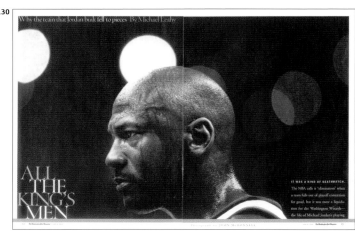

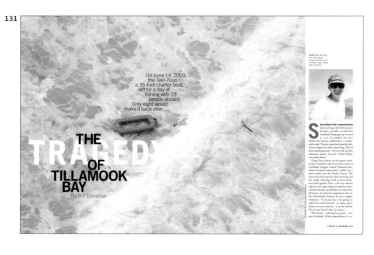

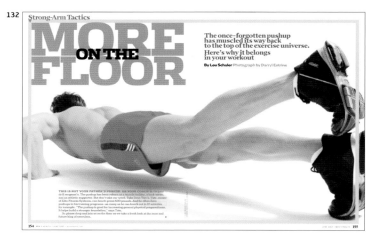

127
Publication **Self**
Design Director **Kati Korpijaakko**
Art Director **Neal Phiefer**
Designer **Neal Phiefer**
Photo Editor **Susan Isaak**
Photographer **David Lawrence**
Publisher **Condé Nast Publications Inc.**
Issue **December 2003**

130
Publication **The Washington Post Magazine**
Art Director **J Porter**
Designer **J Porter**
Photo Editors **Keith Jenkins, Jennifer Beeson**
Photographer **John McDonnell**
Production Manager **Leslie Garcia**
Publisher **The Washington Post Co.**
Issue **June 8, 2003**

128
Publication **Self**
Design Director **Kati Korpijaakko**
Designer **Andrze Janerka**
Photo Editor **Susan Isaak**
Photographer **Jason Kibbler**
Senior Deputy Art Director **Andrzej Janerka**
Publisher **Condé Nast Publications Inc.**
Issue **September 2003**

131
Design Director **Field & Stream**
Art Director **Todd Albertson**
Designer **Todd Albertson**
Photo Editor **Carrie Boretz**
Publisher **Time4Media**
Issue **December 2003/January 2004**

129
Publication **The Washington Post Magazine**
Art Director **J Porter**
Designer **J Porter**
Photo Editors **Keith Jenkins, Jennifer Beeson**
Photographer **D.A. Peterson**
Production Manager **Leslie Garcia**
Publisher **The Washington Post Co.**
Issue **November 30, 2003**

132
Publication **Men's Health**
Art Director **George Karabotsos**
Designer **Jose G. Fernandez**
Photo Editors **Marianne Butler,
Ernie Monteiro**
Publisher **Rodale Inc.**
Issue **June 2003**

133

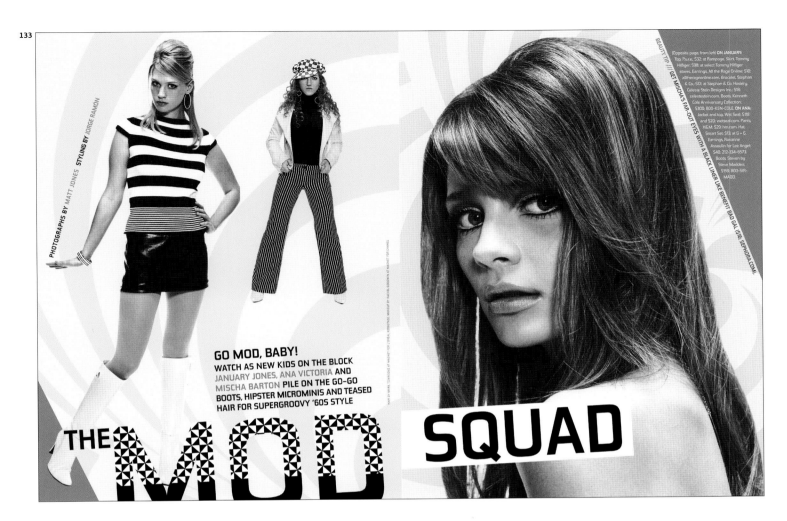

GO MOD, BABY!
WATCH AS NEW KIDS ON THE BLOCK
JANUARY JONES, ANA VICTORIA AND
MISCHA BARTON PILE ON THE GO-GO
BOOTS, HIPSTER MICROMINIS AND TEASED
HAIR FOR SUPERGROOVY '60S STYLE

THE MOD SQUAD

134

133
Publication **Teen People**
Creative Director **Jill Armus**
Art Director **Nazan Akyavas**
Designer **Nazan Akyavas**
Photo Editor **Doris Brautigan**
Photographer **Matt Jones**
Publisher **Time Inc.**
Issue **September 2003**

134
Publication **Teen People**
Creative Director **Jill Armus**
Art Director **Nazan Akyavas**
Designer **Nazan Akyavas**
Illustrator **Robert Piersanti**
Photo Editor **Doris Brautigan**
Publisher **Time Inc.**
Issue **December 2003**

135

136

137
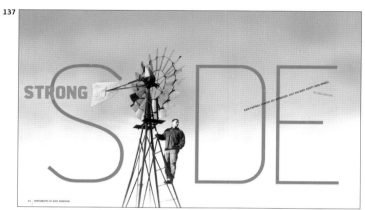

138
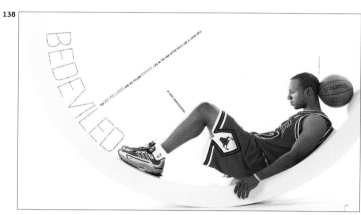

139
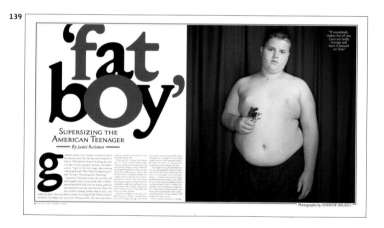

140
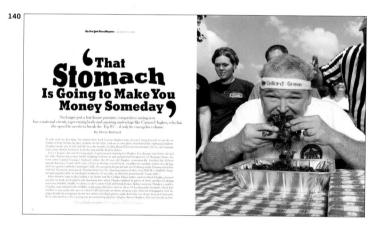

135
Publication **Martha Stewart Living**
Creative Director **Eric Pike**
Art Director **Jill Groeber**
Photo Editors **Stacie McCormick, Beth Krzyzkowski**
Photographer **Maura McEvoy**
Stylist **Tanya Graff**
Craft Editor **Laura Normandin**
Publisher **Martha Stewart Living Omnimedia**
Issue **December 2003**

138
Publication **ESPN The Magazine**
Design Director **Peter Yates**
Art Director **Siung Tjia**
Designer **Siung Tjia**
Photographer **Jennifer Pottheiser**
Director of Photograhy **Nik Kleinberg**
Publisher **ESPN, Inc.**
Issue **March 31, 2003**

136
Publication **Martha Stewart Living**
Design Director **Barbara de Wilde**
Art Director **Yu Mei Tam Compton**
Designer **Amber Blakesley**
Photo Editors **Stacie McCormick, Beth Krzyzkowski**
Photographer **Dana Gallagher**
Stylist **Brian Harter Andriola, Rebecca Robertson, Fritz Karch**
Publisher **Martha Stewart Living Omnimedia**
Issue **September 2003**

139
Publication **Rolling Stone**
Art Director **Andy Cowles**
Designer **Kory Kennedy**
Photographer **Andrew Brusso**
Publisher **Wenner Media**
Issue **November 13, 2003**

137
Publication **ESPN The Magazine**
Design Director **Peter Yates**
Designer **Peter Yates**
Photo Editor **John Toolan**
Photographer **Andy Anderson**
Director of Photograhy **Nik Kleinberg**
Publisher **ESPN, Inc.**
Issue **June 23, 2003**

140
Publication **The New York Times Magazine**
Art Director **Janet Froelich**
Designer **Joele Cuyler**
Photo Editor **Kathy Ryan**
Photographer **Matthias Clamer**
Publisher **The New York Times**
Issue **August 31, 2003**

141

The New York Times Magazine / OCTOBER 12, 2003

The
Triumph
of the
Repressed

Jean Paul Gaultier
made his name as a French designer by drawing upon
all that traditional France disowned. So what is he doing at Hermès,
the most traditional of design houses?

By Cathy Horyn

Photograph by Jean-Baptiste Mondino

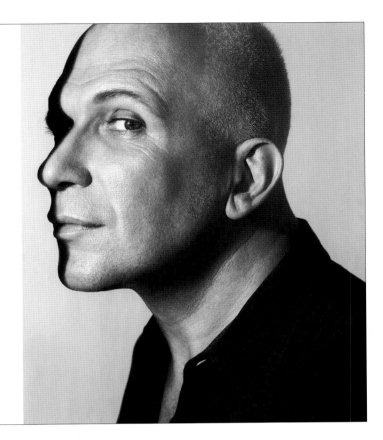

Jean Paul Gaultier, pushing his glasses up on his nose, stood in the middle of the studio and looked at the model Alek Wek being fitted in a black-and-silver lace bodysuit that began as a hood over her head and extended down without a ripple over her neck and shoulders, over the small mound of her breasts, down her long legs and ended at her toes, so that every part of her body was covered in lace except the oval of her ebony face.

"Can you hear?" Gaultier asked, tapping on her right ear. Wek nodded and smiled.

The fittings went on like this for several hours one day early last July, with Gaultier saying little, as other models came and left. He would not admit that he was in trouble with this collection, an haute couture show that in a few days he would stage before 700 editors and clients at the École Nationale Supérieure des Beaux-Arts in Paris. Couture is that hugely indefensible branch of the fashion world that is the opposite of a business,

68

142

What the Camera Sees in Her

Assessing Cate Blanchett. **By Daphne Merkin**

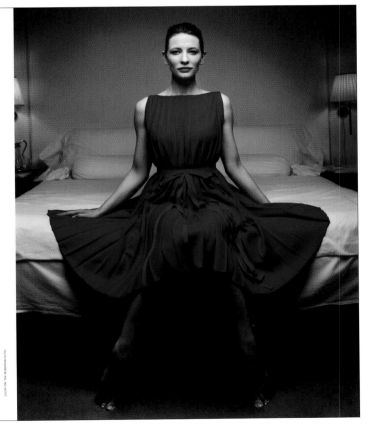

Cate Blanchett is not, at first glance, conventionally beautiful; indeed, her strong face can, from certain angles, seem almost plain. Her cheekbones look less enviably sculptured than they do on-screen, and her gorgeously ripe mouth shows up less than it does when it is slashed with crimson, as it is in "The Talented Mr. Ripley" and "Charlotte Gray." Her ears (as she points out, lest I fail to notice) are big, and she wears her hair scraped back in a non-do. She is not, in fact, immediately recognizable until you get up close and see those extraordinary wraparound eyes, long, narrow and a searching pale blue. Show-stopping eyes that register emotions with a clarity that conveys some Platonic essence of whatever the emotion in question is. So, I think, this is what it means to be photogenic — to have the kind of face that veils its magic until it meets up with the camera.

It's a Saturday afternoon in October, and the 34-year-old actress and I have been having lunch at the Four Seasons Hotel, smack in the middle of New York's shopping heaven. One of the first things I realize about Blanchett is that she is a very unsuperficial person. She is, in fact, incapable of sounding superficial even about topics like the hazards of fame, but since she moves in a world of mirrored surfaces, she wants to make sure I haven't mistaken her for some tinfoil, penny-ante movie star. "You're not going to talk about *clothes*, are you?" She sounds genuinely panic-stricken, as if I had unearthed an incriminating detail from her deep past that no one has confronted her with until now.

Blanchett speaks in a beguiling tumble of words with an elegant, lightly accented voice that is not quite placeable, and this is the first time in our two hours of hopscotching conversation that she has sounded anything other than unfazably low-key. Except when she is being wildly enthusiastic (two of her favorite adjectives are "extraordinary" and "fantastic"), she tends to be wryly deflating of herself or other peoples' perceptions of her. "I don't live in the media," she declares. "Well, you will one day, won't

 Photograph by Robert Maxwell

68

LOCATION: THE MANDARIN HOTEL

141
Publication **The New York Times Magazine**
Art Director **Janet Froelich**
Designer **Joele Cuyler**
Photo Editor **Kathy Ryan**
Photographer **Jean-Baptiste Mondino**
Publisher **The New York Times**
Issue **October 12, 2003**

142
Publication **The New York Times Magazine**
Art Director **Janet Froelich**
Designer **Catherine Gilmore-Barnes**
Photo Editor **Kathy Ryan**
Photographers **Dan Winters, Robert Maxwell**
Publisher **The New York Times**
Issue **November 9, 2003**

143

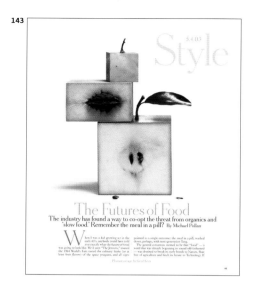

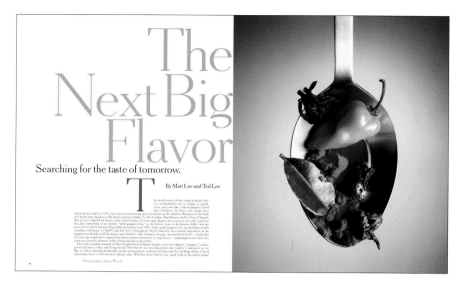

144

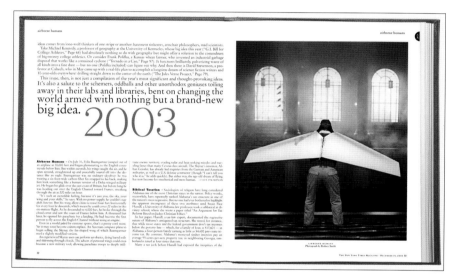

145

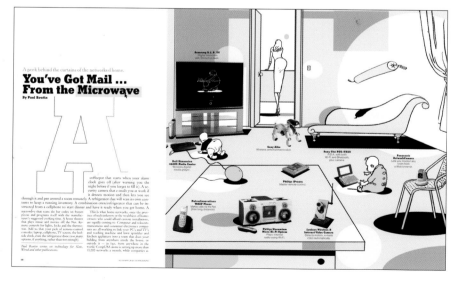

143
Publication **The New York Times Magazine**
Art Director **Janet Froelich**
Designer **Catherine Gilmore-Barnes**
Photographers **Geof Kern, James Wojcik**
Publisher **The New York Times**
Issue **May 4, 2003**

144
Publication **The New York Times Magazine**
Art Director **Janet Froelich**
Designers **Kristina Dimatteo, Joele Cuyler**
Photo Editor **Kathy Ryan**
Publisher **The New York Times**
Issue **December 14, 2003**

145
Publication **The New York Times Magazine**
Art Director **Janet Froelich**
Designers **Jeff Glendenning, Prem Krishnamurthy**
Illustrator **Istvan Banyai**
Photo Editor **Kathy Ryan**
Photographer **Craig Cutler**
Publisher **The New York Times**
Issue **November 16, 2003**

146

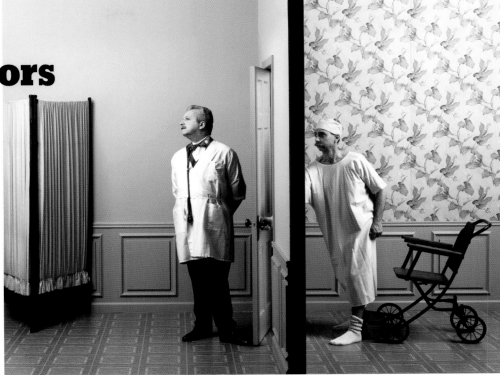

When Doctors Slam the Door

Under the current system, a doctor's reputation may depend on his or her willingness to turn away a dying man. BY SANDEEP JAUHAR, M.D.

When can a doctor refuse to treat a patient? Not surprisingly, there are rules. In 1987, Dr. John Bower, a kidney specialist at the University of Mississippi Medical Center, was sued after dismissing from his practice a patient who regularly missed dialysis appointments, verbally abused nurses and even threatened to kill Bower and a hospital administrator. Bower cited medical noncompliance and violent threats as grounds for terminating care. The Fifth Circuit Court of Appeals, in New Orleans, agreed with him, ruling that doctors can refuse to treat violent or intransigent patients as long as they give proper notice so that the patient can find alternative care. Forcing doctors to treat such patients, the court said, would violate the 13th Amendment, which prohibits involuntary servitude.

Sometimes doctors can refuse to treat on the basis of conscience. I once took care of a man in his 50's who had metastatic tongue cancer and respiratory failure requiring a ventilator. His family refused to turn off the machine and let him die, choosing instead to escalate treatment with even more aggressive interventions. Medicine is a stochastic science — no doctor can predict the future — but in this case the out-

PHOTOGRAPH BY GEOF KERN

32

THE NEW YORK TIMES MAGAZINE / MARCH 16, 2003 33

147

The New York Times Magazine / JUNE 8, 2003

The Sink-or-Swim Economy

If the recession isn't so deep, how come you're feeling so bad? The perils of market efficiency.

BY HARRIS COLLINGWOOD

Photograph by **Christoph Niemann and David Harry Stewart**

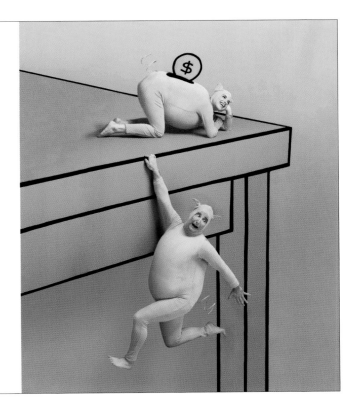

What is it with this economy, anyway? Going strictly by the numbers, the most recent recession has been mild in comparison to previous downturns. Since the economy peaked in March 2001, the major markers of economic health — industrial output, personal income and wholesale and retail sales — have all traced smaller declines than in the average post-World War II recession. That's why many economists, among them Jeffrey Frankel, a professor at Harvard University's Kennedy School of Government, are inclined to dismiss today's complaints about economic stress and anxiety. "People got spoiled by the 90's boom," Frankel says. "They forgot what recessions are like."

But Frankel concedes there's something odd about this latest economic decline. After a short-lived retreat in 2001, gross domestic product after adjustment for inflation actually grew throughout 2002 and managed a 1.9 percent gain in the first quarter of 2003. Yet the economy shed more than 500,000 jobs between January and April. And as Frankel notes dryly, "Wages are not doing so well, either." The latest evidence of wage stagnation: the Labor Department's report last month that the average weekly paycheck, once inflation and seasonal factors are considered, shrank 0.3 percent from March to April of this year. All the contradictory signals have economists wondering what manner of beast stands before them. "In recent economic history," says Robert Hall, an economist

42

+ MERIT PHOTO ILLUSTRATION

146
Publication **The New York Times Magazine**
Art Director **Janet Froelich**
Designer **Nancy Harris**
Photo Editor **Kathy Ryan**
Photographers **Geof Kern, Dan Winters**
Publisher **The New York Times**
Issue **March 16, 2003**

147
Publication **The New York Times Magazine**
Art Director **Janet Froelich**
Designer **Joele Cuyler**
Illustrator **Christoph Niemann**
Photo Editor **Kathy Ryan**
Photographer **David Harry Stewart**
Publisher **The New York Times**

148
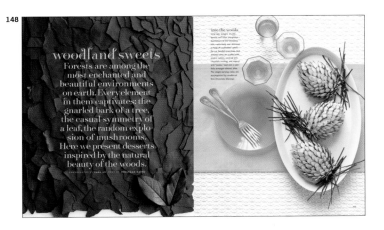

149
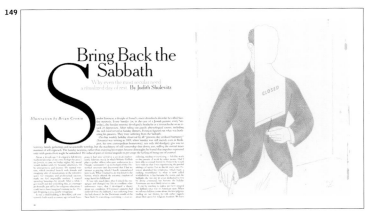

150
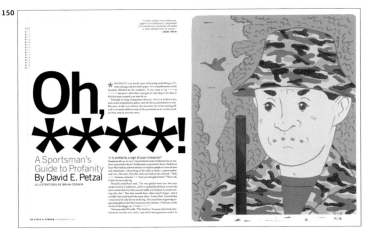

151
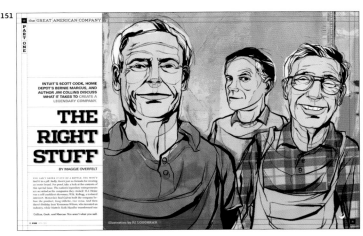

152
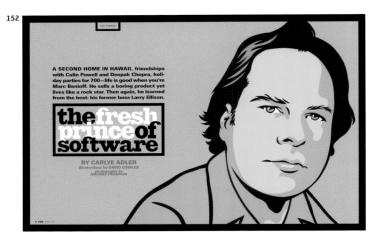

153
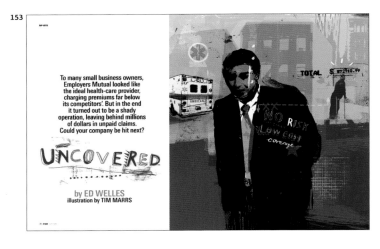

148
Publication **Martha Stewart Living**
Creative Director **Eric Pike**
Designer **Mary Jane Callister**
Photo Editors **Stacie McCormick, Beth Krzyzkowski**
Photographer **Sang An**
Stylist **Ayesha Patel**
Food Editor **Jennifer Aaronson**
Publisher **Martha Stewart Living Omnimedia**
Issue **December 2003**

149
Publication **The New York Times Magazine**
Art Director **Janet Froelich**
Designer **Joele Cuyler**
Illustrator **Brian Cronin**
Publisher **The New York Times**
Issue **March 2, 2003**

150
Publication **Field & Stream**
Art Directors **Todd Albertson, Erin Whelan**
Designers **Todd Albertson, Erin Whelan**
Illustrator **Brian Cronin**
Publisher **Time4Media**
Issue **November 2003**

151
Publication **FSB: Fortune Small Business**
Art Director **Scott A. Davis**
Designer **Randi Shapiro**
Illustrator **PJ Loughran**
Publisher **Time Inc.**
Issue **April 2003**

152
Publication **FSB: Fortune Small Business**
Art Director **Scott A. Davis**
Designer **Mike Novak**
Illustrator **David Cowles**
Publisher **Time Inc.**
Issue **March 2003**

153
Publication **FSB: Fortune Small Business**
Art Director **Scott A. Davis**
Designer **Scott A. Davis**
Illustrator **Tim Marrs**
Publisher **Time Inc.**
Issue **May 2003**

154
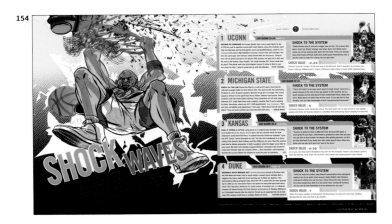

155
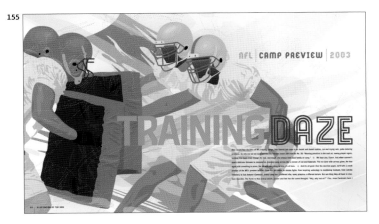

156
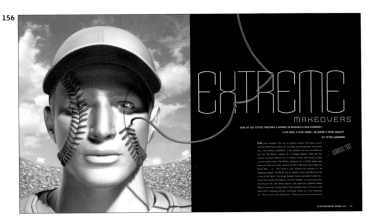

157
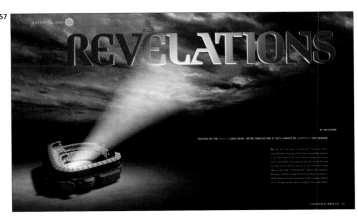

158
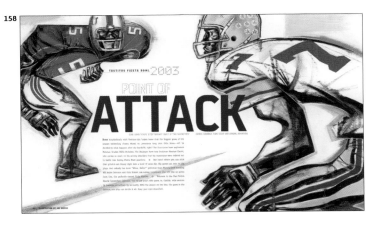

159
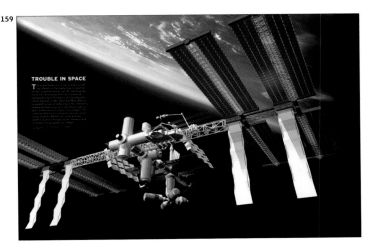

154
Publication **ESPN The Magazine**
Design Director **Peter Yates**
Art Director **Siung Tjia**
Designer **Siung Tjia**
Illustrator **Nathan Fox**
Publisher **ESPN, Inc.**
Issue **November 24, 2003**

155
Publication **ESPN The Magazine**
Design Director **Peter Yates**
Art Director **Tahiti Starship**
Designer **Tahiti Starship**
Illustrator **The BRM**
Publisher **ESPN, Inc.**
Issue **August 4, 2003**

156
Publication **ESPN The Magazine**
Design Director **Peter Yates**
Art Director **Siung Tjia**
Designer **Siung Tjia**
Illustrator **Mirko Ilic**
Publisher **ESPN, Inc.**
Issue **March 17, 2003**

157
Publication **ESPN The Magazine**
Design Director **Peter Yates**
Art Director **Siung Tjia**
Designer **Siung Tjia**
Illustrator **Mirko Ilic**
Publisher **ESPN, Inc.**
Issue **April 14, 2003**

158
Publication **ESPN The Magazine**
Design Director **Peter Yates**
Designer **Peter Yates**
Illustrator **Joe Morse**
Publisher **ESPN, Inc.**
Issue **January 6, 2003**

159
Publication **U.S. News & World Report**
Creative Director **David Griffin**
Design Director **Ken Newbaker**
Art Director **Becky Pajak**
Illustrators **Doug Stern, Rob Cady**
Issue **Special Edition**

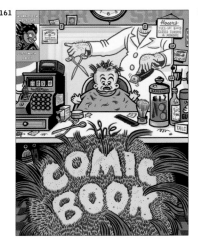

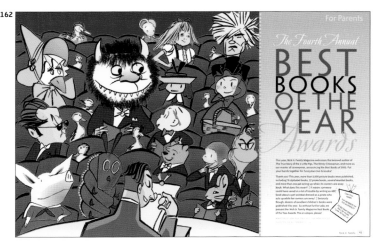

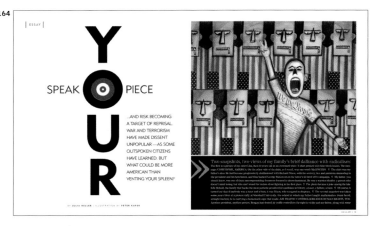

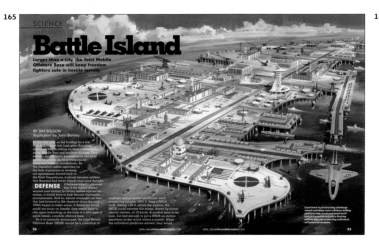

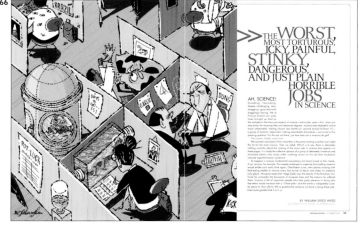

160
Publication **The New York Times**
Art Director **Barbara Richer**
Designer **Barbara Richer**
Illustrator **Yuko Shimizu**
Publisher **The New York Times**
Issue **November 9, 2003**

161
Publication **Nickelodeon Magazine**
Design Director **Justine Strasberg**
Art Director **Chris Duffy**
Designer **Catherine Tutrone**
Illustrators **M. Wartella, (corner box by Nick Bertozzi)**
Publisher **MTV Networks**
Issue **September 2003**

162
Publication **Nick Jr. Family Magazine**
Design Director **Don Morris**
Art Director **Josh Klenert**
Designers **Jennifer Starr, Robert Morris**
Illustrator **Tom Bachtell**
Photo Editor **Karen Shinbaum**
Studio **Don Morris Design**
Publisher **Viacom**
Issue **December 2003/January 2004**

163
Publication **Chicago Tribune Magazine**
Art Directors **Joseph Darrow, David Syrek**
Illustrator **Joseph Darrow**
Publisher **Chicago Tribune Company**
Issue **September 14, 2003**

164
Publication **Chicago Tribune Magazine**
Art Director **David Syrek**
Illustrator **Peter Kuper**
Publisher **Chicago Tribune Company**
Issue **June 29, 2003**

165
Publication **Popular Mechanics**
Creative Director **Bryan Canniff**
Illustrator **John Berkey**
Publisher **The Hearst Corporation-Magazines Division**
Issue **April 2003**

167

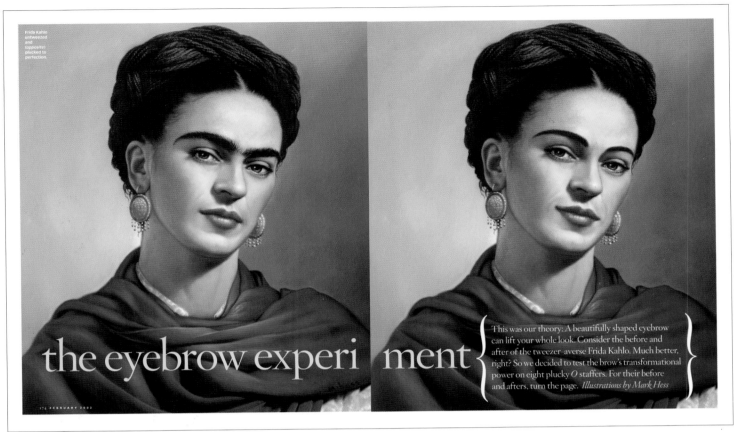

168

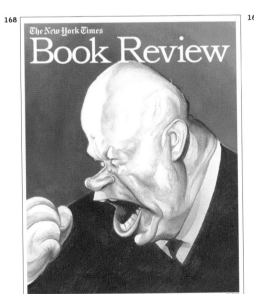

169

166
Publication **Popular Science**
Design Director **Dirk Barnett**
Art Director **Hylah Hill**
Designer **Hylah Hill**
Illustrator **Edwin Fotheringham**
Publisher **Time4Media**
Issue **October 2003**

167
Publication **O, The Oprah Magazine**
Design Director **Carla Frank**
Art Director **Albert Toy**
Illustrator **Mark Hess**
Publisher **The Hearst Corporation-Magazines Division**
Issue **February 2003**

168
Publication **The New York Times Book Review**
Art Director **Steve Heller**
Designer **Steve Heller**
Illustrator **Steve Brodner**
Publisher **The New York Times**
Issue **March 16, 2003**

169
Publication **The New York Times Magazine**
Art Director **Janet Froelich**
Designer **Joele Cuyler**
Illustrator **Brian Cronin**
Publisher **The New York Times**
Issue **June 1, 2003**

170
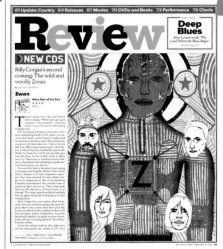

171
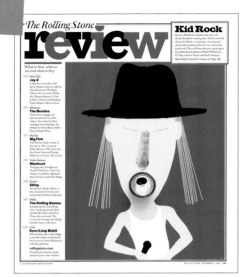

172
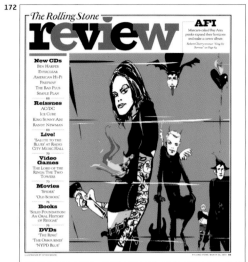

173

174
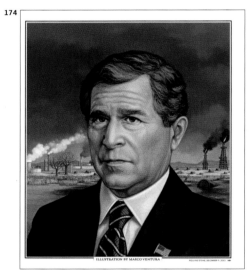

175

170
Publication **Rolling Stone**
Art Directors **Andy Cowles, Devin Pedzwater**
Designer **Devin Pedzwater**
Illustrator **Christian Northeast**
Publisher **Wenner Media**
Issue **February 6, 2003**

171
Publication **Rolling Stone**
Art Directors **Andy Cowles, Devin Pedzwater**
Designer **Devin Pedzwater**
Illustrator **Hanoch Piven**
Publisher **Wenner Media**
Issue **December 11, 2003**

172
Publication **Rolling Stone**
Art Directors **Andy Cowles, Devin Pedzwater**
Designer **Devin Pedzwater**
Illustrator **Istvan Banyai**
Publisher **Wenner Media**
Issue **May 20, 2003**

173
Publication **Rolling Stone**
Art Directors **Andy Cowles, Devin Pedzwater**
Designer **Devin Pedzwater**
Illustrator **Saimon Chow**
Publisher **Wenner Media**
Issue **February 20, 2003**

174
Publication **Rolling Stone**
Art Directors **Andy Cowles, Kory Kennedy**
Designer **Kory Kennedy**
Illustrator **Marco Ventura**
Publisher **Wenner Media**
Issue **December 11, 2003**

175
Publication **Rolling Stone**
Art Directors **Andy Cowles, Kory Kennedy**
Designer **Matthew Ball**
Illustrator **Olaf Hajek**
Publisher **Wenner Media**
Issue **May 15, 2003**

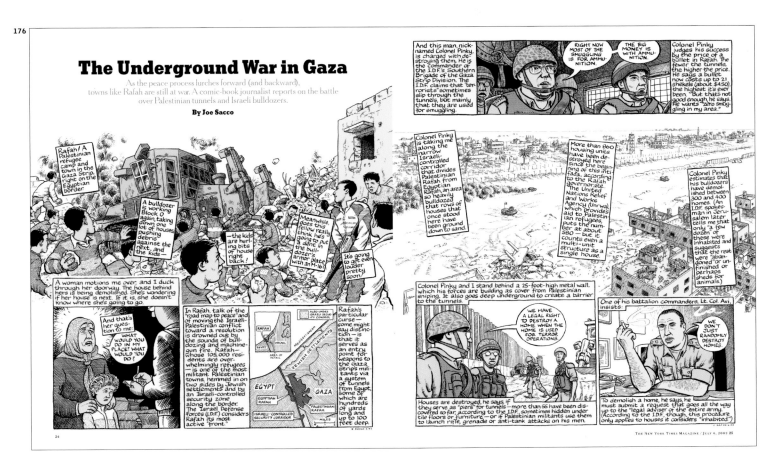

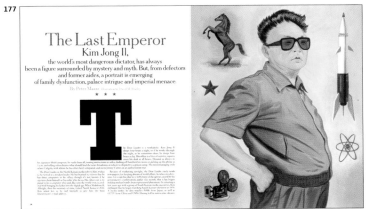

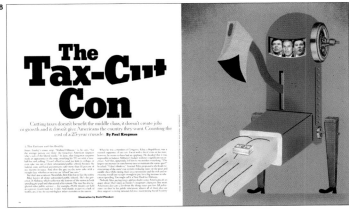

176
Publication **The New York Times Magazine**
Art Director **Janet Froelich**
Designer **Joele Cuyler**
Illustrator **Joe Sacco**
Publisher **The New York Times**
Issue **July 6, 2003**

177
Publication **The New York Times Magazine**
Art Director **Janet Froelich**
Designers **Jeff Glendenning, Catherine Gilmore-Barnes**
Illustrator **David M. Brinley**
Publisher **The New York Times**
Issue **October 19, 2003**

178
Publication **The New York Times Magazine**
Art Director **Janet Froelich**
Designer **Jeff Glendenning**
Illustrator **David Plunkert**
Publisher **The New York Times**
Issue **September 14, 2003**

179

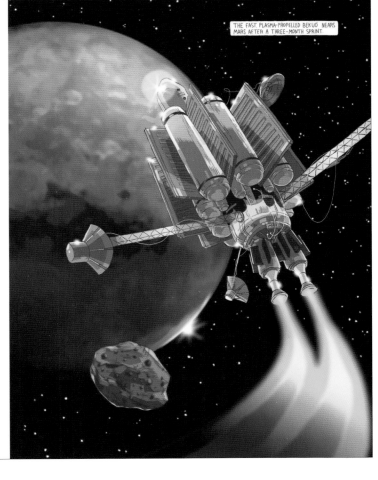

RED PLANET BLUES

2020? 2050? NEVER? PREDICTING THE DATE HUMANS WILL SET FOOT ON MARS IS, IF ANYTHING, BECOMING MORE DIFFICULT. INTENSE RADIATION, ZERO-G BONE LOSS, LETHAL MARS DUST, AND MURDEROUS CABIN FEVER ARE JUST A FEW OF THE MISSION'S UNSOLVED PROBLEMS. *HERE'S* A CHALLENGE TO GET NASA HUMMING AGAIN.

[The Bekuó cruises past Phobos, a small, rocky Martian moon.]

THE FAST, PLASMA-PROPELLED BEKUÓ NEARS MARS AFTER A THREE-MONTH SPRINT.

62

179
Publication **Popular Science**
Design Director **Dirk Barnett**
Designer **Dirk Barnett**
Illustrator **Tomer Hanuka**
Publisher **Time4Media**
Issue **July 2003**

180
Publication **Popular Science**
Design Director **Dirk Barnett**
Art Director **Hylah Hill**
Designers **Dirk Barnett, Hylah Hill**
Illustrators **Josh Mckible, Guilbert Gates**
Publisher **Time4Media**
Issue **November 2003**

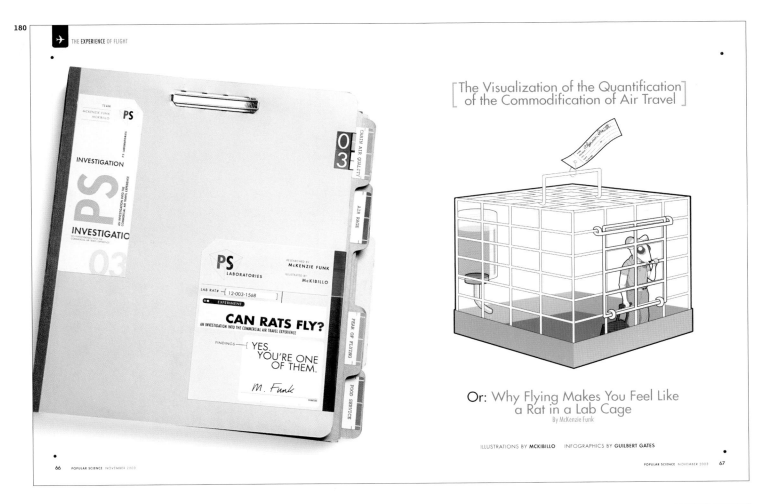

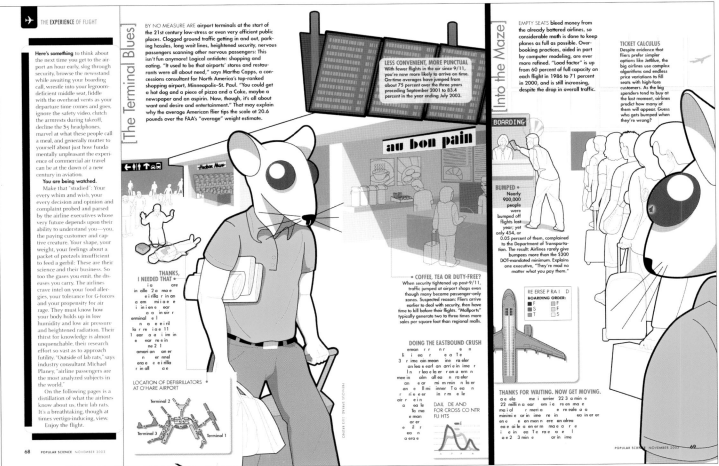

181
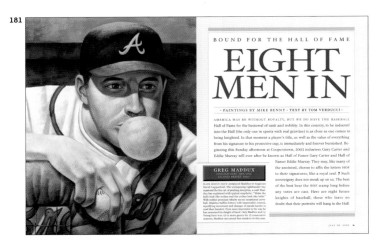

182
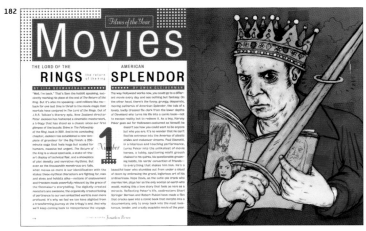

183

184
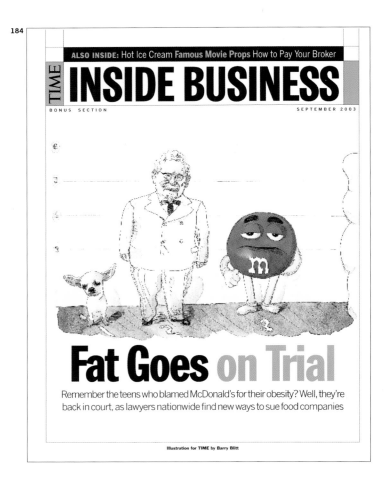

181
Publication **Sports Illustrated**
Creative Director **Steve Hoffman**
Art Director **Edward Truscio**
Designer **Edward Truscio**
Illustrator **Mike Benny**
Publisher **Time Inc.**
Issue **July 28, 2003**

184
Publication **Time Magazine**
Art Director **Marti Golon**
Designer **Avi Litwack**
Illustrator **Barry Blitt**
Publisher **Time Inc.**
Issue **August 11, 2003**

182
Publication **Entertainment Weekly**
Design Director **Geraldine Hessler**
Art Director **John Walker**
Designers **John Walker, Jennifer Procopio, Lee Berresford,
Jennie Chang, Sean Bumgarner, Sara Osten, Bhairavi Patel,
Dian-Aziza Ooka**
Illustrators **Gary Taxali, Harry Campbell, Jonathon Rosen,
Thomas Fuchs, Zohar Lazar, Robert De Michiell, David Hughes,
Justin Wood, Tim Bower, David Cowles, Jody Hewgill**
Photo Editors **Fiona McDonagh, Audrey Landreth, Michele
Romero, Richard Maltz, Suzanne Regan, Freyda Tavin, Jef
Castro, Carrie Levitt, Melissa Roque**
Photographers **Jeff Riedel, Ethan Hill, Robert Maxwell, Christian
Witkin, Gavin Bond, Judson Baker, Julian Broad, Martin
Schoeller, Steve Road, Michael O'Neill, Michael Thompson,
Catherine Lender, Danielle Levitt, Andrew Hetherington**
Publisher **Time Inc.**
Issue **December 26, 2003**

183
Publication **The New York Times Book Review**
Art Director **Steve Heller**
Designer **Steve Heller**
Illustrator **Bruce McCall**
Publisher **The New York Times**
Issue **June 1, 2003**

185
Publication **The New York Times Magazine**
Art Director **Janet Froelich**
Designer **Kristina DiMatteo**
Photo Editor **Kathy Ryan**
Photographer **Rodney Smith**
Publisher **The New York Times**
Issue **December 14, 2003**

185

children and grandmothers, hundreds of thousands of music devotees flocked to Web sites like Bad Blue or Waste. Like Napster and KaZaA, these sites let users sift through the public contents of one another's hard drives and swap files on the Internet. But like the soldiers in Tikrit, file-swappers need an invitation to enter. Inside the velvet-roped cyberclub of the Darknet that Bad Blue or Waste creates, members can trade purloined music or movies or whatever it is they want to exchange, having been waved inside by the bouncers at the door. GARY RIVLIN

DROUGHT-PROOF LAWN
Photograph by Frank Schwere

Drought-Proof Lawn, The · After decades of indulgence, the great American thirst for domestic turf is becoming literally un-quenchable. The nation's 50 million lawns drink 270 billion gallons of water every week. Depending on the city, between 30 and 60 percent of urban fresh water is used for watering lawns. So when water shortages strike, as they increasingly do, the lawn feels it first.

Now, from the fertile land of turf science comes a blade of hope: a variety of grass called siltgrass or seashore paspalum. The grass is drought-tolerant (it grows on as little as half the water of the classic grasses) and can withstand the occasional dousing of salt water — a sure death warrant for the average lawn. The grass is ideal for ocean-front fairways and properties, where salt spray is common. This year, for the first time, the PGA World Cup golf tournament was played on paspalum at the Ocean Course in South Carolina. And paspalum can thrive on reclaimed or recycled "gray" water.

Of course, the latest miracle grass doesn't address the underlying problem: homeowners are flocking to Arizona, New Mexico, Southern California — regions of little rain. No scientist, it seems, has figured out how to satisfy the yen for lawn where no lawn should be. ALAN BURDICK

Enough Debating — Let's Start Hating · Liberals have long complained that the right overwhelms them with personal attacks and vicious allegations, while the left tries, naively, to make a more noble and substantive case. They certainly don't have to worry about that any-

more. A new strand of vitriol has consumed the Bush-hating left. Just look in any bookstore, where the "new and noteworthy" table sports diverse works like Michael Moore's "Dude, Where's My Country?"; Al Franken's "Lies and the Lying Liars Who Tell Them"; "Bushwhacked," by the Texas journalists Molly Ivins and Lou Dubose; Joe Conason's "Big Lies"; "The Lies of George W. Bush," by David Corn; and so on.

Combined with the usual tirades from overexposed conservatives like Ann Coulter and Bill O'Reilly, the new leftist screeds seem to solidify a rising political culture of incivility and overstatement. (Franken's best-selling book, aimed mostly at right-wing commentators, features such chapters as "Ann Coulter: Nutcase," "Bill O'Reilly: Lying, Splotchy Bully" and, in case anyone missed it the first time, "You Know Who I Don't Like? Ann Coulter.") During certain weeks this fall, as many as half of The Times's 10 best-selling nonfiction hardcover books were political polemics from one side or the other, and each, it seemed, rang nastier than the last.

The various expressions of liberal fury are a direct imitation of what the right has been doing for more than a decade. Shouted down by incensed and often irrational conservatives, liberals like Franken and Moore have come to believe that the only way to fight back is in kind. But they seem to have missed an essential lesson from the Clinton era: for all the venom directed his way, Clinton still left office with high approval ratings. Hate isn't much of a message.

Inevitably, the rage on both sides has seeped into official Washington, where the once collegial Senate devolved this year into a contest of dueling and vituperative filibusters and where petting in the House reached such a level that Bill Thomas, the Republican Ways and Means chairman, tried to have Democratic lawmakers arrested for leaving a hearing. (Thomas later tearfully apologized.) It probably shouldn't have surprised anyone when Newsweek recently revealed that Franken was looking into a run for the Senate. MATT BAI

Espresso You Can't Mess Up · Home-brewed espresso used to represent gourmet coffee-making in its highest form. The perfect cup was as much about the ritual of grinding the beans and tamping the coffee just so as it was about the drink itself.

But espresso companies have come up with a system designed to scrap that artistry once and for all, in favor of ease, consistency and convenience. The message? Controlled repetition, not loving care, is what makes a good espresso.

High-end coffee companies like Illy Caffè, Lavazza and La Colombe Torrefaction now sell pre-measured single-serve espresso capsules, or pods. Illy's pods were picked up this year by Wegmans and FreshDirect, and sales are up 41 percent over last year.

Then there's the Nespresso C190. A gleaming aluminum capsule in the shape of a coffee creamer is dropped into a basin. A lever closes the machine, a handle is pushed and hot water is forced through the capsule at just the right pressure, creating a perfect espresso topped with a dense *crema*. When the lever is lifted, the used capsule is deposited into a bin at the back of the machine. The con-

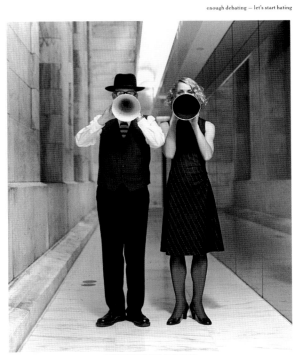

ENOUGH DEBATING — LET'S START HATING
Photograph by Rodney Smith

THE NEW YORK TIMES MAGAZINE · DECEMBER 14, 2003 63

62

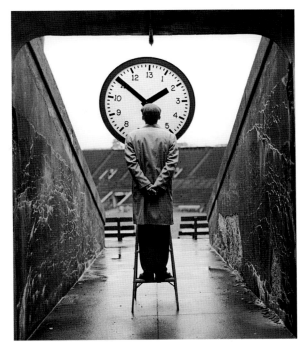

TIME GAP
Photograph by Rodney Smith

96

Thunder Run, The · A convention of military strategy is that you do not rush tanks into the center of a hostile city unless you wish to lose them. In 1994 the Russians learned this fatal lesson when they sent an armored column into Grozny, the capital of Chechnya, and guerrillas picked the tanks off with rocket-propelled grenades.

The Third Infantry Division of the U.S. Army turned convention on its head on April 7, when 88 Abrams tanks and 44 Bradley Fighting Vehicles shot their way into the heart of Baghdad, signaling to Iraqis and the world that the city was no longer under the control of Saddam Hussein. It was an audacious and ad hoc operation, planned only on the evening before its execution, and it was given, by the army colonel who commanded it, the name Thunder Run.

The commander, Col. David Perkins, gambled that if his armored column moved quickly enough and with enough firepower, they could surprise the city's defenders and move behind their lines. "We wanted to create as much chaos as possible," Colonel Perkins said in an interview. "It was their city, so they had the advantage — they knew the streets; they had put up defenses. But they were in rings of static defense. If you can break through and get into the center of the city and get behind them, you have the advantage."

The Thunder Run was a vindication of the be-quicker-and-more-flexible ethos expounded by Secretary of Defense Donald H. Rumsfeld. It demonstrated that rapid movement, combined with heavy and precise firepower, can disorient and demoralize an enemy. It also showed that letting combat leaders choose tactics, as Gen. Tommy Franks did in Iraq, rather than keeping them on a tight leash, can really pay off. PETER MAASS

Time Gap, The · In 1972 the superaccurate atomic clocks that keep the world's official time were "paused" for precisely one second. This little-noticed leap second was a crude solution to a problem that began five years earlier, when atomic clocks replaced the rotation of the earth as the authoritative instrument for measuring time. Because atomic clocks are more consistent than the earth (which slows slightly almost every year), the earth had fallen one second behind. To help the planet keep pace, 31 additional leap seconds have been added since 1972.

But this solution has led to another problem: the widening time gap. Over the years, as leap seconds have been added to official time, atomic time, as calculated by the International Bureau of Weights and Measures in Paris, has held steady. In addition, the Global Positioning System (G.P.S.), the world's dominant navigational tool, was set to official time in 1980 but has not incorporated the 13 leap seconds added since.

As these three time schemes — official, atomic and navigational — slip farther apart with each additional leap second, coordination between them becomes harder and potentially hazardous: just consider that the watches of air-traffic controllers, set to official time, are out of whack with their navigational equipment, set to G.P.S. time. This May a working group of the International Telecommunication Union (I.T.U.) proposed dropping the leap second, which would set the stage for a unified time scale. There might be other advantages too, like avoiding legal disputes over the exact time-stamping of certain sensitive events, like the sale of bonds or securities.

Not everyone, though, would benefit from closing the time gap. Astronomers rely for their measurements on time being in accord with the position of the earth, and a number of them expressed concern this year when the I.T.U. asked them for input. For the rest of us, the consequences would be at once profound and hardly noticeable. If we drop the leap second and rely only on atomic clocks, it will mean severing time's connection to the natural world, so that daytime and nighttime, as determined by the position of the sun in the sky, will very slowly phase out of sync with daytime and nighttime as determined by our watches. Eventually, "high noon" will fall in midmorning — though fortunately that will take thousands of years. JAMES RYERSON

Blown Apart
Beets, before and after
the Windhexe.

TORNADO IN A CAN

Tornado in a Can · The awesome destructive force of tornadoes — iconized in "The Wizard of Oz" and fetishized in "Twister" — has been harnessed by a 65-year-old farmer who, as central casting would have it, hails from Kansas.

Frank Polifka, who farms wheat and milo, invented a contraption called the Windhexe, which creates a tornado-force wind within a steel funnel. A contained cyclone, it turns out, is very useful for pulverizing things. Polifka has reduced broccoli to powder. Same with rocks, aluminum cans, shark cartilage, coal, sewage, household garbage and the membranes that line eggshells. Now, with the help of business partners, his machine is being put to use on bigger things. Energy companies in Australia are using it to remove moisture from coal. A garbage-processing plant in Pennsylvania will go online with

THE NEW YORK TIMES MAGAZINE · DECEMBER 14, 2003 97

186

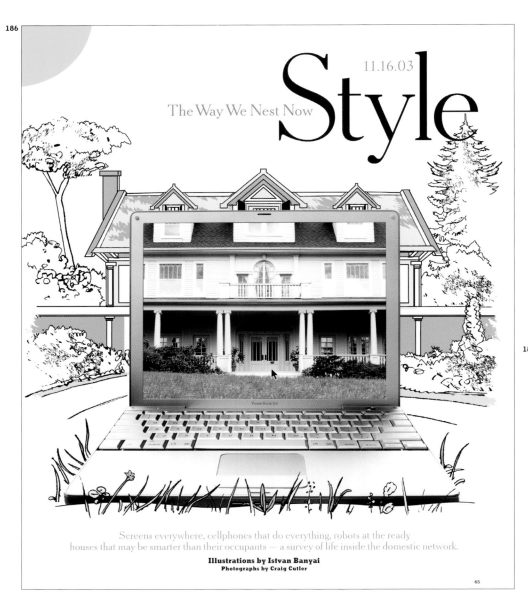

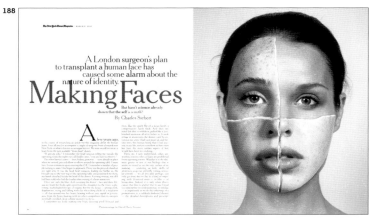

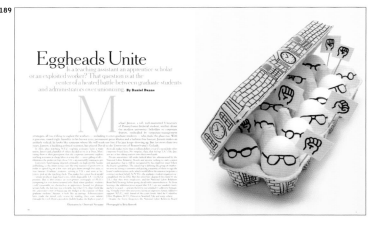

186
Publication **The New York Times Magazine**
Art Director **Janet Froelich**
Designers **Jeff Glendenning, Prem Krishnamurthy**
Illustrator **Istvan Banyai**
Photo Editor **Kathy Ryan**
Photographer **Craig Cutler**
Publisher **The New York Times**
Issue **November 16, 2003**

187
Publication **ESPN The Magazine**
Design Director **Peter Yates**
Art Director **Kathie Scrobanovich**
Designer **Kathie Scrobanovich**
Illustrator **Joe Zeff**
Director of Photography **Nik Kleinberg**
Publisher **ESPN, Inc.**
Issue **November 10, 2003**

188
Publication **The New York Times Magazine**
Art Director **Janet Froelich**
Designer **Catherine Gilmore-Barnes**
Illustrator **David Harry Stewart**
Photo Editor **Kathy Ryan**
Publisher **The New York Times**
Issue **March 9, 2003**

190

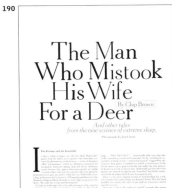

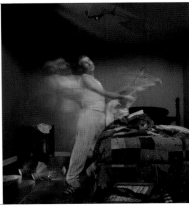

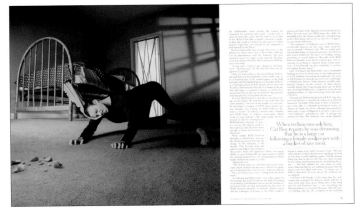

191

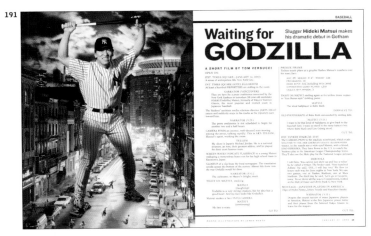

192

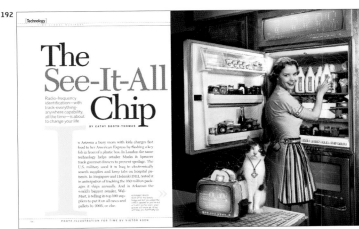

193

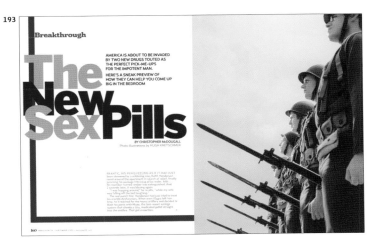

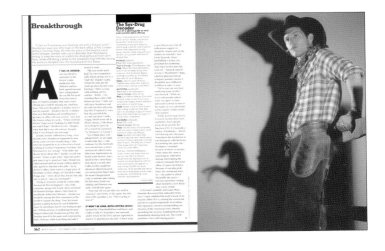

189
Publication **The New York Times Magazine**
Art Director **Janet Froelich**
Designer **Jeff Glendenning**
Illustrator **Christoph Niemann**
Photographer **Bela Borsodi**
Photo Editor **Kathy Ryan**
Publisher **The New York Times**
Issue **May 4, 2003**

190
Publication **The New York Times Magazine**
Art Director **Janet Froelich**
Designer **Joele Cuyler**
Photo Editor **Kathy Ryan**
Photographer **Josef Astor**
Publisher **The New York Times**
Issue **February 2, 2003**

191
Publication **Sports Illustrated**
Creative Director **Steve Hoffman**
Art Director **Edward Truscio**
Designer **Edward Truscio**
Illustrator **James Porto**
Publisher **Time Inc.**
Issue **January 27, 2003**

192
Publication **Time Magazine**
Art Director **Marti Golon**
Designer **Avi Litwack**
Illustrator **Viktor Koen**
Publisher **Time Inc.**
Issue **September 22, 2003**

193
Publication **Men's Health**
Art Director **George Karabotsos**
Designer **Jose G. Fernandez**
Photographer **Hugh Kretschmer**
Publisher **Rodale Inc.**
Issue **September 2003**

194

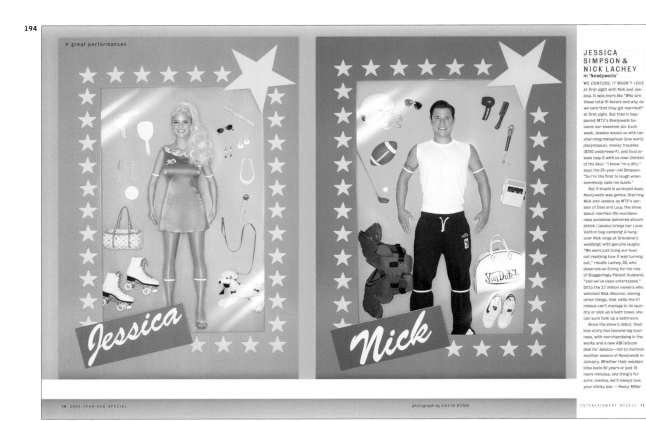

195

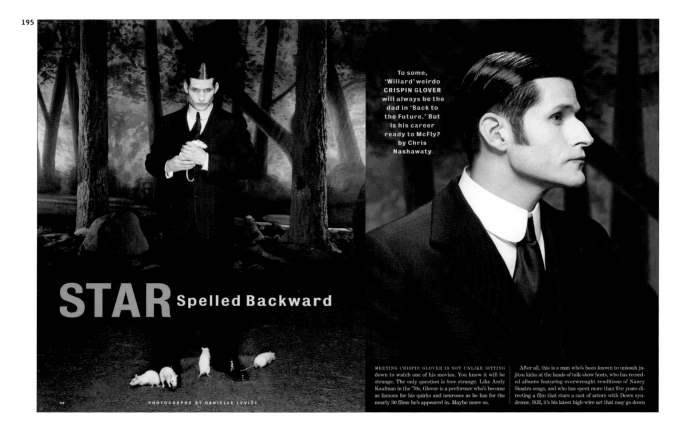

194
Publication **Entertainment Weekly**
Design Director **Geraldine Hessler**
Designer **John Walker**
Photo Editor **Richard Maltz**
Photographer **Gavin Bond**
Photo Director **Fiona McDonagh**
Publisher **Time Inc.**
Issues **December 26, 2003, January 2, 2004**

195
Publication **Entertainment Weekly**
Design Director **Geraldine Hessler**
Designer **Geraldine Hessler**
Photo Editor **Michael Kochman**
Photographer **Danielle Levitt**
Photo Director **Fiona McDonagh**
Publisher **Time Inc.**
Issue **March 28, 2003**

196

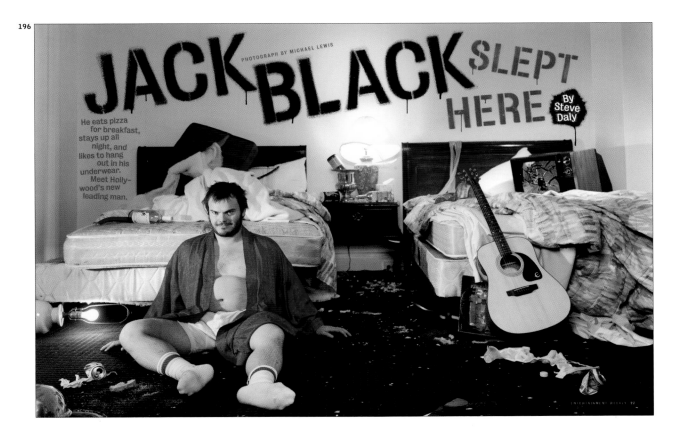

197

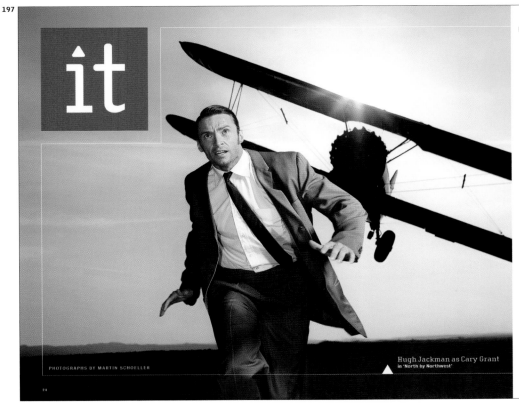

196
Publication **Entertainment Weekly**
Design Director **Geraldine Hessler**
Designer **Lee Berresford**
Photo Editor **Richard Maltz**
Photographer **Michael Lewis**
Photo Director **Fiona McDonagh**
Publisher **Time Inc.**
Issue **October 17, 2003**

197
Publication **Entertainment Weekly**
Design Director **Geraldine Hessler**
Designer **Robert Festino**
Photographer **Martin Schoeller**
Photo Director **Fiona McDonagh**
Publisher **Time Inc.**
Issues **June 27, 2003, July 4, 2003**

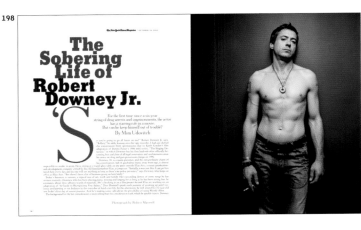

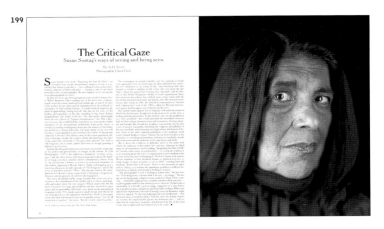

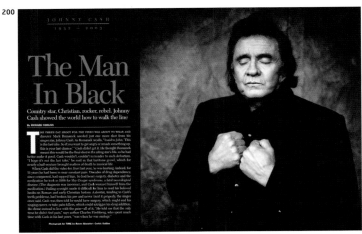

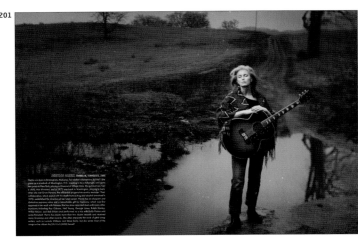

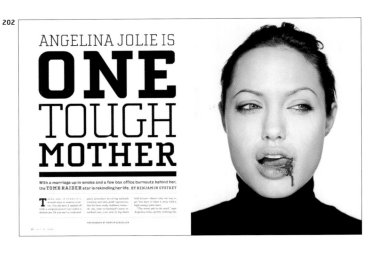

198
Publication **The New York Times Magazine**
Art Director **Janet Froelich**
Photo Editor **Kathy Ryan**
Photographer **Robert Maxwell**
Publisher **The New York Times**
Issue **October 19, 2003**

201
Publication **Vanity Fair**
Design Director **David Harris**
Art Director **Julie Weiss**
Designer **Chris Mueller**
Photo Editor **Lisa Berman**
Photographer **Annie Leibovitz**
Photo Director **Susan White**
Photo Producer **Sarah Czeladnicki**
Publisher **Condé Nast Publications Inc.**
Issue **November 2003**

199
Publication **The New York Times Magazine**
Art Director **Janet Froelich**
Photo Editor **Kathy Ryan**
Photographer **Chuck Close**
Publisher **The New York Times**
Issue **February 23, 2003**

202
Publication **Entertainment Weekly**
Design Director **Geraldine Hessler**
Designer **Jennifer Procopio**
Photographer **Martin Schoeller**
Photo Director **Fiona McDonagh**
Publisher **Time Inc.**
Issue **July 18, 2003**

200
Publication **Time Magazine**
Art Director **Arthur Hochstein**
Photographer **Ruven Afanador**
Associate Art Director **Christine Dunleavy**
Director of Photography **Michele Stephenson**
Picture Editor **Maryanne Golon**
Assistant Picture Editor **Marie Tobias**
Publisher **Time Inc.**
Issue **September 22, 2003**

203
Publication **Entertainment Weekly**
Design Director **Geraldine Hessler**
Designer **Robert Festino**
Photo Editor **Freyda Tavin**
Photographer **Dan Winters**
Photo Director **Fiona McDonagh**
Publisher **Time Inc.**
Issue **October 10, 2003**

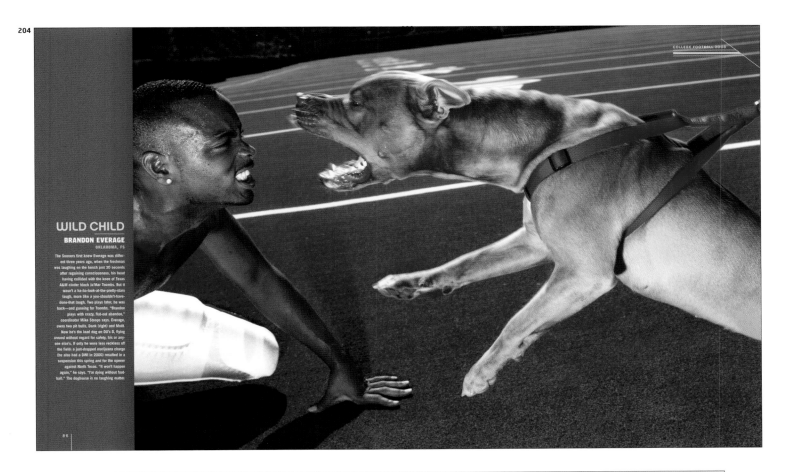

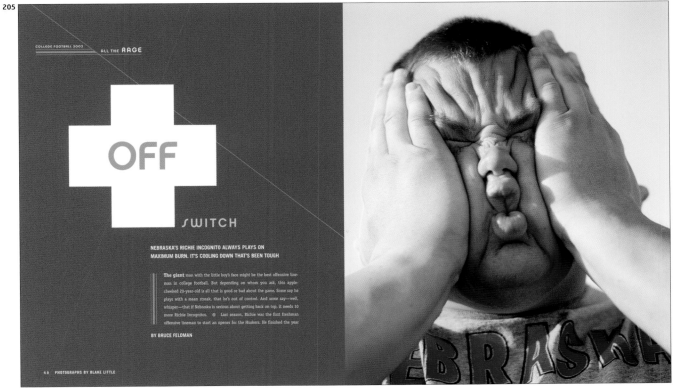

204
Publication **ESPN The Magazine**
Design Director **Peter Yates**
Art Director **Siung Tjia**
Designer **Siung Tjia**
Photographer **Blake Little**
Director of Photography **Nik Kleinberg**
Publisher **ESPN, Inc.**
Issue **September 1, 2003**

205
Publication **ESPN The Magazine**
Design Director **Peter Yates**
Art Director **Siung Tjia**
Designer **Siung Tjia**
Photographer **Zach Gold**
Director of Photography **Nik Kleinberg**
Publisher **ESPN, Inc.**
Issue **September 1, 2003**

206

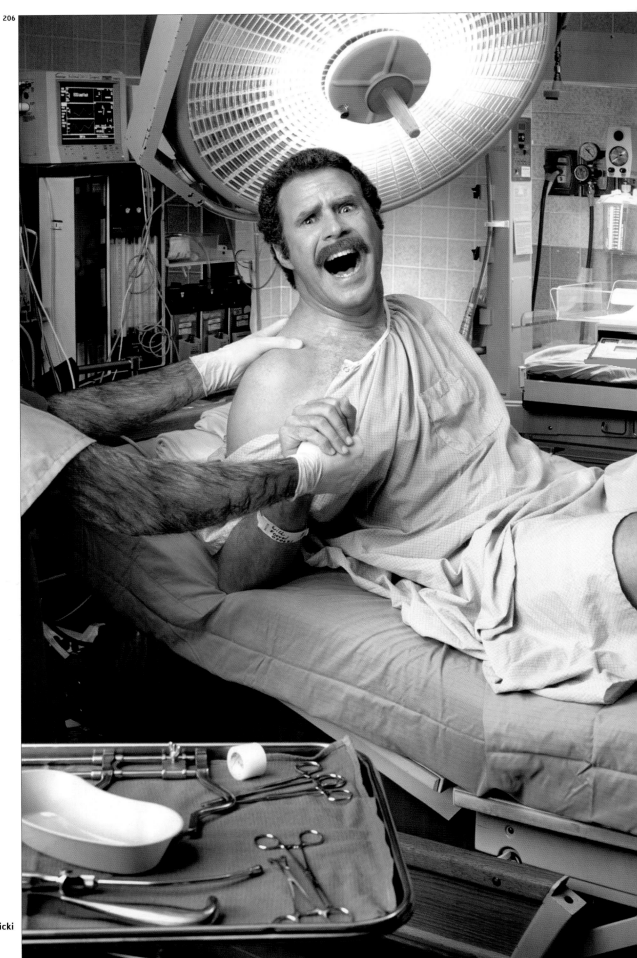

206
Publication **Vanity Fair**
Design Director **David Harris**
Art Director **Julie Weiss**
Designer **Chris Mueller**
Photo Editor **Lisa Berman**
Photographer **Mark Seliger**
Photo Director **Susan White**
Photo Producer **Sarah Czeladnicki**
Publisher **Condé Nast**
Publications Inc.
Issue **December 2003**

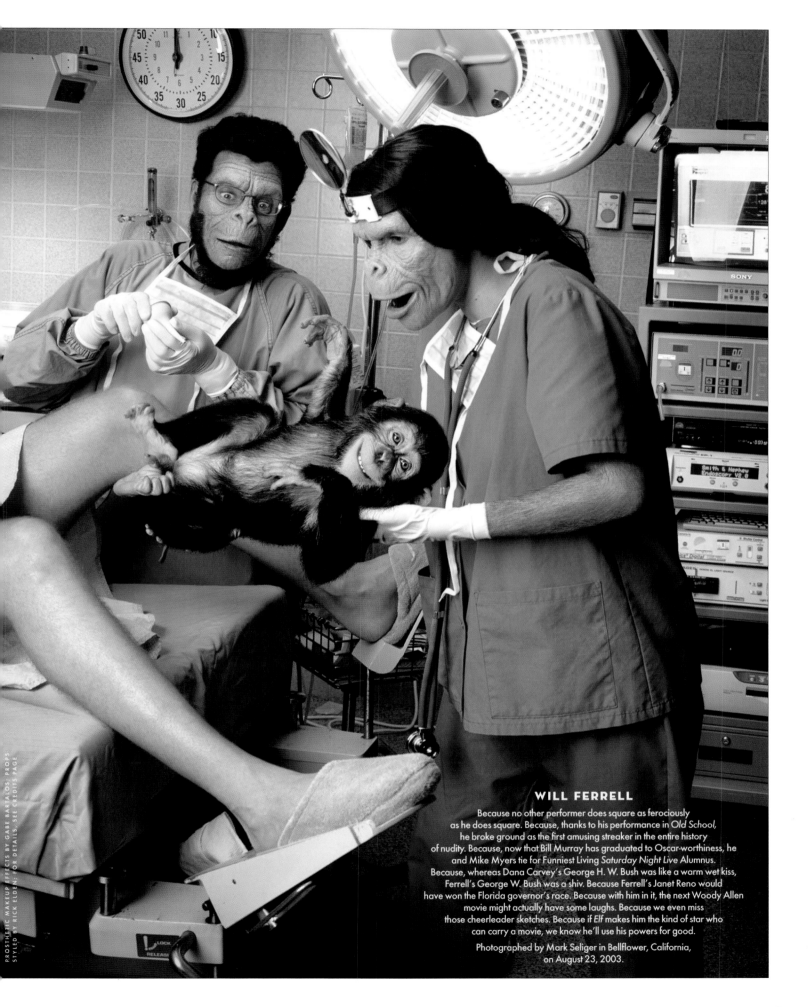

WILL FERRELL

Because no other performer does square as ferociously
as he does square. Because, thanks to his performance in *Old School*,
he broke ground as the first amusing streaker in the entire history
of nudity. Because, now that Bill Murray has graduated to Oscar-worthiness, he
and Mike Myers tie for Funniest Living *Saturday Night Live* Alumnus.
Because, whereas Dana Carvey's George H. W. Bush was like a warm wet kiss,
Ferrell's George W. Bush was a shiv. Because Ferrell's Janet Reno would
have won the Florida governor's race. Because with him in it, the next Woody Allen
movie might actually have some laughs. Because we even miss
those cheerleader sketches. Because if *Elf* makes him the kind of star who
can carry a movie, we know he'll use his powers for good.

Photographed by Mark Seliger in Bellflower, California,
on August 23, 2003.

PROSTHETIC MAKEUP EFFECTS BY GABE BARTALOS; PROPS STYLED BY RICK ELDER; FOR DETAILS, SEE CREDITS PAGE

207

208

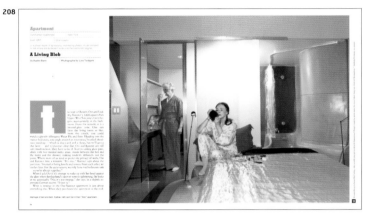

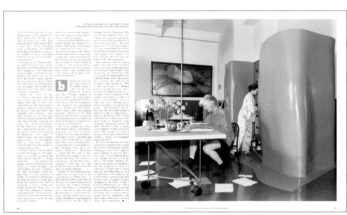

209

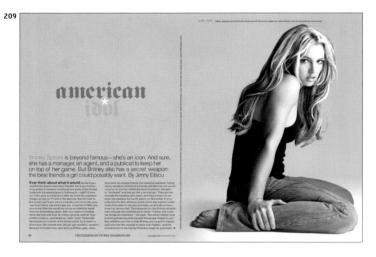

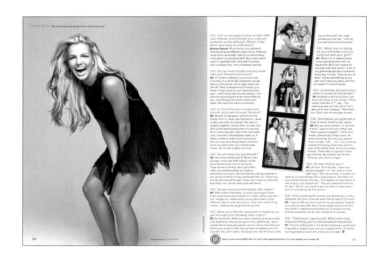

210

207
Publication **Time Magazine**
Art Director **Arthur Hochstein**
Photographer **Brooks Kraft**
Senior Art Director **Thomas M. Miller**
Director of Photography **Michele Stephenson**
Picture Editor **Maryanne Golon**
Deputy Picture Editor **Hillary Raskin**
Publisher **Time Inc.**
Issue **February 10, 2003**

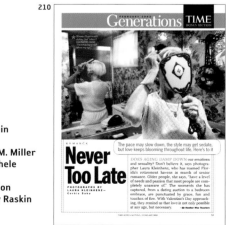

211

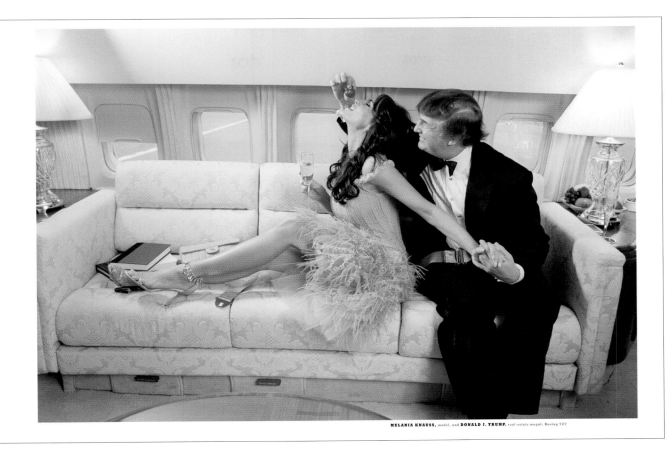

MELANIA KNAUSS, model, and DONALD J. TRUMP, real-estate mogul: Boeing 727

211

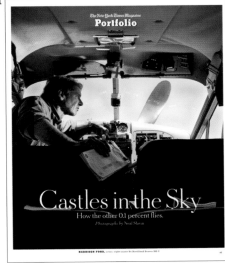

212

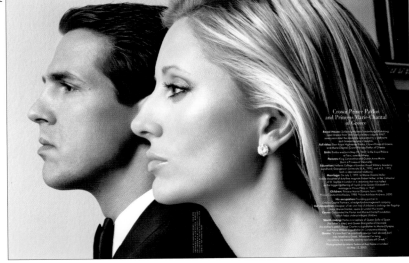

208
Publication **The New York Times Magazine**
Art Director **Janet Froelich**
Designer **Lisa Naftolin**
Photo Editor **Kathy Ryan**
Photographer **Lars Tunbjork**
Publisher **The New York Times**
Issue **May 18, 2003**

209
Publication **Cosmo Girl**
Creative Director **Jacqueline Azria-Palombo**
Design Director **Ron Gabriel**
Designer **Jeffrey Salcito**
Photo Editor **Gena Mann**
Photographer **Patrick Demarchelier**
Publisher **The Hearst Corporation-Magazines Division**
Issue **November 2003**

211
Publication **The New York Times Magazine**
Art Director **Janet Froelich**
Designers **Joele Cuyler, Catherine Gilmore-Barnes**
Photo Editor **Kathy Ryan**
Photographer **Neal Slavin**
Publisher **The New York Times**
Issue **November 23, 2003**

210
Publication **Time**
Art Director **Arthur Hochstein**
Photographer **Laura Kleinhenz**
Special Projects Art Director **Marti Golon**
Director of Photography **Michele Stephenson**
Associate Picture Editor **Dietmar Liz-Lepiorz**
Publisher **Time Inc.**
Issue **February 17, 2003**

212
Publication **Vanity Fair**
Design Director **David Harris**
Art Director **Julie Weiss**
Designer **Chris Israel**
Photo Editor **Lisa Berman**
Photographers **Mario Testino, Jonas Karlsson, Philipp von Hessen, Michel Gronemberger, Jonathan Becker, Helmut Newton, Michel Comte, Julian Broad, Tim Walker**
Photo Director **Susan White**
Photo Producer **Ron Beinner**
Publisher **Condé Nast Publications Inc.**
Issue **September 2003**

213

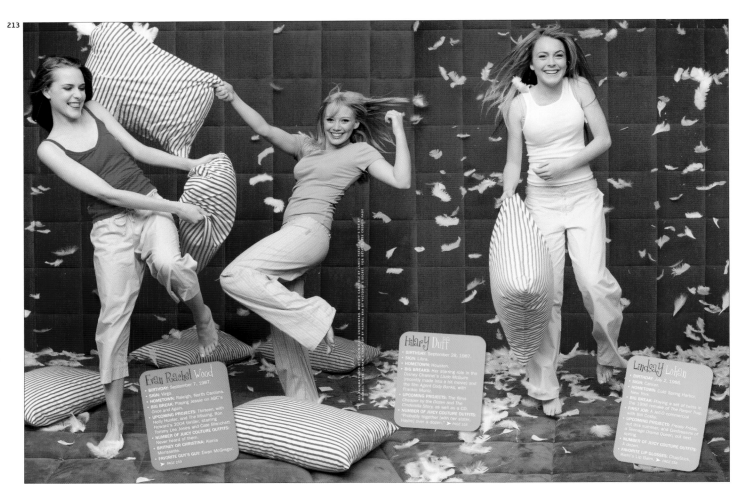

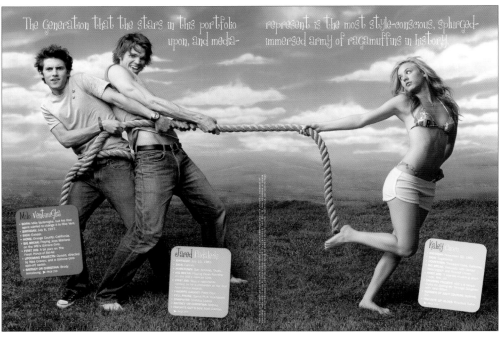

213
Publication **Vanity Fair**
Design Director **David Harris**
Art Director **Julie Weiss**
Designer **Chris Israel**
Photo Editor **Lisa Berman**
Photographer **Mark Seliger**
Photo Director **Susan White**
Photo Producer **Richard Villani**
Publisher **Condé Nast Publications Inc.**
Issue **July 2003**

214
Publication **Vanity Fair**
Design Director **David Harris**
Art Director **Julie Weiss**
Designer **Chris Israel**
Photo Editor **Lisa Berman**
Photographer **Annie Leibovitz**
Photo Director **Susan White**
Photo Producer **Kathryn MacLeod**
Publisher **Condé Nast Publications Inc.**
Issue **May 2003**

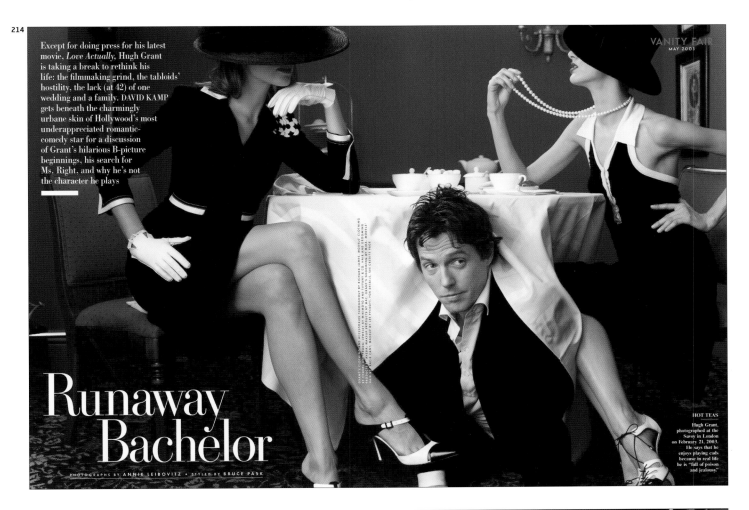

214

Except for doing press for his latest movie, *Love Actually*, Hugh Grant is taking a break to rethink his life: the filmmaking grind, the tabloids' hostility, the lack (at 42) of one wedding and a family. DAVID KAMP gets beneath the charmingly urbane skin of Hollywood's most underappreciated romantic-comedy star for a discussion of Grant's hilarious B-picture beginnings, his search for Ms. Right, and why he's not the character he plays

VANITY FAIR
MAY 2003

Runaway Bachelor

PHOTOGRAPHS BY ANNIE LEIBOVITZ • STYLED BY BRUCE PASK

HOT TEAS

Hugh Grant, photographed at the Savoy in London on February 21, 2003. He says that he enjoys playing cads because in real life he is "full of poison and jealousy."

Elizabeth Hurley, whose early fame as Grant's girlfriend was long ago eclipsed by her status as the ravishing unwed mother for whom King William gave up the throne, paving the way for Harry's coronation . . .

Well, it's not a *totally* far-fetched scenario. This was more or less how Cary Grant, to whom Hugh is sometimes compared, lived out his last decades—traveling the world, acting as a well-compensated spokesman for the Fabergé cosmetics company, serving on the boards of MGM and Western Airlines, working on his tan, attending ball games, remaining impossibly handsome, and resisting all entreaties to return to the screen. And the truth is, Hugh Grant, who will turn 43 this year, doesn't know how much longer he wants to go on making movies. "Imagine what it's like, at 42, to be sitting in Hair and Makeup," he says. "It's fucking ridiculous! I think it's all right if you've written the film and you're directing it; there's some kudos and cool to that. But to be *wheeled on*, a char-monkey at the age of 42—"

I interrupt and tell him that he's being absurd, that actors like Tom Courtenay are still doing great for-hire work in their 60s.

"But, you see," he says, "they're *real* actors. They *love* their work. I never have. I kind of hate it. In fact, I hate it quite a lot—all acting, but especially movie acting. I'm fine at the beginning of the day, when it's a wide shot, I'm quite relaxed and good. But by the end of the day, when it's the same scene you're still shooting, and it's you in close-up, and the entire focus is on you—now you've got to repeat the little amusing thing you did earlier. And it's so brutally difficult to do that, because you're not feeling relaxed anymore. You're trying to repeat something you caught, by sort of instinct, eight hours ago. And you're probably running out of light. You've got to wrap at seven—huge pressure. Just misery. And because, 9 times out of 10, you never really get it as good as you had it before, you go home feeling disappointed and frustrated. And that accumulates over the weeks and years, and you just think, Oh, I don't need this."

Not a moment after unbosoming this complaint, Grant becomes mindful of the kind of response it might engender ("If that silver-spoon pervert Hugh Grant thinks acting is so awful, he should try working a real job like the rest of us!"—A. Shrew, Corpulence, TX), and backpedals somewhat: "Oh, I don't know. I hate it when an actor moans. Really, my CONTINUED ON PAGE 216

178 | VANITY FAIR

"All I feel is nervous exhaustion. I fell into being a successful actor truly by mistake."

BIG GAMBLE

Grant plays poker at the Savoy. He is currently taking a hiatus from acting: "I have called my own bluff, because I said, 'I'm refusing everything, I'm not doing anything for months and months.'"

133

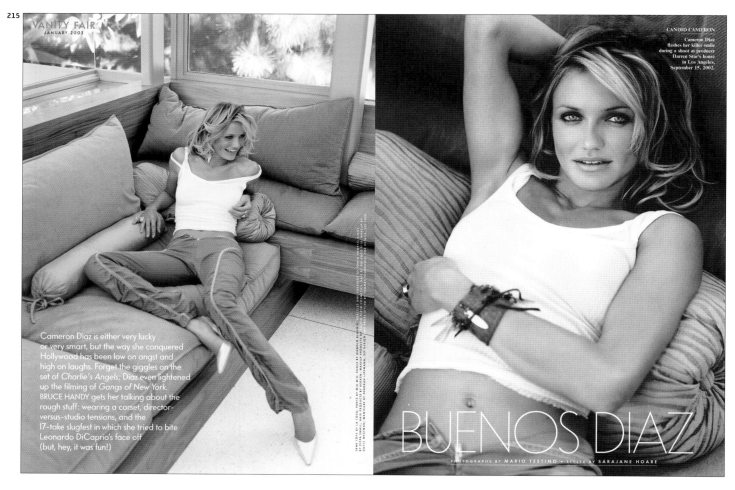

215

VANITY FAIR
JANUARY 2003

Cameron Diaz is either very lucky or very smart, but the way she conquered Hollywood has been low on angst and high on laughs. Forget the giggles on the set of *Charlie's Angels; Diaz* even lightened up the filming of *Gangs of New York.* BRUCE HANDY gets her talking about the rough stuff: wearing a corset, director-versus-studio tensions, and the 17-take slugfest in which she tried to bite Leonardo DiCaprio's face off (but, hey, it was fun!)

CANDID CAMERON
Cameron Diaz flashes her killer smile during a shoot at producer Darren Star's house in Los Angeles, September 15, 2002.

BUENOS DIAZ

PHOTOGRAPHS BY MARIO TESTINO · STYLED BY SARAJANE HOARE

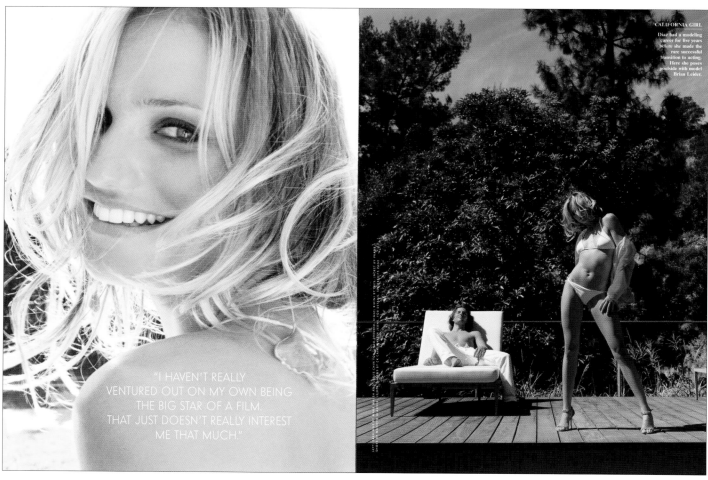

"I HAVEN'T REALLY VENTURED OUT ON MY OWN BEING THE BIG STAR OF A FILM. THAT JUST DOESN'T REALLY INTEREST ME THAT MUCH."

CALIFORNIA GIRL
Diaz had a modeling career for five years before she made the rare successful transition to acting. Here she poses poolside with model Brian Leider.

216

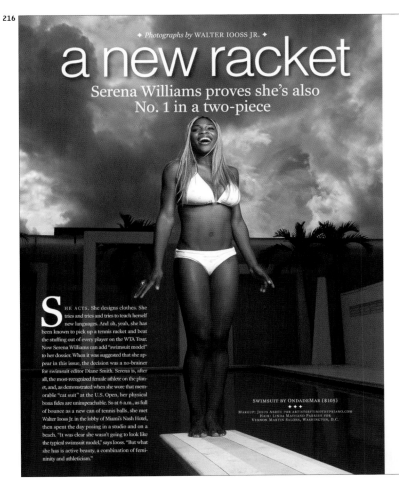

◆ *Photographs by* WALTER IOOSS JR. ◆

a new racket
Serena Williams proves she's also
No. 1 in a two-piece

S HE ACTS. She designs clothes. She tries and tries and tries to teach herself new languages. And oh, yeah, she has been known to pick up a tennis racket and beat the stuffing out of every player on the WTA Tour. Now Serena Williams can add "swimsuit model" to her dossier. When it was suggested that she appear in this issue, the decision was a no-brainer for swimsuit editor Diane Smith. Serena is, after all, the most-recognized female athlete on the planet, and, as demonstrated when she wore that memorable "cat suit" at the U.S. Open, her physical bona fides are unimpeachable. So at 6 a.m., as full of bounce as a new can of tennis balls, she met Walter Iooss Jr. in the lobby of Miami's Nash Hotel, then spent the day posing in a studio and on a beach. "It was clear she wasn't going to look like the typical swimsuit model," says Iooss. "But what she has is active beauty, a combination of femininity and athleticism."

SWIMSUIT BY OndadeMar ($105)
◆ ◆ ◆
MAKEUP: JESUS ABREU FOR ARTISTSBYTIMOTHYPRIANO.COM,
HAIR: LINDA MAYHAND PARRISH FOR
VERNON MARTIN SALONS, WASHINGTON, D.C.

SWIMSUIT BY ANNE KLEIN ($90)
SHIRT BY B WITH G ($115)

217

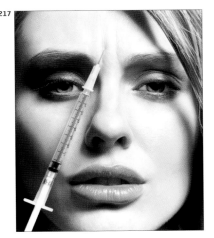

218

215
Publication **Vanity Fair**
Design Director **David Harris**
Art Director **Julie Weiss**
Designer **Chris Israel**
Photo Editor **Lisa Berman**
Photographer **Mario Testino**
Photo Director **Susan White**
Photo Producer **SunHee Grinnell**
Publisher **Condé Nast Publications Inc.**
Issue **January 2003**

217
Publication **Shape Magazine**
Art Director **Jacqueline Moorby**
Photo Editor **Melissa O'Brien**
Photographer **Amy Neunsinger**
Publisher **Weider Publications LLC**
Issue **August 2003**

216
Publication **Sports Illustrated**
Creative Director **Steve Hoffman**
Art Director **Edward Truscio**
Designer **Chris Hercik**
Photographer **Walter Iooss Jr.**
Publisher **Time Inc.**
Issue **Winter 2003 Swimsuit**

218
Publication **Men's Health**
Art Director **George Karabotsos**
Designer **Bobby Lawhorn**
Photo Editors **Marianne Butler, Victoria Rich**
Photographer **Antoine Verglas**
Publisher **Rodale Inc.**
Issue **June 2003**

219

220

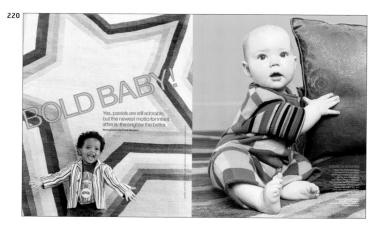

221

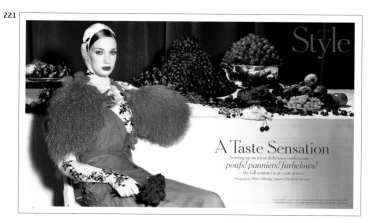

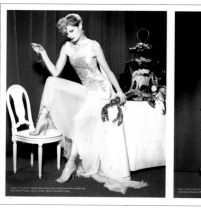
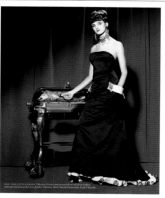

219
Publication **Child Magazine**
Creative Director **Dan Josephs**
Art Directors **Jae Han, Sung Choi, Jacqueline Dashevsky**
Designer **Dan Josephs**
Photo Editor **Topaz LeTourneau**
Photographer **Marc Royce**
Publisher **Gruner & Jahr**
Issue **May 2003**

220
Publication **Child Magazine**
Creative Director **Dan Josephs**
Art Directors **Jae Han, Sung Choi, Jacqueline Dashevsky**
Designer **Dan Josephs**
Photo Editors **Topaz LeTourneau, Ulrika Thunberg**
Photographer **Frank Heckers**
Publisher **Gruner & Jahr**
Issue **October 2003**

221
Publication **The New York Times Magazine**
Art Director **Janet Froelich**
Designer **Kristina DiMatteo**
Photographer **Miles Aldridge**
Stylist **Elizabeth Stewart**
Publisher **The New York Times**
Issue **October 12, 2003**

222

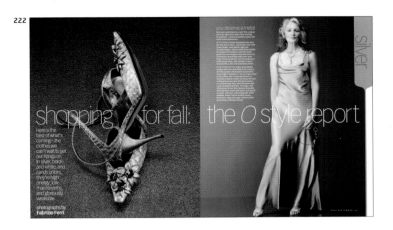

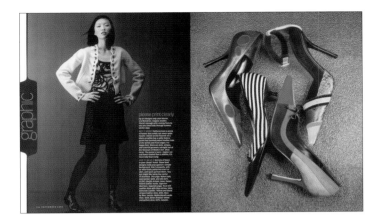

223

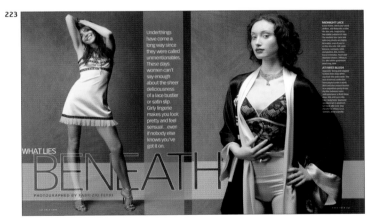

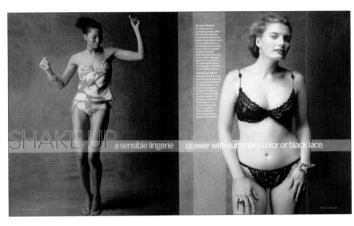

224

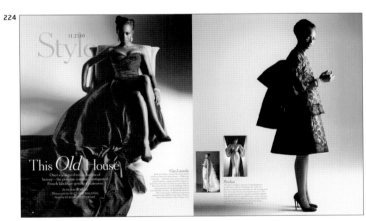

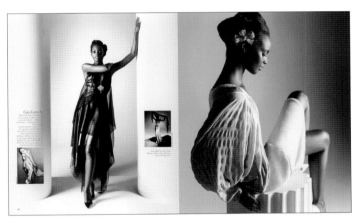

222
Publication **O, The Oprah Magazine**
Design Director **Carla Frank**
Creative Director **Adam Glassman**
Designer **Kristin Fitzpatrick**
Photo Editor **Karen Frank**
Photographer **Fabrizio Ferri**
Publisher **The Hearst Corporation-Magazines Division**
Issue **September 2003**

223
Publication **O, The Oprah Magazine**
Design Director **Carla Frank**
Creative Director **Adam Glassman**
Designer **Randall Leers**
Photo Editor **Karen Frank**
Photographer **Fabrizio Ferri**
Publisher **The Hearst Corporation-Magazines Division**
Issue **July 2003**

224
Publication **The New York Times Magazine**
Art Director **Janet Froelich**
Designer **Janet Froelich**
Photographer **Matthew Rolston**
Stylist **Elizabeth Stewart**
Publisher **The New York Times**
Issue **November 23, 2003**

225

10.26.03

Style
Boo Heaven

Trick or treat . . . or tweed.

PHOTOGRAPHS BY Rodney Smith STYLED BY Elizabeth Stewart

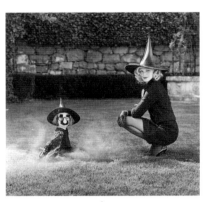

ABOVE: J. MENDEL BLACK
BELTED TWEED JACKET AND COCKTAIL DRESS, $1,795, AT J. MENDEL BOUTIQUES.
MANOLO BLAHNIK SHOES. RUBIE'S COSTUME COMPANY
WITCH COSTUME, STARTING AT $11 AT COSTUME AND HALLOWEEN SHOPS

RIGHT: BEST & COMPANY
WHITE COTTON BLOUSE, $62, BLUE WOOL HERRINGBONE SKIRT, $89, AND TIGHTS
AT BERGDORF GOODMAN.

68 HALLOWEEN ICONS BY NATASHA TIBBOTT

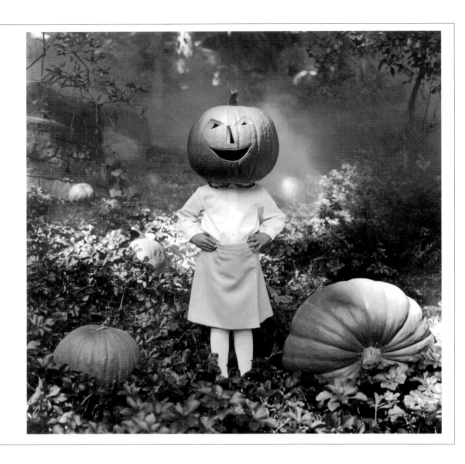

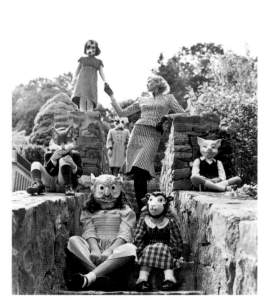

ABOVE: ALEXANDER McQUEEN BLACK
AND WHITE CHECK WOOL DAMIER JACKET, $1,185, AND SKIRT, $600, AT ALEXANDER McQUEEN, 417 WEST 14TH STREET
ON CHILDREN, CLOCKWISE FROM TOP: TOMMY HILFIGER CHILDRENSWEAR BLACK-AND-WHITE DRESS, $36
AT LORD & TAYLOR, MACY'S, BEST & COMPANY. BLUE DRESS-COAT, $262, AT BERGDORF GOODMAN. TOMMY HILFIGER RED PLAID
JUMPER, $42, AND WHITE COTTON BLOUSE, $32, AT LORD & TAYLOR, MACY'S. RALPH LAUREN CHILDRENSWEAR
CHECKED DRESS, $48, AT BLOOMINGDALE'S. BEST & COMPANY DRESS, $160, AND BLAZER, $200, AT BERGDORF GOODMAN
ALL SOCKS, TIGHTS AND SHOES: BEST & COMPANY. ALL MASKS FROM ABRACADABRA, 19 WEST 21ST STREET

RIGHT: CHANEL BLACK WOOL
SUIT, $2,460, AT BLOOMINGDALE'S, BERGDORF GOODMAN. SERGIO ROSSI HANDBAG AND SHOES THROUGHOUT
THESE PAGES: JEWELRY: R.J. GRAZIANO. GLOVES: LACRASIA. HOSIERY: WOLFORD.
FASHION ASSOCIATES: GEORGE KOTSIOPOLLOS AND ANNE LeBLANC. HAIR BY MATTHEW WILLIAMS FOR
MODERN/ORGANIC PRODUCTS AT THE AGENCY. MAKEUP BY REGINA HARRIS FOR M.A.C. PRO AT L'ATELIER NYC. PROPS
BY STEFAN BECKMAN FOR EXPOSURE NY. MODEL: SHIRLEY MALLMAN. CHILD MODELS: NORA, KYLE AND EMMA
MEANEY, SUMMER AND MIA MEREDITH AND SAVANNAH SMITH.

72

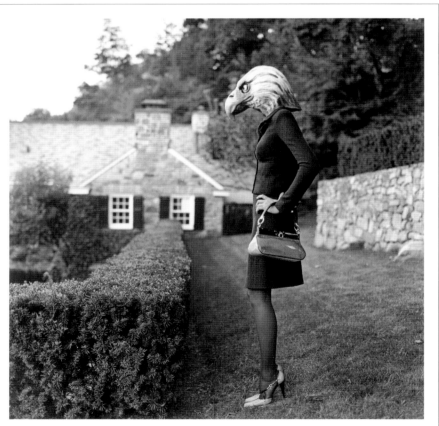

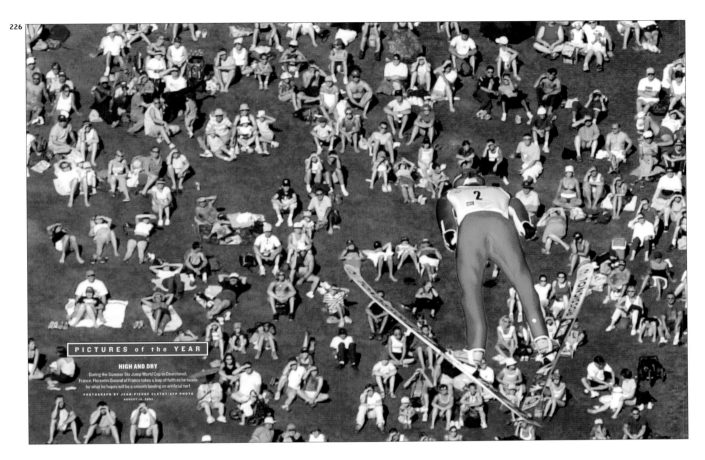

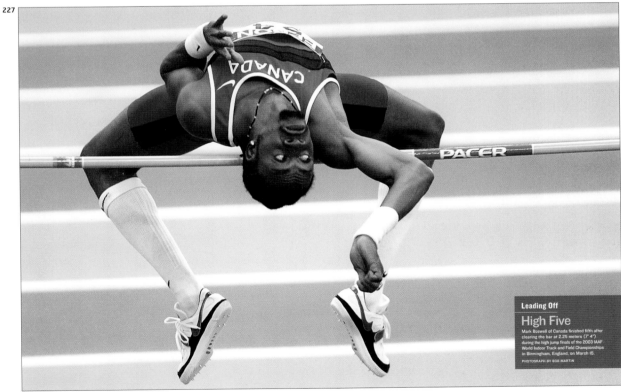

225
Publication **The New York Times Magazine**
Art Director **Janet Froelich**
Photographer **Rodney Smith**
Stylist **Elizabeth Stewart**
Publisher **The New York Times**
Issue **October 26, 2003**

226
Publication **Sports Illustrated**
Creative Director **Steve Hoffman**
Art Director **Edward Truscio**
Designer **Edward Truscio**
Photographer **Jean-Pierre Clatot**
Publisher **Time Inc.**
Issue **June 6, 2003**

227
Publication **Sports Illustrated**
Creative Director **Steve Hoffman**
Art Director **Edward Truscio**
Designer **Neil Jamieson**
Photographer **Bob Martin**
Publisher **Time Inc.**
Issue **March 24, 2003**

228
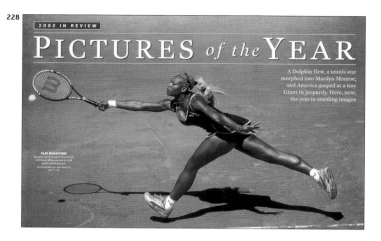

229
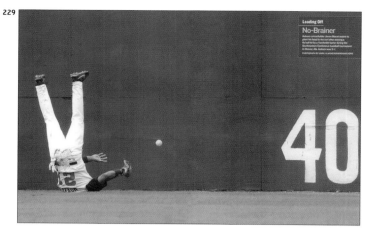

230
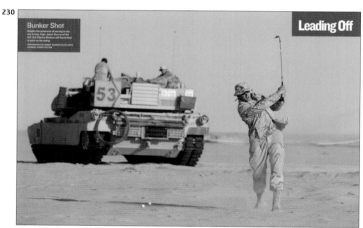

231
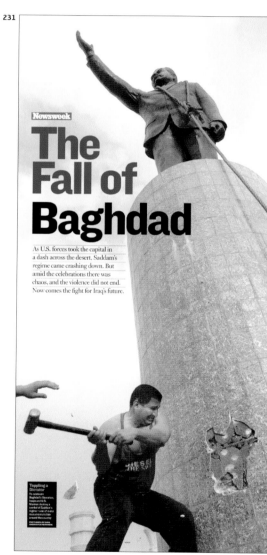

232
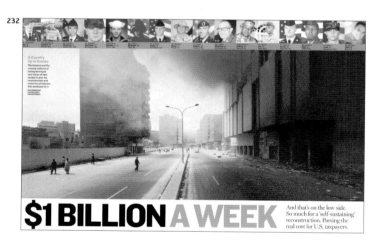

228
Publication **Sports Illustrated**
Creative Director **Steve Hoffman**
Art Director **Edward Truscio**
Designer **Edward Truscio**
Photographer **Bob Martin**
Publisher **Time Inc.**
Issue **January 6, 2003**

230
Publication **Sports Illustrated**
Creative Director **Steve Hoffman**
Art Director **Edward Truscio**
Designer **Neil Jamieson**
Photographer **Brant Sanderlin**
Publisher **Time Inc.**
Issue **April 23, 2003**

229
Publication **Sports Illustrated**
Creative Director **Steve Hoffman**
Art Director **Edward Truscio**
Designer **Neil Jamieson**
Photographer **Mark Almond**
Publisher **Time Inc.**
Issue **June 2, 2003**

231
Publication **Newsweek**
Design Director **Amid Capeci**
Designer **Raymond Choy**
Photo Editor **James Wellford**
Photographer **Luc Delahaye**
Assistant Managing Editor **Lynn Staley**
Directors of Photography **Simon Barnett,
Sarah Harbutt**
Publisher **The Washington Post Co.**
Issue **Landscape of War: Iraq**

232
Publication **Newsweek**
Design Director **Amid Capeci**
Designer **Alexander Ha**
Photo Editor **James Wellford**
Photographer **Ilkka Uimonn**
Assistant Managing Editor **Lynn Staley**
Directors of Photography **Simon Barnett,
Sarah Harbutt**
Publisher **The Washington Post Co.**
Issue **April 21, 2003**

233
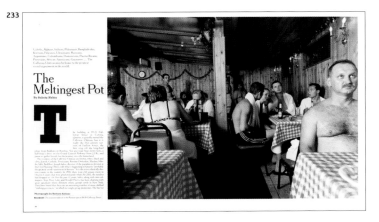

234
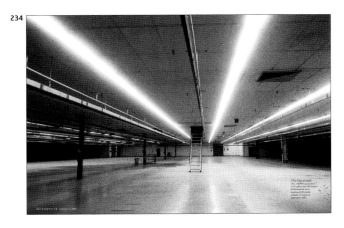

235
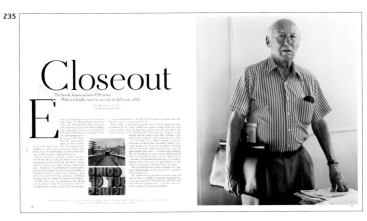

236
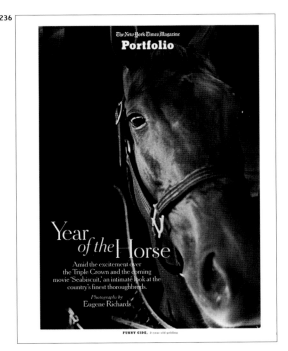

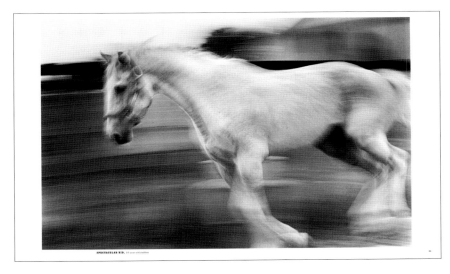

233
Publication **The New York Times Magazine**
Art Director **Janet Froelich**
Designer **Joele Cuyler**
Photo Editor **Kathy Ryan**
Photographer **Barbara Salinas**
Publisher **The New York Times**
Issue **October 5, 2003**

234
Publication **Fortune**
Design Director **Blake Taylor**
Designer **Ann Decker**
Photo Editors **Michele McNally,
Scott Thode**
Photographer **Teru Kuwayama**
Publisher **Time Inc.**
Issue **October 13, 2003**

235
Publication **The New York Times Magazine**
Art Director **Janet Froelich**
Designer **Joele Cuyler**
Photo Editor **Kathy Ryan**
Photographer **Mitch Epstein**
Publisher **The New York Times**
Issue **June 8, 2003**

236
Publication **The New York Times Magazine**
Art Director **Janet Froelich**
Designer **Joele Cuyler**
Photo Editor **Kathy Ryan**
Photographer **Eugene Richards**
Publisher **The New York Times**
Issue **June 15, 2003**

237

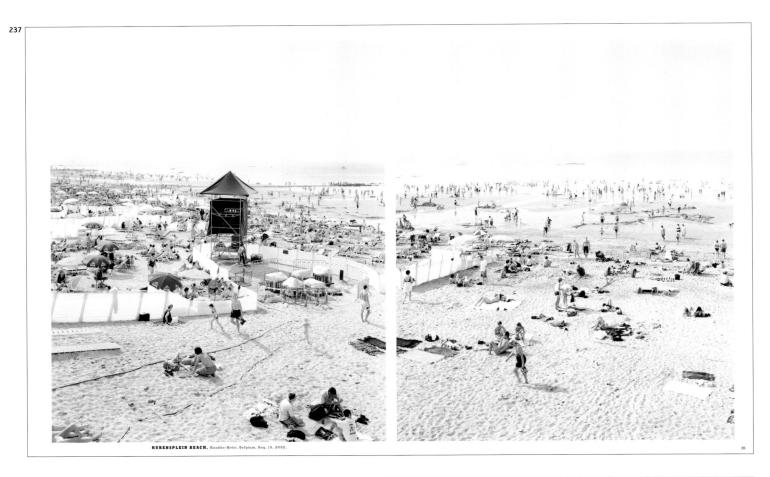

RUBENSPLEIN BEACH, Knokke-Heist, Belgium, Aug. 15, 2002.

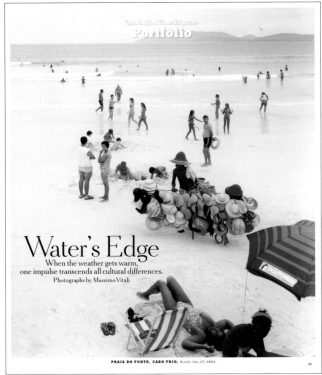

Portfolio

Water's Edge

When the weather gets warm,
one impulse transcends all cultural differences.
Photographs by Massimo Vitali

PRAIA DO FORTE, CABO FRIO, Brazil, Jan. 27, 2003.

238

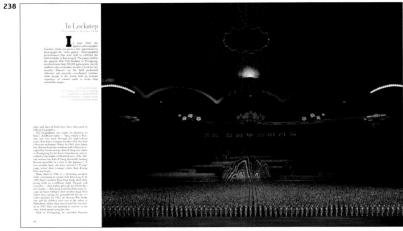

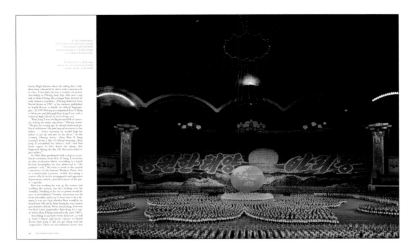

237
Publication **The New York Times Magazine**
Art Director **Janet Froelich**
Designer **Joele Cuyler**
Photo Editor **Kathy Ryan**
Photographer **Massimo Vitali**
Publisher **The New York Times**
Issue **May 4, 2003**

239

Displaced Places

Where refugees try to make a home.

Photographs by Simon Norfolk
Text by David Rieff

This is the age of the refugee. Over the course of the past half-century, ever since the passage in 1951 of the United Nations Convention Relating to the Status of Refugees, it has been a premise of international relations that refugees from war or political oppression have the right to seek asylum and protection in other countries. Today, those rights are under threat. There are now almost 20 million refugees, asylum seekers and "internally displaced persons" in the world.

Countries reeling under the pressure of a vast migration from the poor world are increasingly cracking down on asylum seekers. As a result, instead of being resettled, as the convention intended, refugees often find themselves trapped in camps, and these camps have become worlds unto themselves. Some are makeshift and haphazard. Others, like those that house Afghan refugees in Pakistan, are often hard to distinguish from the established villages around them. In some cases, as in the camps in sub-Saharan Africa, the daily struggle for survival — for water, food and shelter — overwhelms all else. In others, as in the Chechen camps in Ingushetia, the displaced sometimes try to make proper homes for themselves and their families in the tent cities to which they have been consigned.

Simon Norfolk is a British photographer with long experience of war and humanitarian disaster. He takes an unorthodox approach to making his photographs, preferring a large-format camera on a tripod over the usual 35-millimeter. "I love this approach," he says. "It's very slow, and it really gives you a chance to think about a picture's content."

About the camps themselves, Norfolk speaks with both compassion and resignation. "The places ossify into the landscape," he says, "as the refugee crisis becomes a permanent situation."

Moro Camp, Chad, March

Just a few weeks into its existence, this camp already housed several thousand refugees from the Central African Republic. From late 2002 to early 2003, following an attempted coup in the Central African Republic, rebels attacked and pillaged a number of villages in the north of the country. Some 30,000 people, most of them farmers, eventually fled across the border to Chad, despite the Chadian Army's refusing them official entry.

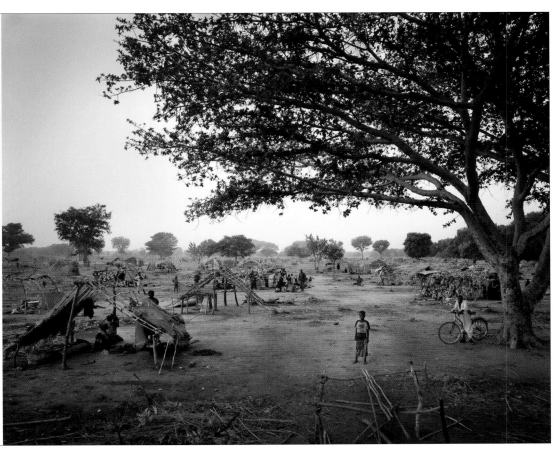

36

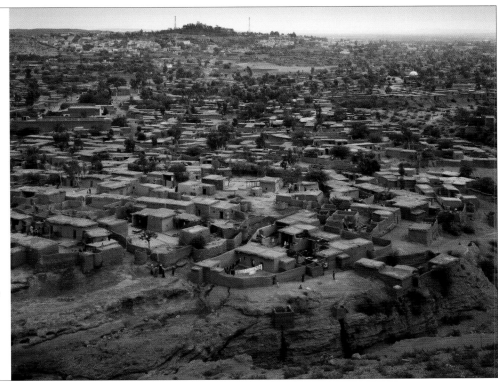

Gamkol Camp, Pakistan, July

The Afghan refugee camps in Pakistan have existed for more than 20 years, swelling and shrinking in concert with the tumultuous history of the region. After December 1979, when the Soviet Union invaded Afghanistan, hundreds of thousands of Afghans sought refuge in Iran and Pakistan. A decade later, more than five million Afghans were refugees. Even after the Soviets withdrew in 1989, asylum seekers continued to flow out of the country. It wasn't until the Soviet-backed government collapsed in 1992 that refugees began to return, only to flee once again when battles among warlords returned the country to chaos. The United States military campaign in Afghanistan in 2001 initially drove about 200,000 more refugees into Pakistan, but since the establishment of the Afghan Interim Authority in December 2001, an estimated 1.6 million refugees have returned home.

40 PHOTOGRAPH BY SIMON NORFOLK FOR THE NEW YORK TIMES

238
Publication **The New York Times Magazine**
Art Director **Janet Froelich**
Designers **Jeff Glendenning, Catherine Gilmore-Barnes**
Photo Editor **Kathy Ryan**
Photographer **Koichiro Otaki**
Publisher **The New York Times**
Issue **October 19, 2003**

239
Publication **The New York Times Magazine**
Art Director **Janet Froelich**
Photo Editor **Kathy Ryan**
Photographer **Simon Norfolk**
Publisher **The New York Times**
Issue **September 21, 2003**

240
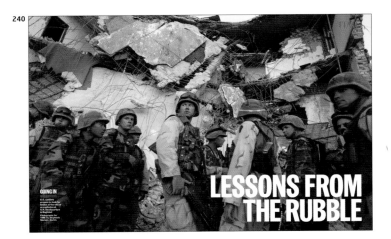

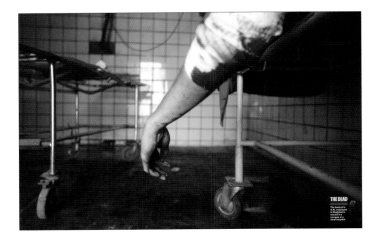

241
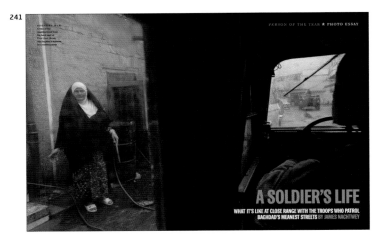

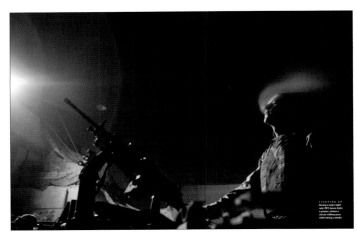

242
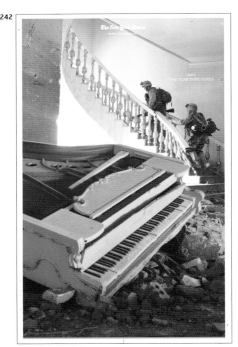

243
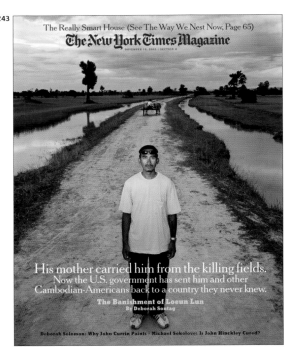

240
Publication **Time**
Art Director **Arthur Hochstein**
Photographer **Stephanie Sinclair**
Senior Art Director **Thomas M. Miller**
Director of Photography **Michele Stephenson**
Picture Editor **Maryanne Golon**
Associate Picture Editor **Alice Gabriner**
Publisher **Time Inc.**
Issue **September 1, 2003**

241
Publication **Time**
Art Director **Arthur Hochstein**
Photographer **James Nachtwey**
Deputy Art Director **D.W. Pine**
Director of Photography **Michele Stephenson**
Picture Editor **Maryanne Golon**
Associate Picture Editor **Alice Gabriner**
Publisher **Time Inc.**
Issue **December 29, 2003**

242
Publication **The New York Times**
Art Director **Paul Jean**
Photo Editors **Nancy Weinstock, Sarah Weissman**
Photographers **Tyler Hicks, various**
Publisher **The New York Times**
Issue **December 29, 2003**

244

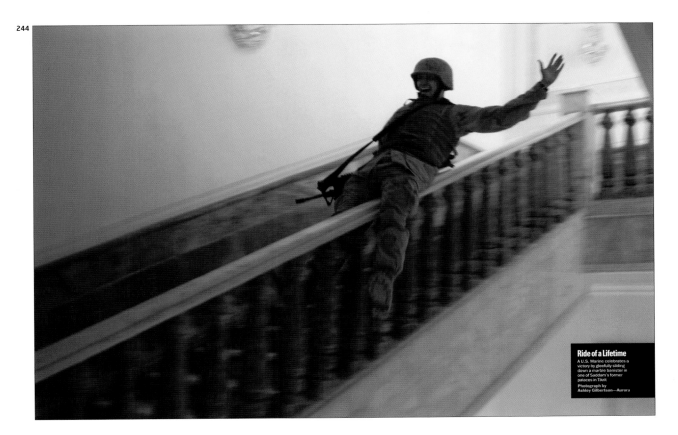

Ride of a Lifetime
A U.S. Marine celebrates a victory by gleefully sliding down a marble banister in one of Saddam's former palaces in Tikrit.
Photograph by Ashley Gilbertson—Aurora

245

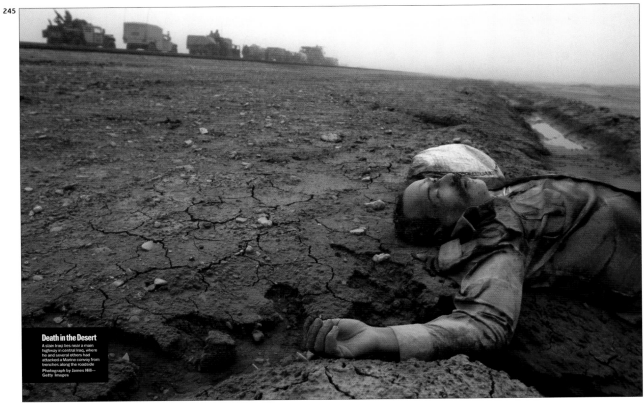

Death in the Desert
A slain Iraqi lies near a main highway in central Iraq, where he and several others had attacked a Marine convoy from trenches along the roadside
Photograph by James Hill—Getty Images

243
Publication **The New York Times Magazine**
Art Director **Janet Froelich**
Designer **Kristina DiMatteo**
Photo Editor **Kathy Ryan**
Photographer **Dan Winters**
Publisher **The New York Times**
Issue **November 16, 2003**

244
Publication **Time**
Art Director **Arthur Hochstein**
Photographers **James Nachtwey, Yuri Kozyrev, Benjamin Lowy , Ashley Gilbertson**
Associate Art Director **Christine Dunleavy**
Director of Photography **Michele Stephenson**
Picture Editor **Maryanne Golon**
Publisher **Time Inc.**
Issue **April 28, 2003**

245
Publication **Time**
Art Director **Arthur Hochstein**
Photographers **Yuri Kozyrev, Christopher Morris, Kate Brooks, Benjamin Lowy, James Hill**
Deputy Art Director **Cynthia A. Hoffman**
Director of Photography **Michele Stephenson**
Picture Editor **Maryanne Golon**
Publisher **Time Inc.**
Issue **April 7, 2003**

246

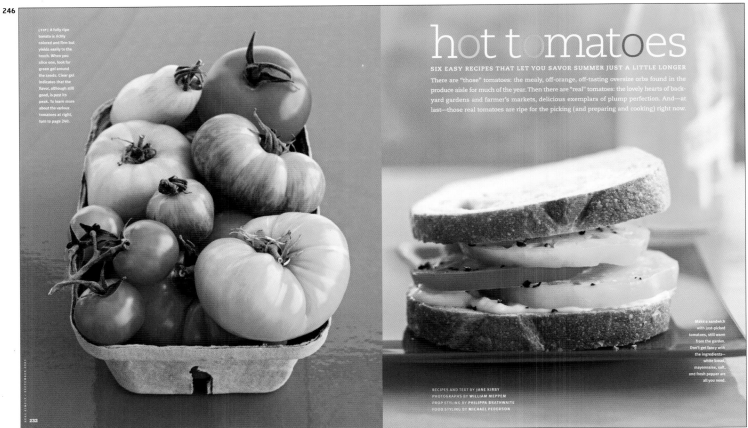

+ MERIT STILL LIFE PHOTOGRAPHY SPREAD

247

248

246
Publication **Real Simple**
Creative Director **Robert Newman**
Art Director **Eva Spring**
Designer **Eva Spring**
Photo Editor **Naomi Nista**
Photographer **William Meppem**
Publisher **Time Inc.**
Issue **September 2003**

247
Publication **Men's Health**
Art Director **George Karabotsos**
Designer **Mark Hewko**
Photo Editors **Marianne Butler, Ernie Monteiro**
Photographer **Todd Huffman**
Publisher **Rodale Inc.**
Issue **September 2003**

248
Publication **Martha Stewart Living**
Design Director **Barbara de Wilde**
Art Director **Angela Gubler**
Photo Editors **Stacie McCormick, Beth Krzyzkowski**
Photographer **Sang An**
Stylist **Ayesha Patel**
Food Editor **Susan Sugarman**
Publisher **Martha Stewart Living Omnimedia**
Issue **February 2003**

249
Publication **Real Simple**
Creative Director **Robert Newman**
Art Director **Eva Spring**
Designer **Eva Spring**
Photo Editor **Naomi Nista**
Photographer **Amy Neunsinger**
Publisher **Time Inc.**
Issue **February 2003**

250
Publication **O, The Oprah Magazine**
Design Director **Carla Frank**
Designer **Kelly Chilton**
Photo Editor **Karen Frank**
Photographer **Gentl & Hyers**
Publisher **The Hearst Corporation-Magazines Division**
Issue **August 2003**

251
Publication **O, The Oprah Magazine**
Design Director **Carla Frank**
Art Director **Adam Glassman**
Designer **Albert Toy**
Photo Editor **Karen Frank**
Photographer **Victor Schrager**
Publisher **The Hearst Corporation-Magazines Division**
Issue **October 2003**

249

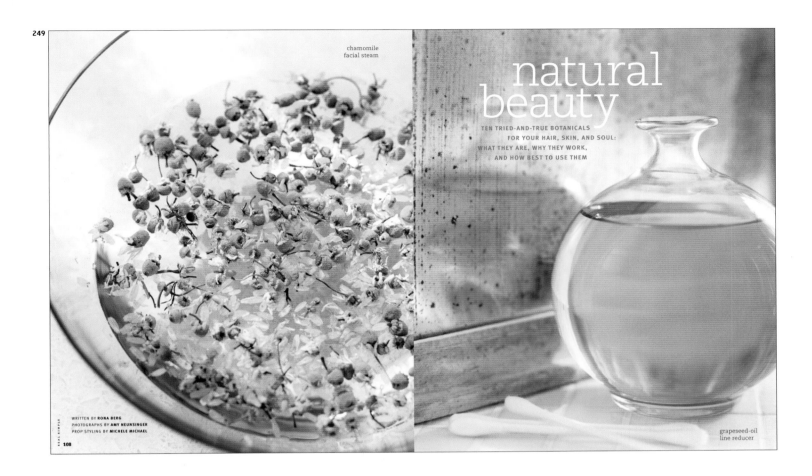

chamomile
facial steam

natural beauty

TEN TRIED-AND-TRUE BOTANICALS
FOR YOUR HAIR, SKIN, AND SOUL:
WHAT THEY ARE, WHY THEY WORK,
AND HOW BEST TO USE THEM

WRITTEN BY RONA BERG
PHOTOGRAPHS BY AMY NEUNSINGER
PROP STYLING BY MICHELE MICHAEL

REAL SIMPLE
108

grapeseed-oil
line reducer

250

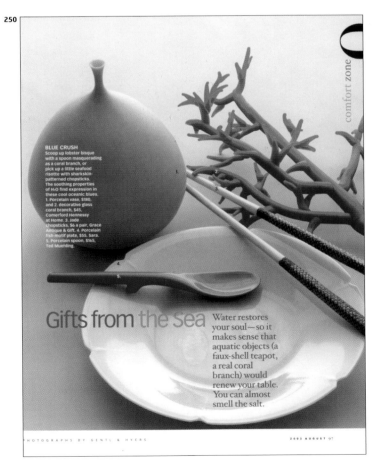

comfort zone

BLUE CRUSH
Scoop up lobster bisque
with a spoon masquerading
as a coral branch, or
pick up a little seafood
risotto with sharkskin-
patterned chopsticks.
The soothing properties
of H₂O find expression in
these cool oceanic blues.
1. Porcelain vase, $180,
and 2. decorative glass
coral branch, $45,
Comerford Hennessy
at Home. 3. Jade
chopsticks, $6 a pair, Grace
Antique & Gift. 4. Porcelain
fish-motif plate, $55, Sara.
5. Porcelain spoon, $165,
Ted Muehling.

Gifts from the sea

Water restores
your soul—so it
makes sense that
aquatic objects (a
faux-shell teapot,
a real coral
branch) would
renew your table.
You can almost
smell the salt.

PHOTOGRAPHS BY GENTL & HYERS 2003 AUGUST 97

251

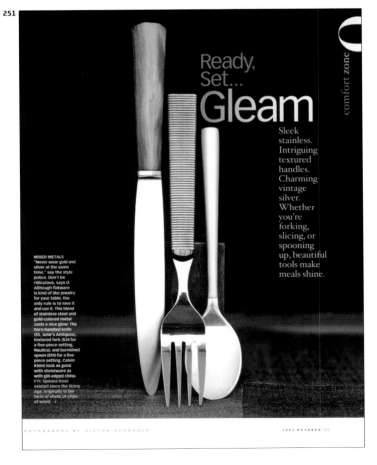

comfort zone

Ready, Set... Gleam

Sleek
stainless.
Intriguing
textured
handles.
Charming
vintage
silver.
Whether
you're
forking,
slicing, or
spooning
up, beautiful
tools make
meals shine.

MIXED METALS
"Never wear gold and
silver at the same
time," say the style
police. Don't be
ridiculous, says O:
Although flatware
is kind of like jewelry
for your table, the
only rule is to love it
and use it. This blend
of stainless steel and
gold-colored metal
casts a nice glow: The
horn-handled knife
($5, June's Antiques),
textured fork ($34 for
a five-piece setting,
Nautica), and burnished
spoon ($110 for a five-
piece setting, Calvin
Klein) look as good
with stoneware as
with gilt-edged china.
FYI: Spoons have
existed since the Stone
Age, originally in the
form of shells or chips
of wood.

PHOTOGRAPHS BY VICTOR SCHRAGER 2003 OCTOBER (1)

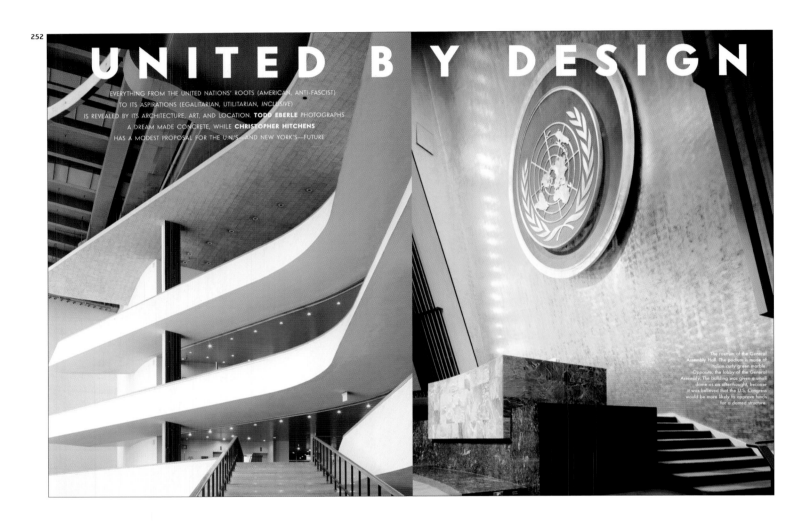

252

UNITED BY DESIGN

EVERYTHING FROM THE UNITED NATIONS' ROOTS (AMERICAN, ANTI-FASCIST)
TO ITS ASPIRATIONS (EGALITARIAN, UTILITARIAN, *INCLUSIVE*)
IS REVEALED BY ITS ARCHITECTURE, ART, AND LOCATION. **TODD EBERLE** PHOTOGRAPHS
A DREAM MADE CONCRETE, WHILE **CHRISTOPHER HITCHENS**
HAS A MODEST PROPOSAL FOR THE U.N.'S—AND NEW YORK'S—FUTURE

The rostrum of the General
Assembly Hall. The podium is made of
Italian curly green marble.
Opposite, the lobby of the General
Assembly. The building was given a small
dome as an afterthought, because
it was believed that the U.S. Congress
would be more likely to approve funds
for a domed structure.

252
Publication **Vanity Fair**
Design Director **David Harris**
Art Director **Julie Weiss**
Designer **Chris Mueller**
Photo Editor **Lisa Berman**
Photographer **Todd Eberle**
Photo Director **Susan White**
Photo Producer **Richard Villani**
Publisher **Condé Nast Publications Inc.**
Issue **June 2003**

253
Publication **The New York Times**
Art Director **Charles Blow**
Designers **Bill McNulty, Matthew Ericson**
Publisher **The New York Times**
Issue **April 10, 2003**

254
Publication **The New York Times**
Illustrators **Matthew Ericson, Farhana Hossain**
Publisher **The New York Times**
Issue **April 20, 2003**

255
Publication **Popular Science**
Design Director **Dirk Barnett**
Art Director **Hylah Hill**
Designer **Hylah Hill**
Illustrator **Mika Grondahl**
Publisher **Time4Media**
Issue **March 2003**

253

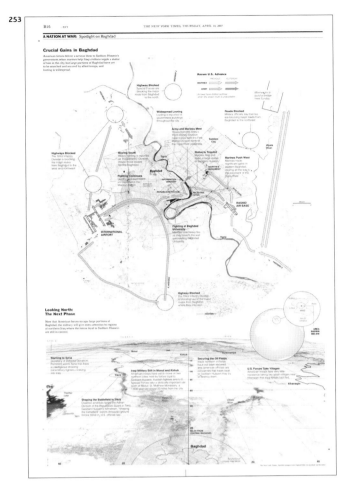

254

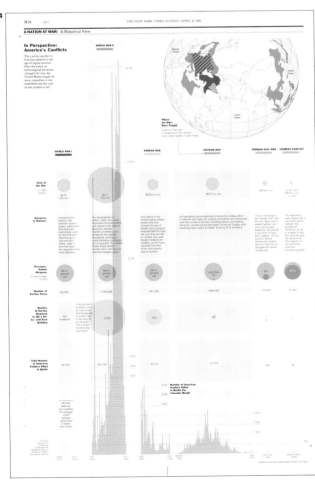

255

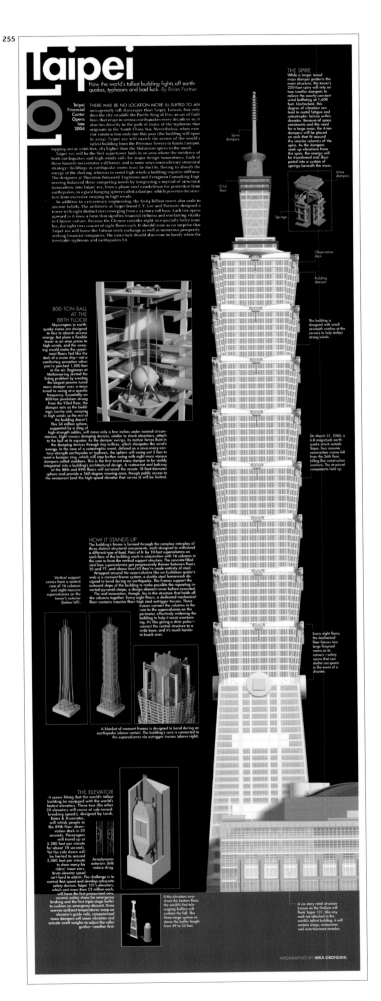

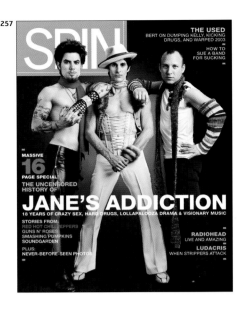

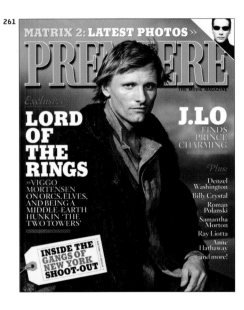

256
Publication **Fast Company**
Art Director **Dean Markadakis**
Designer **Dean Markadakis**
Illustrator **Bill Mayer**
Publisher **Gruner & Jahr USA Publishing**
Issue **December 2003**

257
Publication **Spin**
Design Director **Arem Duplessis**
Art Director **Brandon Kavulla**
Designer **Arem Duplessis**
Photo Editor **Cory Jacobs**
Photographer **Norman Jean Roy**
Publisher **Vibe/Spin Ventures LLC**
Issue **August 2003**

258
Publication **Spin**
Design Director **Arem Duplessis**
Art Director **Brandon Kavulla**
Designer **Arem Duplessis**
Photo Editor **Cory Jacobs**
Photographer **Jeff Minton**
Publisher **Vibe/Spin Ventures LLC**
Issue **November 2003**

259
Publication **Discover**
Design Director **Michael Mrak**
Art Director **John Seeger Gilman**
Designer **Michael Mrak**
Photo Editor **Maisie Todd**
Photographer **Dan Winters**
Publisher **Disney Publishing Worldwide**
Issue **October 2003**

260
Publication **Metropolitan Home**
Art Director **Keith D'Mello**
Designers **Keith D'Mello, Emily Furlani**
Photo Editor **Dan Golden**
Photographer **Peter Murdock**
Publisher **Hachette Filipacchi Media U.S.**
Issue **November/December 2003**

261
Publication **Premiere**
Art Director **Richard Baker**
Designer **Richard Baker**
Photo Editor **Catriona NiAolain**
Photographer **Norman Jean Roy**
Publisher **Hachette Filipacchi Media U.S.**
Issue **January 2003**

262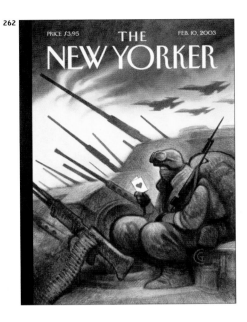

263

264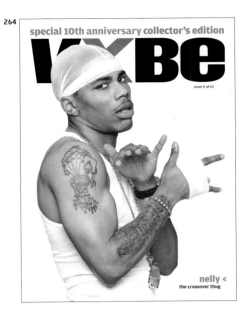

265

266

267

262
Publication **The New Yorker**
Art Director **Françoise Mouly**
Illustrator **Carter Goodrich**
Publisher **Condé Nast Publications Inc.**
Issue **February 10, 2003**

265
Publication **Premiere**
Art Director **Richard Baker**
Designer **Richard Baker**
Photo Editor **Catriona NiAolain**
Photographer **Platon**
Publisher **Hachette Filipacchi Media U.S.**
Issue **May 2003**

263
Publication **Travel+Leisure**
Creative Director **Luke Hayman**
Art Director **Emily Crawford**
Designer **Luke Hayman**
Photo Editors **David Cicconi, Katie Dunn**
Photographer **Max Kim-Bee**
Publisher **American Express Publishing Co.**
Issue **November 2003**

266
Publication **Wired**
Creative Director **Darrin Perry**
Design Director **Susana Rodriguez deTembleque**
Designer **Darrin Perry**
Photo Editor **Brenna Britton**
Photographer **Art Streiber**
Publisher **Condé Nast Publications Inc.**
Issue **July 2003**

264
Publication **Vibe**
Design Director **Florian Bachleda**
Photo Editors **George Pitts, Dora Somosi**
Photographer **Albert Watson**
Publisher **Vibe/Spin Ventures**
Issue **September 2003**

267
Publication **Wired**
Creative Director **Darrin Perry**
Design Director **Susana Rodriguez deTembleque**
Designer **Darrin Perry**
Illustrator **Darrin Perry**
Photographer **Bettmann/ Corbis**
Publisher **Condé Nast Publications Inc.**
Issue **February 2003**

268

269

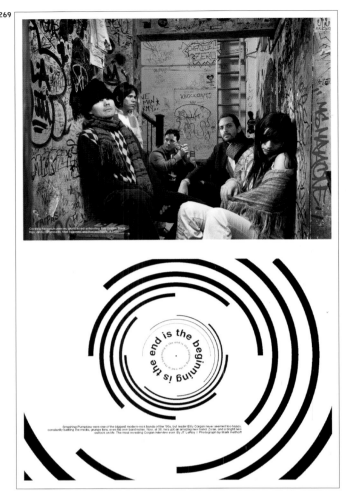

270

268
Publication **Esquire**
Design Director **John Korpics**
Photo Editor **Nancy Jo Iacoi**
Photographer **James White**
Publisher **The Hearst Corporation-Magazines Division**
Issue **August 2003**

269
Publication **Spin**
Design Director **Arem Duplessis**
Art Director **Brandon Kavulla**
Designers **Maili Holiman, Alexander Chow, Arem Duplessis, Brandon Kavulla**
Photo Editors **Cory Jacobs, Prim Chuensumran, Lisa Corson**
Photographers **Jeff Minton, Sye Williams, Danielle Levitt, Todd Cole, Michael Edwards, Michael Schmelling, Todd Selby, Alexei Hay, Mark Heithoff, Alex Cayley, Jelle Wagenaar**
Publisher **Vibe/Spin Ventures LLC**
Issue **June 2003**

271

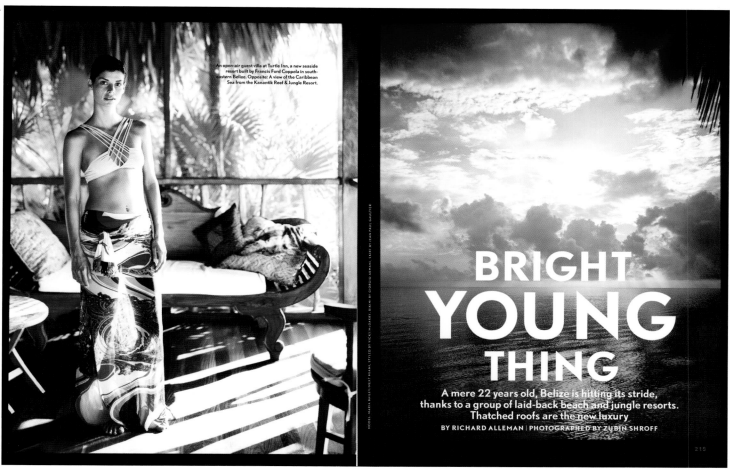

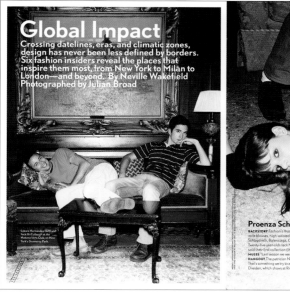

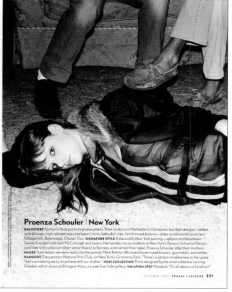

270
Publication **Travel+Leisure**
Creative Director **Luke Hayman**
Art Director **Emily Crawford**
Designers **Emily Crawford, Gillian Goodman, Sandra Garcia, Nancy Chan**
Illustrators **Juliette Borda, Peter Arkle, Demetrios Psillos, Damian Gascoigne, Joel Holland, Roderick Mills**
Photo Editors **David Cicconi, Katie Dunn**
Photographers **Joao Canziani, Simon Watson, Christian Kerber, Charles Masters, Max Kim-Bee, Julian Broad, Mikkel Vang, Dook, Coliena Rentmeester**
Publisher **American Express Publishing Co.**
Issue **November 2003**

271
Publication **Travel+Leisure**
Creative Director **Luke Hayman**
Art Director **Emily Crawford**
Designers **Emily Crawford, Gillian Goodman, Nancy Chan**
Illustrators **Tinou Le Joly Senoville, Sayed Hasan, Trisha Krauss, Roderick Mills**
Photo Editors **David Cicconi, Katie Dunn**
Photographers **Doug Rosa, Mikkel Vang, Andrea Fazzari, Tztsuya Miura, Bobby Fischer, Julian Broad, Martin Morrell, Zubin Shroff, Cedric Angeles, François Dischinger**
Publisher **American Express Publishing Co.**
Issue **October 2003**

272

273

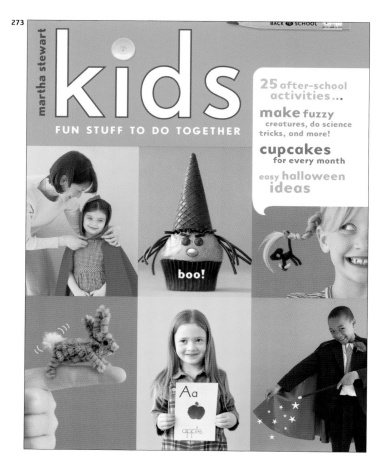

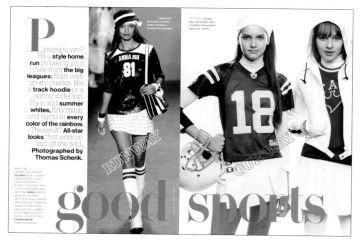

274

272
Publication **Teen Vogue**
Art Director **Lina Kutsovskaya**
Designers **James Casey, Jason Engdahl,
Holly Stevenson, Emily Wardwell**
Photo Editor **Lucy Lee**
Photographers **Mario Testino, Tim Walker,
Thomas Schenk, Freddie Helwig,
Raymond Meier**
Associate Photo Editor **Brody Baker**
Assistant Photo Editor **Jillian Johnson**
Publisher **Condé Nast Publications Inc.**
Issue **June/July 2003**

273
Publication **Martha Stewart Kids**
Creative Director **Gael Towey**
Design Director **Deb Bishop**
Art Directors **Jennifer Wagner, Brooke Reynolds, Jennifer Dahl**
Illustrators **Lane Smith, James Bennett**
Photo Editors **Stacie McCormick, Jamie Bass Perrotta**
Photographers **Sang An, Stephen Lewis,
Christopher Baker, Victor Schrager, James Baigrie**
Stylists **Jodi Levine, Ayesha Patel, Tara Bench, Anna Beckman,
Charlyne Mattox, Katie Hatch, Tanya Graff**
Publisher **Martha Stewart Living Omnimedia**
Issue **Fall 2003**

274
Publication **GQ**
Design Director **Fred Woodward**
Designer **Ken DeLago**
Illustrator **Anita Kunz**
Photo Editor **Jennifer Crandall**
Publisher **Condé Nast Publications Inc.**
Issue **June 2003**

275

276

277

278

279

280

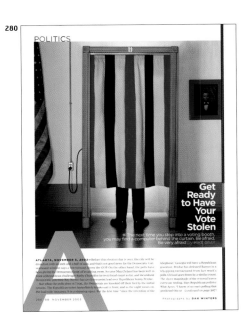

275
Publication **Wired**
Creative Director **Darrin Perry**
Design Director **Susana Rodriguez deTembleque**
Designer **Susana Rodriguez deTembleque**
Photo Editor **Carolyn Rauch**
Photographer **Morten Kettel**
Publisher **Condé Nast Publications Inc.**
Issue **May 2003**

276
Publication **Vibe**
Design Director **Florian Bachleda**
Designer **Michael Friel**
Illustrator **Robert Risko**
Publisher **Vibe/Spin Ventures**
Issue **September 2003**

277
Publication **Travel+Leisure**
Creative Director **Luke Hayman**
Art Director **Emily Crawford**
Designer **Robin Hewitt**
Photo Editors **David Cicconi, Katie Dunn**
Photographer **Cyril Jay-Rayon**
Publisher **American Express Publishing Co.**
Issue **April 2003**

278
Publication **GQ**
Design Director **Fred Woodward**
Designer **Hudd Byard**
Photo Editors **Jennifer Crandall, Michael Norseng**
Photographer **Dan Winters**
Publisher **Condé Nast Publications Inc.**
Issue **December 2003**

279
Publication **GQ**
Design Director **Fred Woodward**
Designer **Matthew Lenning**
Photo Editors **Jennifer Crandall, Kristen Schaefer**
Photographer **Tom Schierlitz**
Publisher **Condé Nast Publications Inc.**
Issue **June 2003**

280
Publication **GQ**
Design Director **Fred Woodward**
Designer **Sara Viñas**
Photo Editor **Jennifer Crandall**
Photographer **Dan Winters**
Publisher **Condé Nast Publications Inc.**
Issue **November 2003**

281
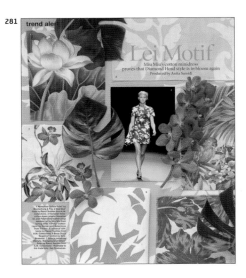

282

283

284
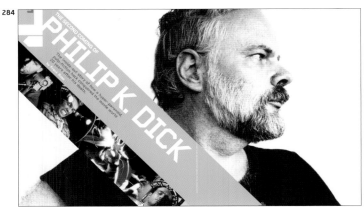

285
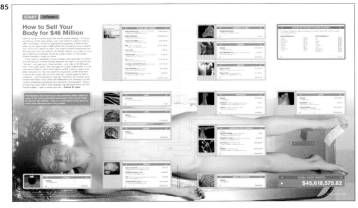

286
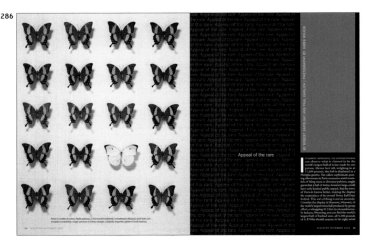

287
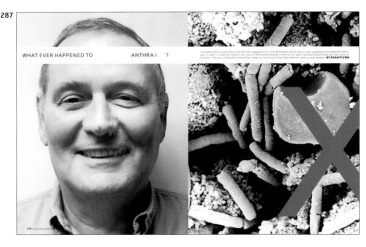

281
Publication **Elle Decor**
Art Director **Florentino Pamintuan**
Designer **Noah Dreier**
Photo Editor **Melissa LeBoeuf**
Photographer **Monica Buck**
Design & Decoration Editor **Anita Sarsidi**
Publisher **Hachette Filipacchi Media U.S.**
Issue **May 2003**

284
Publication **Wired**
Creative Director **Darrin Perry**
Designer **Darrin Perry**
Illustrator **Kenn Brown**
Publisher **Condé Nast Publications, Inc.**
Issue **December 2003**

282
Publication **Spin**
Design Director **Arem Duplessis**
Art Director **Brandon Kavulla**
Designer **Maili Holiman**
Photo Editor **Lisa Corson**
Photographer **Jelle Wagenaar**
Publisher **Vibe/Spin Ventures LLC**
Issue **April 2003**

285
Publication **Wired**
Creative Director **Darrin Perry**
Design Director **Susana Rodriguez deTembleque**
Designer **Mark Wasyl**
Photo Editor **Amy Hoppy**
Photographer **Michael Elins**
Publisher **Condé Nast Publications Inc.**
Issue **August 2003**

283
Publication **Wired**
Creative Director **Darrin Perry**
Design Director **Susana Rodriguez deTembleque**
Designer **Mark Wasyl**
Publisher **Condé Nast Publications Inc.**
Issue **April 2003**

286
Publication **Discover**
Design Director **Michael Mrak**
Art Director **John Seeger Gilman**
Designer **John Seeger Gilman**
Photo Editor **Maisie Todd**
Photographer **James Wojcik**
Publisher **Disney Publishing Worldwide**
Issue **November 2003**

288
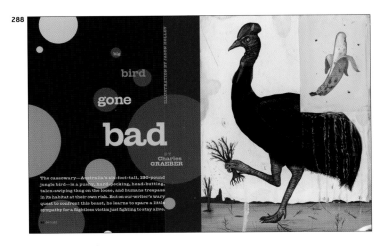

289
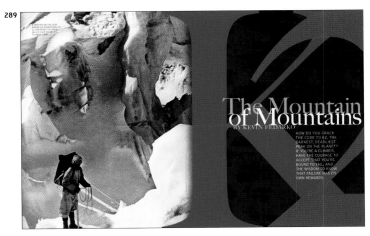

290
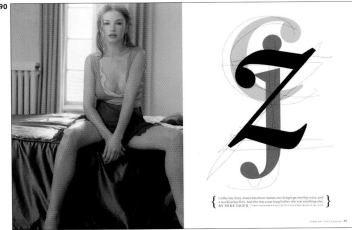

+ MERIT PORTRAIT PHOTOGRAPHY ENTIRE STORY

291
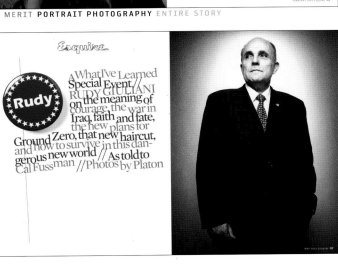

292
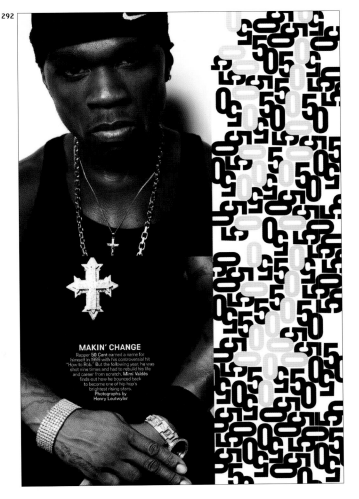

287
Publication **Esquire**
Design Director **John Korpics**
Publisher **The Hearst Corporation-
Magazines Division**
Issue **March 2003**

288
Publication **Outside**
Creative Director **Hannah McCaughey**
Designer **Hannah McCaughey**
Illustrator **Jason Holley**
Publisher **Mariah Media, Inc.**
Issue **February 2003**

289
Publication **Outside**
Creative Director **Hannah McCaughey**
Designer **Hannah McCaughey**
Photo Editor **Rob Haggart**
Photographer **Archival**
Publisher **Mariah Media, Inc.**
Issue **November 2003**

290
Publication **Esquire**
Design Director **John Korpics**
Photo Editor **Nancy Jo Iacoi**
Photographer **Marc Hom**
Publisher **The Hearst Corporation-
Magazines Division**
Issue **February 2003**

291
Publication **Esquire**
Design Director **John Korpics**
Photo Editor **Nancy Jo Iacoi**
Photographer **Platon**
Publisher **The Hearst Corporation-
Magazines Division**
Issue **May 2003**

292
Publication **Vibe**
Design Director **Florian Bachleda**
Designer **Wyatt Mitchell**
Photo Editors **George Pitts, Dora Somosi**
Photographer **Henry Leutwyler**
Publisher **Vibe/Spin Ventures**
Issue **March 2003**

293

THE SOUND OF MUSIC

Hip hop has redefined the cultural landscape of America. And while the artists stroll the red carpet and floss under the lights, it's the producers who create the chart-topping and mind-blowing hits. MIMI VALDÉS tracks the EVOLUTION OF URBAN MUSIC over the last decade through the eyes of the maestros who got us here.
ILLUSTRATION BY EDDIE GUY

200 VIBE

294

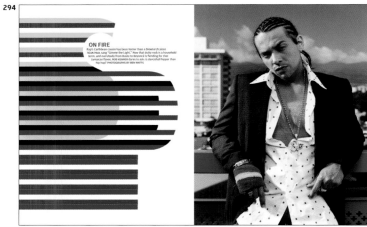

295

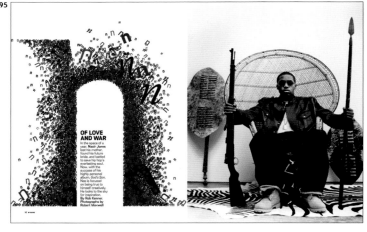

293
Publication **Vibe**
Design Director **Florian Bachleda**
Designer **Alice Alves**
Illustrator **Eddie Guy**
Publisher **Vibe/Spin Ventures**
Issue **September 2003**

294
Publication **Vibe**
Design Director **Florian Bachleda**
Designer **Michael Friel**
Photo Editors **George Pitts, Dora Somosi**
Photographer **Ben Watts**
Publisher **Vibe/Spin Ventures**
Issue **December 2003**

295
Publication **Vibe**
Design Director **Florian Bachleda**
Designer **Michael Friel**
Photo Editors **George Pitts, Dora Somosi**
Photographer **Robert Maxwell**
Publisher **Vibe/Spin Ventures**
Issue **June 2003**

296
Publication **Vibe**
Design Director **Florian Bachleda**
Designer **Michael Friel**
Photo Editors **George Pitts, Dora Somosi**
Photographer **David LaChapelle**
Publisher **Vibe/Spin Ventures**
Issue **October 2003**

297
Publication **Vibe**
Design Director **Florian Bachleda**
Designer **Wyatt Mitchell**
Illustrator **Robert Risko**
Publisher **Vibe/Spin Ventures**
Issue **November 2003**

298 (on next spread)
Publication **Vibe**
Design Director **Florian Bachleda**
Designer **Alice Alves**
Illustrators **George Pitts, Dora Somosi**
Photographer **Alex Cayley**
Publisher **Vibe/Spin Ventures**
Issue **January 2003**

296

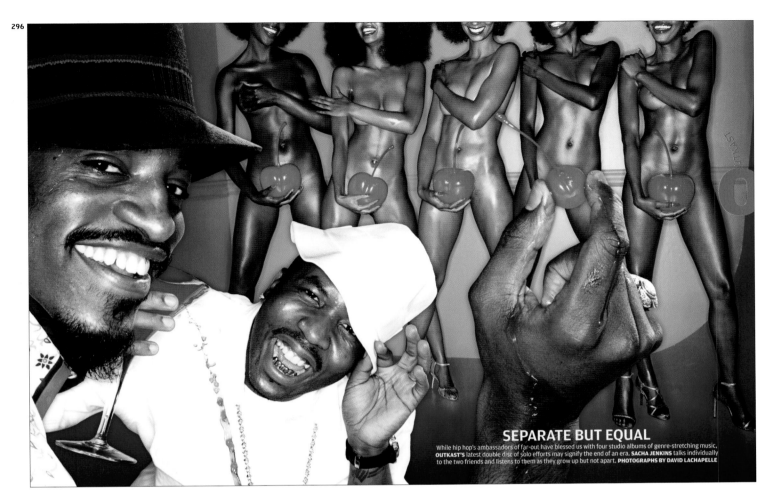

SEPARATE BUT EQUAL

While hip hop's ambassadors of far-out have blessed us with four studio albums of genre-stretching music, **OUTKAST'S** latest double disc of solo efforts may signify the end of an era. **SACHA JENKINS** talks individually to the two friends and listens to them as they grow up but not apart. **PHOTOGRAPHS BY DAVID LACHAPELLE**

297

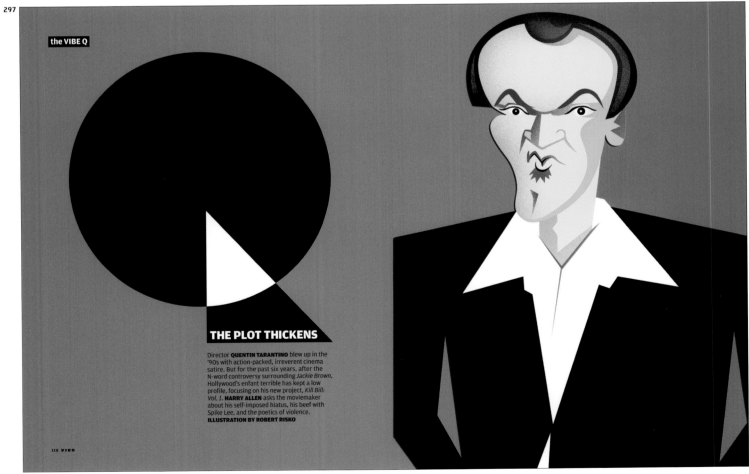

the VIBE Q

THE PLOT THICKENS

Director **QUENTIN TARANTINO** blew up in the '90s with action-packed, irreverent cinema satire. But for the past six years, after the N-word controversy surrounding *Jackie Brown*, Hollywood's enfant terrible has kept a low profile, focusing on his new project, *Kill Bill: Vol. 1*. **HARRY ALLEN** asks the moviemaker about his self-imposed hiatus, his beef with Spike Lee, and the poetics of violence. **ILLUSTRATION BY ROBERT RISKO**

298

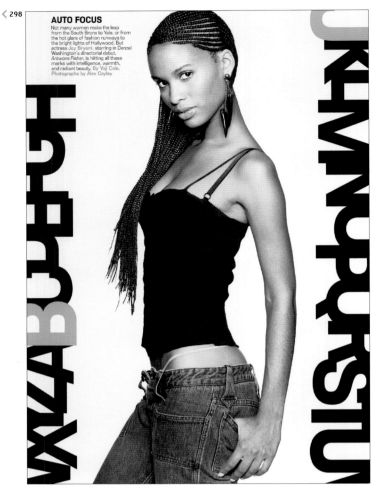

AUTO FOCUS

Not many women make the leap from the South Bronx to Yale, or from the hot glare of fashion runways to the bright lights of Hollywood. But actress Joy Bryant, starring in Denzel Washington's directorial debut, *Antwone Fisher*, is hitting all these marks with intelligence, warmth, and radiant beauty. By Yoji Cole. Photographs by Alex Cayley.

299

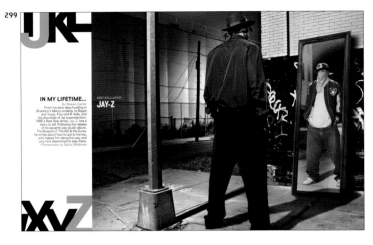

IN MY LIFETIME...
By Shawn Carter
From his early days hustling in Brooklyn's Marcy projects, to Biggie and Tupac, Foxy and R. Kelly, and the downside of rap superstardom, VIBE's Best Solo Artist, JAY-Z, has a story to tell. Following the release of his seventh solo studio album, *The Blueprint 2: The Gift & the Curse,* he writes about how he got to the top, who helped him along the way, and why he's determined to stay there. Photographs by Sacha Waldman

300

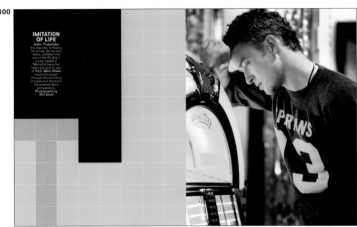

IMITATION OF LIFE
Justin Timberlake, the pop star, is flipping the script. On his solo debut, *Justified,* the son of the Southern music capital of Memphis bares his heart and soul to, wiry R&B. Mimi Valdés tracks the singer through the recording process and discovers his greatest fears and passions. Photographs by Phil Knott

301

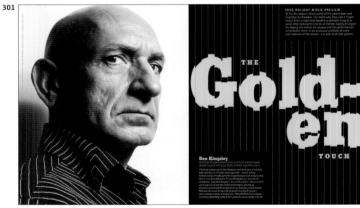

THE **Gold-en** TOUCH

Ben Kingsley

302

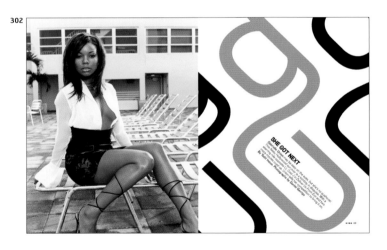

SHE GOT NEXT

299
Publication **Vibe**
Design Director **Florian Bachleda**
Photo Editors **George Pitts, Dora Somosi**
Photographer **Sacha Waldman**
Publisher **Vibe/Spin Ventures**
Issue **January 2003**

300
Publication **Vibe**
Design Director **Florian Bachleda**
Photo Editors **George Pitts, Dora Somosi**
Photographer **Phil Knott**
Publisher **Vibe/Spin Ventures**
Issue **February 2003**

301
Publication **Premiere**
Art Director **Richard Baker**
Designer **David Schlow**
Photo Editors **Catriona NiAolain, Linda Liang**
Photographer **James Dimmock**
Publisher **Hachette Filipacchi Media U.S.**
Issue **December 2003**

302
Publication **Vibe**
Design Director **Florian Bachleda**
Designer **Michael Friel**
Photo Editors **George Pitts, Dora Somosi**
Photographer **Daniel Garriga**
Publisher **Vibe/Spin Ventures**
Issue **March 2003**

303
Publication **GQ**
Design Director **Fred Woodward**
Designer **Paul Martinez**
Photo Editors **Jennifer Crandall, Kristen Schaefer**
Photographer **Patrik Giardino**
Publisher **Condé Nast Publications Inc.**
Issue **July 2003**

304
Publication **GQ**
Design Director **Fred Woodward**
Designer **Paul Martinez**
Photo Editors **Jennifer Crandall, Kristen Schaefer**
Photographer **Martin Schoeller**
Publisher **Condé Nast Publications Inc.**
Issue **November 2003**

303

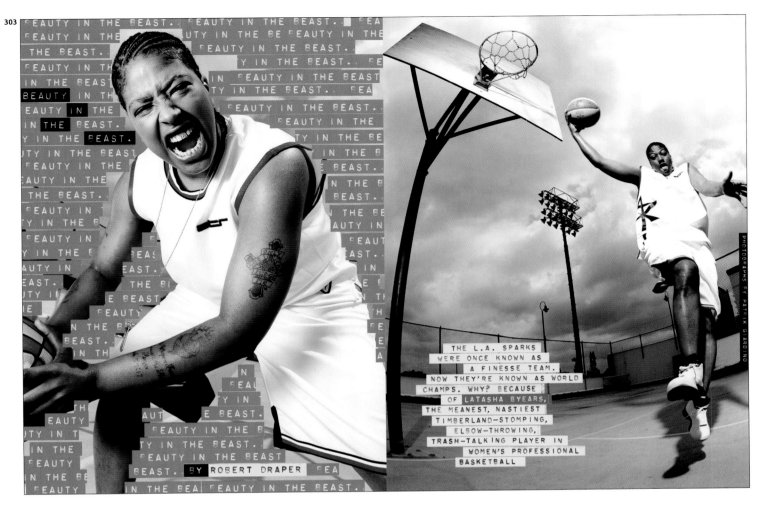

BEAUTY IN THE BEAST.

BY ROBERT DRAPER

THE L.A. SPARKS WERE ONCE KNOWN AS A FINESSE TEAM. NOW THEY'RE KNOWN AS WORLD CHAMPS. WHY? BECAUSE OF LATASHA BYEARS, THE MEANEST, NASTIEST TIMBERLAND-STOMPING, ELBOW-THROWING, TRASH-TALKING PLAYER IN WOMEN'S PROFESSIONAL BASKETBALL

PHOTOGRAPHS BY PATRIK GIARDINO

304

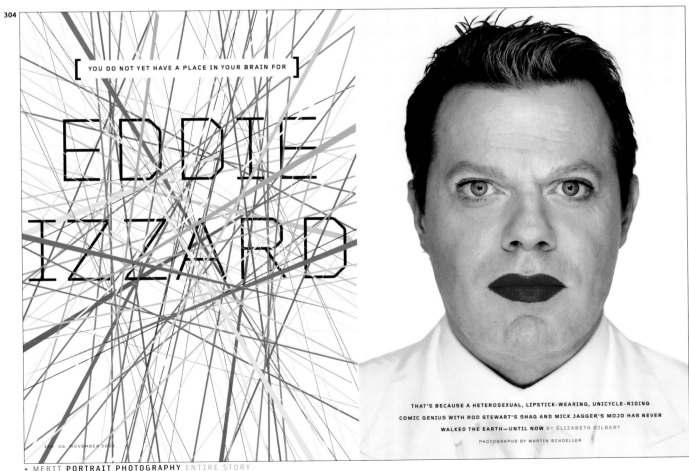

[YOU DO NOT YET HAVE A PLACE IN YOUR BRAIN FOR]

EDDIE IZZARD

THAT'S BECAUSE A HETEROSEXUAL, LIPSTICK-WEARING, UNICYCLE-RIDING
COMIC GENIUS WITH ROD STEWART'S SHAG AND MICK JAGGER'S MOJO HAS NEVER
WALKED THE EARTH—UNTIL **NOW** BY ELIZABETH GILBERT

PHOTOGRAPHS BY MARTIN SCHOELLER

+ MERIT **PORTRAIT PHOTOGRAPHY** ENTIRE STORY

305

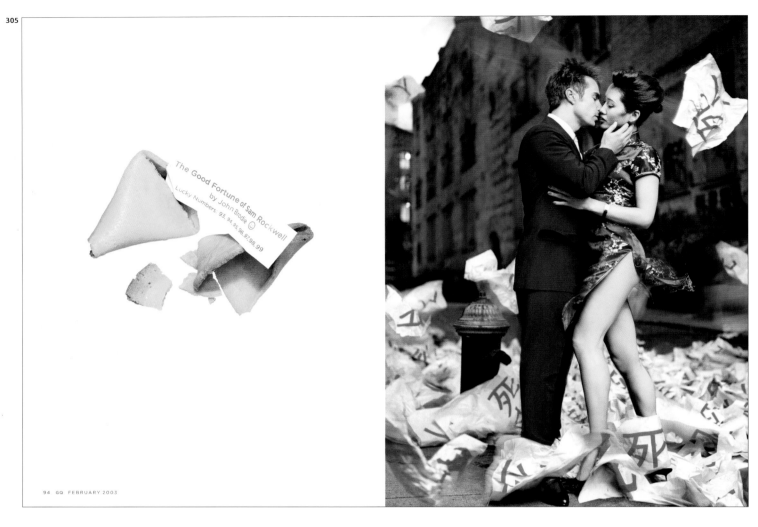

306

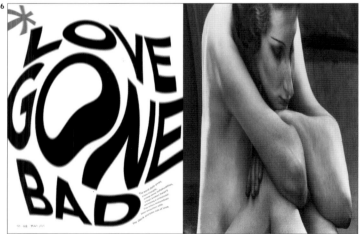

307

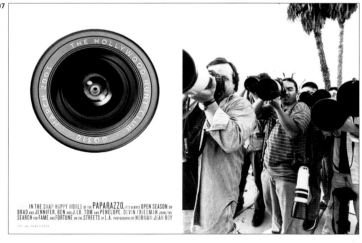

305
Publication **GQ**
Design Director **Fred Woodward**
Designer **Paul Martinez**
Photo Editor **Jennifer Crandall**
Photographer **Mark Seliger**
Creative Director, Fashion **Jim Moore**
Publisher **Condé Nast Publications Inc.**
Issue **February 2003**

306
Publication **GQ**
Design Director **Fred Woodward**
Designer **Ken DeLago**
Photo Editors **Jennifer Crandall, Catherine Talese**
Photographer **André Kertez**
Publisher **Condé Nast Publications Inc.**
Issue **May 2003**

307
Publication **GQ**
Design Director **Fred Woodward**
Designer **Paul Martinez**
Photo Editor **Jennifer Crandall**
Photographer **Norman Jean Roy**
Publisher **Condé Nast Publications Inc.**
Issue **March 2003**

308

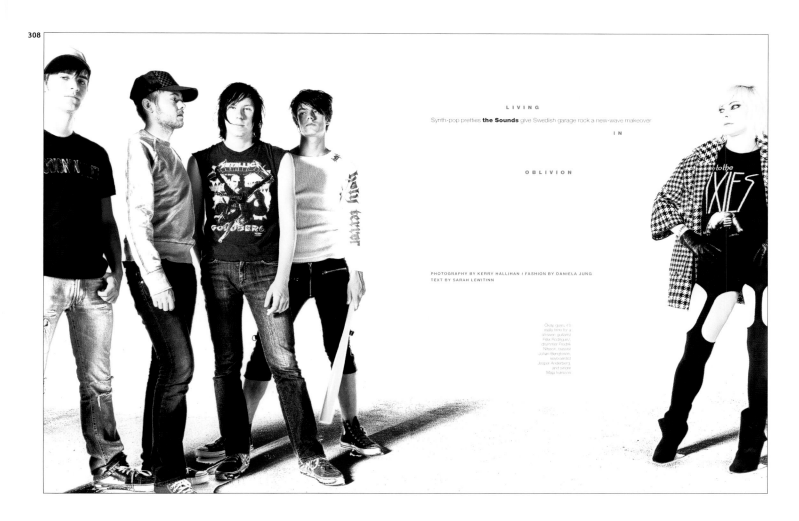

LIVING

Synth-pop pretties **the Sounds** give Swedish garage rock a new-wave makeover

IN

OBLIVION

PHOTOGRAPHY BY KERRY HALLIHAN | FASHION BY DANIELA JUNG
TEXT BY SARAH LEWITINN

309 310

308
Publication **Spin**
Design Director **Arem Duplessis**
Art Director **Brandon Kavulla**
Designer **Arem Duplessis**
Photo Editor **Cory Jacobs**
Photographer **Kerry Hallihan**
Fashion Director **Daniela Jung**
Publisher **Vibe/Spin Ventures LLC**
Issue **November 2003**

309
Publication **GQ**
Design Director **Fred Woodward**
Designer **Matthew Lenning**
Photo Editor **Jennifer Crandall**
Photographer **Mitchell Feinberg**
Creative Director, Fashion **Jim Moore**
Publisher **Condé Nast Publications Inc.**
Issue **February 2003**

310
Publication **GQ**
Design Director **Fred Woodward**
Designer **Matthew Lenning**
Photo Editors **Jennifer Crandall,
Kristen Schaefer**
Creative Director, Fashion **Jim Moore**
Publisher **Condé Nast Publications Inc.**
Issue **January 2003**

311
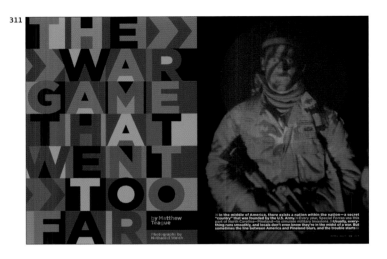

312

313
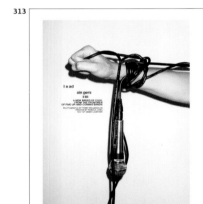 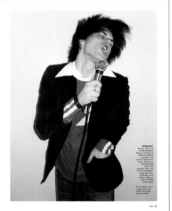

314
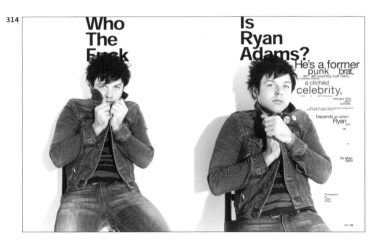

315

316

317
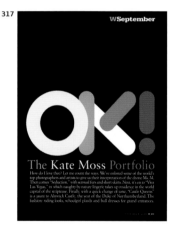

311
Publication **GQ**
Design Director **Fred Woodward**
Designer **Ken DeLago**
Photo Editors **Jennifer Crandall,**
Catherine Talese
Photographer **Nathaniel Welch**
Publisher **Condé Nast Publications Inc.**
Issue **April 2003**

312
Publication **Spin**
Design Director **Arem Duplessis**
Designer **Alexander Chow**
Illustrator **Rachel Salomon**
Publisher **Vibe/Spin Ventures LLC**
Issue **January 2003**

313
Publication **Spin**
Design Director **Arem Duplessis**
Art Director **Brandon Kavulla**
Designer **Arem Duplessis**
Photo Editor **Cory Jacobs**
Photographer **Terry Richardson**
Fashion Director **Daniela Jung**
Publisher **Vibe/Spin Ventures LLC**
Issue **July 2003**

314
Publication **Spin**
Design Director **Arem Duplessis**
Art Director **Brandon Kavulla**
Designer **Arem Duplessis**
Photo Editor **Cory Jacobs**
Photographer **Collier Schorr**
Publisher **Vibe/Spin Ventures LLC**
Issue **December 2003**

315
Publication **Spin**
Design Director **Arem Duplessis**
Art Director **Brandon Kavulla**
Designers **Arem Duplessis, Brandon Kavulla**
Publisher **Vibe/Spin Ventures LLC**
Issue **April 2003**

316
Publication **W Magazine**
Creative Director **Dennis Freedman**
Design Director **Edward Leida**
Art Director **Kirby Rodriguez**
Designers **Edward Leida, Angela Panichi, Shanna Greenberg**
Photographer **Steven Klein**
Publisher **Fairchild Publications**
Issue **October 2003**

318

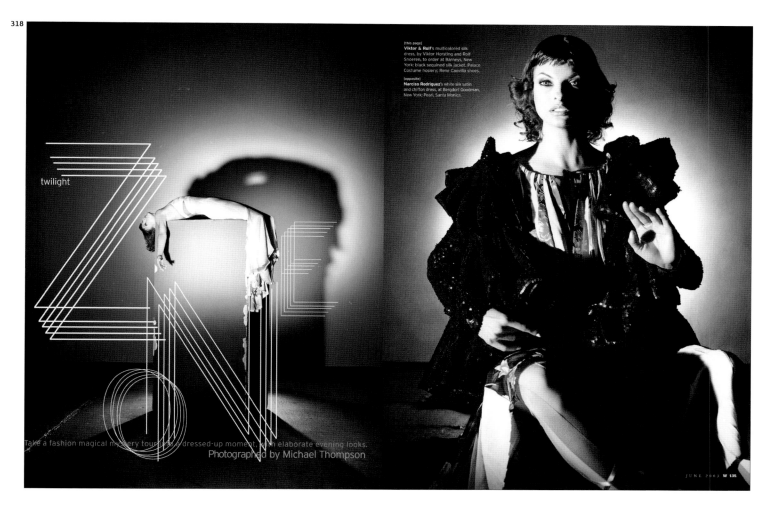

twilight

Take a fashion magical mystery tour into a dressed-up moment, with elaborate evening looks. Photographed by Michael Thompson

[this page]
Viktor & Rolf's multicolored silk dress, by Viktor Horsting and Rolf Snoeren, to order at Barneys, New York; black sequined silk jacket. Palace Costume hosiery; Rene Caovilla shoes.

[opposite]
Narciso Rodriguez's white silk satin and chiffon dress, at Bergdorf Goodman, New York; Pearl, Santa Monica.

319

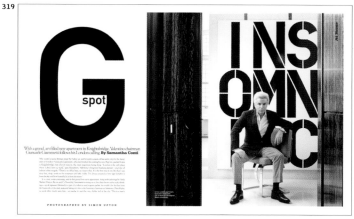

G spot

INSOMNIAC

320

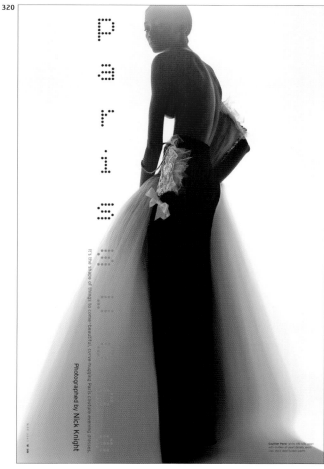

317
Publication **W Magazine**
Creative Director **Dennis Freedman**
Design Director **Edward Leida**
Art Director **Kirby Rodriguez**
Designers **Edward Leida, Angela Panichi, Shanna Greenberg**
Publisher **Fairchild Publications**
Issue **September 2003**

319
Publication **W Magazine**
Creative Director **Dennis Freedman**
Design Director **Edward Leida**
Art Director **Kirby Rodriguez**
Designers **Kirby Rodriguez, Angela Panichi, Shanna Greenberg**
Photographer **Simon Upton**
Publisher **Fairchild Publications**
Issue **May 2003**

318
Publication **W Magazine**
Creative Director **Dennis Freedman**
Design Director **Edward Leida**
Art Director **Kirby Rodriguez**
Designers **Edward Leida, Angela Panichi, Shanna Greenberg**
Photographer **Michael Thompson**
Publisher **Fairchild Publications**
Issue **June 2003**

320
Publication **W Magazine**
Creative Director **Dennis Freedman**
Design Director **Edward Leida**
Art Director **Kirby Rodriguez**
Designers **Edward Leida, Angela Panichi, Shanna Greenberg**
Photographer **Nick Knight**
Publisher **Fairchild Publications**
Issue **May 2003**

321

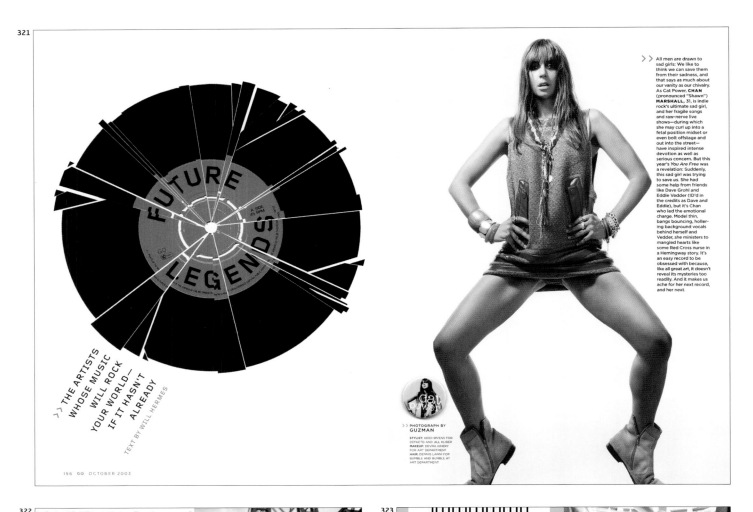

>> PHOTOGRAPH BY
GUZMAN

+ MERIT FASHION PHOTOGRAPHY ENTIRE STORY

322

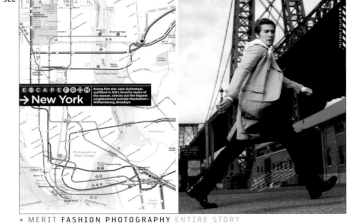

323

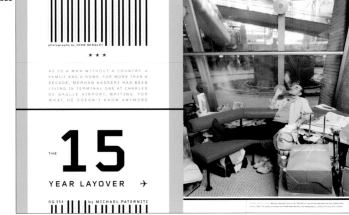

321
Publication **GQ**
Design Director **Fred Woodward**
Designer **Paul Martinez**
Photo Editors **Jennifer Crandall, Kristen Schaefer**
Photographers **Guzman , Anton Corbijn, Mark Seliger,
Charles Peterson, Danny Clinch, Phil Knott**
Publisher **Condé Nast Publications Inc.**
Issue **October 2003**

322
Publication **GQ**
Design Director **Fred Woodward**
Designer **Paul Martinez**
Photo Editor **Jennifer Crandall**
Photographer **Mark Seliger**
Creative Director **Jim Moore**
Fashion Director **Madeline Weeks**
Publisher **Condé Nast Publications Inc.**
Issue **January 2003**

323
Publication **GQ**
Design Director **Fred Woodward**
Designer **Ken DeLago**
Photo Editors **Jennifer Crandall, Catherine Talese**
Photographer **John Midgley**
Publisher **Condé Nast Publications Inc.**
Issue **September 2003**

324
Publication **Travel+Leisure**
Creative Director **Luke Hayman**
Art Director **Emily Crawford**
Designer **Emily Crawford**
Photo Editors **David Cicconi, Katie Dunn**
Photographer **Martina Hoogland Ivanow**
Publisher **American Express Publishing Co.**
Issue **December 2003**

325
Publication **Travel+Leisure**
Creative Director **Luke Hayman**
Art Director **Emily Crawford**
Designer **Emily Crawford**
Photo Editors **David Cicconi, Katie Dunn**
Photographer **Stewart Ferebee**
Publisher **American Express Publishing Co.**
Issue **December 2003**

324

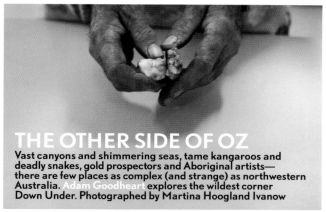

THE OTHER SIDE OF OZ

Vast canyons and shimmering seas, tame kangaroos and deadly snakes, gold prospectors and Aboriginal artists—there are few places as complex (and strange) as northwestern Australia. Adam Goodheart explores the wildest corner Down Under. Photographed by Martina Hoogland Ivanow

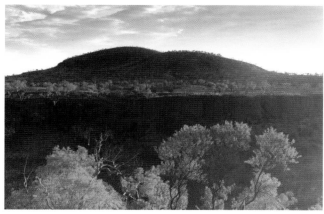

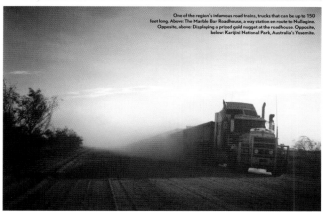

One of the region's infamous road trains, trucks that can be up to 150 feet long. Above: The Marble Bar Roadhouse, a way station en route to Nullagine. Opposite, above: Displaying a prized gold nugget at the roadhouse. Opposite, below: Karijini National Park, Australia's Yosemite.

178 TRAVEL + LEISURE DECEMBER 2003

DECEMBER 2003 TRAVEL + LEISURE 179

+ MERIT TRAVEL PHOTOGRAPHY ENTIRE STORY

325

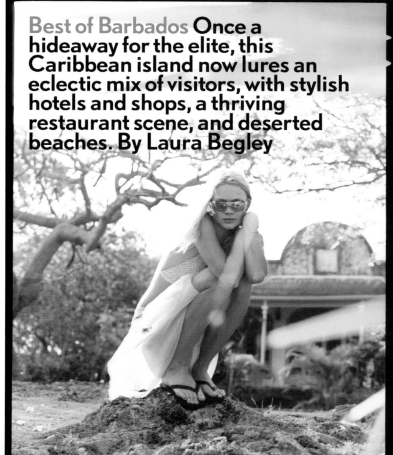

Best of Barbados Once a hideaway for the elite, this Caribbean island now lures an eclectic mix of visitors, with stylish hotels and shops, a thriving restaurant scene, and deserted beaches. By Laura Begley

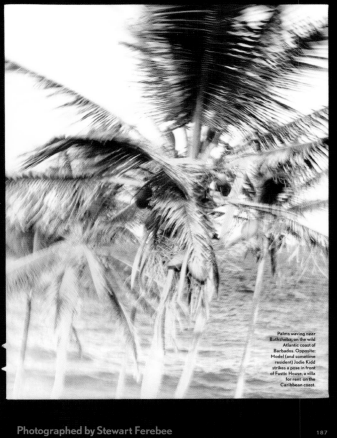

Palms waving near Bathsheba, on the wild Atlantic coast of Barbados. Opposite: Model (and sometime resident) Jodie Kidd strikes a pose in front of Fustic House, a villa for rent on the Caribbean coast.

Photographed by Stewart Ferebee

187

326

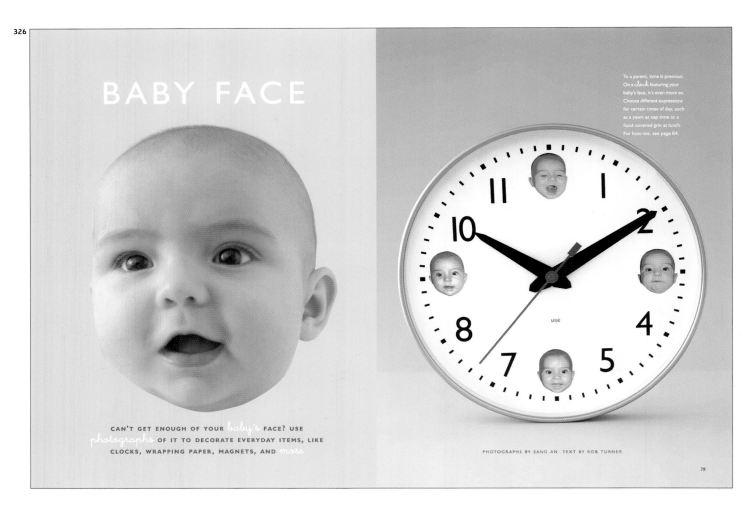

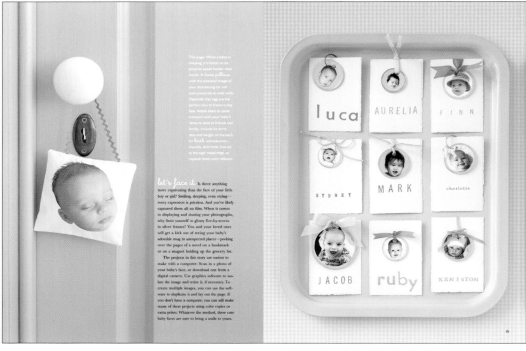

326
Publication **Martha Stewart Baby**
Creative Director **Gael Towey**
Design Director **Deb Bishop**
Photo Editors **Stacie McCormick, Jamie Bass**
Photographer **Sang An**
Stylist **Jodi Levine**
Publisher **Martha Stewart Living Omnimedia**
Issue **Spring 2003**

327
Publication **Martha Stewart Kids**
Creative Director **Gael Towey**
Design Director **Deb Bishop**
Photo Editors **Stacie McCormick, Jamie Bass Perrotta**
Photographer **Victor Schrager**
Stylist **Jodi Levine**
Publisher **Martha Stewart Living Omnimedia**
Issue **Fall 2003**

327

seeing is believing

9 amazing science tricks to try at home

try this! Use an eyedropper to scatter a few droplets of water onto a piece of waxed paper, then slide the waxed paper over a page of this magazine to make the type appear larger. The smaller the drop of water, the bigger the print will look!

why it works A water droplet bulges, like a magnifying glass, stretching an image seen through it. The more curved the droplet is, the greater the magnification of the image.

000

DO YOU BELIEVE IN MAGIC? You might not notice it, but there is a kind of magic that surrounds you every day, waiting to be discovered. It exists in the way water travels upward from the ground through a flower's stem and leaves, and in the way a beetle skims across the surface of a swimming pool without sinking. Such feats are fascinating to us, but they're no big deal for flowers or beetles. If you're inquisitive, you can understand these mysteries, too; the magic behind them is science.

You don't need any special equipment to witness science in action. The best demonstrations use everyday objects to illustrate basic ideas. After you try the experiments on these pages, look for science at work in the real world: The same principles help explain why buildings stand and thunderstorms arise. Before long, you'll start to see the little magic tricks that science performs every day—even if you don't believe your eyes.

106

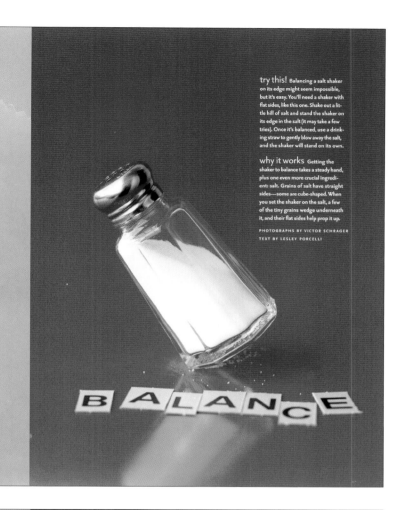

try this! Balancing a salt shaker on its edge might seem impossible, but it's easy. You'll need a shaker with flat sides, like this one. Shake out a little hill of salt and stand the shaker on its edge in the salt (it may take a few tries). Once it's balanced, use a drinking straw to gently blow away the salt, and the shaker will stand on its own.

why it works Getting the shaker to balance takes a steady hand, plus one even more crucial ingredient: salt. Grains of salt have straight sides—some are cube-shaped. When you set the shaker on the salt, a few of the tiny grains wedge underneath it, and their flat sides help prop it up.

PHOTOGRAPHS BY VICTOR SCHRAGER
TEXT BY LESLEY PORCELLI

try this! Would you believe a single sheet of paper can hold several heavy books? Roll a piece of paper into a wide cylinder. Slip on a rubber band to secure it. Stand the cylinder upright, and stack books centered on top of it one by one—it will support them. Try pushing down on the books. You will have to push harder than you might think to collapse the cylinder; eventually the paper will crumple.

why it works A cylinder is a very strong shape; it supports weight equally—it has no weakest point. This trick shows that even something as flimsy as a piece of paper can be quite sturdy if it is arranged into the right form. When the cylinder finally does give way, it crumples evenly all around the base because the whole thing fails at once—there is no one weak side that gives way first.

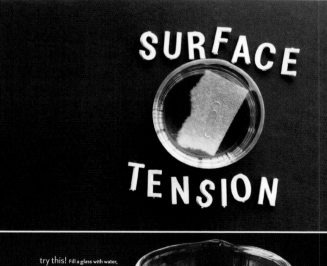

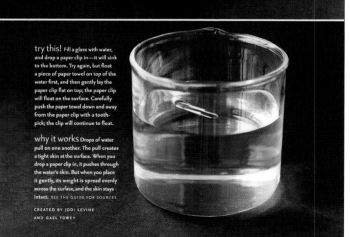

try this! Fill a glass with water, and drop a paper clip in—it will sink to the bottom. Try again, but float a piece of paper towel on top of the water first, and then gently lay the paper clip flat on top; the paper clip will float on the surface. Carefully push the paper towel down and away from the paper clip with a toothpick; the clip will continue to float.

why it works Drops of water pull on one another. The pull creates a tight skin at the surface. When you drop a paper clip in, it pushes through the water's skin. But when you place it gently, its weight is spread evenly across the surface, and the skin stays intact. SEE THE GUIDE FOR SOURCES

CREATED BY JODI LEVINE
AND GAEL TOWEY

328

GAng of Five

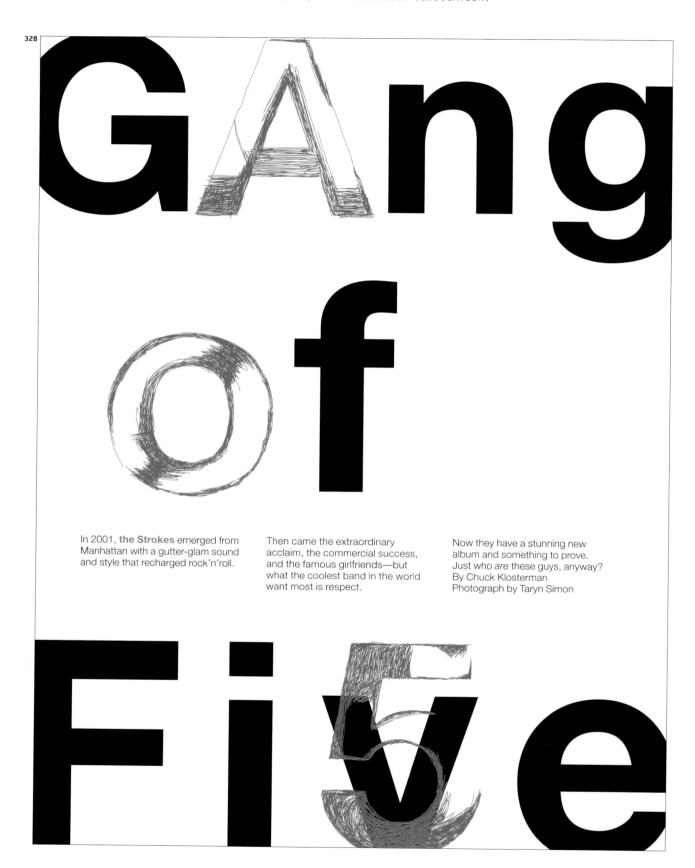

In 2001, **the Strokes** emerged from Manhattan with a gutter-glam sound and style that recharged rock'n'roll.

Then came the extraordinary acclaim, the commercial success, and the famous girlfriends—but what the coolest band in the world want most is respect.

Now they have a stunning new album and something to prove. Just who *are* these guys, anyway? By Chuck Klosterman Photograph by Taryn Simon

328
Publication **Spin**
Design Director **Arem Duplessis**
Art Director **Brandon Kavulla**
Designer **Arem Duplessis**
Photo Editor **Cory Jacobs**
Photographer **Taryn Simon**
Publisher **Vibe/Spin Ventures LLC**
Issue **December 2003**

329
Publication **Spin**
Design Director **Arem Duplessis**
Art Director **Brandon Kavulla**
Designer **Brandon Kavulla**
Photo Editor **Prim Chuensumran**
Publisher **Vibe/Spin Ventures LLC**
Issue **November 2003**

330
Publication **Spin**
Design Director **Arem Duplessis**
Art Director **Brandon Kavulla**
Designers **Arem Duplessis, Brandon Kavulla**
Photo Editor **Cory Jacobs**
Photographer **Tom Schierlitz**
Publisher **Vibe/Spin Ventures LLC**
Issue **September 2003**

329

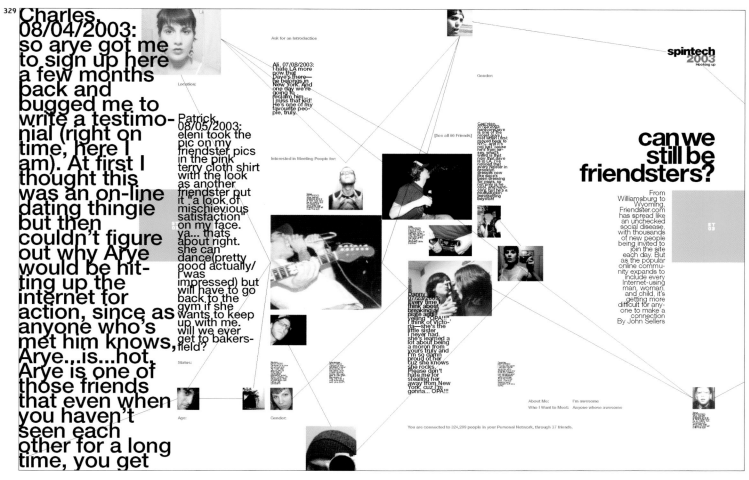

330

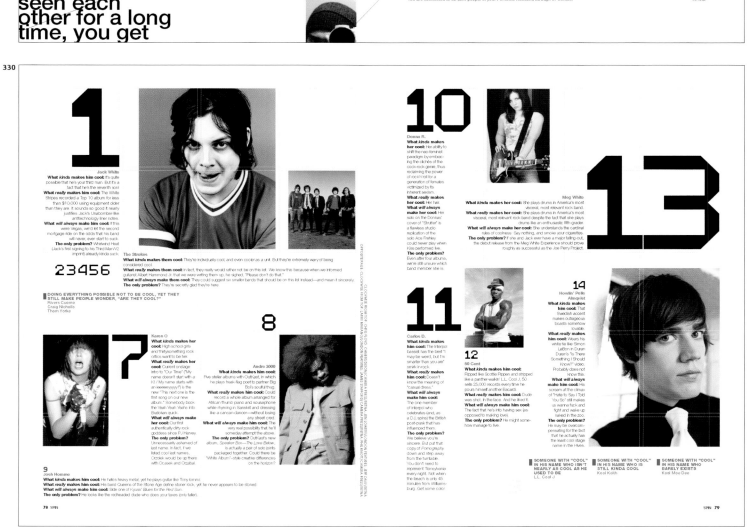

331

THE CONNECTORS

MEET THE HYPERNETWORKED NODES WHO SECRETLY RUN THE WORLD.
BY JEFF HOWE

In 1974, a Harvard sociologist made a seemingly unremarkable discovery. It is, in fact, who you know. His study asked several hundred white-collar workers how they'd landed their jobs. More than half credited a "personal connection." Duh. But then it got interesting: The researcher, Mark Granovetter, dug deeper and discovered that four-fifths of these backdoor hires barely knew their benefactors. As it turns out, close friends are great for road trips, intimate dinners, and the occasional interest-free loan, but they suck for job leads and blind dates – they know the same people you do. In other words, it's not so much who you know, but who you vaguely know. Granovetter called the phenomenon "the strength of weak ties." He had discovered the human node.

In a computer network, a node performs the crucial task of data routing, playing digital matchmaker to packets of information. In a social network, a node is the person whose PDA runneth over with people they met once on an airplane. Nodes host countless dinner parties, leave movie theaters to answer cell phones, and actually enjoy attending conferences. It seems like they know everybody, because they very nearly do – and most important, their connections are from all walks of life, creating a panoply of weak ties. Mensches with an intellectual bent, nodes perform invaluable feats of synthesis, bringing together thinkers, scholars, captains of industry, and the odd professional rugby player, all for the sake of adding new spices to their melting pots. Great books, products, partnerships, and technological innovations form in their chaotic wake, and one could make an argument that they run the world, if only by accident. But chief among the node's attributes is a tendency to stay behind the scenes, which raises an irresistible question: Who are these people, what do they do, and how do they do it? *Wired* combed our corner of the earth to pick the brains of prime specimens.

Jeff Howe (jeff.howe@wiredmag.com) is a contributing editor at Wired. The latest addition to his Rolodex, art powerhouse Takashi Murakami, is profiled on page 180.

THE TECH NODE
Clay Shirky: Consultant, writer, and adjunct professor at NYU's graduate Interactive Telecommunications Program. Node cred: Shirky, 39, is one of the handful of people with justifiable claim to the *digerati* moniker. He's become a consistently prescient voice on networks, social software, and technology's effects on society. He publishes everywhere from the *Harvard Business Review* to *The Wall Street Journal*, but his most influential essays (like last February's "Power Laws, Weblogs, and Inequality") appear on Shirky.com. Operating system: "I like to use email to broker introduction. There are three levels of email introduction: One is when you just provide a party with the other party's info. The second is when you say, 'Yeah, and use my name.' The third is sending email to both, CC'ing them. You have to be careful about which level you use. If you do it right, it's just enough of a spark to get people close." Node wisdom: "The most important person you know is someone you haven't met. There was this urban myth rocketing around the Valley in the '90s that 500 people – certain CEOs and venture capitalists – ran the world. Then Shawn Fanning came along."

174 · 11|2003 · WIRED

332

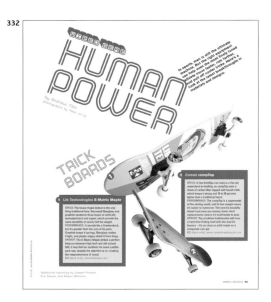

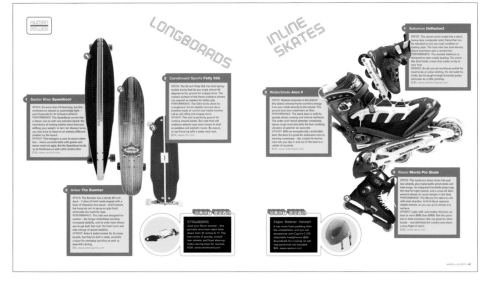

333

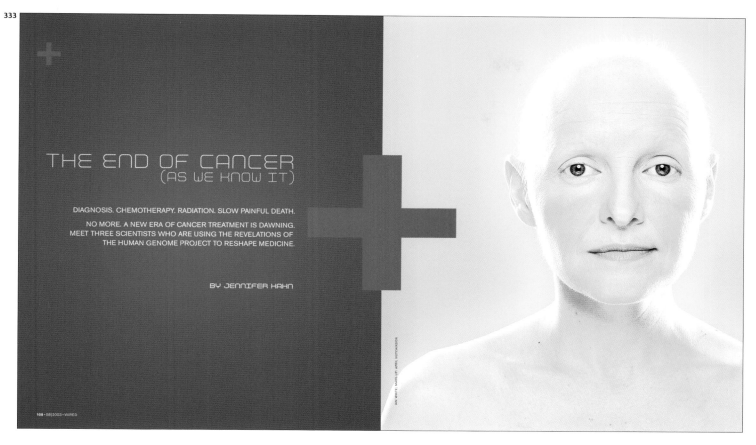

THE END OF CANCER
(AS WE KNOW IT)

DIAGNOSIS. CHEMOTHERAPY. RADIATION. SLOW PAINFUL DEATH.

NO MORE. A NEW ERA OF CANCER TREATMENT IS DAWNING.
MEET THREE SCIENTISTS WHO ARE USING THE REVELATIONS OF
THE HUMAN GENOME PROJECT TO RESHAPE MEDICINE.

BY JENNIFER KAHN

108 · 08|2003 · WIRED

334

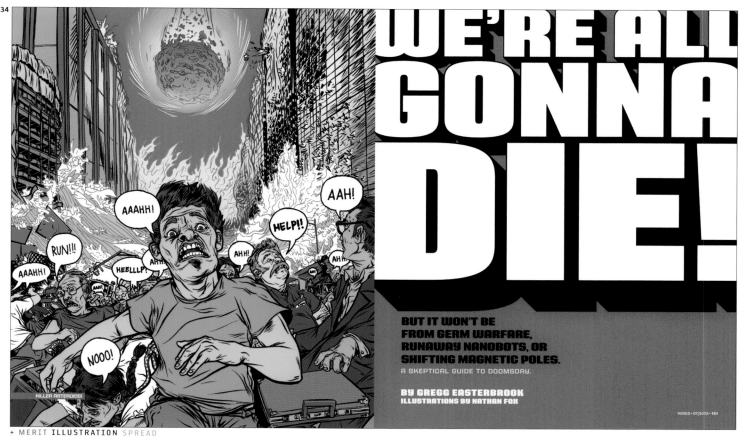

WE'RE ALL GONNA DIE!

BUT IT WON'T BE
FROM GERM WARFARE,
RUNAWAY NANOBOTS, OR
SHIFTING MAGNETIC POLES.
A SKEPTICAL GUIDE TO DOOMSDAY.

BY GREGG EASTERBROOK
ILLUSTRATIONS BY NATHAN FOX

WIRED · 07|2003 · 151

+ MERIT ILLUSTRATION SPREAD

335

SUPER PRODUCERS

THEY'RE **REINVENTING** THE **SOUND** OF MUSIC. AND THE MUSIC **INDUSTRY.**

THE NEPTUNES
NIGEL GODRICH
THE MATRIX
TIMBALAND
DFA
DAN THE AUTOMATOR
FELIX DA HOUSECAT
BUTCH VIG

126 · 10|2003 · WIRED

Producers used to live on the B-side of the music business: behind the scenes. They were **masters** of the **mixes** that pushed **pop songs up the charts,** but still slaves to the rhythms of record labels and fickle divas. Yet, while file-sharing hogs the headlines in music's digital evolution, there's been a quiet revolution in the studio, where the music gets made. ▶ The tools of professional sound production keep getting faster, cheaper, and smaller. The time-honored, king-sized mixing station is now a luxury item reserved for sonic chauvinists, and even the industry-standard Pro Tools is getting squeezed from below by pure desktop systems. As youngblood and old-school producers alike are finding out, the new technology means **creative freedom,** a chance to dance to the beat of a different drum machine, to sample sounds from around the world and back through time. ▶ Now the production wizards themselves are rising up from the digital **underground,** armed with unlimited content and unprecedented control. Their trademark styles attract a growing parade of pop singers eager for a piece of the new sound. And so a generation is stepping out of the shadows to rule the record industry: They're hitmakers and powerbrokers, and their names have moved from the liner notes to the front of their own albums. They're the new rock stars. Meet the Superproducers.

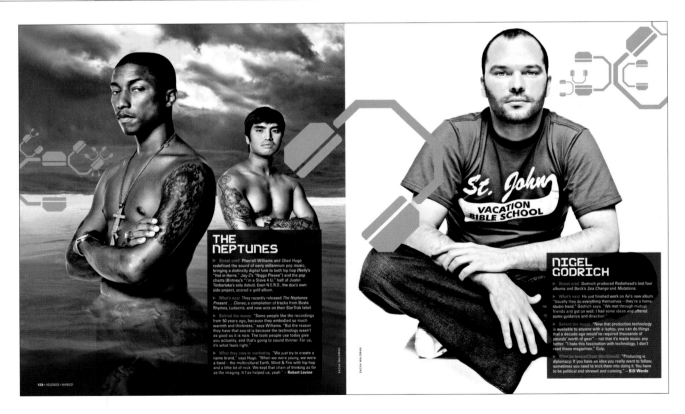

THE NEPTUNES

▶ **Street cred:** Pharrell Williams and Chad Hugo redefined the sound of early millennium pop music, bringing a distinctly digital funk to both hip hop (Nelly's "Hot in Herre," Jay-Z's "Nigga Please") and the pop charts (Britney's "I'm a Slave 4 U," half of Justin Timberlake's solo debut). Even N.E.R.D., the duo's own side project, scored a gold album.

▶ **What's next:** They recently released *The Neptunes Present... Clones,* a compilation of tracks from Busta Rhymes, Ludacris, and new acts on their StarTrak label.

▶ **Behind the music:** "Some people like the recordings from 50 years ago, because they embodied so much warmth and thickness," says Williams. "But the reason they have that sound is because the technology wasn't as good as it is now. The tools people use today give you actuality, and that's going to sound thinner. For us, it's what feels right."

▶ **What they owe to marketing:** "We just try to create a name brand," says Hugo. "When we were young, we were a band – the multicultural Earth, Wind & Fire with hip hop and a little bit of rock. We kept that chain of thinking as far as the imaging. It has helped us, yeah." – **Robert Levine**

126 · 10|2003 · WIRED

NIGEL GODRICH

▶ **Street cred:** Godrich produced Radiohead's last four albums and Beck's *Sea Change* and *Mutations.*

▶ **What's next:** He just finished work on Air's new album. "Usually they do everything themselves – they're a home-studio band," Godrich says. "We met through mutual friends and got on well. I had some ideas and offered some guidance and direction."

▶ **Behind the music:** "Now that production technology is available to anyone with a laptop, you can do things that a decade ago would've required thousands of pounds' worth of gear" – not that it's made music any better. "I hate this fascination with technology. I don't read those magazines." Gulp.

▶ **What he learned from Machiavelli:** "Producing is diplomacy. If you have an idea you really want to follow, sometimes you need to trick them into doing it. You have to be political and shrewd and cunning." – **Bill Werde**

335
Publication **Wired**
Creative Director **Darrin Perry**
Design Director **Susana Rodriguez deTembleque**
Designer **Ryan Hicks**
Illustrator **Ezra Eismont**
Photo Editor **Brenna Britton**
Photographers **Sacha Waldman, Ian White, F. Scott Schafer, Mike Ruiz, Jasper James**
Publisher **Condé Nast Publications Inc.**
Issue **October 2003**

336
Publication **Wired**
Creative Director **Darrin Perry**
Design Director **Susana Rodriguez deTembleque**
Designer **Darrin Perry**
Photo Editor **Carolyn Rauch**
Photographer **David Clugston**
Publisher **Condé Nast Publications Inc.**
Issue **October 2003**

Extreme Makeover

PCs ARE A MARVEL OF ENGINEERING ON THE INSIDE. The shell of a garden-variety desktop machine, on the other hand, is as dull as a command prompt. Users longing for a box whose beauty is more than CPU-deep have invented a new form of self-expression: casemodding – altering a PC's exterior to make it as distinctive as its owner. Think of it as nerd folk art, equal parts Linus Torvalds and Martha Stewart. Modders don't just dress up stock boxes. They stuff motherboards into gasoline cans, build containers that resemble gingerbread houses, and custom-fabricate phantasmagoric adornments; they combine expert craftsmanship with whimsy, nostalgia, and a *Transformers*-inspired sensawunda. **IT'S A MOD, MOD, MOD, MOD WORLD.**

by Cory Doctorow

photographs by David Clugston

BUBBACOMP

MODDER: Jeff Dyer
Radio personality, CJYM/CFYM
Rosetown, Saskatchewan
SPECS: 933 MHz VIA C3
(x86-compatible CPU), 256 Mbytes
RAM, 10-Gbyte hard disk
COST: $50 in kegs, LEDs, and
Plexiglas; $250 in computer
components
TIME: 30 hours over two months
INSPIRATION: "I wanted to use a
mini-ITX board I had lying around,
and I needed something compact
and cheap to put it in. Being from
a small Canadian town, I thought
of Molson's Bubba beer keg."
CHALLENGE: "Power, heat, and
attention to detail. I had to measure
out exactly how all the ports and
cuts lined up."

AMD BIG BLOCK

MODDER: Rainer Wingender
Manager, BITS-Consulting
Siegenburg, Germany
SPECS: left side: 1.8-GHz AMD XP
Thoroughbred 2200, 512 Mbytes RAM,
Nvidia GeForce4 graphics card, 110-
Gbyte hard disk, DVD-ROM; right side:
450-MHz AMD K6-2, 256 Mbytes RAM,
44xCD, CD-RW, 40-Gbyte hard disk.
COST: $1,000 in cooling plates,
exhaust, intakes, and gauges; $2,000
in computer components
TIME: 250 hours over three months
INSPIRATION: "A 1971 Ford Mustang
I owned when I was 18. If you've ever
driven a V-8, you know the feeling."
CHALLENGE: "Designing good-looking
feet. Early tries seemed too small, but
when I added the punched bars, it
balanced just right visually."

Cory Doctorow (cory@craphound.com), coeditor of boingboing.net, wrote about overclockers in Wired 11.03.

ALIEN

MODDER: Paul Capello
Web designer
Brooklyn, New York
SPECS: 2.2-GHz AMD Athlon
(overclocked to 2.4 GHz), 1 Gbyte
RAM, 240-Gbyte hard disk, Nvidia
GeForce FX 5600 graphics card
COST: $400 in model kit parts,
auto body filler, and knickknacks;
$1,800 in computer components
TIME: 80 hours over 10 weeks
INSPIRATION: "The events of 9/11.
I live near the towers, and I witnessed
the incident. Building this case was
mental hygiene. And it's a tribute to
more innocent times, to movies I saw
as a child, like *Star Wars* and *Alien*."
CHALLENGE: "Airbrushing the patina
to the point where I was happy with
the colors and reflections."

"**Building this case was mental hygiene.**"

PITFALL PROJECT

MODDER: Kermit Woodall
Special-effects software developer,
Nova Design
Richmond, Virginia
SPECS: 800-MHz VIA C3, 256 Mbytes
RAM, 6-Gbyte hard disk, SlimDVD
COST: $20 for six Atari 2600 cases
("I bought them in bulk – I might
make more"); $430 in computer
components
TIME: 300 hours over four months
INSPIRATION: "After turning an Amiga
1000 into a Windows computer, I was
looking for something more challeng-
ing. The guts ran an Atari emulator!"
CHALLENGE: "Making it appear, at
first glance, to be unmodified. The
the most dramatic changes are in
the back, but the SlimDVD is hidden
under the 2600's front lip."

"**It took me 300 hours over four months.**"

337

338

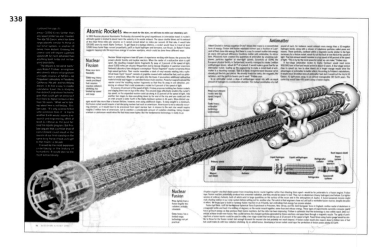

339

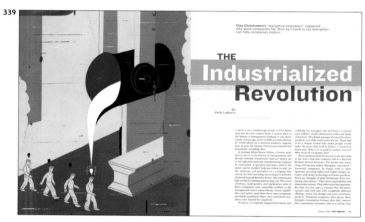

340

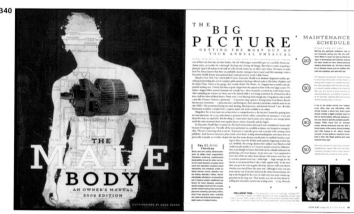

341

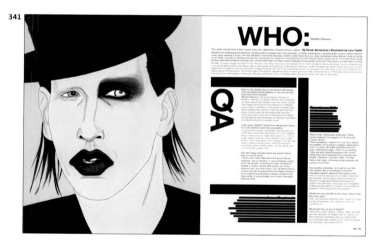

342

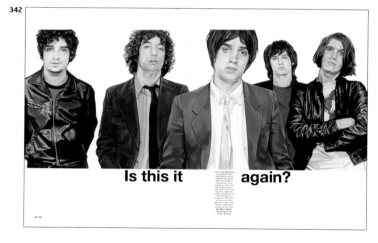

337
Publication **Discover**
Design Director **Michael Mrak**
Art Director **John Seeger Gilman**
Designer **Michael Mrak**
Illustrator **Don Foley**
Publisher **Disney Publishing Worldwide**
Issue **September 2003**

340
Publication **Men's Journal**
Design Director **Michael Lawton**
Designer **Chris MacManus**
Illustrator **Doug Hoang**
Photo Editor **Allyson Torrisi**
Publisher **Wenner Media LLC**
Issue **January 2003**

338
Publication **Discover**
Design Director **Michael Mrak**
Art Director **John Seeger Gilman**
Designer **Michael Mrak**
Illustrator **Don Foley**
Publisher **Disney Publishing Worldwide**
Issue **August 2003**

341
Publication **Spin**
Design Director **Arem Duplessis**
Art Director **Brandon Kavulla**
Designers **Maili Holiman, Alexander Chow**
Illustrator **Lara Tomlin**
Publisher **Vibe/Spin Ventures LLC**
Issue **June 2003**

339
Publication **Fast Company**
Art Director **Dean Markadakis**
Designer **Lisa Kelsey**
Illustrator **Brian Cronin**
Publisher **Gruner & Jahr USA Publishing**
Issue **November 2003**

342
Publication **Spin**
Design Director **Arem Duplessis**
Art Director **Brandon Kavulla**
Designer **Maili Holiman**
Illustrator **Chris Kasch**
Publisher **Vibe/Spin Ventures LLC**
Issue **November 2003**

343

344

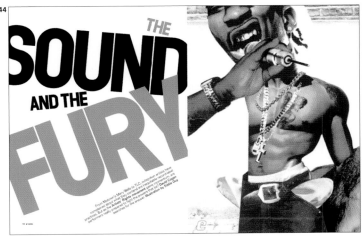

345

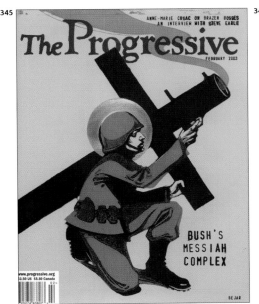

346

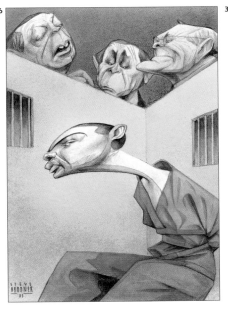

347

343
Publication **Vibe**
Design Director **Florian Bachleda**
Designer **Alice Alves**
Illustrator **David Cowles**
Publisher **Vibe/Spin Ventures**
Issue **August 2003**

344
Publication **Vibe**
Design Director **Florian Bachleda**
Designer **Alice Alves**
Illustrator **Eddie Guy**
Publisher **Vibe/Spin Ventures**
Issue **May 2003**

345
Publication **The Progressive**
Art Director **Nick Jehlen**
Illustrator **Daniel Bejar**
Client **The Progressive**
Issue **February 2003**

346
Publication **The New Yorker**
Art Director **Caroline Mailhot**
Illustrator **Steve Brodner**
Illustration Editor **Chris Curry**
Publisher **Condé Nast Publications Inc.**
Issue **March 10, 2003**

347
Publication **Food & Wine**
Creative Director **Stephen Scoble**
Art Director **Patricia Sanchez**
Illustrator **Stina Wirsén**
Photo Editor **Fredrika Stjarne**
Publisher **American Express Publishing Co.**
Issue **January 2003**

348

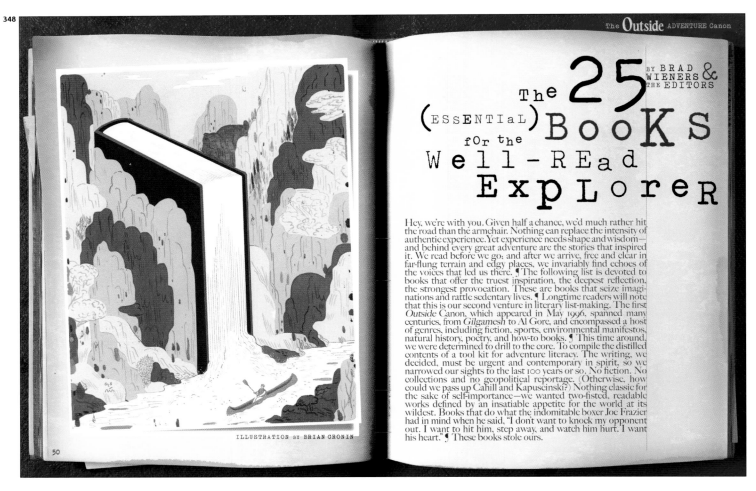

349

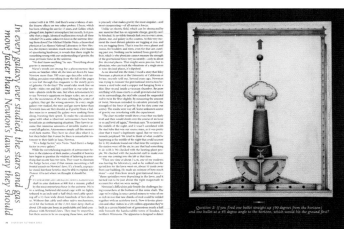

348
Publication **Outside**
Creative Director **Hannah McCaughey**
Designers **Hannah McCaughey, Marshall McKinney, Sue Boylan, Jana Meier**
Illustrator **Brian Cronin**
Publisher **Mariah Media, Inc.**
Issue **January 2003**

349
Publication **Discover**
Design Director **Michael Mrak**
Art Director **John Seeger Gilman**
Photo Editor **Maisie Todd**
Photographer **Dan Winters**
Publisher **Disney Publishing Worldwide**
Issue **October 2003**

350
Publication **Vibe**
Design Director **Florian Bachleda**
Art Director **Wyatt Mitchell**
Designers **Alice Alves, Michael Friel**
Illustrators **Dynamic Duo, Johanna Goodman, Mark Ulriksen, Edel Rodriguez, Bob Eckstein, David Cowles, Gary Panter, Lyle Monroe, Paul Corio**
Publisher **Vibe/Spin Ventures**
Issue **August 2003**

LARGER THAN LIFE

Elephant Man's live performances are among the greatest shows on earth. His 45s dominate dancehall playlists, and now he's got a big-budget video to go along with his outrageous hairstyles. **Rob Kenner** tracks the self-anointed Energy God as he elevates to new heights.

Illustration by **LYLE MONROE**
AFTER VINCENT VAN GOGH

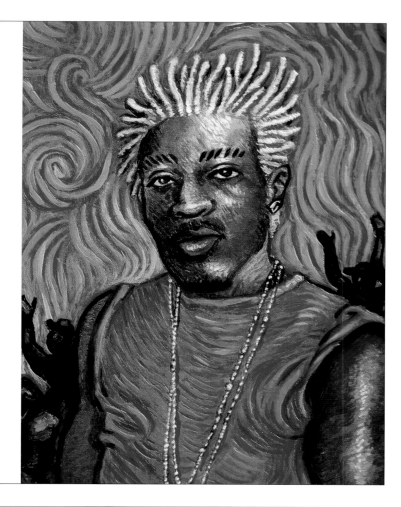

JOY AND PAIN

Death, drugs, and destruction: **Keith Murray** confronts the man in the mirror and explains how he's trying to turn an anguished past into the most beautifullest thing in this world. **Adam Matthews** catches the rapper's reflection.

Illustration by **GARY PANTER**
AFTER JEAN-MICHEL BASQUIAT

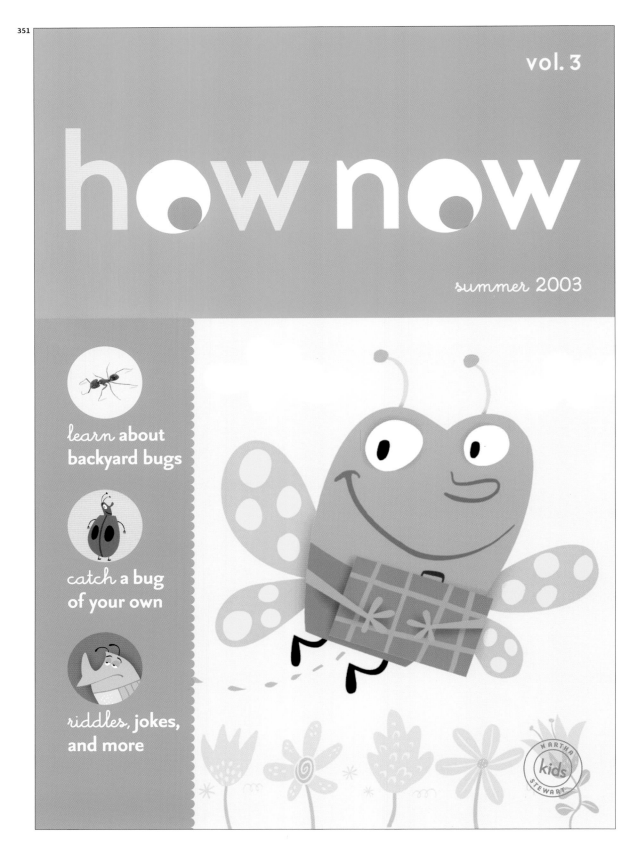

351
Publication **Martha Stewart Kids**
Creative Director **Gael Towey**
Design Director **Deb Bishop**
Illustrator **David Sheldon**
Photo Editors **Stacie McCormick,**
Jamie Bass Perrotta
Photographers **Victor Schrager, Annie Schlechter**
Stylist **Shannon Carter**
Publisher **Martha Stewart Living Omnimedia**
Issue **Summer 2003**

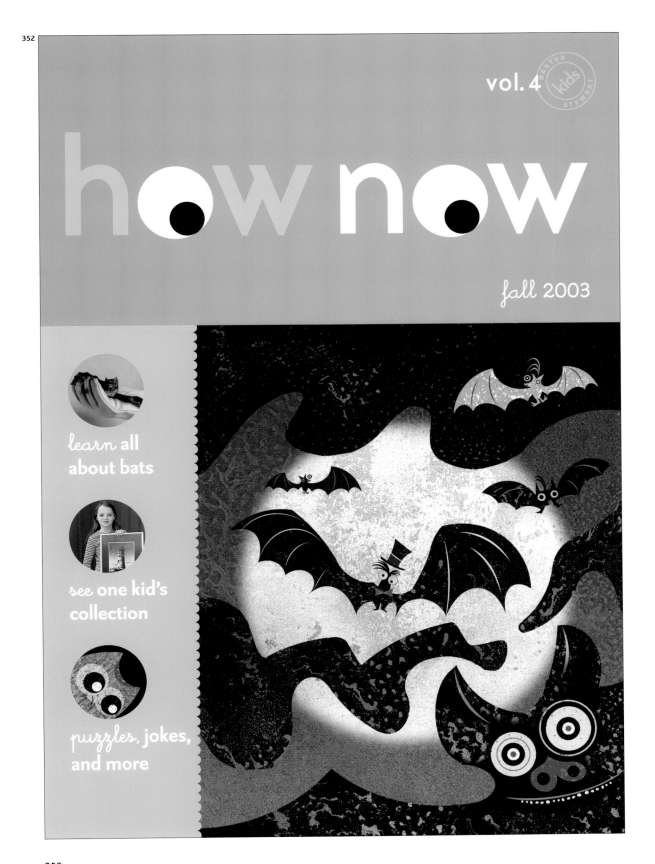

352
Publication **Martha Stewart Kids**
Creative Director **Gael Towey**
Design Director **Deb Bishop**
Art Director **Jennifer Wagner**
Illustrator **Lane Smith**
Photo Editors **Stacie McCormick, Jamie Bass Perrotta**
Photographers **Victor Schrager, Formula Z/S**
Stylist **Charlyne Mattox**
Publisher **Martha Stewart Living Omnimedia**
Issue **Fall 2003**

353

Illustrations by **LANE SMITH**

start

THIS BOOK
belongs to

Find your way through
this maze, between the
slithering snakes, from
spooky start to eerie end.

end

answer on page 80

up all night

Night is a time of stillness and quiet. But while you sleep,
some animals are at their busiest. They are nocturnal, which
means they are active at night. Mice like darkness because
it's hard for hungry predators to see them. How do creatures
find their way after dark? Owls have keen eyes and ears,
and foxes use their noses. What do bats do? Turn the page.

67

354

Illustrations by **DAVID SHELDON**

This Book
belongs to

Each of these silly bugs
leaves behind a differ-
ent pattern of colored
dots as it walks. Can
you tell which color is
missing from each bug's
path? answer on page 72

bug travel

Here are a few of the ways that bugs get around.
❋ Gray processionary caterpillars creep in single file, like
a little freight train, when they're looking for food.
❋ Monarch butterflies fly up to 3,000 miles in a single trip,
heading south in the fall and returning north in the spring.
❋ Slugs glide by secreting slime that helps them move.
❋ Black cutworm moths get swept up by storm fronts, which
can carry them hundreds of miles.
❋ Lice don't move much, but they can cover great distances
because they "hitchhike" rides on people and animals.

353
Publication **Martha Stewart Kids**
Creative Director **Gael Towey**
Design Director **Deb Bishop**
Art Director **Jennifer Wagner**
Illustrator **Lane Smith**
Photo Editors **Stacie McCormick, Jamie Bass Perrotta**
Photographers **Victor Schrager, Formula Z/S**
Publisher **Martha Stewart Living Omnimedia**
Issue **Fall 2003**

354
Publication **Martha Stewart Kids**
Creative Director **Gael Towey**
Design Director **Deb Bishop**
Illustrator **David Sheldon**
Photo Editors **Stacie McCormick, Jamie Bass Perrotta**
Photographers **Victor Schrager, Annie Schlechter**
Publisher **Martha Stewart Living Omnimedia**
Issue **Summer 2003**

355
Publication **Martha Stewart Kids**
Creative Director **Gael Towey**
Design Director **Deb Bishop**
Art Director **Jennifer Wagner**
Illustrator **Greg Clarke**
Photo Editors **Stacie McCormick, Jamie Bass Perrotta**
Photographers **Victor Schrager, Laura Stojanovic**
Publisher **Martha Stewart Living Omnimedia**
Issue **Winter/Spring 2003**

355

This Book BELONGS TO:

all four chocolates line up (down or across) in only one place. Where? answer on page 72

illustrations by **GREG CLARKE**

chocolate

Many things we love to eat are a balance of flavors that aren't so good on their own. Chocolate comes from a bean that is very bitter, like coffee. The first chocolate lovers made the bean into a strong, frothy drink that they gulped down quickly. Now, lots of sugar, milk, and cocoa butter are used to make a smooth, delicious (and barely bitter) chocolate bar.

JOKES AND RIDDLES!

what happened to the sharks who met on valentine's day?

it was love at first bite

what button does a bear use most on a vcr remote?

paws

why can't the groundhog be sure if there will be six more weeks of winter?

he always has a shadow of a doubt

what sounds does a canary make if you feed it cocoa?

chocolate cheeps

what happens when you step over a valentine's card?

you cross your heart

why didn't the restaurant let the cub in?

he had bear feet

"forward, march!"

why wasn't goldilocks scared when she saw baby bear's backside?

it was just a furry tail

what did the parade leader say at the end of February?

the top den list

why did the kid put a jalapeño pepper on his candy bar?

he wanted hot chocolate

what do you call a directory of the best bears' houses?

61

356

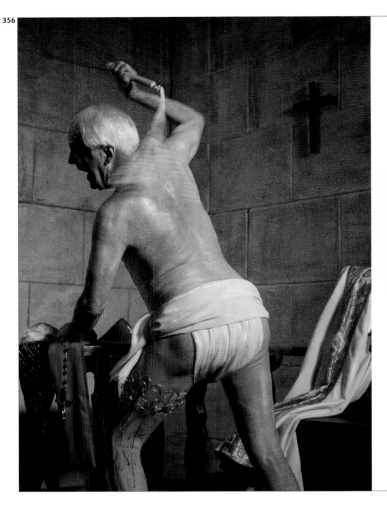

Thank you Lord may I have another?

As the controversy over Mel Gibson's *The Passion of Christ* rages on and the pope withers, a new breed of rigid, right-wing Catholicism is catching fire. Among the most powerful sects is Opus Dei, the secretive group at the center of the best-selling novel *The Da Vinci Code*. Why are so many influential Americans signing on, and what's with the whips? *by* CRAIG OFFMAN

Photo illustration by MICHAEL ELINS DECEMBER 2003 GQ 271

357

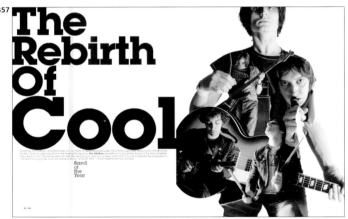

The Rebirth Of Cool

Band of the Year

358

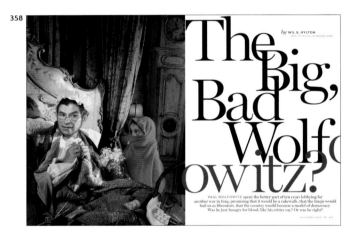

by WIL S. HYLTON

The Big, Bad Wolfowitz?

PAUL WOLFOWITZ spent the better part of ten years lobbying for another war in Iraq, promising that it would be a cakewalk, that the Iraqis would hail us as liberators, that the country would become a model of democracy. Was he just hungry for blood, like his critics say? Or was he right?

356
Publication **GQ**
Design Director **Fred Woodward**
Art Director **Matthew Lenning**
Photo Editor **Jennifer Crandall**
Photographer **Michael Elins**
Publisher **Condé Nast Publications Inc.**
Issue **December 2003**

357
Publication **Spin**
Design Director **Arem Duplessis**
Designer **Arem Duplessis**
Photo Editor **Cory Jacobs**
Photographer **Phil Poynter**
Publisher **Vibe/Spin Ventures LLC**
Issue **January 2003**

359
Publication **Esquire**
Design Director **John Korpics**
Designer **Chris Martinez**
Illustrator **Matt Mahurin**
Publisher **The Hearst Corporation-Magazines Division**
Issue **May 2003**

358
Publication **GQ**
Design Director **Fred Woodward**
Designer **Matthew Lenning**
Photo Editor **Jennifer Crandall**
Photographer **Michael Elins**
Publisher **Condé Nast Publications Inc.**
Issue **November 2003**

360
Publication **Wired**
Creative Director **Darrin Perry**
Design Director **Susana Rodriguez deTembleque**
Designer **Federico Gutierrez Schott**
Photo Editor **Brenna Britton**
Photographers **Sacha Waldman, Todd Eberle**
Publisher **Condé Nast Publications Inc.**
Issue **January 2003**

359

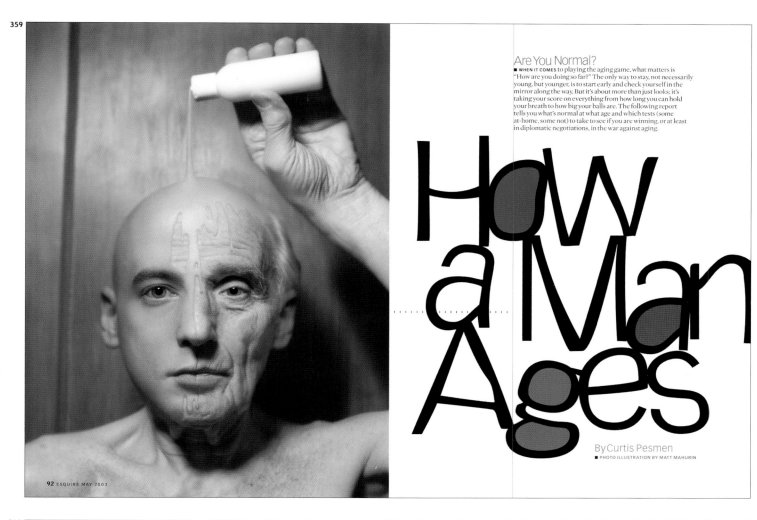

Are You Normal?
■ **WHEN IT COMES** to playing the aging game, what matters is "How are you doing so far?" The only way to stay, not necessarily young, but younger, is to start early and check yourself in the mirror along the way. But it's about more than just looks; it's taking your score on everything from how long you can hold your breath to how big your balls are. The following report tells you what's normal at what age and which tests (some at-home, some not) to take to see if you are winning, or at least in diplomatic negotiations, in the war against aging.

How a Man Ages

By Curtis Pesmen

■ PHOTO ILLUSTRATION BY MATT MAHURIN

92 ESQUIRE MAY 2003

360

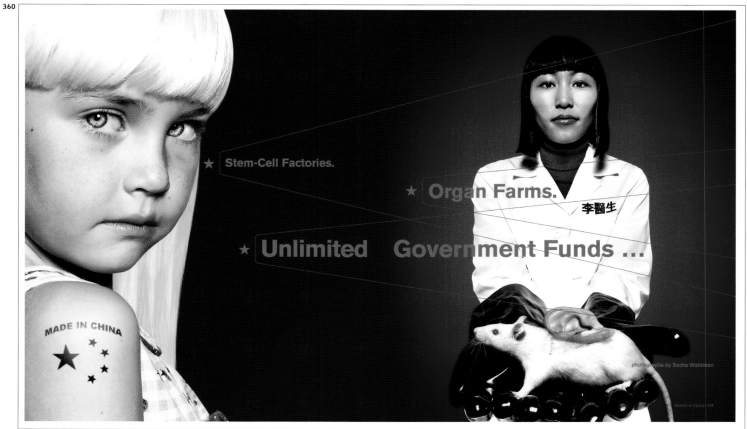

★ Stem-Cell Factories.

★ Organ Farms.

李醫生

★ Unlimited Government Funds ...

photographs by Sacha Waldman

361

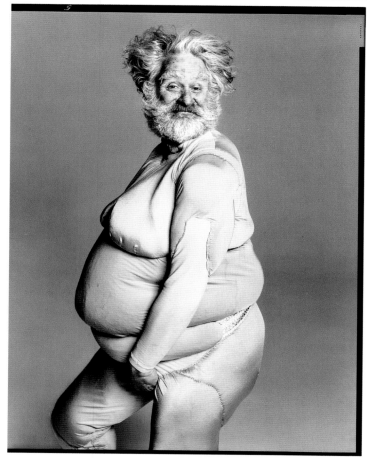

361
Publication **The New Yorker**
Visuals Editor **Elisabeth Biondi**
Photo Editor **Natasha Lunn**
Photographer **Richard Avedon**
Publisher **Condé Nast Publications Inc.**
Issue **December 1, 2003**

362
Publication **The New Yorker**
Visuals Editor **Elisabeth Biondi**
Photo Editor **Natasha Lunn**
Photographer **Ruven Afanador**
Publisher **Condé Nast Publications Inc.**
Issue **October 20, 2003**

363
Publication **The New Yorker**
Visuals Editor **Elisabeth Biondi**
Photo Editor **Natasha Lunn**
Photographer **Richard Avedon**
Publisher **Condé Nast Publications Inc.**
Issue **September 8, 2003**

364
Publication **Premiere**
Art Director **Richard Baker**
Designer **David Schlow**
Photo Editor **Catriona NiAolain**
Photographer **Norman Jean Roy**
Publisher **Hachette Filipacchi Media U.S.**
Issue **March 2003**

365
Publication **Premiere**
Art Director **Richard Baker**
Designer **David Schlow**
Photo Editors **Catriona NiAolain, Linda Liang**
Photographer **Brigitte Lacombe**
Publisher **Hachette Filipacchi Media U.S.**
Issue **December 2003**

366
Publication **Vibe**
Design Director **Florian Bachleda**
Designer **Alice Alves**
Photo Editors **George Pitts, Dora Somosi**
Photographer **Kwaku Alston**
Publisher **Vibe/Spin Ventures**
Issue **April 2003**

364

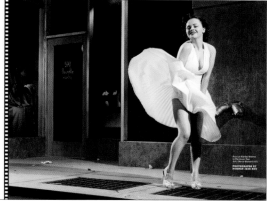

365

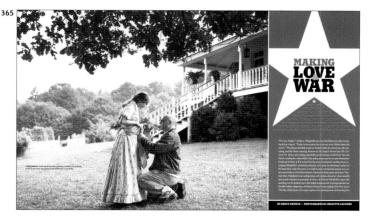

366

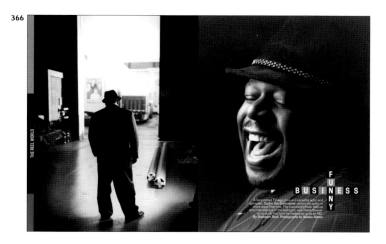

367

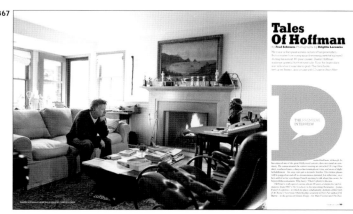

368

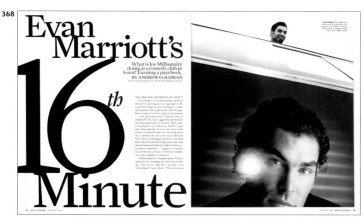

369

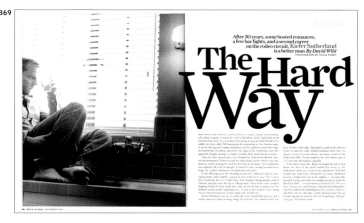

370

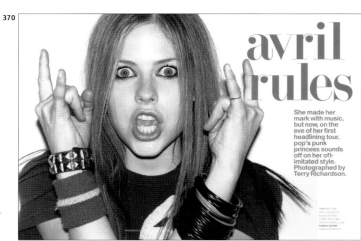

367
Publication **Premiere**
Art Director **Richard Baker**
Designer **Richard Baker**
Photo Editor **Catriona NiAolain**
Photographer **Brigitte Lacombe**
Publisher **Hachette Filipacchi Media U.S.**
Issue **June 2003**

369
Publication **Men's Journal**
Art Director **Deanna Lowe**
Designer **Deanna Lowe**
Photo Editor **Allyson Torrisi**
Photographer **Nigel Parry**
Publisher **Wenner Media LLC**
Issue **September 2003**

368
Publication **Men's Journal**
Art Director **Deanna Lowe**
Designer **Deanna Lowe**
Photo Editor **Allyson Torrisi**
Photographer **Jeff Mermelstein**
Publisher **Wenner Media LLC**
Issue **August 2003**

370
Publication **Teen Vogue**
Art Director **Lina Kutsovskaya**
Designers **James Casey, Jason Engdahl,
Holly Stevenson, Emily Wardwell**
Photo Editor **Lucy Lee**
Photographer **Terry Richardson**
Publisher **Condé Nast Publications Inc.**
Issue **April/May 2003**

371

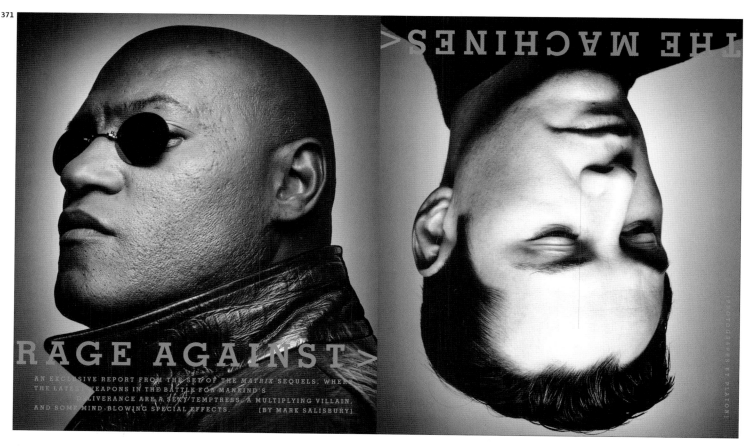

RAGE AGAINST>

THE MACHINES>

AN EXCLUSIVE REPORT FROM THE SET OF THE MATRIX SEQUELS, WHERE
THE LATEST WEAPONS IN THE BATTLE FOR MANKIND'S
DELIVERANCE ARE A SEXY TEMPTRESS, A MULTIPLYING VILLAIN,
AND SOME MIND-BLOWING SPECIAL EFFECTS. [BY MARK SALISBURY]

372

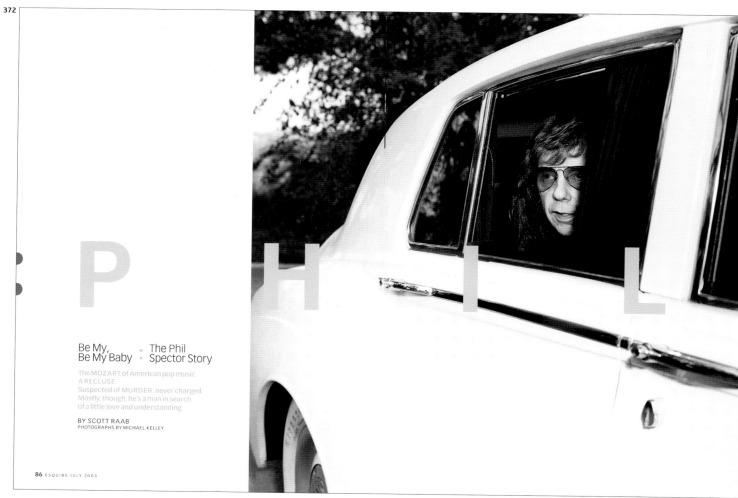

P H I L L

Be My, • The Phil
Be My Baby • Spector Story

The MOZART of American pop music.
A RECLUSE.
Suspected of MURDER, never charged.
Mostly, though, he's a man in search
of a little love and understanding.

BY SCOTT RAAB
PHOTOGRAPHS BY MICHAEL KELLEY

86 ESQUIRE JULY 2003

373

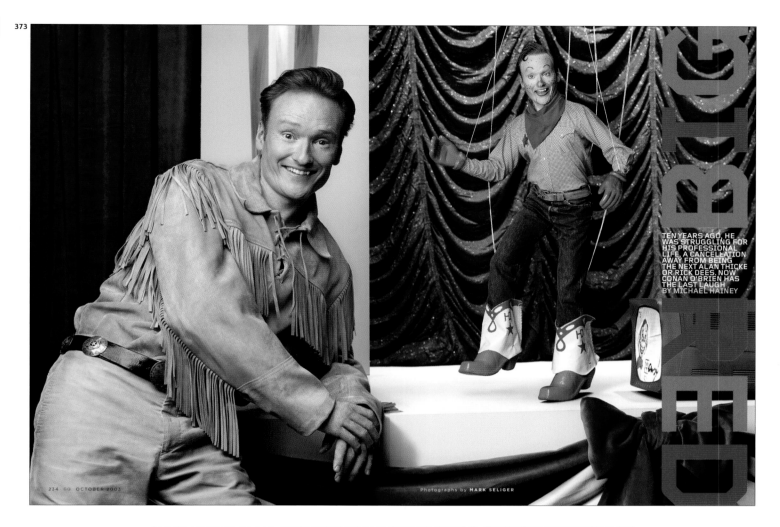

TEN YEARS AGO, HE WAS STRUGGLING FOR HIS PROFESSIONAL LIFE, A CANCELLATION AWAY FROM BEING THE NEXT ALAN THICKE OR RICK DEES. NOW CONAN O'BRIEN HAS THE LAST LAUGH
BY MICHAEL HAINEY

Photographs by **MARK SELIGER**

234 GQ OCTOBER 2003

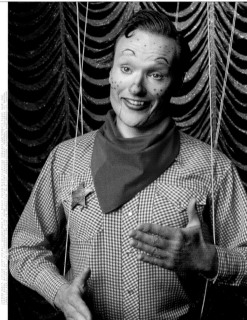

"Sometimes I have a dream where Letterman steals my penis and says, 'You'll never make it, kid.' But I don't know what that means."

236 GQ OCTOBER 2003

371
Publication **Premiere**
Art Director **Richard Baker**
Designer **David Schlow**
Photo Editor **Catriona NiAolain**
Photographer **Platon**
Publisher **Hachette Filipacchi Media U.S.**
Issue **May 2003**

372
Publication **Esquire**
Design Director **John Korpics**
Designer **Chris Martinez**
Photo Editor **Nancy Jo Iacoi**
Photographer **Michael Kelly**
Publisher **The Hearst Corporation-Magazines Division**
Issue **July 2003**

373
Publication **GQ**
Design Director **Fred Woodward**
Designer **Ken DeLago**
Photo Editor **Jennifer Crandall**
Photographer **Mark Seliger**
Publisher **Condé Nast Publications Inc.**
Issue **October 2003**

374

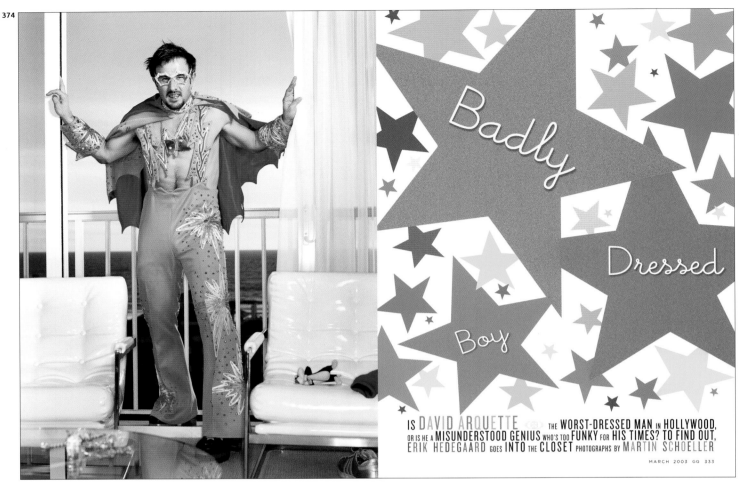

IS DAVID ARQUETTE THE WORST-DRESSED MAN IN HOLLYWOOD, OR IS HE A MISUNDERSTOOD GENIUS WHO'S TOO FUNKY FOR HIS TIMES? TO FIND OUT, ERIK HEDEGAARD GOES INTO THE CLOSET PHOTOGRAPHS BY MARTIN SCHOELLER

MARCH 2003 GQ 333

375

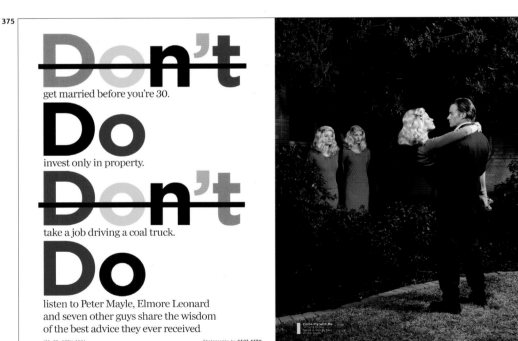

Don't get married before you're 30.

Do invest only in property.

Don't take a job driving a coal truck.

Do listen to Peter Mayle, Elmore Leonard and seven other guys share the wisdom of the best advice they ever received

172 GQ APRIL 2003

Photographs by GEOF KERN

374
Publication **GQ**
Design Director **Fred Woodward**
Designer **Matthew Lenning**
Photo Editors **Jennifer Crandall, Michael Norseng**
Photographer **Martin Schoeller**
Publisher **Condé Nast Publications Inc.**
Issue **March 2003**

375
Publication **GQ**
Design Director **Fred Woodward**
Designer **Ken DeLago**
Photo Editors **Jennifer Crandall, Catherine Talese**
Photographer **Geof Kern**
Publisher **Condé Nast Publications Inc.**
Issue **April 2003**

376
Publication **GQ**
Design Director **Fred Woodward**
Designer **Ken DeLago**
Photo Editor **Jennifer Crandall**
Photographer **Michael Thompson**
Publisher **Condé Nast Publications Inc.**
Issue **December 2003**

✱ In Quentin Tarantino's whacked-out chop-socky homage, Uma Thurman is an ass-kicking, sword-wielding, limb-lopping assassin. In life she's a mythic beauty and a fearless mother of two. Now, ask yourself:

by
Brian Raftery

photographs by
Michael Thompson

Would you cheat on this woman?

210
DECEMBER 2003

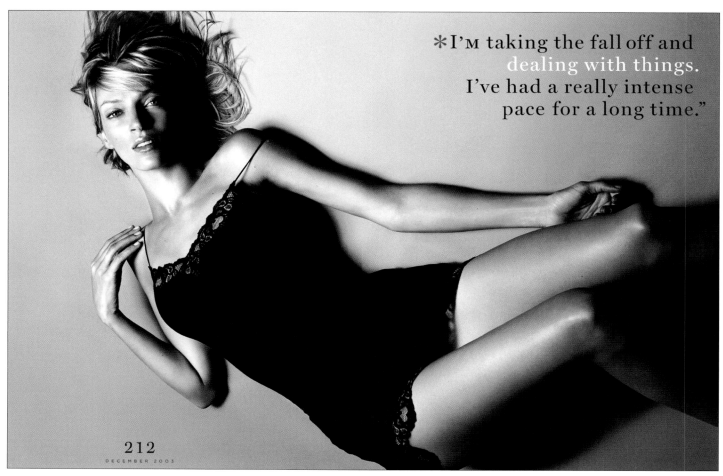

✱ I'm taking the fall off and dealing with things. I've had a really intense pace for a long time."

212
DECEMBER 2003

377

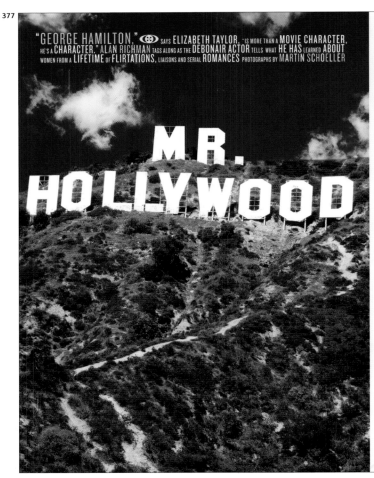

"GEORGE HAMILTON," SAYS ELIZABETH TAYLOR, "IS MORE THAN A MOVIE CHARACTER, HE'S A CHARACTER." ALAN RICHMAN TAGS ALONG AS THE DEBONAIR ACTOR TELLS WHAT HE HAS LEARNED ABOUT WOMEN FROM A LIFETIME OF FLIRTATIONS, LIAISONS AND SERIAL ROMANCES PHOTOGRAPHS BY MARTIN SCHOELLER

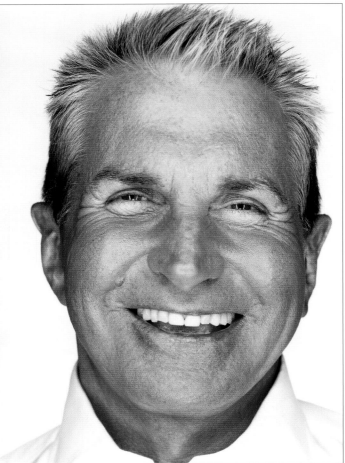

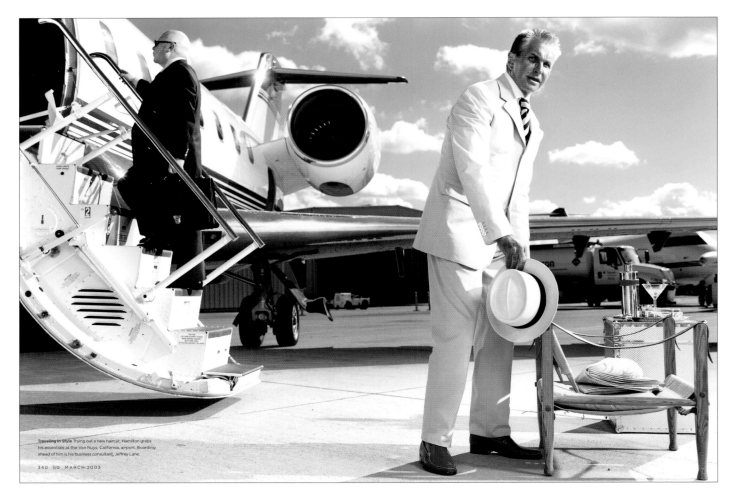

Traveling in Style Trying out a new haircut, Hamilton grabs his essentials at the Van Nuys, California, airport. Boarding ahead of him is his business consultant, Jeffrey Lane.

340 GQ MARCH 2003

378

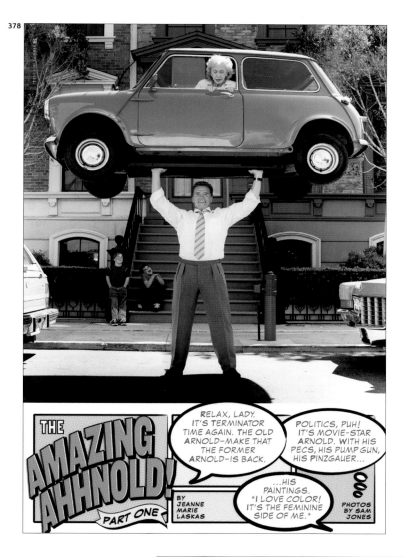

379

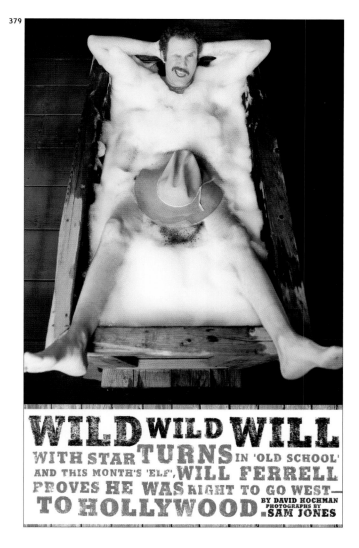

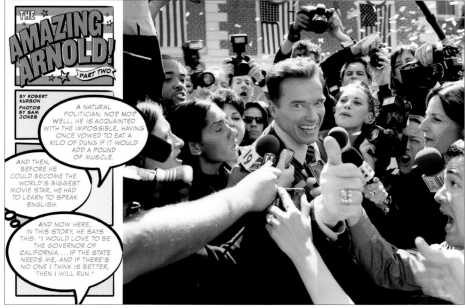

377
Publication **GQ**
Design Director **Fred Woodward**
Designer **Ken DeLago**
Photo Editors **Jennifer Crandall, Catherine Talese**
Photographer **Martin Schoeller**
Publisher **Condé Nast Publications Inc.**
Issue **March 2003**

378
Publication **Esquire**
Design Director **John Korpics**
Photo Editor **Nancy Jo Iacoi**
Photographers **Sam Jones**
Publisher **The Hearst Corporation-Magazines Division**
Issue **July 2003**

379
Publication **Premiere**
Art Director **Richard Baker**
Designer **David Schlow**
Photo Editor **Catriona NiAolain**
Photographer **Sam Jones**
Publisher **Hachette Filipacchi Media U.S.**
Issue **November 2003**

380

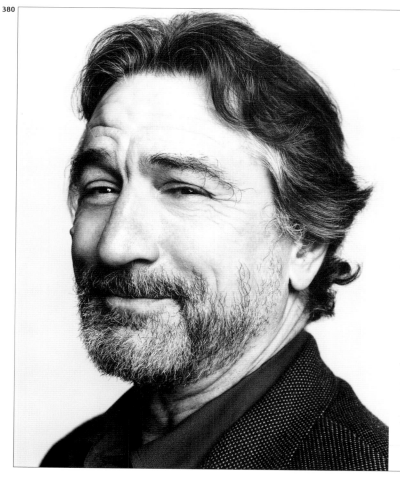

Robert De Niro — What I've Learned

[Actor, 59, New York City]

I like it when interviews are brief. Are we done yet?

When I was a teenager, I went to the Dramatic Workshop at the New School. The school had a lot of actors under the GI Bill—Rod Steiger, Harry Belafonte, the generation ahead of me. I went in there and the director said to me, "Vy do you vant to be an acteh?" I didn't know how to answer, so I didn't say anything. And he said, "To express yourself!" And I said, "Yeah, yeah, that's it. That's right."

We used to roller-skate. Not like these souped-up Rollerblades they have today. Roller skates with ball bearings. We'd hang on to the back of a truck and go for a ride for a couple of blocks until the streetlight turned red and the truck stopped. Then one day they changed the lights to a stagger system. Only we didn't know. All the lights changed up an avenue at intervals so you could go twenty or thirty blocks without stopping. Suddenly, I'm stuck on the back of one of these trucks, and after four blocks, I'm realizing that the next light isn't going to turn red. The driver doesn't know you're on the back. You have no choice but to keep hanging on till he stops. There are things you do that when you get older, you realize how stupid they were.

Some people say, "New York's a great place to visit, but I wouldn't want to live there." I say that about other places.

You have no idea that years later, people in cars will recognize you on the street and shout, "You talkin' to *me*?" I don't remember the original script, but I don't think the line was in it. We improvised. For some reason it touched a nerve. That happens.

Marty Scorsese listens. He's open to unexpected things on that—this is a flowery way of saying it—on that voyage. He takes ideas, and he's not afraid to try them.

There's no such thing as not being afraid.

Money makes your life easier. If you're lucky to have it, you're lucky.

I left a meeting right after they hit the World Trade Center. I went to my apartment, which looks south, and I watched it out my window. I could see the line of fire across the North Tower. I had my binoculars and a video camera—though I didn't want to video it. I saw a few people jump. Then I saw the South Tower go. It was so unreal, I had to confirm it by immediately looking at the television screen. CNN was on. That was the only way to make it real. Like my son said: "It was like watching the moon fall."

I didn't have a problem with rejection, because when you go into an audition, you're rejected already. There are hundreds of other actors. You're behind the eight ball when you go in there.

At this point in my career, I don't have to deal with audition rejections. So I get my rejection from other things. My children can make me feel rejected. They can humble you pretty quick.

It's true: I spent lunchtime in a grave during the filming of *Bloody Mama*. When you're younger, you feel that's what you need to do to help you stay in character. When you get older, you become more confident and less intense about it—and you can achieve the same effect. You might even be able to achieve more if you take your mind off it, because you're relaxed. That's the key to it all. When you're relaxed and confident, you get good stuff.

The hardest thing about being famous is that people are always nice to you. You're in a conversation and everybody's agreeing with what you're saying—even if you say something totally crazy. You need people who can tell you what you *don't* want to hear.

Movies are hard work. The public doesn't see that. The critics don't see it. But they're a lot of work. A lot of work.

When I'm directing a great dramatic scene, part of me is saying, "Thank God I don't have to do that." Because I know how fucking hard it is to act. It's the middle of the night. It's freezing. You gotta do this scene. You gotta get it up to get to that point. And yet, as a director, you've got to get the actors to that point. It's hard either way.

What's the difference between sex and love? Hmm. That's a good question. Hey, you interviewed Al Pacino. How'd *he* answer this?

When a parent dies, it's the end. I always wanted to chronicle the family history with my mother. She was always interested in that. I wanted some researchers I'd worked with to talk to my mother, but my mother was a little antsy about it. I know she would've gotten into it. It would have been okay with my father, too. But I wasn't forceful, and I didn't make it happen. That's one regret I have. I didn't get as much of the family history as I could have for the kids.

As you get older, the more complicated things get. It's almost therapeutic to be doing simple things with the kids.

If you don't go, you'll never know.

INTERVIEWED BY **Cal Fussman** // Photographs by **Sam Jones**

JANUARY 2003 ESQUIRE **49**

381

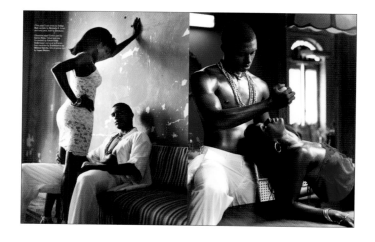

380
Publication **Esquire**
Design Director **John Korpics**
Designers **Chris Martinez, Kim Forsberg**
Photo Editors **Nancy Jo Iacoi, David Carthas**
Photographers **Sam Jones, Bryce Duffy, Gerald Forster, James Smolka, Michael Lewis, Chris Buck, Brian Velenchenko, Dan Winters**
Publisher **The Hearst Corporation-Magazines Division**
Issue **January 2003**

381
Publication **Vibe**
Design Director **Florian Bachleda**
Designer **Wyatt Mitchell**
Photo Editors **George Pitts, Dora Somosi**
Photographer **Davide Cernuschi**
Publisher **Vibe/Spin Ventures**
Issue **May 2003**

382
Publication **Vibe**
Design Director **Florian Bachleda**
Designer **Michael Friel**
Photo Editors **George Pitts, Dora Somosi**
Photographer **Mark Abrahams**
Publisher **Vibe/Spin Ventures**
Issue **October 2003**

382

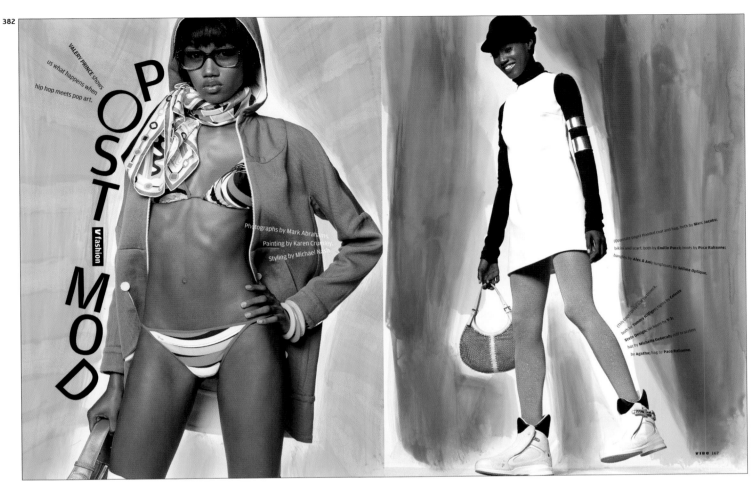

VALERY PRINCE shows us what happens when hip hop meets pop art.

POST MOD

V fashion

Photographs by Mark Abrahams. Painting by Karen Crumley. Styling by Michael Nash.

(Opposite page) Hooded coat and hat, both by Marc Jacobs; bikini and scarf, both by Emilio Pucci; boots by Paco Rabanne; bangles by Alex & Ani; sunglasses by Selima Optique.

(This page) Dress (worn as a sweater), both by Tommy Hilfiger; shoes by Canesta, both by Tommy Hilfiger; ski boots by Y-3; Stein Design; ski boots by Y-3; hat by Michelle Deborah; cuff bracelets by Agatha; bag by Paco Rabanne.

VIBE 167

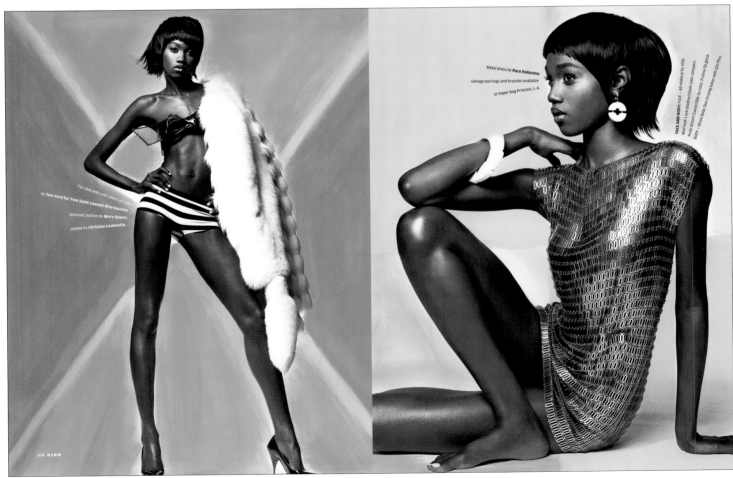

Fur coat with sash (worn as a top) by Tom Ford for Yves Saint Laurent Rive Gauche; swimsuit bottom by Mary Quant; pumps by Christian Louboutin.

Metal dress by Paco Rabanne; vintage earrings and bracelet available at Paper Bag Princess, L.A.

FACE AND BODY: FACE – All makeup by stila: Nude-Bloom Convertible eye color, Convertible cheek color compact, and Pirouette lip glaze. BODY – Nivea Body Skin Firming lotion with Q10 Plus.

168 VIBE

383

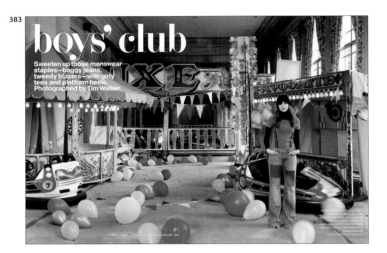

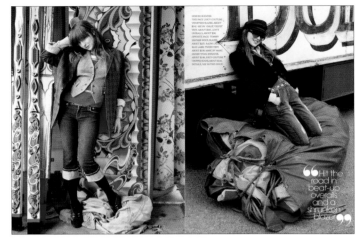

384

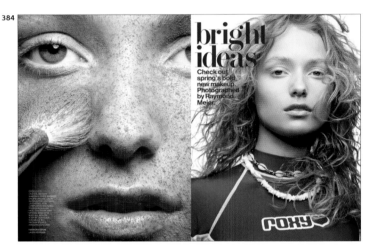

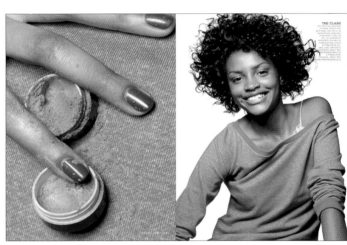

385

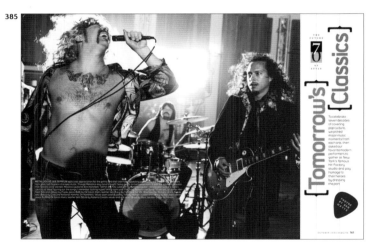

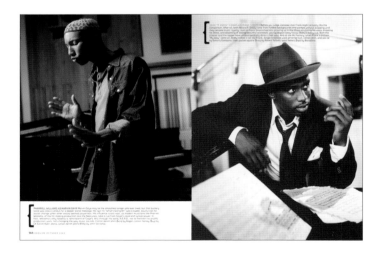

383
Publication **Teen Vogue**
Art Director **Lina Kutsovskaya**
Designers **James Casey, Jason Engdahl,
Holly Stevenson, Emily Wardwell**
Photo Editor **Lucy Lee**
Photographer **Tim Walker**
Associate Photo Editor **Brody Baker**
Assistant Photo Editor **Jillian Johnson**
Publisher **Condé Nast Publications Inc.**
Issue **December/January 2003**

384
Publication **Teen Vogue**
Art Director **Lina Kutsovskaya**
Designers **James Casey, Jason Engdahl,
Holly Stevenson, Emily Wardwell**
Photo Editor **Lucy Lee**
Photographer **Raymond Meier**
Associate Photo Editor **Brody Baker**
Assistant Photo Editor **Jillian Johnson**
Publisher **Condé Nast Publications Inc.**
Issue **February/March 2003**

385
Publication **Esquire**
Design Director **John Korpics**
Designer **Chris Martinez**
Photo Editor **Nancy Jo Iacoi**
Photographers **Ben Watts**
Publisher **The Hearst Corporation-Magazines Division**
Issue **October 2003**

386

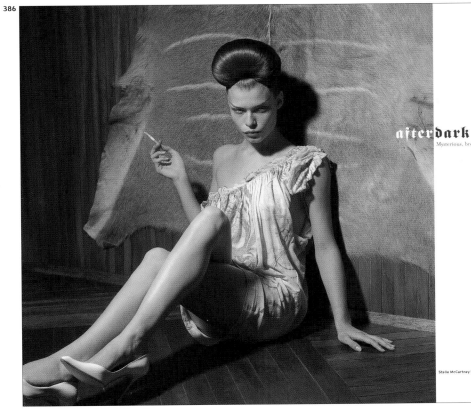

afterdark

Mysterious, brooding spring evening looks are all curved lines and sensual provocation.

PHOTOGRAPHS BY MERT ALAS AND MARCUS PIGGOTT

Stella McCartney's silk chiffon dress, at Neiman Marcus, Los Angeles; Stella McCartney, New York. Manolo Blahnik shoes.

MARCH 2003 W 403

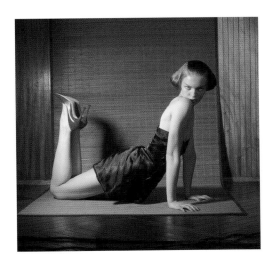

Costume National's acetate satin minidress, by Ennio Capasa, at Bergdorf Goodman and Barneys, New York; Costume National, New York and Los Angeles. Alain Tondowski shoes.

404 W MARCH 2003

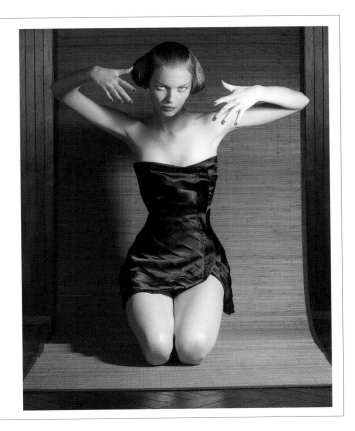

386
Publication **W Magazine**
Creative Director **Dennis Freedman**
Design Director **Edward Leida**
Art Director **Kirby Rodriguez**
Designers **Kirby Rodriguez, Angela Panichi, Shanna Greenberg**
Photographers **Mert Alas, Marcus Piggot**
Publisher **Fairchild Publications**
Issue **March 2003**

387

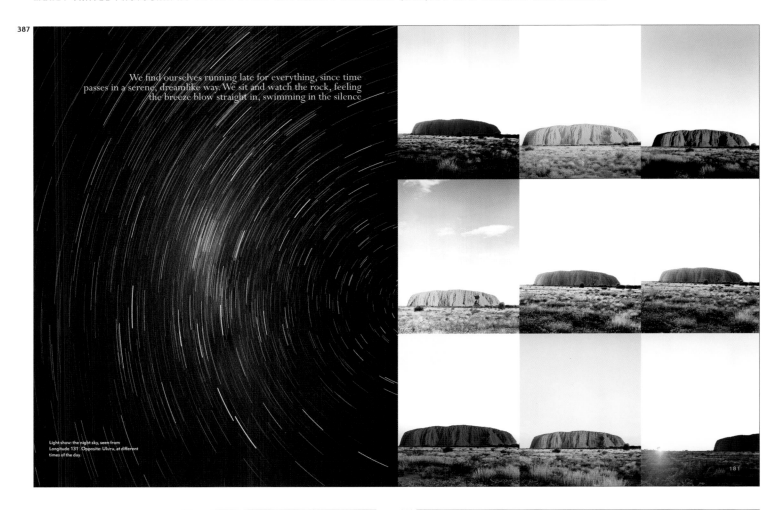

We find ourselves running late for everything, since time passes in a serene, dreamlike way. We sit and watch the rock, feeling the breeze blow straight in, swimming in the silence

Light show: the night sky, seen from Longitude 131°. Opposite: Uluru, at different times of the day.

388

389

387
Publication **Travel+Leisure**
Creative Director **Luke Hayman**
Art Director **Emily Crawford**
Designer **Luke Hayman**
Photo Editors **David Cicconi, Katie Dunn**
Photographer **Mikkel Vang**
Publisher **American Express Publishing Co.**
Issue **June 2003**

388
Publication **The New Yorker**
Visuals Editor **Elisabeth Biondi**
Photo Editor **Natasha Lunn**
Photographer **Mary Ellen Mark**
Publisher **Condé Nast Publications Inc.**
Issue **October 27, 2003**

389
Publication **The New Yorker**
Visuals Editor **Elisabeth Biondi**
Photo Editor **Natasha Lunn**
Photographer **Mary Ellen Mark**
Publisher **Condé Nast Publications Inc.**
Issue **June 30, 2003**

390
Publication **Travel+Leisure**
Creative Director **Luke Hayman**
Art Director **Emily Crawford**
Designer **Rob Hewitt**
Photo Editors **David Cicconi, Katie Dunn**
Photographer **Frédéric Lagrange**
Publisher **American Express Publishing Co.**
Issue **March 2003**

391
Publication **Travel+Leisure**
Creative Director **Luke Hayman**
Art Director **Emily Crawford**
Designer **Emily Crawford**
Photo Editors **David Cicconi, Katie Dunn**
Photographer **Cedric Angeles**
Publisher **American Express Publishing Co.**
Issue **April 2003**

392
Publication **Travel+Leisure**
Creative Director **Luke Hayman**
Art Director **Emily Crawford**
Designer **Luke Hayman**
Photo Editors **David Cicconi, Katie Dunn**
Photographer **Martin Morrell**
Publisher **American Express Publishing Co.**
Issue **October 2003**

390

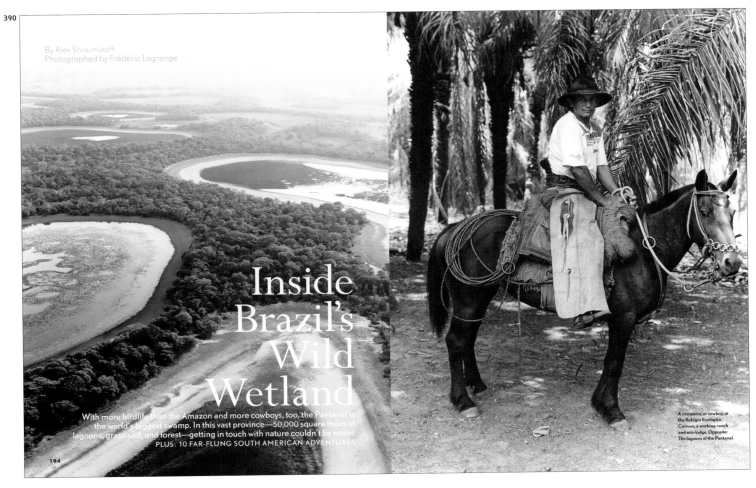

By Alex Shoumatoff
Photographed by Frédéric Lagrange

Inside Brazil's Wild Wetland

With more birdlife than the Amazon and more cowboys, too, the Pantanal is the world's biggest swamp. In this vast province—50,000 square miles of lagoons, grassland, and forest—getting in touch with nature couldn't be easier
PLUS: 10 FAR-FLUNG SOUTH AMERICAN ADVENTURES

194

A campeiro, or cowboy, at the Refúgio Ecológico Caiman, a working ranch and eco-lodge. Opposite: The lagoons of the Pantanal.

391

A GOOD RIDE In Aiken, South Carolina, polo matches, fox hunts, and horse races are the order of the day. Now a restored inn is giving outsiders entrée into an exclusive world.
BY JOHN SEABROOK · PHOTOGRAPHED BY CEDRIC ANGELES

Too rich to work, but too active and restless to sit still, the men and women of Aiken's Winter Colony developed a hectic style of leisure that became a preppy convention

392

Paris Modern
How does it feel to return to a place you once called home—and find it utterly transformed? From the side streets of St.-Germain to the gleaming glass towers of the 13th Arrondissement, Kate Betts charts the changes—and the constants—of one of the world's most stylish cities.
Photographed by Martin Morrell

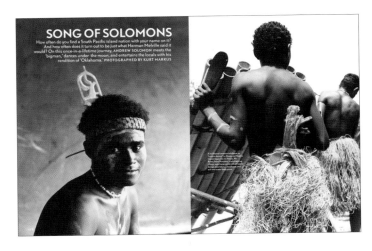

SONG OF SOLOMONS
How often do you find a South Pacific island nation with your name on it? And how often does it turn out to be just what Herman Melville said it would? On this once-in-a-lifetime journey, ANDREW SOLOMON meets the 'bigman,' dances under the moon, and entertains the locals with his rendition of 'Oklahoma.' PHOTOGRAPHED BY KURT MARKUS

393

Brightly painted houses and neatly trimmed lawns, the general store, Main Street—**the American town is Norman Rockwell, but it's more than that too.** It's desert cowboys, casinos by the lake, a red and gold music hall, shrimp boats at the dock, and bingo games at the VFW. Four writers—**Denis Johnson, Amy Bloom, Elizabeth Hardwick, and Aimee Bender**—reflect on the places they love

SMALL TOWN U.S.A.

PLUS
10 towns you'll want to make your own

Photographed by Trujillo/Paumier

220

A hunter's house, Eureka, South Dakota.

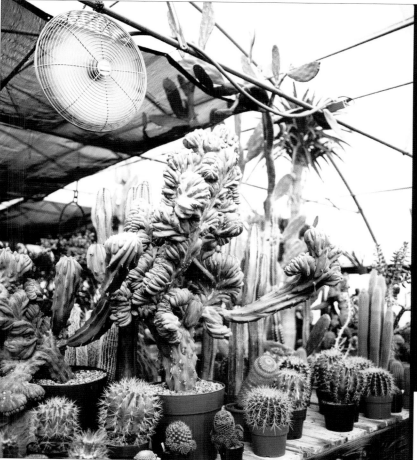

Dolores Roux of Dolores's Sweet Shoppe, below, in Apalachicola, Florida, with her signature pecan pie. Left: Buffalo Bill's Exotic Cactus Ranch, in Truth or Consequences, New Mexico.

Buffalo Bill's Exotic Cactus Ranch, a greenhouse with every imaginable variety of cactus, **turned out to be what Truth or Consequences needed**

229

394

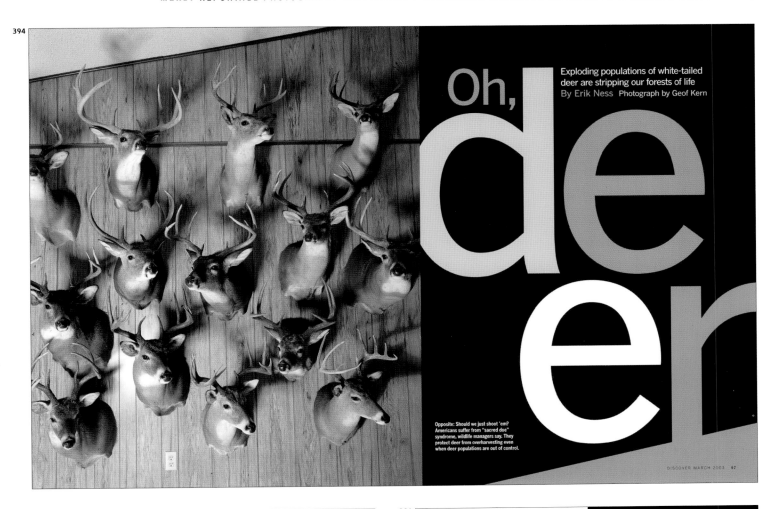

Oh, de er

Exploding populations of white-tailed
deer are stripping our forests of life
By Erik Ness Photograph by Geof Kern

Opposite: Should we just shoot 'em?
Americans suffer from "sacred doe"
syndrome, wildlife managers say. They
protect deer from overharvesting even
when deer populations are out of control.

DISCOVER MARCH 2003 67

395

396

393
Publication **Travel+Leisure**
Creative Director **Luke Hayman**
Art Director **Emily Crawford**
Designer **Luke Hayman**
Photo Editors **David Cicconi, Katie Dunn**
Photographer **Trujillo/Paumier**
Publisher **American Express Publishing Co.**
Issue **April 2003**

394
Publication **Discover**
Design Director **Michael Mrak**
Art Director **John Seeger Gilman**
Photo Editor **Maisie Todd**
Photographer **Geof Kern**
Publisher **Disney Publishing Worldwide**
Issue **March 2003**

395
Publication **Vibe**
Design Director **Florian Bachleda**
Designer **Alice Alves**
Photo Editors **George Pitts, Dora Somosi**
Photographer **Vanessa Vick**
Publisher **Vibe/Spin Ventures**
Issue **February 2003**

396
Publication **Vibe**
Design Director **Florian Bachleda**
Designer **Wyatt Mitchell**
Photo Editors **George Pitts, Dora Somosi**
Photographer **Teru Kuwayama**
Publisher **Vibe/Spin Ventures**
Issue **December 2003**

397

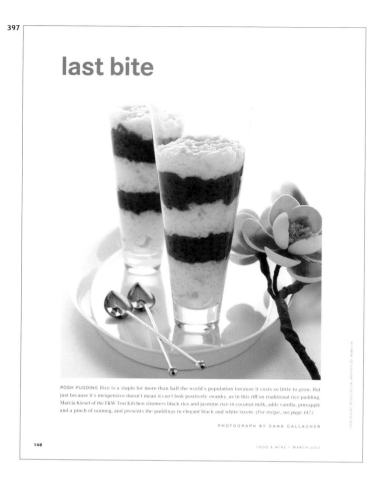

last bite

POSH PUDDING Rice is a staple for more than half the world's population because it costs so little to grow. But just because it's inexpensive doesn't mean it can't look positively swanky, as in this riff on traditional rice pudding. Marcia Kiesel of the F&W Test Kitchen simmers black rice and jasmine rice in coconut milk, adds vanilla, pineapple and a pinch of nutmeg, and presents the puddings in elegant black and white layers. *(For recipe, see page 147.)*

PHOTOGRAPH BY DANA GALLAGHER

148

398

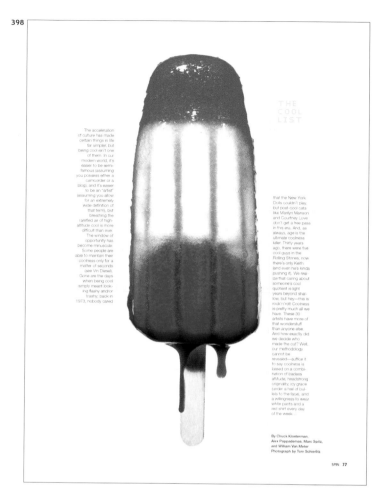

399

400

397
Publication **Food & Wine**
Creative Director **Stephen Scoble**
Art Director **Patricia Sanchez**
Designer **Andrew Haug**
Photo Editor **Fredrika Stjarne**
Photographer **Dana Gallagher**
Publisher **American Express Publishing Co.**
Issue **March 2003**

399
Publication **Elle Decor**
Art Director **Florentino Pamintuan**
Photo Editor **Melissa LeBoeuf**
Photographer **Pieter Estersohn**
Publisher **Hachette Filipacchi Media U.S.**
Issue **April 2003**

398
Publication **Spin**
Design Director **Arem Duplessis**
Art Director **Brandon Kavulla**
Designers **Brandon Kavulla, Arem Duplessis**
Photo Editor **Cory Jacobs**
Photographer **Tom Schierlitz**
Publisher **Vibe/Spin Ventures LLC**
Issue **September 2003**

400
Publication **Elle Decor**
Art Director **Florentino Pamintuan**
Photo Editor **Melissa LeBoeuf**
Photographer **Pieter Estersohn**
Design & Decoration Editor **Anita Sarsidi**
Publisher **Hachette Filipacchi Media U.S.**
Issue **April 2003**

401
Publication **Martha Stewart Baby**
Creative Director **Gael Towey**
Design Director **Deb Bishop**
Art Director **Jennifer Wagner**
Photo Editors **Stacie McCormick, Jamie Bass**
Stylists **Robin Herrick, Judith Lockhart**
Publisher **Martha Stewart Living Omnimedia**
Issue **Spring 2003**

401

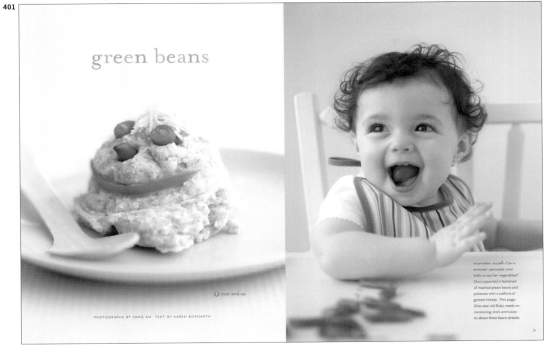

green beans

+ MERIT STILL LIFE PHOTOGRAPHY SPREAD

402

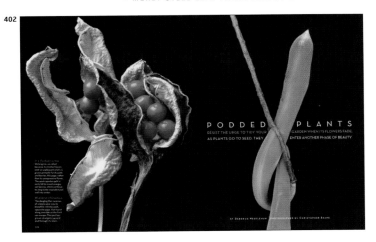

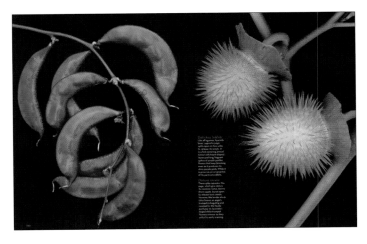

403

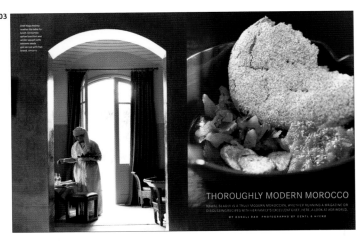

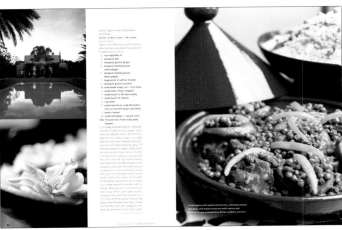

402
Publication **House and Garden**
Art Director **Anthony Jazzar**
Designer **Trent Farmer**
Photo Editor **Lucy Gilmour**
Photographer **Christopher Beane**
Publisher **Condé Nast Publications Inc.**
Issue **September 2003**

403
Publication **Food & Wine**
Creative Director **Stephen Scoble**
Art Director **Patricia Sanchez**
Designer **Delgis Canahuate**
Photo Editor **Fredrika Stjarne**
Photographer **Gentl + Hyers**
Publisher **American Express Publishing Co.**
Issue **February 2003**

404

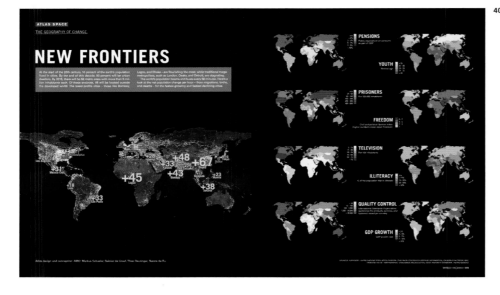

405

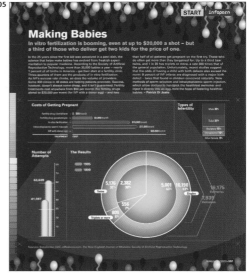

404
Publication **Wired**
Creative Director **Darrin Perry**
Design Director **Susana Rodriguez deTembleque**
Designers **Donald Ngai, Federico Gutierrez Schott**
Publisher **Condé Nast Publications Inc.**
Issue **June 2003**

405
Publication **Wired**
Creative Director **Darrin Perry**
Design Director **Susana Rodriguez deTembleque**
Designer **Mark Wasyl**
Publisher **Condé Nast Publications Inc.**
Issue **January 2003**

406

407

408

409

410

411

406
Publication **New York**
Design Director **David Matt**
Photo Editors **Chris Dougherty, Armin Harris,
Lauren Reichbach, Jolanta Beilat, Kate Lacey,
Stephanie Heimann**
Publisher **Primedia**
Issue **December 22-29, 2003**

407
Publication **New York**
Design Director **David Matt**
Photo Editor **Chris Dougherty**
Photographer **Louis Moses**
Publisher **Primedia**
Issue **January 13, 2003**

408
Publication **TimeOut New York**
Art Director **Leah Esposito**
Photo Editor **Sara Shaoul**
Photographer **Timothy White**
Publisher **TimeOut New York Partners, LP**
Issue **December 4-11, 2003**

409
Publication **Bon Magazine**
Creative Director **Johan Lindskog**
Design Director **Christoffer Wessel**
Art Directors **Christoffer Wessel, Magnus Naddermier**
Photographer **Henrik Halvarsson**
Publisher **Letterhead AB**
Issue **October 2003**

410
Publication **Los Angeles**
Design Director **Joe Kimberling**
Photo Editor **Kathleen Clark**
Photographer **Dan Winters**
Publisher **Emmis**
Issue **October 2003**

411
Publication **Los Angeles**
Design Director **Joe Kimberling**
Photo Editor **Kathleen Clark**
Photographer **Matthew Rolston**
Publisher **Emmis**
Issue **November 2003**

412

413

414

415

416

417

412
Publication **El Mundo Metropoli**
Design Director **Carmelo Caderot**
Art Director **Rodrigo Sanchez**
Designer **Rodrigo Sanchez**
Publisher **Unidad Editorial S.A.**
Issue **October 10, 2003**

413
Publication **El Mundo Metropoli**
Design Director **Carmelo Caderot**
Art Director **Rodrigo Sanchez**
Designer **Rodrigo Sanchez**
Publisher **Unidad Editorial S.A.**
Issue **May 16, 2003**

414
Publication **El Mundo Metropoli**
Design Director **Carmelo Caderot**
Art Director **Rodrigo Sanchez**
Designer **Rodrigo Sanchez**
Publisher **Unidad Editorial S.A.**
Issue **May 9, 2003**

415
Publication **El Mundo Metropoli**
Design Director **Carmelo Caderot**
Art Director **Rodrigo Sanchez**
Designer **Rodrigo Sanchez**
Publisher **Unidad Editorial S.A.**
Issue **July 11, 2003**

416
Publication **El Mundo Metropoli**
Design Director **Carmelo Caderot**
Art Director **Rodrigo Sanchez**
Designer **Rodrigo Sanchez**
Photo Editor **Rodrigo Sanchez**
Publisher **Unidad Editorial S.A.**
Issue **March 21, 2003**

417
Publication **El Mundo Metropoli**
Design Director **Carmelo Caderot**
Art Director **Rodrigo Sanchez**
Designer **Rodrigo Sanchez**
Publisher **Unidad Editorial S.A.**
Issue **August 5, 2003**

418

EL MUNDO

METROPOLI

LA REVISTA DE MADRID. N.665. DEL 21 AL 27 DE FEBRERO DE 2003

00:00	00:30	01:00	01:30
02:00	02:30	03:00	03:30
04:00	04:30	05:00	05:30
06:00	06:30	07:00	07:30
08:00	08:30	09:00	09:30
10:00	10:30	11:00	11:30
12:00	12:30	13:00	13:30
14:00	14:30	15:00	15:30
16:00	16:30	17:00	17:30
18:00	18:30	19:00	19:30
20:00	20:30	21:00	21:30
22:00	22:30	23:00	23:30

LAS HORAS DE TRES VIDAS SEGÚN VIRGINIA WOOLF

418
Publication **El Mundo Metropoli**
Design Director **Carmelo Caderot**
Art Director **Rodrigo Sanchez**
Designer **Rodrigo Sanchez**
Publisher **Unidad Editorial S.A.**
Issue **February 21, 2003**

419

420

421

422

420
Publication **City**
Creative Director **Fabrice Frere**
Art Director **Adriana Jacoud**
Photo Editor **Piera Gelardi**
Photographer **Alexander Deutsch**
Publisher **City Publishing L.L.C.**
Issue **March/April 2003**

421
Publication **Metropolis**
Art Director **DJ Stout**
Designer **Erin Mayes**
Studio **Pentagram Design, Inc.**
Publisher **Bellerophon Publications**
Client **Metropolis**
Issue **October 2003**

422
Publication **Big**
Creative Director **Marc Atlan**
Photo Editor **Marc Atlan**
Photographer **Albert Giordan**
Studio **Marc Atlan Design, Inc.**
Publisher **Big Magazine, Inc.**
Issue **March 2003**

423
Publication **The Bark**
Creative Director **Cameron Woo**
Designers **Cameron Woo, Dirk Walter**
Photographer **Rachel Hale**
Publisher **The Bark, Inc.**
Issue **Winter 2003**

419
Publication **Nordic Reach**
Editor-in-Chief **Ulf Mårtensson**
Creative Director **Flat**
Art Director **Petter Ringbom**
Designers **Petter Ringbom, Lily Williams**
Photographer **Ana Mattson**
Publisher **Swedish News**
Issue **September 2003**

423

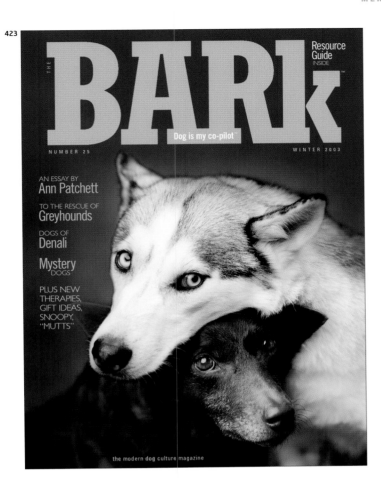

424

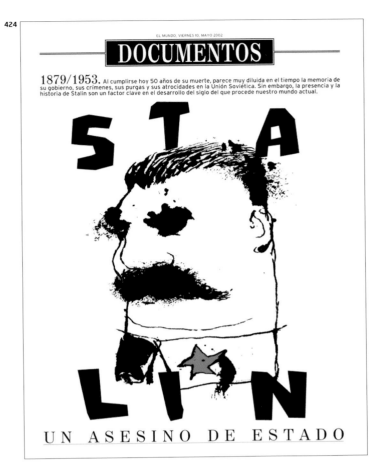

425

426

427

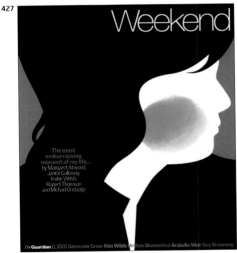

424
Publication **El Mundo**
Design Director **Carmelo Caderot**
Art Director **Manuel deMiguel**
Designer **Carmelo Caderot**
Illustrator **Raul Arias**
Issue **March 5, 2003**

425
Publication **The Guardian**
Art Director **Roger Browning**
Designer **Liz Couldwell**
Photographer **Zygmunt Januszewski**
Publisher **Guardian Newspapers Limited**
Issue **April 19, 2003**

426
Publication **The Hartford Courant - Northeast Magazine**
Designer **Josue Evilla**
Design Editor **Melanie Shaffer**
Publisher **Tribune Publishing Co.**
Issue **January 19, 2003**

427
Publication **The Guardian Weekend**
Art Director **Maggie Murphy**
Illustrator **Paul Oakley**
Publisher **Guardian Newspapers**
Issue **October 11, 2003**

428

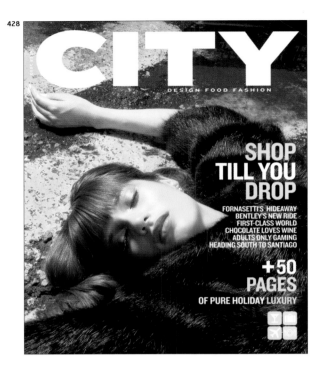

429

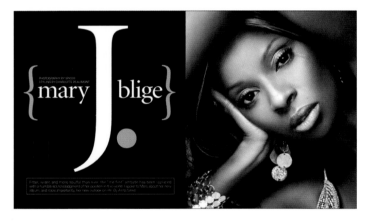

430

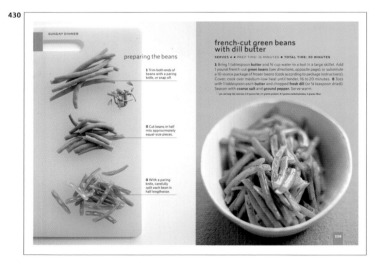

431

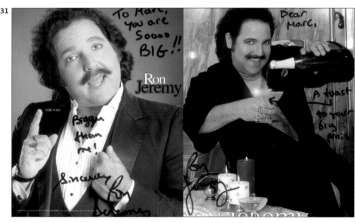

428
Publication **City**
Creative Director **Fabrice Frere**
Art Director **Adriana Jacoud**
Photo Editor **Piera Gelardi**
Publisher **City Publishing L.L.C.**
Issue **Winter 2003**

429
Publication **City**
Creative Director **Fabrice Frere**
Art Director **Adriana Jacoud**
Photo Editor **Piera Gelardi**
Publisher **City Publishing L.L.C.**
Issue **Fall 2003**

430
Publication **Everyday Food**
Creative Directors **Gael Towey, Eric Pike**
Design Director **Scot Schy**
Art Directors **Michele Outland, William van Roden**
Photographer **Con Poulos**
Stylist **Susie Theodorou**
Publisher **Martha Stewart Omnimedia**
Issue **October 2003**

432

COVER STORY

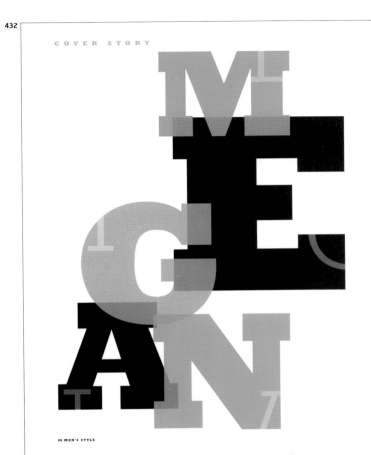

MEGAN

80 MEN'S STYLE

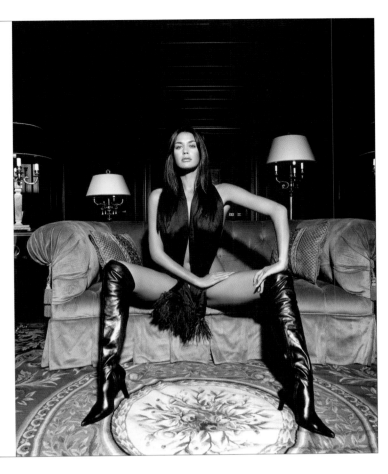

433

431
Publication **Big**
Creative Director **Marc Atlan**
Illustrators **Arthur Mount, Paul Ritter, Guillaume Wolf**
Photo Editor **Marc Atlan**
Photographers **Spike Jonze, Roman Coppola, Max Vadukul, Matthias Vriens, Juliana Sohn, Dewey Nicks, Mike Mills, Anette Aurell, Steven Lippman**
Studio **Marc Atlan Design, Inc.**
Publisher **Big Magazine, Inc.**
Issue **March 2003**

432
Publication **Men's Style Australia**
Creative Director **Andy Foster**
Designer **Andy Foster**
Illustrators **Nigel Buchanan, Jeff Raglus, Rosanna Vecchio, Edwina White, John Yates**
Photographers **Patrizio di Renzo, Stephen Oxenbury, Philip Riches, Thomas Dworzak, Richard Weinstein, Sage , Kerry Wilson, Frances Mocnik, Harold David, Geoffrey Boccalatte, Louise Lister, Andreas Bommert, Jim Marshall, Simon Davidson, Richard Mortimer, Julian Kingma, Sion Touhig**
Studio **Flash Art**
Publisher **Australian Consolidated Press**
Issue **September 2003**

433
Publication **Step inside design**
Art Director **Robert Valentine**
Designers **Brandon Jameson, Judy Minn, Michael Ulrich**
Publisher **Dynamic Graphics Group**
Issue **November/December 2003**

434

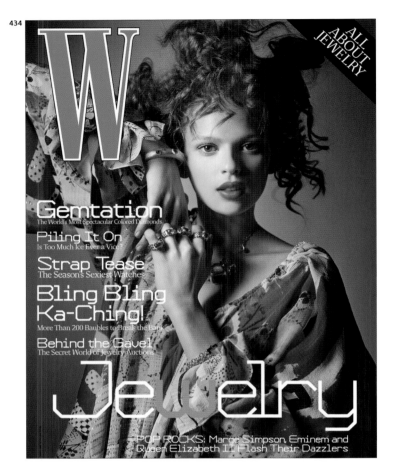

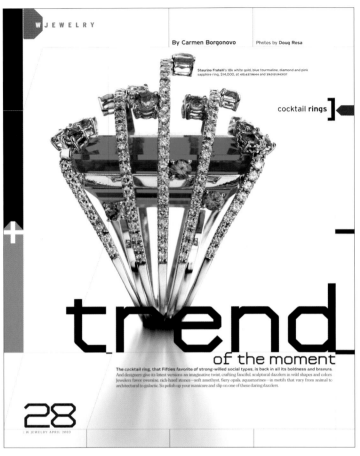

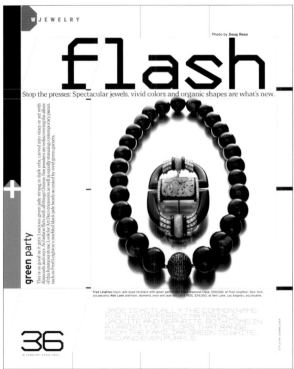

434
Publication **W Jewelry**
Creative Director **Dennis Freedman**
Design Director **Edward Leida**
Art Director **Kirby Rodriguez**
Designers **Edward Leida, Kirby Rodriguez,
Angela Panichi, Shanna Greenberg**
Publisher **Fairchild Publications**
Issue **Spring 2003**

435
Publication **W Jewelry**
Creative Director **Dennis Freedman**
Design Director **Edward Leida**
Art Director **Kirby Rodriguez**
Designers **Edward Leida, Kirby Rodriguez,
Angela Panichi, Shanna Greenberg**
Publisher **Fairchild Publications**
Issue **Fall 2003**

435

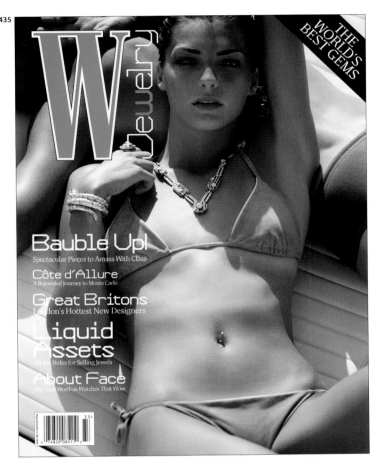

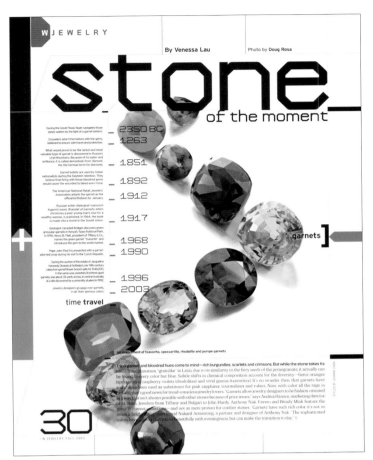

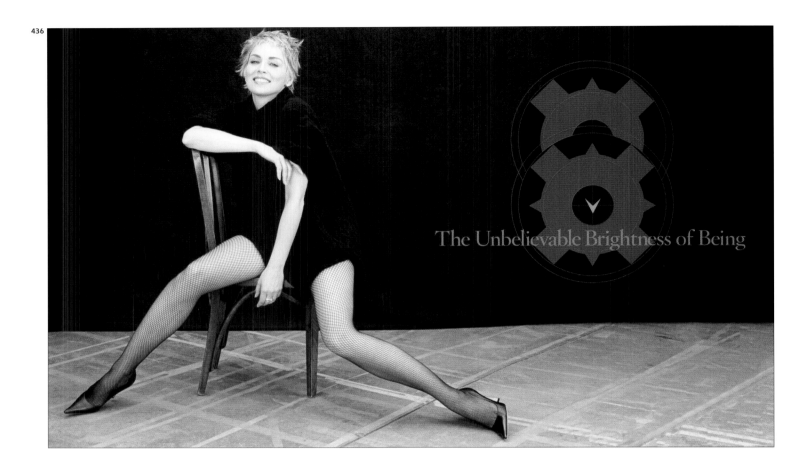

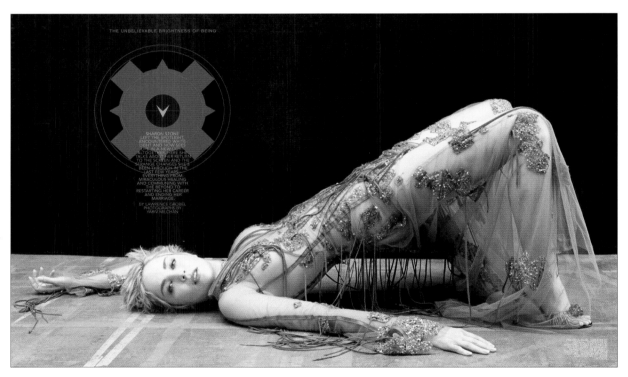

436
Publication **Hollywood Life**
Creative Director **Robert Priest**
Designers **Robert Priest, Peter Cury, Ron Jones**
Photo Editor **Aya Muto**
Photographers **Yariv Milchan, Lorenzo Aguis, Matt Jones**
Studio **Priest Media Inc.**
Publisher **Line Publications**
Issue **July/August 2003**

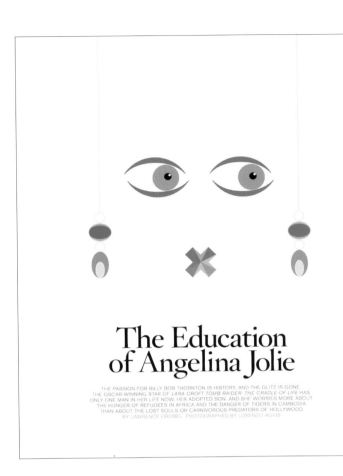

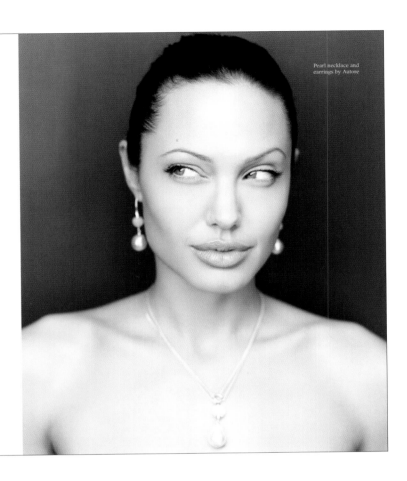

Pearl necklace and earrings by Autore

The Education of Angelina Jolie

THE PASSION FOR BILLY BOB THORNTON IS HISTORY, AND THE GLITZ IS GONE.
THE OSCAR-WINNING STAR OF *LARA CROFT TOMB RAIDER: THE CRADLE OF LIFE* HAS
ONLY ONE MAN IN HER LIFE NOW, HER ADOPTED SON, AND SHE WORRIES MORE ABOUT
THE HUNGER OF REFUGEES IN AFRICA AND THE DANGER OF TIGERS IN CAMBODIA
THAN ABOUT THE LOST SOULS OR CARNIVOROUS PREDATORS OF HOLLYWOOD.
BY LAWRENCE GROBEL PHOTOGRAPHED BY LORENZO AGIUS

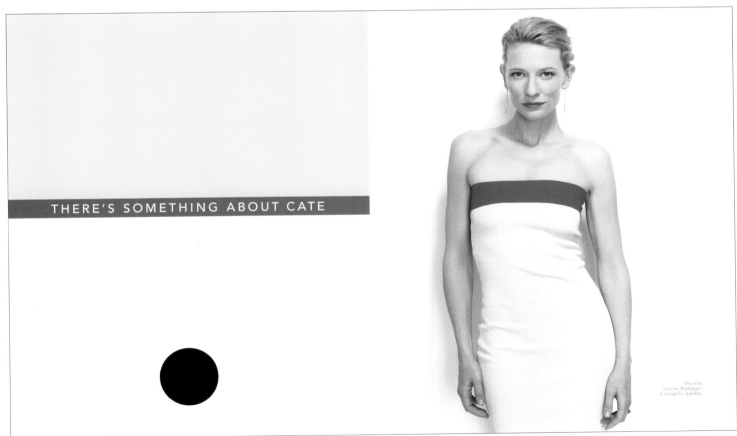

THERE'S SOMETHING ABOUT CATE

Dress by
Narciso Rodriguez
Earrings by Ippolita

437

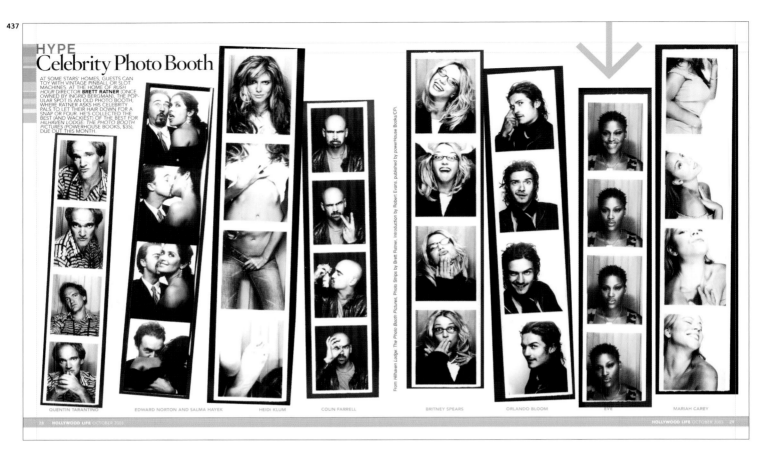

438

439

440
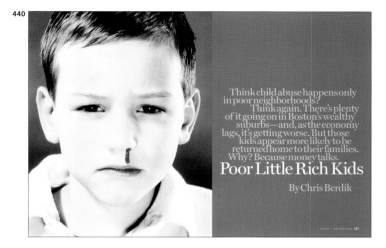

441

442

443

444
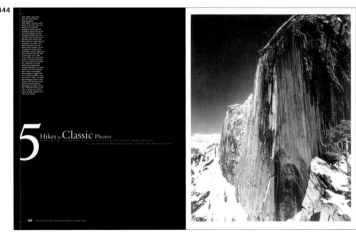

439
Publication **Travel+Leisure Family**
Creative Director **Luke Hayman**
Art Director **Emily Crawford**
Designer **Emily Crawford**
Photo Editor **Katie Dunn**
Photographer **Graham MacIndoe**
Publisher **American Express Publishing Co.**
Issue **Winter 2003/04**

442
Publication **Sports Illustrated on Campus**
Art Director **Michael Lawton**
Illustrator **Robert M. Thompson**
Photo Editor **Maureen Grise**
Publisher **Time Inc.**
Issue **October 21, 2003**

440
Publication **Boston Magazine**
Art Director **Robert Parsons**
Photographer **Olaf Tiedje**
Publisher **Metrocorp**
Issue **December 2003**

443
Publication **Selling Power Magazine**
Art Director **Colleen Quinnell**
Designer **Colleen Quinnell**
Illustrator **Serge Bloch**
Issue **April 2003**

441
Publication **Hawaii Skin Diver**
Art Director **Clifford Cheng**
Designer **Clifford Cheng**
Photographer **Sterling Kaya**
Studio **Voice**
Publisher **Hawaii Skin Diver Publishing**
Issue **Fall 2003**

444
Publication **Backpacker**
Art Director **Matthew Bates**
Designer **Matthew Bates**
Photo Editor **Liz Reap**
Photographer **Ansel Adams**
Publisher **Rodale Press**
Issue **September 2003**

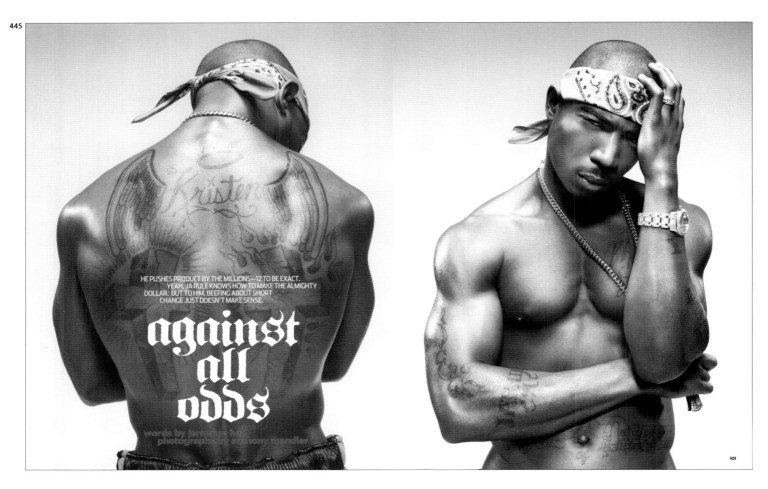

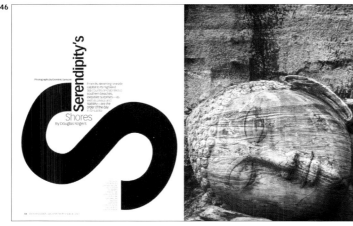

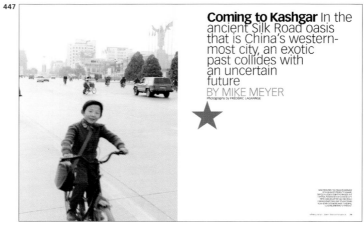

445
Publication **The Source**
Art Director **Paul Scirecalabrisotto**
Designers **Miguel Rivera, Hilary Sopczak,**
Darhil Crooks
Photographer **Anthony Mandler**
Director of Photography **Katherine S. Schad**
Publisher **The Source Enterprises, Inc.**
Issue **February 2003**

446
Publication **DestinAsian**
Creative Director **Tom Brown**
Art Director **Ingrid Tedjakumala**
Designer **Tom Brown**
Photographer **Dominic Sansoni**
Studio **TBA+D**
Publisher **DestinAsian Communications Ltd.**
Issue **August/September 2003**

447
Publication **DestinAsian**
Creative Director **Tom Brown**
Art Director **Ingrid Tedjakumala**
Designer **Tom Brown**
Photographer **Frédéric Lagrange**
Studio **TBA+D**
Publisher **DestinAsian Communications Ltd.**
Issue **April/May 2003**

448

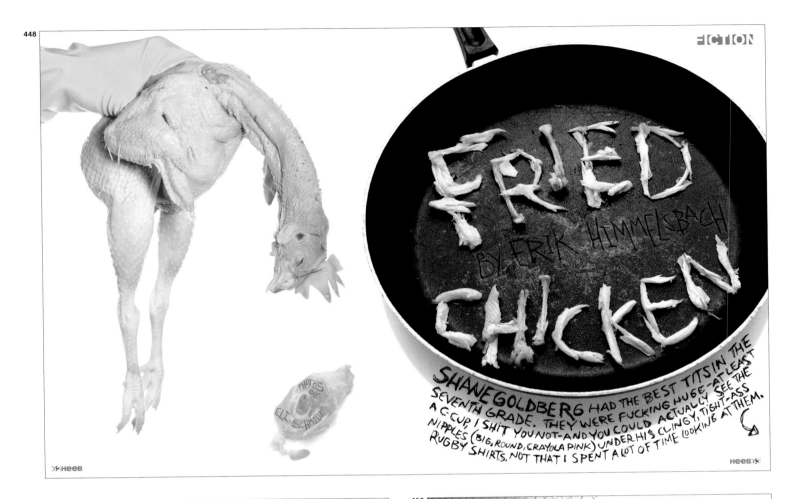

449

450

448
Publication **Heeb**
Design Director **Omar Mrva**
Designer **Omar Mrva**
Photographer **Eli Schmidt**
Publisher **Heeb Magazine**
Issue **Spring 2003**

449
Publication **DestinAsian**
Creative Director **Tom Brown**
Art Director **Ingrid Tedjakumala**
Designer **Tom Brown**
Photographer **Gareth Brown**
Studio **TBA+D**
Publisher **DestinAsian Communications Ltd.**
Issue **April/May 2003**

450
Publication **Guitar World**
Design Director **Andy Omel**
Designer **Andy Omel**
Photographer **Justin Borucki**
Publisher **Harris Publications**
Issue **October 2003**

451

452

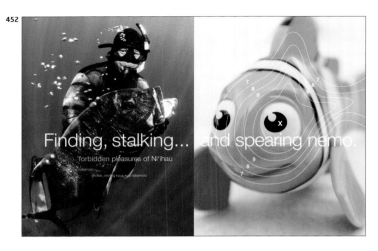

453

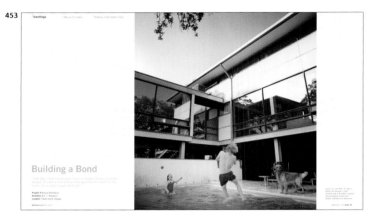

454

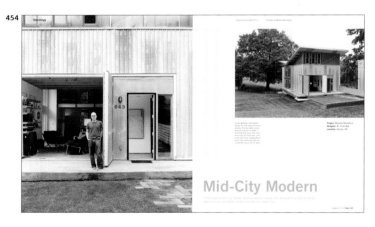

455

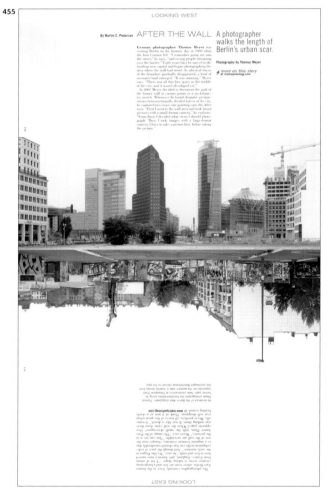

451
Publication **Hoop and Inside Stuff Magazines**
Design Director **Yvette Francis**
Photographer **Jennifer Pottheiser**
Publisher **Professional Sports Publications**
Issue **March 2003**

452
Publication **Hawaii Skin Diver**
Art Director **Clifford Cheng**
Designer **Clifford Cheng**
Photographers **Sterling Kaya, Clifford Cheng**
Studio **Voice**
Publisher **Hawaii Skin Diver Publishing**
Issue **Summer 2003**

453
Publication **dwell**
Creative Director **Jeanette Hodge Abbink**
Designers **Jeanette Hodge Abbink,
Shawn Hazen, Craig Bromley**
Photo Editors **Maren Levinson, Aya Brackett**
Photographer **Craig Cameron Olsen**
Publisher **Dwell LLC**
Issue **September 2003**

454
Publication **dwell**
Creative Director **Jeanette Hodge Abbink**
Designers **Jeanette Hodge Abbink, Shawn Hazen, Craig Bromley**
Photo Editors **Maren Levinson, Aya Brackett**
Photographer **Mark Steinmetz**
Publisher **Dwell LLC**
Issue **September 2003**

455
Publication **Metropolis**
Art Director **Criswell Lappin**
Photo Editor **Sara Barrett**
Photographer **Thomas Meyer**
Publisher **Bellerophon Publications**
Issue **November 2003**

456
Publication **Texas Monthly**
Art Director **Scott Dadich**
Designers **Scott Dadich, TJ Tucker**
Photo Editor **Scott Dadich**
Photographer **Dan Winters**
Publisher **Emmis Communications Corp.**
Issue **June 2003**

456

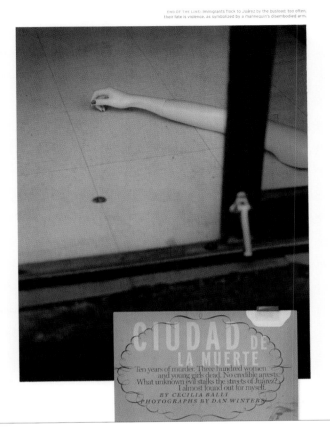

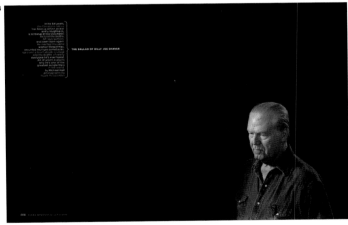

457

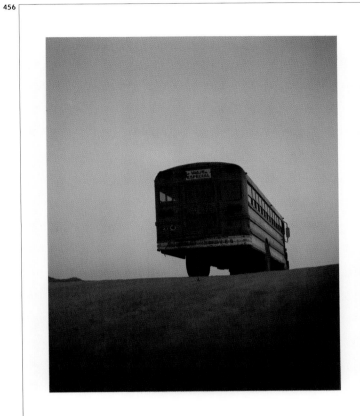

458

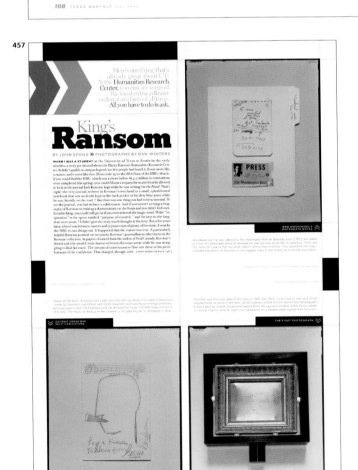

457
Publication **Texas Monthly**
Art Director **Scott Dadich**
Designers **Scott Dadich, TJ Tucker**
Photo Editors **Scott Dadich, TJ Tucker**
Photographer **Dan Winters**
Publisher **Emmis Communications Corp.**
Issue **October 2003**

458
Publication **Texas Monthly**
Art Director **Scott Dadich**
Designers **Scott Dadich, TJ Tucker**
Photo Editor **Scott Dadich**
Photographer **Wyatt McSpadden**
Publisher **Emmis Communications Corp.**
Issue **December 2003**

459

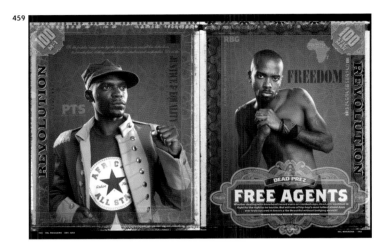

460

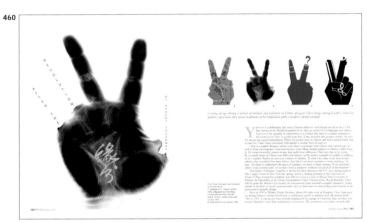

462

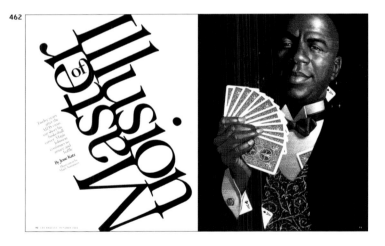

461

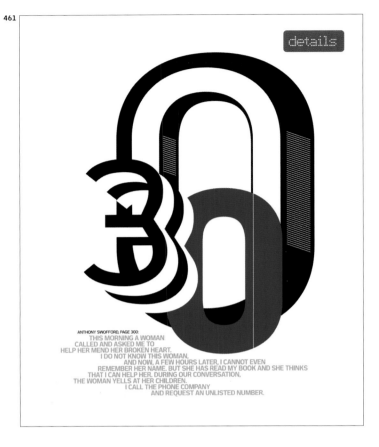

ANTHONY SWOFFORD, PAGE 300:
THIS MORNING A WOMAN
CALLED AND ASKED ME TO
HELP HER MEND HER BROKEN HEART.
I DO NOT KNOW THIS WOMAN,
AND NOW, A FEW HOURS LATER, I CANNOT EVEN
REMEMBER HER NAME. BUT SHE HAS READ MY BOOK AND SHE THINKS
THAT I CAN HELP HER. DURING OUR CONVERSATION,
THE WOMAN YELLS AT HER CHILDREN.
I CALL THE PHONE COMPANY
AND REQUEST AN UNLISTED NUMBER.

463

459
Publication **XXL Magazine**
Art Directors **Rommel Alama, Davina Lennard**
Designer **Rommel Alama**
Photo Editor **Sally Berman**
Photographer **Olugbenro**
Publisher **Harris**
Issue **December 2003**

460
Publication **Print**
Creative Director **Steven Brower**
Designer **Stephanie Skirvin**
Illustrator **Chen Fang**
Publisher **F & W Publications**
Issue **July/August 2003**

461
Publication **Details**
Design Director **Rockwell Harwood**
Publisher **Condé Nast Publications Inc.**
Issue **September 2003**

462
Publication **Los Angeles**
Design Director **Joe Kimberling**
Illustrator **Mark Summers**
Publisher **Emmis**
Issue **October 2003**

463
Publication **Details**
Design Director **Rockwell Harwood**
Publisher **Condé Nast Publications Inc.**
Issue **June/July 2003**

464

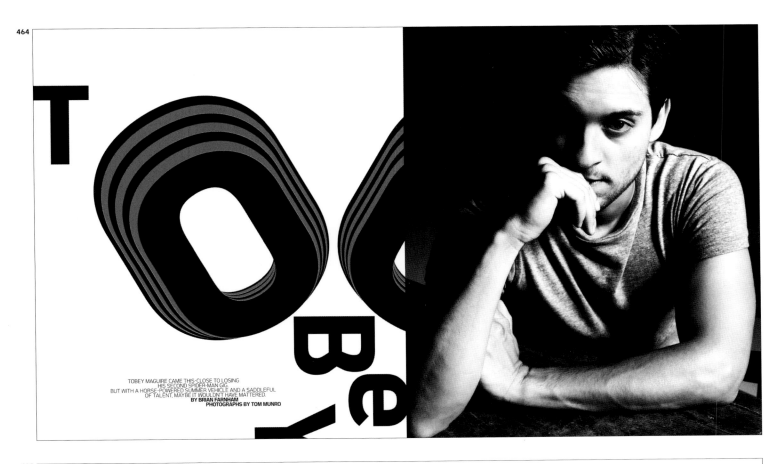

TOBEY MAGUIRE CAME THIS-CLOSE TO LOSING
HIS SECOND SPIDER-MAN GIG.
BUT WITH A HORSE-POWERED SUMMER VEHICLE AND A SADDLEFUL
OF TALENT, MAYBE IT WOULDN'T HAVE MATTERED.
BY BRIAN FARNHAM
PHOTOGRAPHS BY TOM MUNRO

465

*my*brain*tumor* For this 31-year-old guy, life was great until his body started jerking like a puppet and he woke up in the hospital with a hole in his skull. By Tom O'Connell Photographs by Philip Heying

HEAD CASE: Fifteen minutes before surgery. The author's skull has been swabbed with antiseptic and clamped tight in a vise. The tubes in his mouth aid breathing.

IN THE CUT: The surgeon holds up a piece of tumor that he's just removed. Ultimately, he would scoop out enough abnormal tissue to fill a Fancy Feast cat food can.

+ MERIT REPORTAGE PHOTOGRAPHY ENTIRE STORY

464
Publication Details
Design Director Rockwell Harwood
Publisher Condé Nast Publications Inc.
Issue August 2003

465
Publication Details
Design Director Rockwell Harwood
Publisher Condé Nast Publications Inc.
Issue November 2003

466

YOURS

A MOUNTING BODY OF EVIDENCE SUGGESTS THAT MANY, MANY STRAIGHT MEN ENJOY THE OCCASIONAL FINGER IN THE REAR. YES, A BIT OF PENETRATION AND PROSTATE PLAY CAN BE A FULFILLING PART OF A HETEROSEXUAL RELATIONSHIP BUT JUST TRY FINDING A GUY WHO'LL ADMIT IT. BY CARL SWANSON PHOTOGRAPHS BY MATT GUNTHER

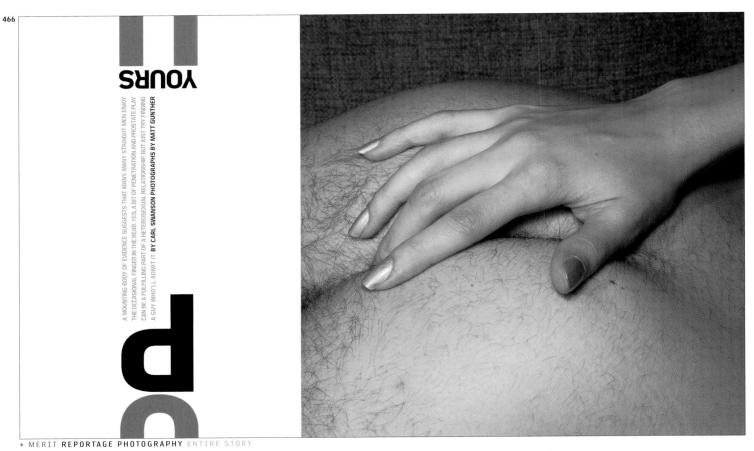

+ MERIT REPORTAGE PHOTOGRAPHY ENTIRE STORY

467

W

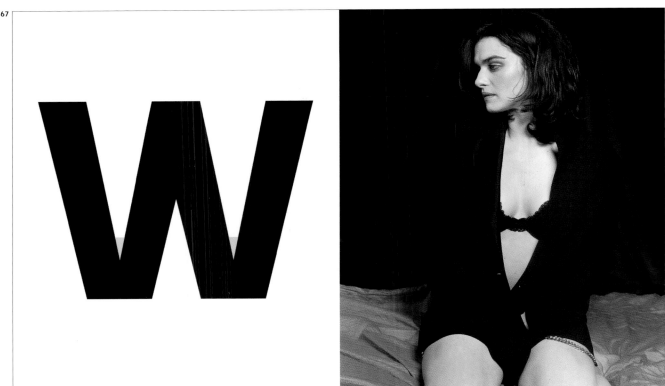

466
Publication **Details**
Design Director **Rockwell Harwood**
Photo Editor **Amy Steigbigel**
Publisher **Condé Nast Publications Inc.**
Issue **April 2003**

467
Publication **Details**
Design Director **Rockwell Harwood**
Publisher **Condé Nast Publications Inc.**
Issue **May 2003**

468

WHY WE SPEND THE WAY DADDY DIDN'T

HOW AMERICA FINALLY GREW A CROP OF YOUNG MEN WITH TASTE
OF THEIR OWN—AND THE CASH TO SHOW IT OFF.

BY CLIVE THOMPSON
PHOTOGRAPHS BY MIKAKO KOYAMA

469

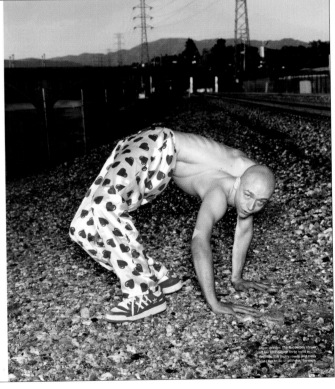

468
Publication **Details**
Design Director **Rockwell Harwood**
Photo Editor **Judith Puckett**
Photographer **Mikako Koyama**
Publisher **Condé Nast Publications Inc.**
Issue **September 2003**

469
Publication **Details**
Design Director **Rockwell Harwood**
Publisher **Condé Nast Publications Inc.**
Issue **June/July 2003**

470
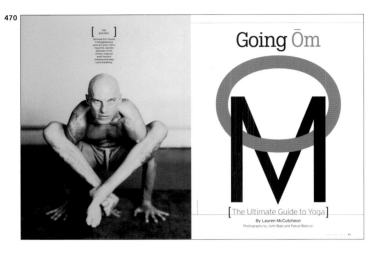

471
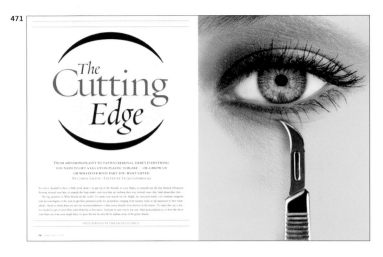

472
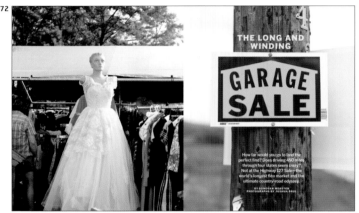

473

474
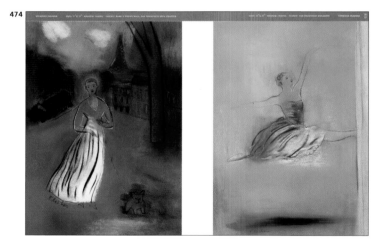

475
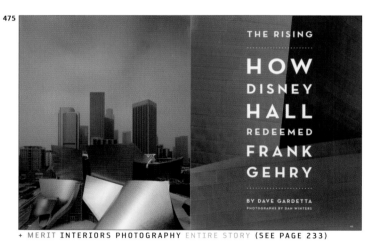

+ MERIT INTERIORS PHOTOGRAPHY ENTIRE STORY (SEE PAGE 233)

470
Publication **Philadelphia Magazine**
Art Director **Tim Baldwin**
Designer **John Goryl**
Photo Editor **Zoey Sless-Kitain**
Photographer **Pascal Blancon**
Publisher **Metrocorp**
Issue **May 2003**

471
Publication **Philadelphia Magazine**
Art Director **Tim Baldwin**
Designers **Tim Baldwin, John Goryl**
Photo Editor **Zoey Sless-Kitain**
Photographers **Pier Nicola D'Amico, Dominic Savini**
Publisher **Metrocorp**
Issue **February 2003**

472
Publication **Budget Living**
Design Director **Sheri Geller**
Designer **Sheri Geller**
Illustrator **Aaron Meshon**
Photo Editor **Julie Mihaly**
Photographer **Joshua Paul**
Publisher **Budget Living, LLC**
Issue **August/September 2003**

473
Publication **Virginia Living**
Art Director **Tyler Darden**
Photographers **Dementi Studio, Ezra Stoller**
Publisher **Cape Fear Publishing**
Issue **June 2003**

474
Publication **3x3**
Creative Director **Charles Hively**
Art Director **Sarah Munt**
Designers **Charles Hively, Sarah Munt**
Illustrator **Vivienne Flesher**
Photographer **Ward Schumaker**
Publisher **3x3**
Issue **Fall/Winter 2003**

475
Publication **Los Angeles**
Design Director **Joe Kimberling**
Photo Editor **Kathleen Clark**
Photographer **Dan Winters**
Publisher **Emmis**
Issue **October 2003**

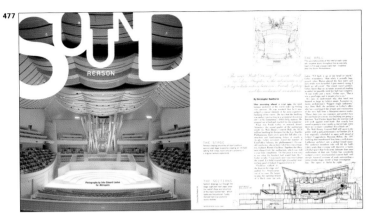

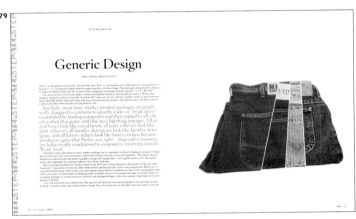

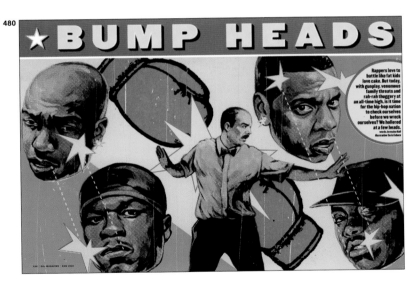

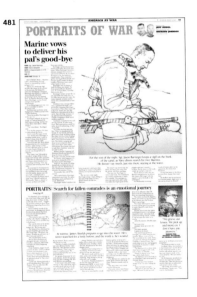

476
Publication **Print**
Creative Director **Steven Brower**
Designers **Maira Kalman, Nicci Gabriel**
Illustrator **Maira Kalman**
Publisher **F & W Publications**
Issue **September/October 2003**

477
Publication **Metropolis**
Art Director **Criswell Lappin**
Photo Editor **Sara Barrett**
Photographer **John Edward Linden**
Publisher **Bellerophon Publications**
Issue **October 2003**

478
Publication **Step inside design**
Art Director **Robert Valentine**
Designers **Brandon Jameson, Judy Minn**
Publisher **Dynamic Graphics Group**
Issue **November/December 2003**

479
Publication **Step inside design**
Art Director **Michael Ulrich**
Designer **Kathie Alexander**
Publisher **Dynamic Graphics Group**
Issue **July/August 2003**

480
Publication **XXL Magazine**
Art Directors **Rommel Alama, Davina Lennard**
Designer **Rommel Alama**
Photo Editor **Sally Berman**
Photographer **Tavis Coburn**
Publisher **Harris**
Issue **August 2003**

481
Publication **Detroit Free Press**
Design Director **Steve Dorsey**
Art Director **Richard Johnson**
Designer **Steve Anderson**
Illustrator **Richard Johnson**
Writer **Jeff Seidel**
Publisher **Knight-Ridder Newspapers**
Issue **March 27, 2003**

482

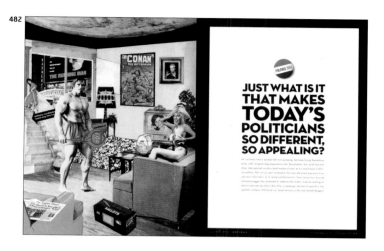

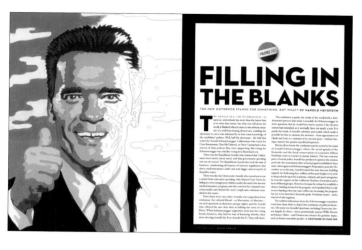

483

484

485

482
Publication **Los Angeles**
Design Director **Joe Kimberling**
Illustrators **John Craig, Daniel Adel, David Cowles**
Publisher **Emmis**
Issue **December 2003**

483
Publication **New York**
Design Director **David Matt**
Art Director **Robert Perino**
Designers **Robert Perino, Mae Ariola, Andrew Horton**
Illustrator **Viktor Koen**
Publisher **Primedia**
Issue **May 12-19, 2003**

484
Publication **Philadelphia Magazine**
Art Director **Tim Baldwin**
Designers **John Goryl, Tim Baldwin**
Photo Editor **Zoey Sless-Kitain**
Photographers **Pier Nicola D'Amico, Dominic Savini**
Publisher **Metrocorp**
Issue **February 2003**

485
Publication **Voyageur**
Art Director **Laura Petrides Wall**
Designer **Vickie McClintock**
Photographers **Kerrick James, Paul Rezendes, Tom Till, Laurence Parent, Cliff Biettel**
Publisher **Pace Communications**
Issue **July-September 2003**

486
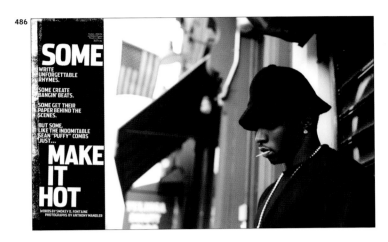

487
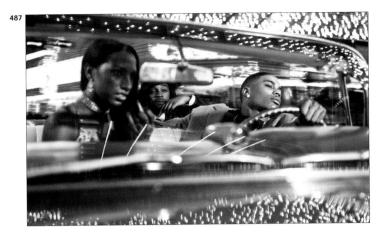

488
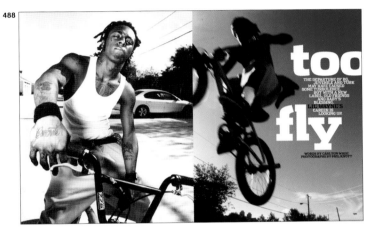

489
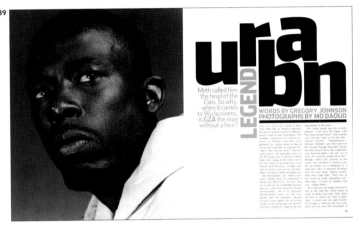

490
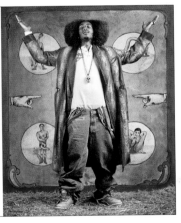

491
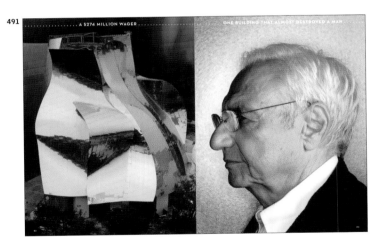

486
Publication **The Source**
Art Director **Paul Scirecalabrisotto**
Designers **Miguel Rivera, Hilary Sopczak**
Director of Photography **Katherine S. Schad**
Publisher **The Source Enterprises, Inc.**
Issue **May 2003**

489
Publication **The Source**
Art Director **Paul Scirecalabrisotto**
Designers **Miguel Rivera, Hilary Sopczak, Darhil Crooks**
Photographer **Mo Daoud**
Director of Photography **Katherine S. Schad**
Publisher **The Source Enterprises, Inc.**
Issue **January 2003**

487
Publication **The Source**
Art Director **Paul Scirecalabrisotto**
Designers **Miguel Rivera, Hilary Sopczak**
Photographer **Jim Fiscus**
Director of Photography **Katherine S. Schad**
Publisher **The Source Enterprises, Inc.**
Issue **January 2004**

490
Publication **The Source**
Art Director **Paul Scirecalabrisotto**
Designers **Miguel Rivera, Hilary Sopczak**
Photographer **Jim Fiscus**
Director of Photography **Katherine S. Schad**
Publisher **The Source Enterprises, Inc.**
Issue **November 2003**

488
Publication **The Source**
Art Director **Paul Scirecalabrisotto**
Designers **Miguel Rivera, Hilary Sopczak**
Photographer **Phil Knott**
Director of Photography **Katherine S. Schad**
Publisher **The Source Enterprises, Inc.**
Issue **December 2003**

491
Publication **Los Angeles**
Design Director **Joe Kimberling**
Photo Editor **Kathleen Clark**
Photographer **Dan Winters**
Publisher **Emmis**
Issue **October 2003**

492

Los colores de la vida | Buscando las búfalas de la mozzarella | El mejor guía para no perderse

MAGAZINE

EL ◆ MUNDO
n°197. Domingo 6 de julio de 2003

UN VERANO
EXTRAORDINARIO
NUEVA SECCIÓN
PARA APRENDER
DIVIRTIÉNDOSE
UN BICHO
UNA ISLA
UN HETERODOXO
EL KAMASUTRA

Irrepetibles

La odisea de dos periodistas
para encontrar a los personajes
más extraños que habitan
el planeta

POR VIRGINIE LUC Y GÉRARD RANCINAN

1

El hombre lobo

[Danny Ramoz, 22 años,
vive en México]

492
Publication **El Mundo Magazine**
Design Director **Carmelo Caderot**
Art Director **Rodrigo Sanchez**
Designers **Rodrigo Sanchez, María González**
Photo Editor **Rodrigo Sanchez**
Photographer **Gerard Rancinan**
Issue **July 6, 2003**

Irrepetibles

|por Virginie Luc. Fotografías de Gérard Rancinan|

3

Jeffrey Stanton Bell, ¿negro o blanco? Nació negro, pero el vitíligo está ganando la partida y la mayor parte de su cuerpo ya es de color blanco. Jeffrey, de 43 años, era un cotizado modelo en Nueva York hasta que esta enfermedad de la piel le retiró de las pasarelas, le dejó casi sin amigos y le sumió en la depresión y en la angustia. "Sólo tenía una obsesión: dar sentido a mi existencia", dice. Ha abandonado los tratamientos a base de rayos ultravioleta y ha decidido asumir su cambio de identidad. "Cuando comprendí que la naturaleza había hecho su camino y que sus pasos eran irreversibles, me dejé llevar por el río de la vida". Hoy regenta un bar en Manhattan y lee a los clásicos.

"Lo más doloroso es sentirse marginado, vivo una pesadilla. La gente teme que les contamine"

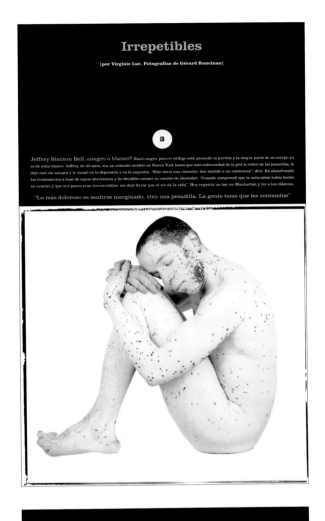

Irrepetibles

|por Virginie Luc. Fotografías de Gérard Rancinan|

5

Deb Teighlor, una modelo de 250 kilos. Un desarreglo hormonal y una enfermedad genética le han condenado a vivir recluida. A los 16 años ya pesaba 126 kilos, una cifra que ahora duplica. "Y lo que es peor, he sufrido lo equivalente en humillaciones y desprecios". Ante una vida llena de dificultades, Deb convirtió la comida en su válvula de escape. Decidió trabajar como modelo bajo el nombre artístico de Teighlor. "Es una forma de sentirme deseada", afirma. Esta norteamericana lidera una asociación de obesos de su país, que celebra el próximo día 5 su convención anual. "Queremos que cada cual aprenda a vivir con su cuerpo sin plegarse a la dictadura de lo socialmente correcto".

"A los gordos se nos trata como si fuéramos delincuentes"

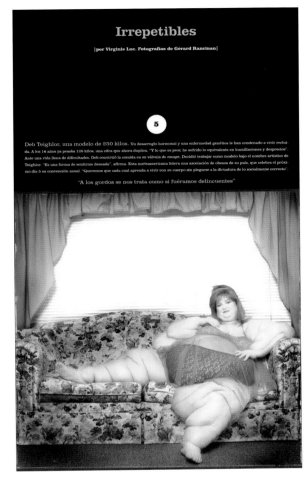

Irrepetibles

|por Virginie Luc. Fotografías de Gérard Rancinan|

4

Hervé Paillet, el actor sin piernas. Tenía tres años cuando se las amputaron. Su familia no podía cuidar de él y pasó la infancia y la adolescencia en centros de educación especial, donde se rebelaba contra la disciplina y la falta de libertad. "No vi prácticamente a mis padres". Encontró refugio en el teatro, la pintura y practicando halterofilia -fue campeón mundial- "para espantar mi locura". Y también en sus dos hijas. En la imagen sostiene a la pequeña, de 10 meses. La cortina oculta el estado de Hervé. "Lo más importante es que mis hijas no tengan miedo a hacerme daño, que exterioricen sus sentimientos". Para el actor, condenado a una silla de ruedas, "la vida tiene algo de prisión".

"Sólo deseo que mis hijas no aparten nunca la vista de mi cuerpo"

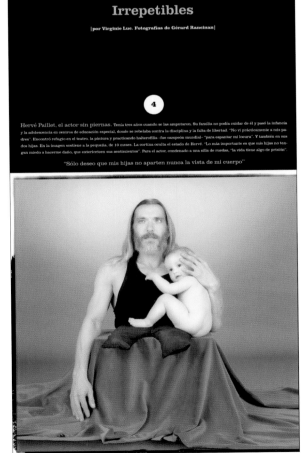

Irrepetibles

|por Virginie Luc. Fotografías de Gérard Rancinan|

6

Jimmy Vidales, 1,10 metros frente al toro. La vida de este colombiano cambió cuando, a los 20 años, conoció a los miembros de la compañía El Bombero Torero. Decidió abandonarlo todo y unirse a ellos. Desde entonces, recorre España y Latinoamérica ganándose la vida como matador de toros en un espectáculo cómico. "Aquí encontré, sin buscarlo, un lugar adecuado a mi tamaño". Hace cinco años que vive con una mujer de estatura normal y afirma que, aunque tuviera hijos enanos, no recurriría a la cirugía que permite estirar los huesos. "Reparar significa que algo está mal, pero ser pequeño no es una enfermedad. Yo soy pequeño, pero estoy entero y soy fuerte".

"La grandeza no está en el tamaño, sino en la conducta del hombre"

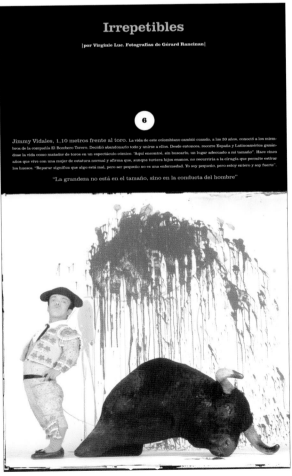

493
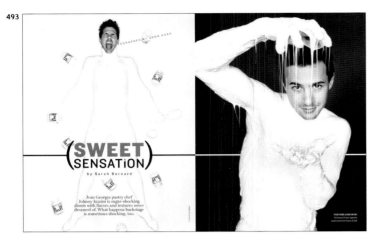

494
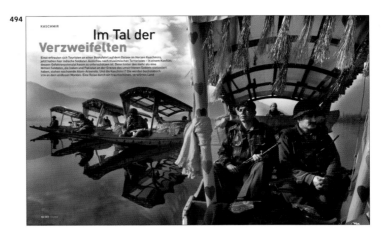

495
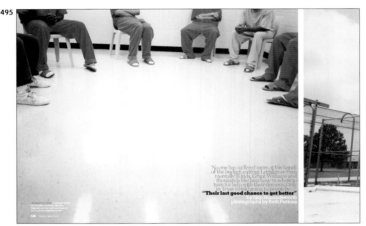

496
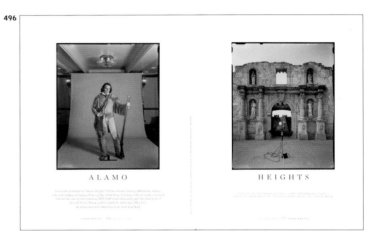

497
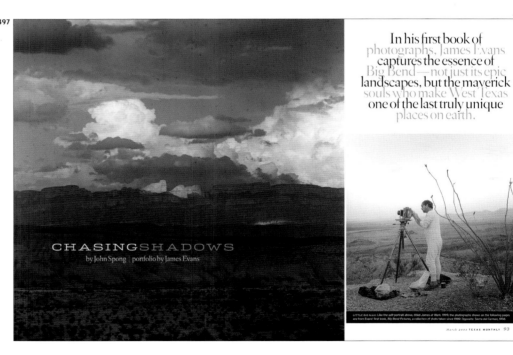

493
Publication **New York**
Design Director **David Matt**
Art Director **Robert Perino**
Designer **Robert Perino**
Photo Editors **Chris Dougherty, Armin Harris**
Photographer **John Huba**
Publisher **Primedia**
Issue **May 26, 2003**

494
Publication **GEO**
Art Director **Jutta Krueger**
Photo Editor **Venita Kaleps**
Photographer **Ami Vitale**
Director of Photography **Ruth Eichhorn**
Publisher **Gruner & Jahr**
Issue **October 2003**

495
Publication **Texas Monthly**
Art Director **Scott Dadich**
Designers **Scott Dadich, TJ Tucker**
Photo Editor **Scott Dadich**
Photographer **Beth Perkins**
Publisher **Emmis Communications Corp.**
Issue **November 2003**

496
Publication **Texas Monthly**
Art Director **Scott Dadich**
Designers **Scott Dadich, TJ Tucker**
Photo Editor **Scott Dadich**
Photographer **Dan Winters**
Publisher **Emmis Communications Corp.**
Issue **December 2003**

498

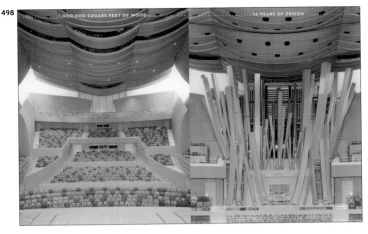

499

500

501

502

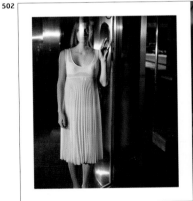

497
Publication **Texas Monthly**
Art Director **Scott Dadich**
Designer **Scott Dadich**
Photo Editor **Scott Dadich**
Photographer **James Evans**
Publisher **Emmis Communications Corp.**
Issue **March 2003**

500
Publication **Flair**
Creative Director **Alex Gonzalez**
Art Director **Ting Ting Lee**
Designer **Nobi Kashiwagi**
Photographer **Michael Thompson**
Studio **AR**
Publisher **Mondadori**
Issue **March 2003**

498
Publication **Los Angeles**
Design Director **Joe Kimberling**
Photo Editor **Kathleen Clark**
Photographer **Dan Winters**
Publisher **Emmis**
Issue **October 2003**

501
Publication **City**
Creative Director **Fabrice Frere**
Art Director **Adriana Jacoud**
Photo Editor **Piera Gelardi**
Photographer **Bharat Sikka**
Stylist **Wayne Gross**
Publisher **City Publishing L.L.C.**
Issue **Fall 2003**

499
Publication **Budget Living**
Design Director **Sheri Geller**
Designer **Sheri Geller**
Photo Editors **Julie Mihaly, Winnie Lee**
Photographer **Daniela Stallinger**
Publisher **Budget Living, LLC**
Issue **April/May 2003**

502
Publication **City**
Creative Director **Fabrice Frere**
Art Director **Adriana Jacoud**
Photo Editor **Piera Gelardi**
Photographer **Faubel Christensen**
Stylist **Beverley Hyde**
Publisher **City Publishing L.L.C.**
Issue **May/June 2003**

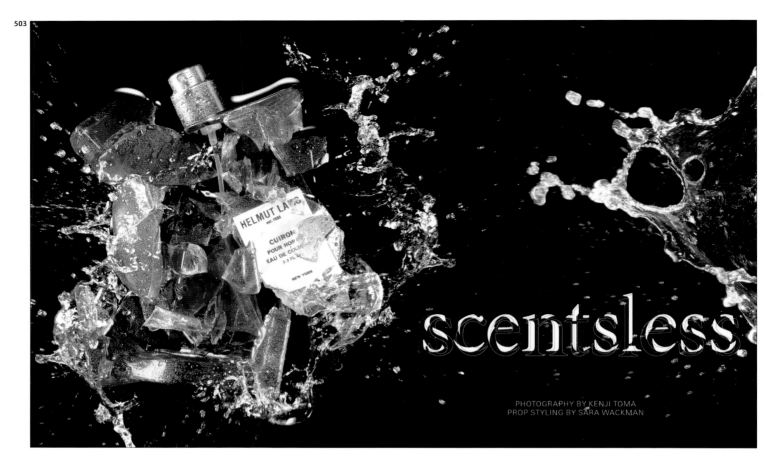

503
Publication **City**
Creative Director **Fabrice Frere**
Art Director **Adriana Jacoud**
Photo Editor **Piera Gelardi**
Photographer **Kenji Toma**
Prop Stylist **Sara Wacksman**
Publisher **City Publishing L.L.C.**
Issue **Winter 2003**

504
Publication **Mass Appeal**
Creative Director **Sally Thurer**
Design Director **Jill Topol**
Art Director **Sally Thurer**
Photo Editor **Angela Boatwright**
Photographer **Kenji Toma**
Studio **Apostrophe**
Publisher **Mass Appeal Magazine**
Issue **Number 22**

505
Publication **Technology Review**
Art Director **Linda Koury**
Designer **Jamie Dannecker**
Illustrator **5W Infographic**
Publisher **Massachusetts Institute of Technology**
Issue **December 2003/January 2004**

506

NOCTURNAL ADMISSIONS

WET DREAMS AREN'T JUST FOR OVERPRODUCTIVE YOUTH, AND THEY'RE NOTHING TO BE ASHAMED OF. (SO YOU MIGHT AS WELL LEARN TO ENJOY THEM.)

LITTLE TOMMY SHUNT WAS THE FIRST KID IN MY third-grade class to have a wet dream. He was also the oldest kid, having repeated the second grade. Tommy was a small-foreheaded, future janitor of a boy who once pinned his younger sister, Lisa, down on the soccer field and proceeded to push her shirt up and "milk them little titties" with his thumb and forefinger. (All names have been changed to protect the ignorant.) ¶ We all learned everything we knew about sex from Tommy, including such pearls as "Fags have long hair and eat each other's shit" and "Babies happen because your dad jerks off inside your mother's pee hole." ¶ When Tommy had a wet dream, he called a press conference at recess. Five of us boys huddled next to the swing set and Tommy explained what had happened. ¶ "I dreamed that Lizzy was licking me and wagging her tail and then she started humping me and then I turned around and started humping her and then all of a sudden, I started to feel it. It was like my whole body was exploding, but in a good way. And she started barking and then I woke up and my sheets were sticky." ¶ Most boys will at some point experience a wet dream, otherwise known as a nocturnal emission. They are completely natural and normal, the body's way of expelling extra semen during masturbatory dry spells. Many men look back on them fondly as the watershed between boyhood and manhood. And, contrary to what many people assume, some boys grow up to be men who still have wet dreams—on a regular basis (although some of them don't know it until they wake up to find soggy boxers or a girlfriend swabbing her leg) ¶ I was suspicious when I heard that some grown men have wet dreams. The closest I've ever come to having a wet dream as a man was pissing in bed when I was really, really drunk. ¶ "Well, they're sort of a pain," my friend Brian tells me. "It's like, I'm asleep, but I know I'm about to have one. And I can pull back and stop or I can just let it rip. But then what if my meat is poking out through my boxers? I don't want to shoot on Karen's legs or the sheets." ¶ Brian is typical of the men I spoke with who continue to have wet dreams as adults. He's a "regular guy" who is married, has sex less often than he'd like (not hourly, in other words), but gets laid enough. And when he feels frisky, he takes matters into his own hands. Still, he has wet dreams. ¶ Why is this? All the physiological evidence points to a simple answer just because. Some men need to ejaculate more semen than others. And if the hand won't do it, the body takes care of itself. (In more ways than one: A recent study suggests that frequent masturbation—and I'll assume a wet dream counts—helps significantly reduce the chance of getting prostate cancer.) Certain experts believe that wet dreams may also serve as a stress reliever, given that they occur most often in adolescents and young men, not the most Zen of demographics. So think of them as sexual circuit breakers. ¶ As most men know, wet dreams are often accompanied by alarming visuals. Family members, members of the same sex (if you're straight), or even animals are likely to appear in a variety of quite appalling scenarios. But however disturbing it may be to have an intense, sexual dream involving your pet and your sister, it is not uncommon. These dreams are not your subconscious telling you that you're a fruit or a beast lover. They're just dreams. ¶ So look at it this way: If you're over 16 and still being swept up in the occasional wet dream, you're holding on to a piece of childhood that a lot of men leave behind. In other words, you're not sick. You're lucky. ∎

SEPTEMBER 2003 **DETAILS** 125

507

ARCH DE TRIOMPHE

PHOTO-GRAPHS BY MARTIN PARR

506
Publication **Details**
Design Director **Rockwell Harwood**
Photo Editor **Judith Puckett**
Photographer **Augusten Burroughs**
Publisher **Condé Nast Publications Inc.**
Issue **September 2003**

507
Publication **Details**
Design Director **Rockwell Harwood**
Photographer **Martin Parr**
Publisher **Condé Nast Publications Inc.**
Issue **March 2003**

508

509

510

511
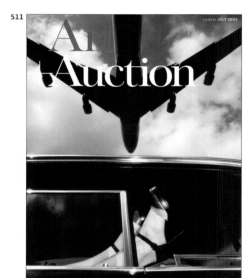

512

513

508
Publication **arcCA**
Design Director **Bob Aufuldish**
Designer **Bob Aufuldish**
Studio **Aufuldish & Warinner**
Publisher **McGraw-Hill/AIACC**
Client **American Inst. of Architects California
Council**
Issue **April 2003**

511
Publication **Art & Auction**
Creative Director **Stephen Wolstenholme**
Art Directors **Miranda Dempster, Tom Phillips**
Designer **Phoebe J. Flynn**
Photo Editor **Adam Beinash**
Photographer **Guy Bourdin**
Publisher **LTB Art**
Issue **July 2003**

509
Publication **Food Arts Magazine**
Art Director **Nancy Karamarkos**
Designers **Nancy Karamarkos, Fanny Li**
Photo Editor **Jessica Ochs**
Photographer **Peter Pioppo**
Stylist **Nir Adar**
Publisher **M.Shanken Communications**
Issue **September 2003**

512
Publication **InFurniture**
Design Director **Jean Griffin**
Art Directors **Michael Gambardella, Grace Alberto**
Designer **Grace Alberto**
Illustrator **Wen -Wyst Jean Mary**
Publisher **Fairchild Publications**
Issue **October 2003**

510
Publication **CMYK magazine**
Creative Director **Genéviève Astrelli**
Art Director **Amy Chang**
Illustrator **Jason Greenberg**
Publisher **Aroune-Freigen Publishing Co.**
Issue **Fall 2003**

513
Publication **@issue 9.1**
Creative Director **Kit Hinrichs**
Designer **Maria Wenzel**
Illustrators **Yvette Fedorova, Seymour Chwast**
Photographers **Barry Robinson, Jock McDonald**
Studio **Pentagram Design, SF**
Publisher **Corporate Design Foundation**
Client **Sappi Fine Papers**
Issue **Fall 2003**

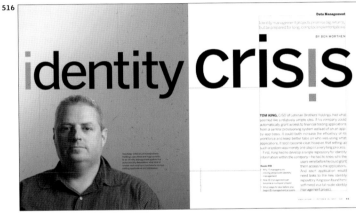

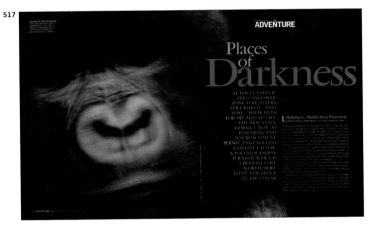

514
Publication **Network Magazine**
Art Director **David Yamada**
Designers **Peter Casella, Bob Powers**
Illustrator **Ryan Etter**
Publisher **CMP Media**
Issue **November 2003**

515
Publication **CIO Magazine**
Creative Director **Mary Lester**
Art Director **Kaajal Asher**
Designer **Kaajal Asher**
Photographer **Steven Vote**
Publisher **CXO Media**
Issue **October 2003**

516
Publication **DWR Profile**
Art Director **Jennifer Morla**
Designers **Jennifer Morla, Hizam Heron, Brian Singer**
Photographers **Russell Abraham, Bill Acheson, Tony Cunba, Stephano Massei, Julius Shulman**
Studio **Morla Design**
Publisher **Design Within Reach**
Issue **2003**

517
Publication **National Geographic Adventure**
Design Director **Julie Curtis**
Designer **David Huang**
Photo Editor **Sabine Meyer**
Photographer **Michael Nichols**
Publisher **National Geographic Society**
Issue **December/January 2003**

518
Publication **Information Week**
Creative Director **Michael Gigante**
Art Director **Mary Ellen Forte**
Designer **Mary Ellen Forte**
Illustrator **Christoph Niemann**
Publisher **CMP Media**
Issue **June 30, 2003**

519

520

521

522
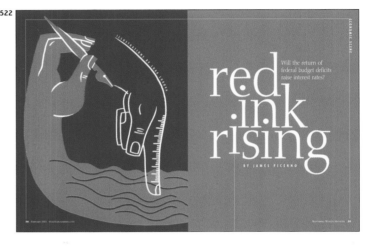

523
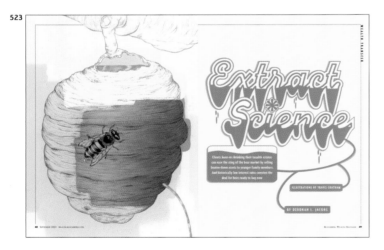

524
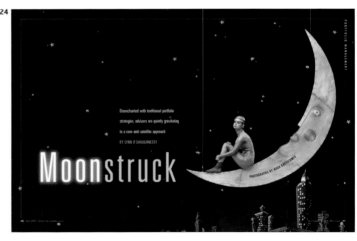

519
Publication **Bloomberg Wealth Manager**
Art Directors **Laura Zavetz,**
Beatrice McDonald-Burke
Designer **Frank Tagariello**
Photographer **Rodney Smith**
Publisher **Bloomberg L.P.**
Issue **July/August 2003**

520
Publication **Bloomberg Wealth Manager**
Art Directors **Laura Zavetz,**
Beatrice McDonald-Burke
Designer **Laura Zavetz**
Photographer **Hugh Kretschmer**
Publisher **Bloomberg L.P.**
Issue **April 2003**

521
Publication **Bloomberg Wealth Manager**
Art Directors **Laura Zavetz,**
Beatrice McDonald-Burke
Photographer **Gary Taxali**
Publisher **Bloomberg L.P.**
Issue **December 2003**

522
Publication **Bloomberg Wealth Manager**
Art Directors **Laura Zavetz,**
Beatrice McDonald-Burke
Illustrator **Luba Lukova**
Publisher **Bloomberg L.P.**
Issue **February 2003**

523
Publication **Bloomberg Wealth Manager**
Art Directors **Laura Zavetz,**
Beatrice McDonald-Burke
Designer **Beatrice McDonald-Burke**
Illustrator **Travis Chatham**
Publisher **Bloomberg L.P.**
Issue **September 2003**

524
Publication **Bloomberg Wealth Manager**
Art Directors **Laura Zavetz,**
Beatrice McDonald-Burke
Designer **Laura Zavetz**
Photographer **Hugh Kretschmer**
Publisher **Bloomberg L.P.**
Issue **May 2003**

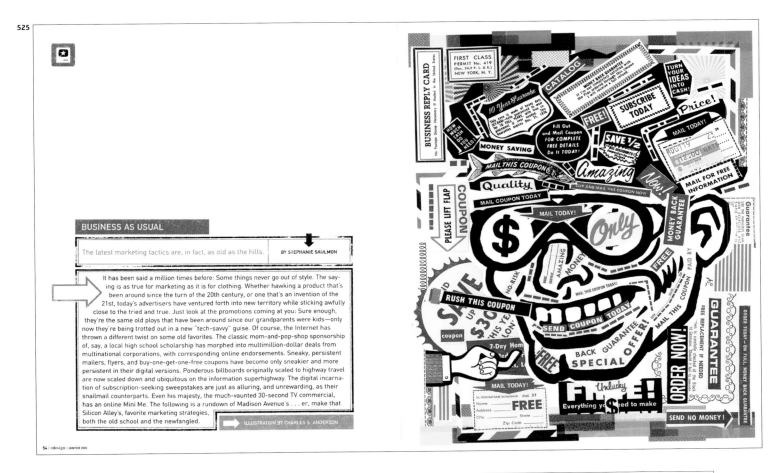

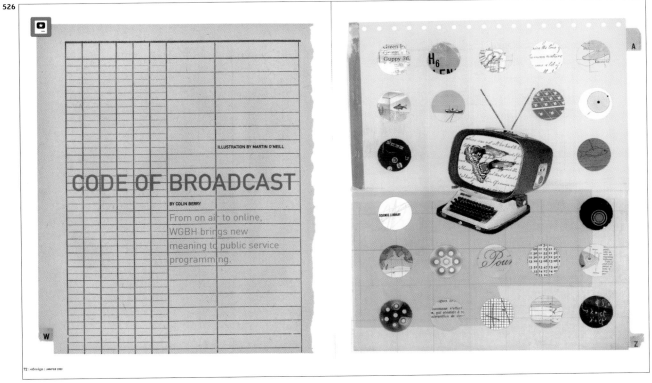

525
Publication **eDesign**
Art Director **Anke Stohlmann**
Designer **Anke Stohlmann**
Illustrator **Charles S. Anderson**
Publisher **eDesign Communications Inc.**
Issue **February 2003**

526
Publication **eDesign**
Art Director **Anke Stohlmann**
Designer **Anke Stohlmann**
Illustrator **Martin O'Neill**
Publisher **eDesign Communications Inc.**
Issue **February 2003**

527

528

529

530

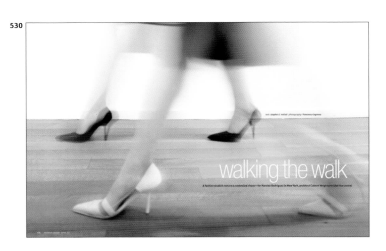

531

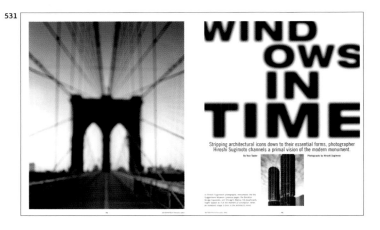

532

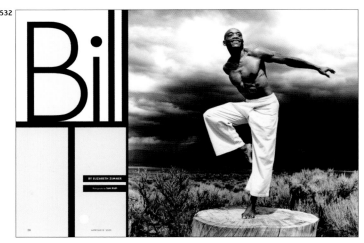

527
Publication **Interior Design**
Art Director **Claudia P. Marulanda**
Designer **Claudia P. Marulanda**
Photographer **Starwood Hotels**
Publisher **Reed Business Information**
Issue **March 2003**

528
Publication **CRN**
Art Director **David Nicastro**
Designer **Giulia Fini-Pobjecky**
Illustrator **Christoph Niemann**
Publisher **CMP Media LLC**
Issue **April 2003**

529
Publication **Art & Auction**
Creative Director **Stephen Wolstenholme**
Art Director **Miranda Dempster**
Designers **Tom Phillips, Phoebe J. Flynn**
Photo Editor **Adam Beinash**
Photographer **Jason Schmidt**
Publisher **LTB Art**
Issue **October 2003**

530
Publication **Interior Design**
Art Director **Claudia P. Marulanda**
Designer **Claudia P. Marulanda**
Photographer **Francesco Lagnese**
Publisher **Reed Business Information**
Issue **April 2003**

531
Publication **Metropolis**
Art Director **Criswell Lappin**
Photo Editor **Sara Barrett**
Photographer **Hiroshi Sugimoto**
Publisher **Bellerophon Publications**
Issue **November 2003**

532
Publication **Dance Magazine**
Art Director **James Lambertus**
Designer **James Lambertus**
Photographers **Len Irish, Bruce Feeley,
Lois Greenfield**
Publisher **Macfadden Dance Magazine , L.L.C.**
Issue **November 2003**

533
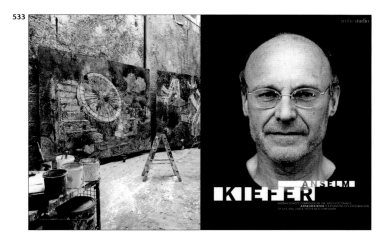

534

535

536

537

538

533
Publication **Art & Auction**
Creative Director **Stephen Wolstenholme**
Art Directors **Miranda Dempster, Tom Phillips**
Designer **Phoebe J. Flynn**
Photo Editor **Adam Beinash**
Photographer **Wist Thorpe**
Publisher **LTB Art**
Issue **July, 2003**

536
Publication **The American Lawyer**
Art Director **Joan Ferrell**
Illustrator **John Ritter**
Publisher **American Lawyer Media**
Issue **December 2003**

534
Publication **Art & Auction**
Creative Director **Stephen Wolstenholme**
Art Directors **Miranda Dempster, Tom Phillips**
Designer **Phoebe J. Flynn**
Photo Editor **Adam Beinash**
Photographers **Christopher Sturman, Diana LIU,
Adam Beinash, Suzy Poling**
Publisher **LTB Art**
Issue **December 2003**

537
Publication **CSO**
Art Director **Steve Traynor**
Illustrator **Serge Bloch**
Publisher **CXO Media Inc.**
Issue **March 2003**

535
Publication **IEEE Spectrum**
Art Director **Mark Montgomery**
Illustrator **Tavis Coburn**
Publisher **IEEE**
Issue **May 2003**

538
Publication **Optimize**
Creative Director **Micheal Gigante**
Art Director **Douglas Adams**
Designer **Douglas Adams**
Illustrator **Gary Taxali**
Publisher **CMP Media**
Issue **July 2003**

539

540

541

542

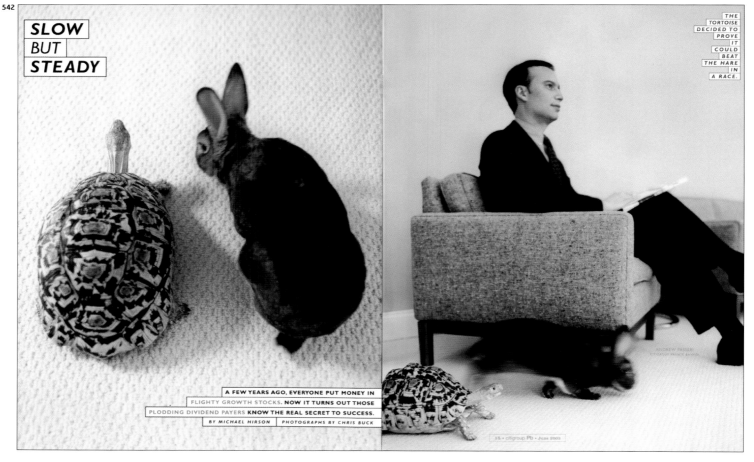

539
Publication **Attaché**
Art Director **Holly Holliday**
Designers **Jennifer Hill, Holly Holliday**
Photographer **Mark Wagoner**
Publisher **Pace Communications**
Client **U.S. Airways**
Issue **June 2003**

540
Publication **Attaché**
Art Director **Holly Holliday**
Designers **Jennifer Hill, Holly Holliday**
Photographer **Mark Wagoner**
Publisher **Pace Communications**
Client **U.S. Airways**
Issue **October 2003**

541
Publication **C - The Design of Culture**
Creative Director **Cheryl Heller**
Designer **Karina Hadida**
Photo Editor **Jennifer Miller**
Director of Photography **Alice Rose George**
Director of Research **Ingrid Caruso**
Publisher **Stora Enso North America**
Issue **May 2003**

542
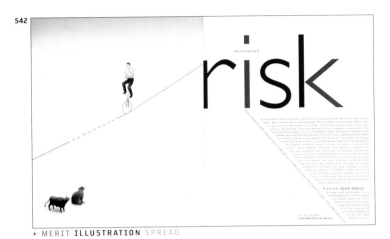

+ MERIT ILLUSTRATION SPREAD

544

543
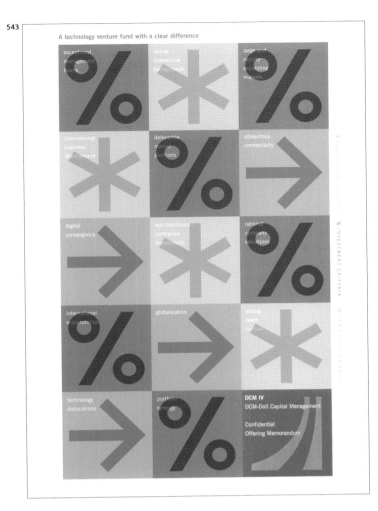

545

542
Publication **Citigroup PB**
Creative Director **Carin Goldberg**
Art Director **Jason Lancaster**
Photo Editor **Linda Fernbacher**
Publisher **Time Inc. Custom Publishing**
Issue **June 2003**

545
Publication **Quarterly**
Creative Director **Mike Meire**
Art Director **Mirko Borsche**
Designer **Kurt Wilhelm**
Photo Editor **Tamara Hansinger**
Studio **Meire und Meire**
Publisher **Hoffmann und Campe Verlag GmbH, Hamburg**
Client **BMW AG, Munich**
Issue **June 2003**

543
Publication **Offering Memorandum**
Creative Director **Earl Gee**
Designers **Earl Gee, Fani Chung**
Illustrator **Earl Gee**
Photographer **Geoffrey Nelson**
Studio **Gee + Chung Design**
Publisher **DCM-Doll Capital Management**
Issue **December 15, 2003**

544
Publication **Wildwest Timer 2004**
Creative Director **Frank M. Orel**
Art Director **Dennis Orel**
Designer **Dennis Orel**
Illustrator **Dennis Orel**
Photographers **Mike Nanz, Patrick Dembski**
Publisher **Fotostudio Frank M. Orel**

546

547
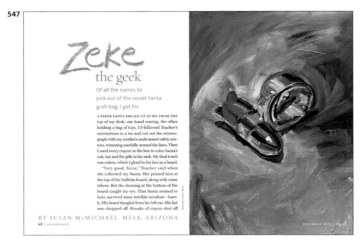

548

549

550
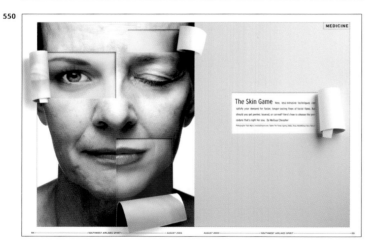

551
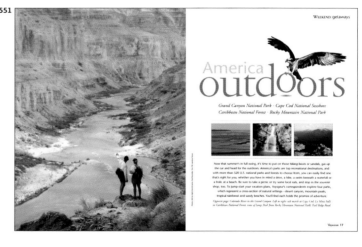

546
Publication **Feat**
Creative Director **Robb Allen**
Art Director **Jennifer Napier**
Designer **Patricia Ryan**
Photo Editor **Danielle Place**
Publisher **Hachette Filipacchi Custom Publishing**
Client **The Rockport Company**
Issue **Spring /Summer 2003**

549
Publication **My Ford**
Creative Director **Carin Goldberg**
Design Director **Chris Teoh**
Art Director **Jason Mischka**
Photo Editor **Jonathan Kane**
Assist. Art Director **Randi Brookman**
Publisher **Time Inc. Custom Publishing**
Client **Ford Motor Company**
Issue **Fall 2003**

547
Publication **Guideposts**
Creative Director **Francesca Messina**
Art Director **Francesca Messina**
Designer **Francesca Messina**
Illustrator **Tom Christopher**
Publisher **Guideposts**
Issue **December 2003**

550
Publication **Southwest Airlines Spirit Magazine**
Design Director **JR Arebalo**
Art Director **Dianne Gibson**
Photographer **Tadd Myers**
Publisher **AA Publishing**
Issue **August 2003**

548
Publication **Southwest Airlines Spirit Magazine**
Design Director **JR Arebalo**
Art Director **Dianne Gibson**
Illustrator **Scott Garrett**
Photographer **Tadd Myers**
Publisher **AA Publishing**
Issue **December 2003**

551
Publication **Voyageur**
Art Director **Laura Petrides Wall**
Designer **Vickie McClintock**
Photographers **Kerrick James, Paul Rezendes, Tom Till, Laurence Parent, Cliff Biettel**
Publisher **Pace Communications**
Issue **July-September 2003**

552
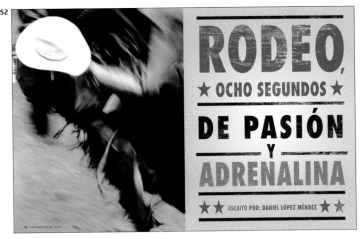

553

554
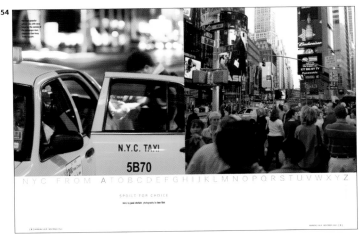

555

556

557

552
Publication **Departures**
Creative Director **Bernard Scharf**
Art Director **Trent Johnson**
Designer **Bernard Scharf**
Photo Editor **Alice Albert**
Photographer **Victor Schrager**
Publisher **American Express Publishing Co.**
Issue **January/February 2003**

555
Publication **NYSE Magazine**
Creative Director **Carin Goldberg**
Art Director **Kristina DiMatteo**
Designer **Shigeto Akiyama**
Photo Editors **Bess Hauser, Julie Claire**
Publisher **Time Inc. Custom Publishing**
Client **NYSE**
Issue **May/June 2003**

553
Publication **Fibra 8**
Creative Director **Piedad Rivadeneira**
Designers **Piedad Rivadeneira, Renato Diaz,
Ines Picchetti**
Photographer **Joseph Desler Costa**
Publisher **Telefonica CTC Chile**
Issue **May 2003**

556
Publication **Hallmark Magazine**
Creative Director **Roe Intrieri**
Design Director **Liza Aelion**
Designer **Sara Viñas**
Photo Editor **Grace How**
Photographer **William Meppem**
Studio **The Publishing Agency**
Client **Hallmark**
Issue **May/June 2003**

554
Publication **Morning Calm**
Creative Director **Davide Butson**
Art Director **Hyzein Kamarudin**
Photo Editor **Jennifer Spencer Kentrup**
Photographer **Ben Fink**
Studio **Emphasis Media Ltd.**
Client **Korean Air**
Issue **November 2003**

557
Publication **Edition Two**
Creative Director **Horst Moser**
Designer **Horst Moser**
Photo Editor **Horst Moser**
Photographers **Hans Doering, Marion Eiber**
Studio **Independent Medien Design**
Publisher **Allianz AG**
Issue **March 2003**

558

559
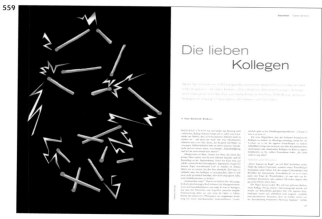

560
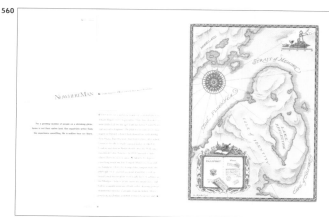

561
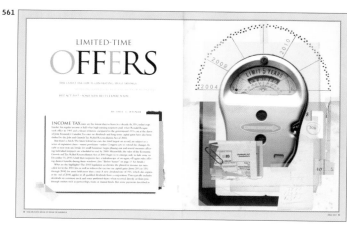

562
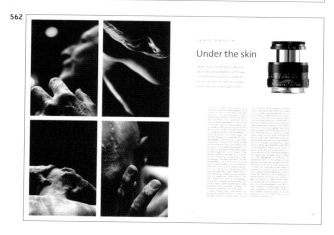

563
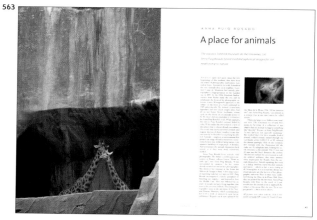

558
Publication **Citigroup PB**
Creative Director **Carin Goldberg**
Art Director **Jason Lancaster**
Illustrator **Nick Dewar**
Photo Editor **Linda Fernbacher**
Publisher **Time Inc. Custom Publishing**
Issue **October 2003**

561
Publication **The Private Bank**
Creative Director **Carin Goldberg**
Design Director **Lisa DiLillo**
Designer **Lisa DiLillo**
Illustrator **Lisa Franke**
Publisher **Time Inc. Custom Publishing**
Client **Bank of America**
Issue **Fall 2003**

559
Publication **Forum**
Creative Director **Horst Moser**
Designer **Petra Schmidt**
Illustrator **Pierre Thomé**
Photo Editor **Andrea Roth**
Studio **Independent Medien-Design**
Publisher **Independent Medien-Design**
Issue **December 2003**

562
Publication **Leica World**
Creative Director **Horst Moser**
Designer **Horst Moser**
Photo Editors **Michael Koetzle, Horst Moser**
Photographer **Jamie Drouin**
Studio **Independent Medien-Design**
Publisher **Leica Camera AG**
Issue **February 2003**

560
Publication **Hemispheres**
Design Director **Jaimey Easler**
Art Director **Jody Mustain**
Designer **Jaimey Easler**
Illustrator **Lazlo Kubinyi**
Publisher **Pace Communications**
Client **United Airlines**
Issue **January 2003**

563
Publication **Leica World**
Creative Director **Horst Moser**
Designer **Horst Moser**
Photo Editors **Michael Koetzle, Horst Moser**
Photographer **Anna Puig Rosado**
Studio **Independent Medien-Design**
Publisher **Leica Camera AG**
Issue **February 2003**

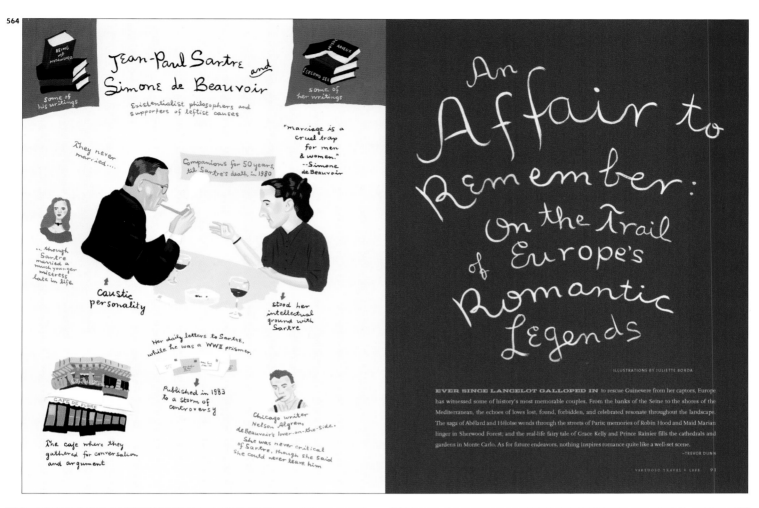

564
Publication **Travel+Life**
Art Director **Rick Jost**
Illustrator **Juliette Borda**
Publisher **Virtuoso**
Issue **January/February 2003**

565
Publication **Southwest Airlines Spirit Magazine**
Design Director **JR Arebalo**
Art Director **Dianne Gibson**
Illustrator **Anita Kunz**
Publisher **AA Publishing**
Issue **July 2003**

566
Publication **5**
Creative Director **Vickie Peslak**
Designer **Matt Bouloutian**
Photographer **David Ferrua**
Studio **Platinum Design Inc.**
Publisher **Hearst Custom Publishing**
Client **Saks Fifth Avenue**
Issue **Holiday 2003**

567

Garden Of
Unearthly Delights

Egyptian scarabs, Victorian butterflies, Art Nouveau dragonflies.
Jewelry designers have always been captivated by creatures and critters.

By Kathleen Fitzpatrick and Capucine Irato Hoybach

Photographs by Gentl & Hyers

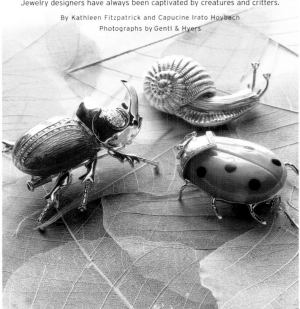

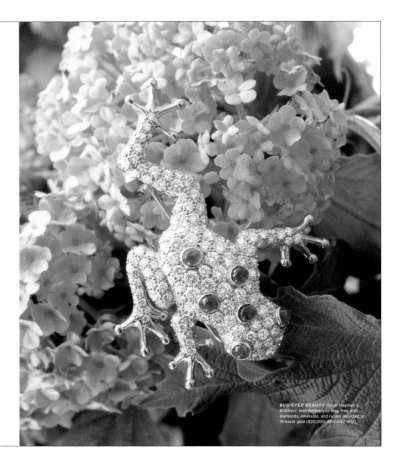

RANDOM HARVEST Tiffany & Co.'s gold and green enamel beetle brooch with diamonds ($8,500; 800-526-0649). Kentshire's ca. 1950 French snail brooch in gold with turquoise and diamonds ($3,650; 212-872-8653). Coral, diamond, and gold ladybug brooch from Aaron Basha ($2,400; 212-935-1960).

BUG-EYED BEAUTY Oscar Heyman & Brothers' look-before-you-leap frog with diamonds, emeralds, and rubies mounted in 18-karat gold ($30,000; 800-642-1912).

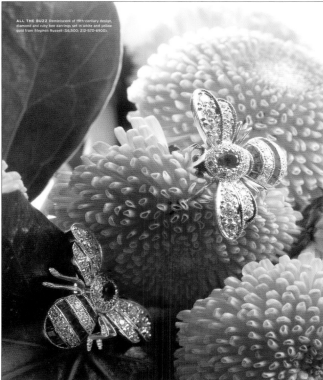

ALL THE BUZZ Reminiscent of 19th-century design, diamond and ruby bee earrings set in white and yellow gold from Stephen Russell ($6,500; 212-570-6900).

SUMMER CRITTER Enamel and 18-karat gold cicada with diamonds and sapphires from Nardi ($4,600; 212-974-9360).

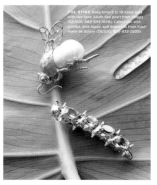

THE STING Wasp brooch in 18-karat gold with two-tone South-Sea pearl from Hirops ($6,500; 888-893-1648). Caterpillar with peridot, blue topaz, and diamonds from Kaufmann de Suisse ($8,500; 800-832-2300).

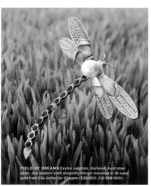

FIELD OF DREAMS Ceylon sapphire, diamond, Australian pearl, and abalone shell dragonfly brooch mounted in 18-karat gold from Ella Gafter for Ellagem ($38,000; 212-398-0101).

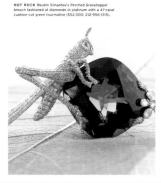

HOT ROCK Reubin Simantov's Perched Grasshopper brooch fashioned of diamonds in platinum with a 47-carat cushion-cut green tourmaline ($52,000; 212-956-1315).

567
Publication **Departures**
Creative Director **Bernard Scharf**
Art Director **Trent Johnson**
Designer **Bernard Scharf**
Photo Editor **Alice Albert**
Photographer **Gentl + Hyers**
Publisher **American Express Publishing Co.**
Issue **July/August 2003**

568
Publication **Departures**
Creative Director **Bernard Scharf**
Art Director **Trent Johnson**
Designer **Bernard Scharf**
Photo Editor **Alice Albert**
Photographer **Victor Schrager**
Publisher **American Express Publishing Co.**
Issue **January/February 2003**

568

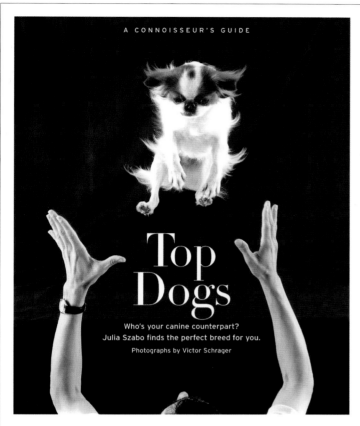

A CONNOISSEUR'S GUIDE

Top Dogs

Who's your canine counterpart?
Julia Szabo finds the perfect breed for you.

Photographs by Victor Schrager

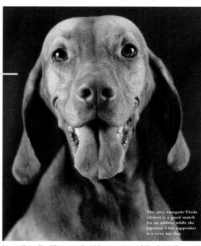

t's a February evening in Manhattan as thousands of people dressed in black tie pour into Madison Square Garden—a small fraction of the 2.8 million who will be watching this event on television. Backstage, two handlers hover over their starlet with feverish intensity. One is coaxing a swath of hair from a curler and lovingly blowing it dry. The other is fussing over a pedicure with a

The spry, energetic Vizsla (above) is a good match for an athlete, while the Japanese Chin (opposite) is a cozy lap dog.

long silver file. They are slavishly attentive, while their charge sits silently, patiently, exuding a bemused condescension—her nose in the air, her thoughts evidently elsewhere. She's not a supermodel, but she might as well be. She is a standard poodle being primped for her turn in the spotlight at the annual Westminster Kennel Club Dog Show, where she will compete with 150 other breeds for the title Best in Show.

99

569

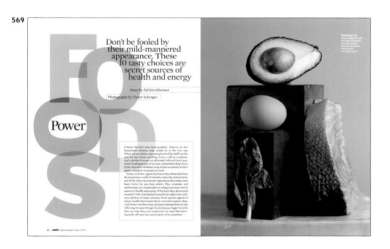

Don't be fooled by their mild-mannered appearance. These 10 tasty choices are secret sources of health and energy

Story by Sid Kirchheimer

Photographs by Victor Schrager

Power FOODS

570

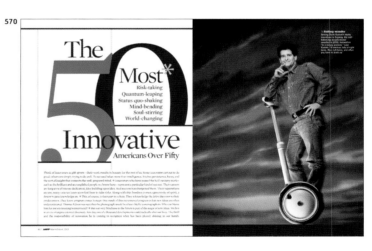

The 50 Most*
Risk-taking
Quantum-leaping
Status quo-shaking
Mind-bending
Soul-stirring
World-changing

Innovative Americans Over Fifty

571

[∞ | EVERLASTING]

569
Publication **AARP The Magazine**
Creative Director **Carl Lehmann-Haupt**
Design Director **Eric Seidman**
Art Director **Courtney Murphy Price**
Designer **Courtney Murphy Price**
Photo Editor **Wendy Tiefenbacher**
Publisher **AARP**
Issue **March/April 03**

571
Publication **Everlasting**
Design Director **Isaac Gertman**
Designers **Isaac Gertman, Lily Smith +
Kirkley, Kirk von Rohr**
Publisher **Maryland Institute College of Art**
Client **Maryland Institute College of Art**
Issue **January 2003**

570
Publication **AARP The Magazine**
Creative Director **Carl Lehmann-Haupt**
Design Director **Eric Seidman**
Art Director **Courtney Murphy Price**
Designers **Courtney Murphy Price, Gina Toole,
Charlotte Van Wagner, David Vogin, Lynn Murphy, Jakki Sears**
Illustrator **Francisco Caceres**
Photo Editors **Jessida Day, Wendy Tiefenbacher, Sarah Hoff,
Madeline Dance**
Photographers **Scogin Mayo, Victor Schrager**
Publisher **AARP**
Issue **September/October 2003**

571
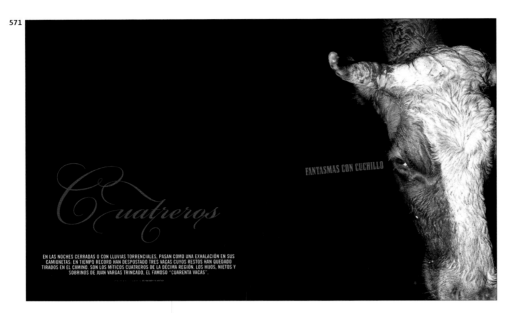

572
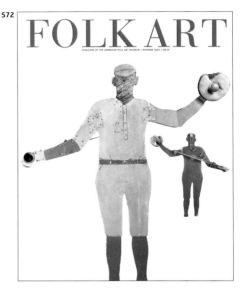

573

574

575

571
Publication **Fibra 14**
Creative Director **Piedad Rivadeneira**
Designers **Piedad Rivadeneira, Renato Diaz,**
Ines Picchetti
Photographer **Roberto Farias**
Publisher **Telefonica CTC Chile**
Issue **November 2003**

573
Publication **Asiatica**
Creative Director **Kelly Doe**
Designer **Kelly Doe**
Photo Editor **Kelly Doe**
Photographer **John Tsantes**
Studio **Kelly Doe Studio**
Publisher **Sackler Freer Galleries**
Issue **2003**

572
Publication **Folk Art**
Art Director **Jeffrey Kibler**
Studio **The Magazine Group**
Publisher **American Folk Art Museum**
Issue **Summer 2003**

574
Publication **Perla**
Designers **Coral Diaz, Barbara Schelling**
Illustrator **Peter Arkle**
Studio **Pale**
Publisher **Perla**
Issue **April/May 2003**

575
Publication **Sundance Institute Case Statement**
Design Director **Don Morris**
Art Director **Josh Klenert**
Designers **Jennifer Starr, Robert Morris**
Photographer **Len Jenshel**
Studio **Don Morris Design**
Publisher **Sundance Institute**
Issue **2003**

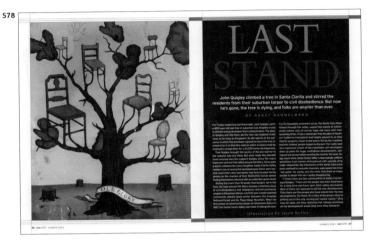

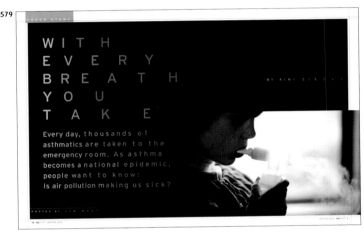

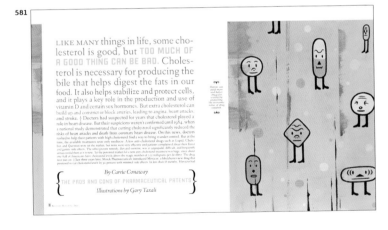

576
Publication **Christian Research Journal**
Creative Director **Dwayne Cogdill**
Designer **Dwayne Cogdill**
Studio **Cognition Design**
Publisher **Christian Research Institute**
Issue **Volume 25/Number 03**

577
Publication **Discipleship Journal**
Designer **Adele Mulford**
Senior Art Director **Anne Meskey Elhajoui**
Publisher **NavPress**
Issue **July/August 2003**

578
Publication **OnEarth**
Art Director **Gail Ghezzi**
Designer **Gail Ghezzi**
Illustrator **Jason Holley**
Issue **Summer 2003**

579
Publication **OnEarth**
Art Director **Gail Ghezzi**
Designer **Gail Ghezzi**
Photographer **Jim West**
Issue **Winter 2003**

580
Publication **Common Ground: Preserving Our
Nation's Heritage**
Creative Director **David Andrews**
Designer **David Andrews**
Photo Editor **David Andrews**
Photographers **Jack E. Boucher, Richard Nickel,
Ronald Partridge, Marvin Rand, Cervin Robinson,
Walter Smalling, Jr.**
Publisher **National Park Service**
Issue **Fall 2003**

581
Publication **Regional Review**
Design Director **Ronn Campisi**
Illustrator **Gary Taxali**
Studio **Ronn Campisi Design**
Publisher **Federal Reserve Bank**
Issue **Quarter I, 2003**

582
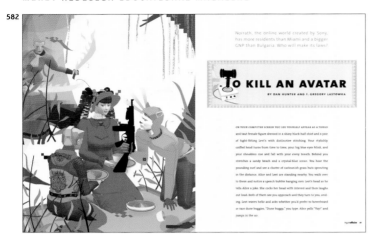

583

584
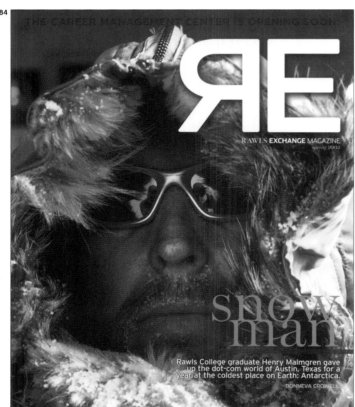

584

585
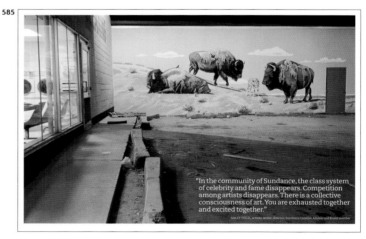

582
Publication **Legal Affairs**
Creative Director **Alissa Levin**
Art Director **Benjamin Levine**
Designers **Alissa Levin, Benjamin Levine**
Illustrator **Justin Wood**
Studio **Point Five Design**
Publisher **Legal Affairs, Inc.**
Issue **July/August 2003**

583
Publication **Teaching Tolerance**
Design Director **Russell Estes**
Illustrator **Craig Frazier**
Publisher **Southern Poverty Law Center**
Issue **Spring 2003**

584
Publication **Rawls Exchange Magazine**
Creative Director **Artie Limmer**
Designers **Alyson Keeling Cameron, TJ Tucker**
Illustrator **TJ Tucker**
Photographers **Artie Limmer, Joey Hernandez,
Melissa Frazier**
Publisher **Texas Tech University**
Issue **Spring 2003**

585
Publication **Sundance Institute Case Statement**
Design Director **Don Morris**
Art Director **Josh Klenert**
Designers **Jennifer Starr, Robert Morris**
Photographer **Len Jenshel**
Studio **Don Morris Design**
Publisher **Sundance Institute**
Issue **2003**

586
Publication **Vistas: Texas Tech Research**
Creative Director **Artie Limmer**
Designer **TJ Tucker**
Photographer **Artie Limmer**
Publisher **Texas Tech University**
Issue **Winter 2003**

587
Publication **Vistas: Texas Tech Research**
Creative Director **Artie Limmer**
Art Director **Misty Pollard**
Designer **Misty Pollard**
Photographer **Melissa Frazier**
Publisher **Texas Tech University**
Issue **Summer 2003**

586

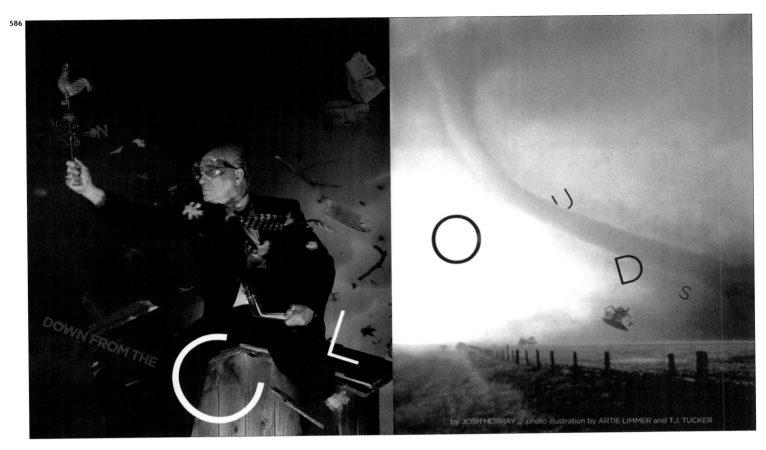

DOWN FROM THE

by JOSH MURRAY // photo illustration by ARTIE LIMMER and T.J. TUCKER

587

Living Partnership

588

589

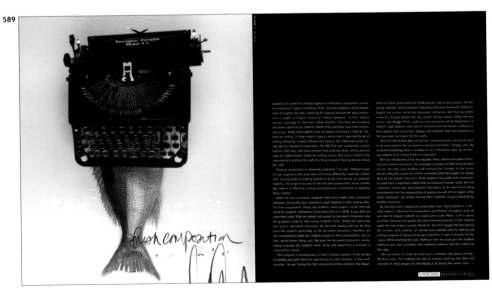

fresh composition

588
Publication **Vistas: Texas Tech Research**
Design Director **Misty Pollard**
Designer **Misty Pollard**
Publisher **Texas Tech University**
Issue **Summer 2003**

589
Publication **Vistas: Texas Tech Research**
Creative Director **Artie Limmer**
Art Director **TJ Tucker**
Designer **TJ Tucker**
Photographer **Artie Limmer**
Publisher **Texas Tech University**
Issue **Winter 2003**

590

591

592

593

594

595

596

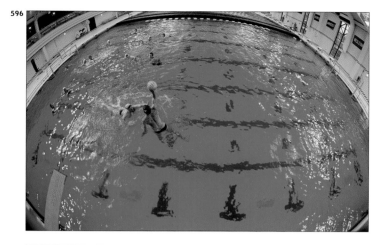

597

598

599

596
Publication **Middlebury Magazines**
Designer **Pamela Fogg**
Photographer **Bob Handelman**
Publisher **Middlebury College**
Issue **Fall 2003**

597
Publication **BK**
Creative Director **Diego Timpanaro**
Art Director **Diego Timpanaro**
Designer **Diego Ladron de Guevara**
Photographer **Juan Salvarredy**
Senior Contributing Editor **Sebastian Cangiano**
Publisher **Hey Group**
Issue **October 2003**

598
Publication **Nick Jr. Family Magazine**
Design Director **Don Morris**
Art Director **Josh Klenert**
Designers **Jennifer Starr, Robert Morris**
Illustrator **Hanoch Piven**
Photo Editor **Karen Shinbaum**
Studio **Don Morris Design**
Publisher **Viacom**
Issue **February/March 2003**

599
Publication **Children's Memorial Hospital**
Creative Director **Brock Haldeman**
Designer **Jennifer Stortz**
Illustrator **Celine Malepart**
Photographer **Russell Ingram**
Studio **Pivot Design, Inc.**
Publisher **Children's Memorial Hospital, Chicago**
Issue **January 2003**

600

601

602

602

600
Publication **The Scope**
Creative Director **Mitch Shostak**
Art Director **Heather Haggerty**
Photographer **Amelia Panico**
Studio **Shostak Studios, Inc.**
Publisher **Weill Medical College and Graduate
School of Medical Sciences, Cornell University**
Issue **December 2003**

601
Publication **Wired**
Creative Director **Darrin Perry**
Design Director **Susana Rodriguez deTembleque**
Designer **Donald Ngai**
Illustrator **Tronic**
Publisher **Condé Nast Publications Inc.**
Issue **2003**

602
Publication **Artsword 2003**
Creative Director **Lanny Sommese**
Design Director **Lanny Sommese**
Art Director **Lanny Sommese**
Designers **Clinton Van Gemert, Joe Shumbat, Roman Dhuman**
Studio **Sommese Design**
Publisher **Penn State University, School of Visual Arts**
Issue **Fall 2003**

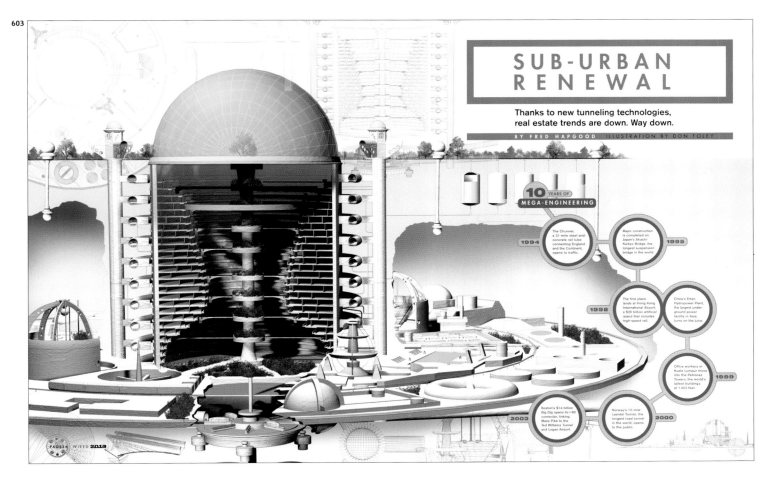

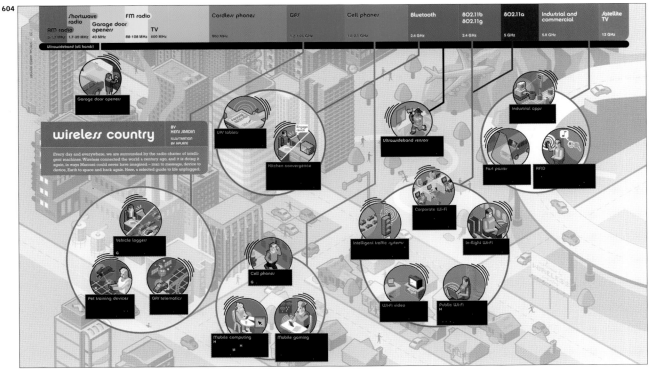

603
Publication **Wired**
Creative Director **Darrin Perry**
Design Director **Susana Rodriguez deTembleque**
Designer **Federico Gutierrez-Schott**
Illustrator **Don Foley**
Publisher **Condé Nast Publications Inc.**
Issue **2003**

604
Publication **Wired**
Creative Director **Darrin Perry**
Design Director **Susana Rodriguez deTembleque**
Designer **Donald Ngai**
Illustrator **Xplane**
Publisher **Condé Nast Publications Inc.**
Issue **2003**

605

JaneBownRock

606

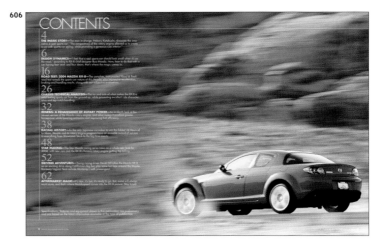

607

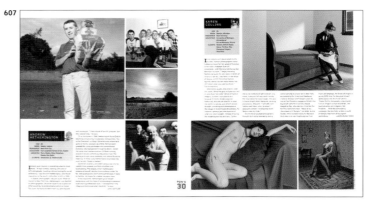

608

605
Publication **The Guardian**
Creative Director **Mark Porter**
Designer **Richard Turley**
Photographer **Jane Bown**
Publisher **Guardian Newspapers Limited**
Issue **2003**

606
Publication **Road + Track's Guide to the Mazda RX-8**
Design Director **Richard Baron**
Art Director **Tanya Owens Nuchols**
Photographer **John Lamm**
Publisher **Hachette Filipacchi Media, US, Inc.**
Issue **April 2003**

607
Publication **Photo District News**
Creative Director **Darren Ching**
Designers **Igor Glushkin, Stephanie Wenzel**
Photo Editor **Paul Moakley**
Photographer **various**
Publisher **VNU Business Publications**
Issue **March 2003**

609

611

610

611
Publication **NYTimes.com**
Design Director **Sumin Chou**
Lead Designer **Angelie Zaslavsky**
Flash Developer **Nick Cook**
Studio **NYTimes.com Design Dept.**
Publisher **The New York Times**

608
Publication **Boston magazine's Home & Garden**
Creative Director **Anne Bigler**
Designer **Anne Bigler**
Photographer **John Romeo**
Issue **Spring/Summer 03**

609
Publication **Better Homes and Gardens**
Design Director **Mike Harrington**
Art Director **Donni Alley**
Designer **Jared Christenson**
Publisher **Meredith Corporation**

610
Publication **Time Inc. Online**
Design Director **Lisa Michurski**
Art Directors **Steve Gullo, Dixon Rohr**
Designer **Alexander Knowlton, Ana Manrique,
Partricia Marroquin**

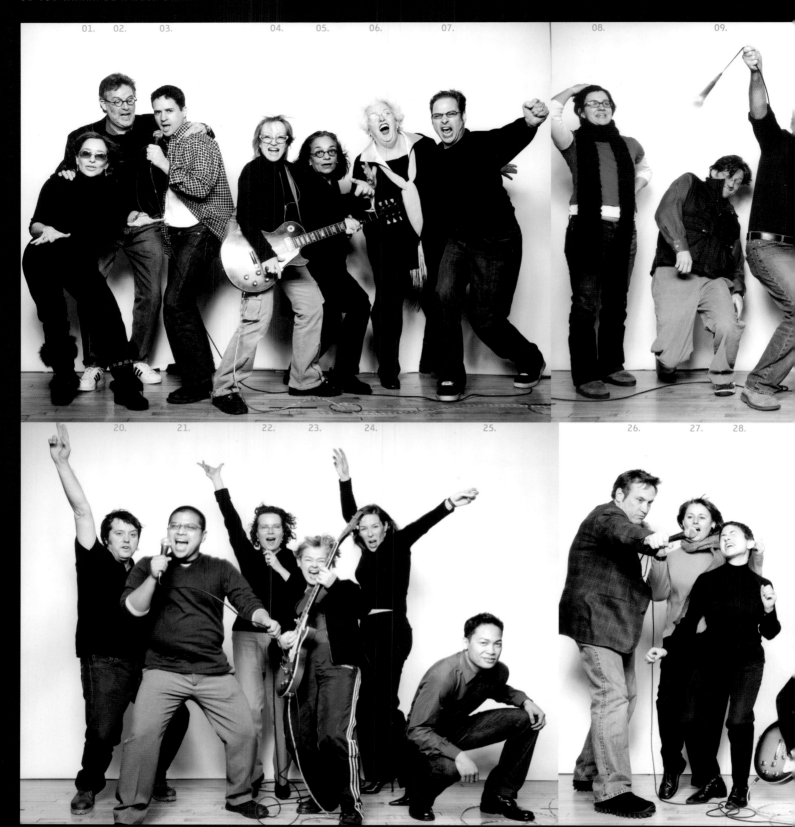

01. **CARLA FRANK**, Design Director, O, The Oprah Magazine (**COMPETITION CO-CHAIR, NEWSSTAND**) 02. **MITCH SHOSTAK**, Principal, Shostak Studios (**COMPETITION CO-CHAIR, NON-NEWSSTAND**) 03. **LUKE HAYMAN**, Design Director, New York Magazine (**COMPETITION CO-CHAIR, NEWSSTAND**) 04. **INA SALTZ**, Principal, Saltz Design (**MAGAZINE OF THE YEAR CHAIR**) 05. **DIANA LAGUARDIA**, (**VICE PRESIDENT, SPD**) 06. **BRIDE WHELAN** 07. **PAUL SCHRYNEMAKERS**, Creative Director, iVillage (**NEW MEDIA CHAIR**) 08. **Emily Crawford**, Design Director, Travel+Leisure 09. **Amid Capeci**, Art Director, Rolling Stone 10. **Andy Cowles**, Creative Director, IPC Media 11. **Maxine Davidowitz**, Group Art Director, Rodale (Captain) 12. **Anke Stohlmann**, Design Director, Time Inc. Custom Publishing 13. **Tom Brown**, Principal, TBA+D 14. **Florian Bachleda**, Design Director, Vibe (Captain) 15. **Michael Bierut**, Partner, Pentagram 16. **Julie Weiss**, Art Director, Vanity Fair 17. **Holland Utley**, Design Director,

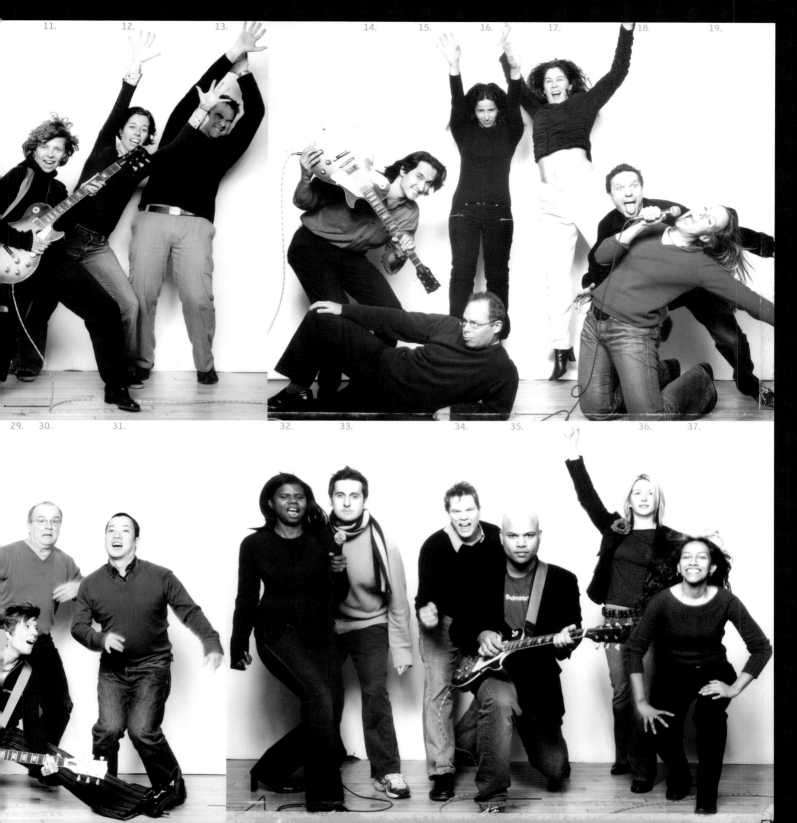

Glamour 18. **Dan Josephs**, Creative Director, Child 19. **Theresa Griggs**, Art Director, Entertainment Weekly 20. **Rodrigo Sanchez**, Art Director, El Mundo Metropoli 21. **Paul Carlos**, Partner, Pure+Applied 22. **Jennifer Crandall**, Director of Photography, GQ 23. **Joele Culer**, Design Director, Martha Stewart Living (Captain) 24. **Rina Migliaccio**, Creative Director, People 25. **Florentino Pamintuan**, Art Director, Elle Décor 26. **Robb Allen**, Creative Director, Hachette Filipacchi Custom Publishing 27. **Anna Egger-Schlesinger**, Design Director, Architectural Record 28. **Kayo Der Sarkissian**, Art Director, Parenting 29. **Francesca Messina**, Art Director, Guideposts (Captain) 30. **David Herbick**, Principal, David Herbick Design 31. **Darren Ching**, Creative Director, PDN 32. **Yvette Francis**, Design Director, IS & Hoop 33. **Chris Dixon**, Art Director, Studio Plural 34. **Michael Mrak**, Design Director, Discover 35. **Arem Duplessis**, Art Director, The New York Times Magazine (Captain) 36. **Eva Spring**, Art Director, Real Simple 37. **Claudia Marulanda**, Art Director, Interior Design

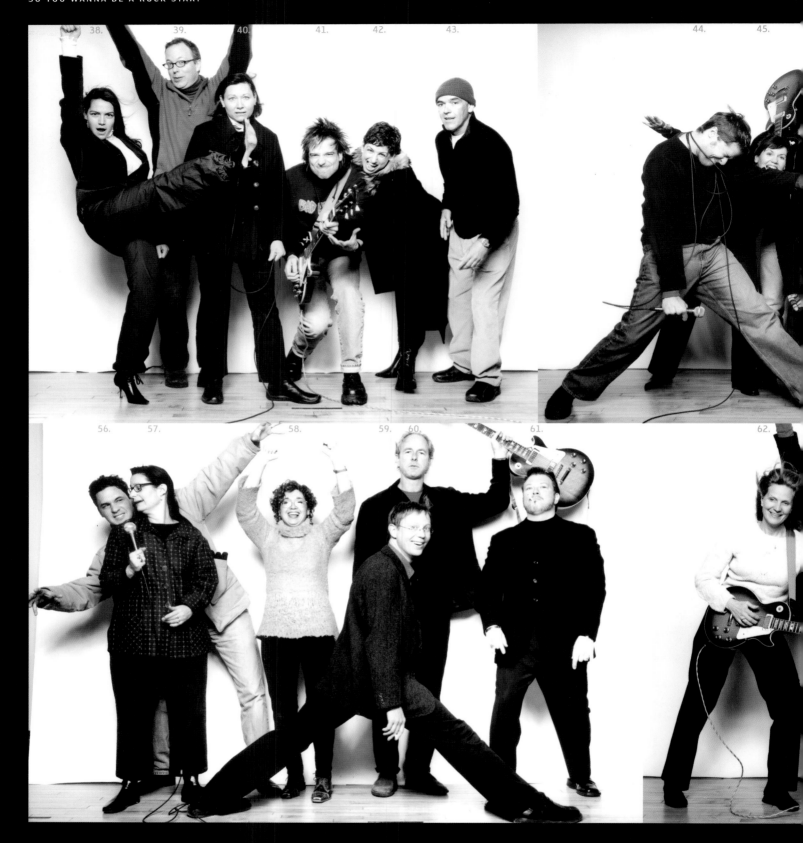

38. **Siobhan Hardy**, Design Director, Lifetime 39. **Alex Isley**, Principal, Alexander Isley, Inc. 40. **Judith Christ-LaFond**, Design Director, Scholastic 41. **Richard Demler**, Art Director, PC Magazine 42. **Melanie McLaughlin**, Partner, M Studios (Captain) 43. **David Armario**, Creative Director, David Armario Design 44. **Criswell Lappin**, Art Director, Metropolis 45. **Deb Bishop**, Design Director, Martha Stewart Kids (Captain) 46. **Darrin Perry**, Creative Director, Wired 47. **Miranda Dempster**, Art Director, Art+Auction 48. **Fabrice Frere**, Creative Director, City 49. **Jean Griffin**, Group Design Director, Fairchild Publications 50. **Bernard Scharf**, Creative Director, Departures 51. **Deanna Lowe**, Art Director 52. **Robert Newman**, Design Director, Fortune (Captain) 53. **Simon Esterson**, Principal, Esterson Associates 54. **Mary Jane Fahey**, Partner, FaheyO'Connor Design 55. **Lina Kutsovskaya**, Art Director, Teen Vogue 56. **David Matt**, Design

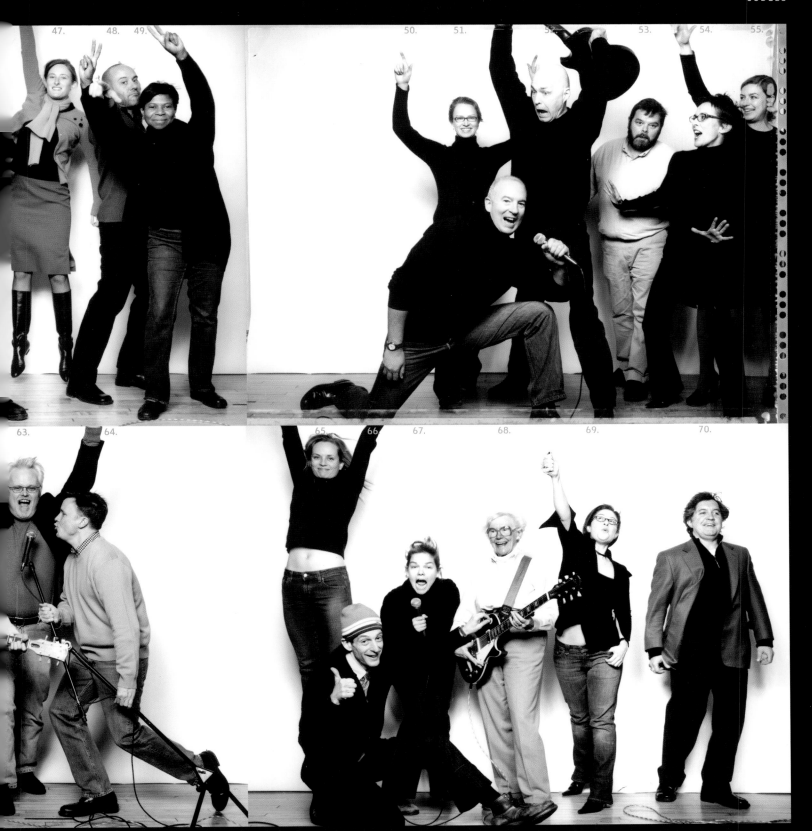

Director, Men's Journal (Captain) 57. **Carin Goldberg**, Creative Director, Time Inc. Custom Publishing 58. **Sheri Geller**, Design Director, Budget Living 59. **Don Morris**, Principal, Don Morris Design 60. **Robert Lesser**, Design Director, CFO Magazine 61. **Jaimey Easler**, Design Director, Hemispheres 62. **Dixon Rohr**, Senior User Interface Designer, Time Inc. Interactive 63. **Mike Harrington**, Design Director, Meredith Interactive 64. **Alex Knowlton**, Design Director, Time Inc. Custom Publishing 65. **Fiona McDonagh**, Director of Photography, Entertainment Weekly 66. **Scot Schy**, Design Director, Everyday Food 67. **Hannah McCaughey**, Creative Director, Outside (Captain) 68. **Jean Coyne**, Executive Editor, Communication Arts 69. **Kristin Fitzpatrick**, Art Director, O, The Oprah Magazine 70. **Joseph Heroun**, Principal, H2C Design

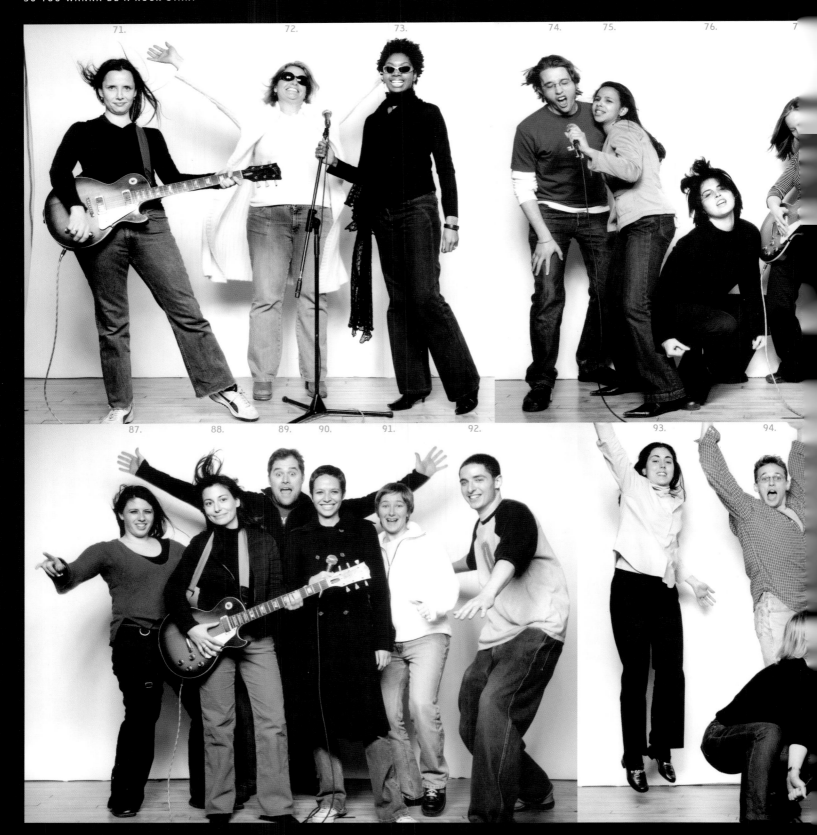

71. **Erin Whelan**, Associate Art Director, Field & Stream 72. **Emily Smith**, Notorious Girl 1, SPD 73. **Keisha Dean**, Notorious Girl 2, SPD 74. **Thomas Alberty**, Designer, GQ 75. **Judith Perez** 76. **Liana Zamora** 77. **Heather Haggerty**, Art Director, Shostak Studios 78. **Donald Partyka**, Associate Art Director, Guideposts 79. **Kim Forsberg**, Associate Art Director, Esquire 80. **Deena Goldblatt** 81. **Nathalie Kirsheh**, Senior Associate Art Director, Seventeen 82. **Melissa Devlin** 83. **Mimi Duvall** 84. **Dan Hertzberg** 85. **Anne Todd**, Art Director, AMI Mini Mags 86. **Nancy Stamatopoulos** 87. **Rebecca Fain**, Photo Editor, Revolver 88. **Dora Somosi**,

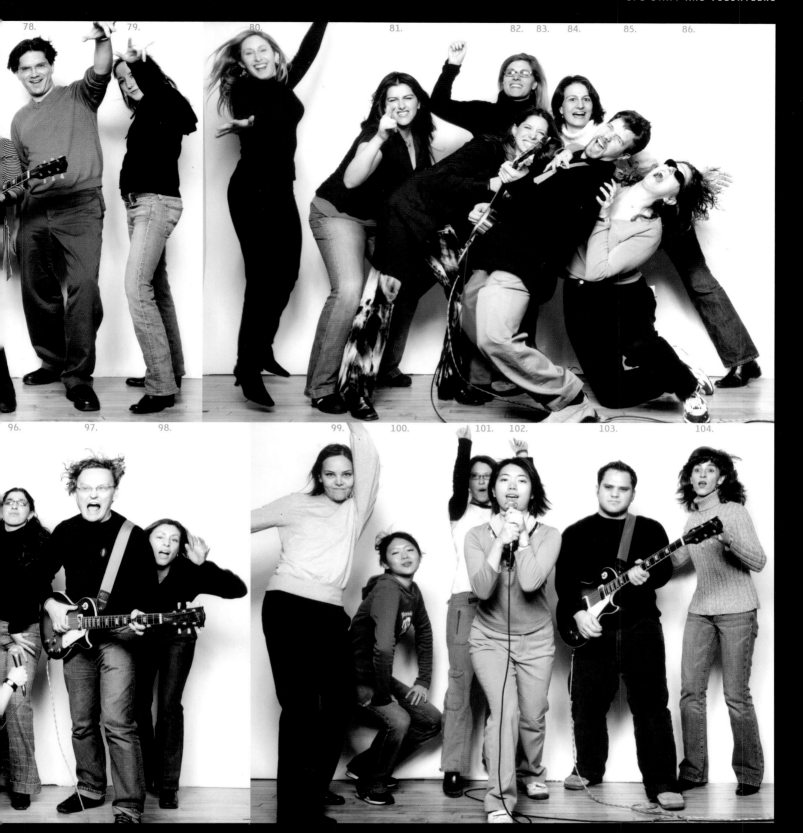

Photo Editor, Marie Claire 89. **Jesper Goransson** 90. **Alice Alves**, Associate Art Director, Vibe 91. **Sunna Gunnlaugs** 92. **Michael Friel**, Designer, Vibe 93. **Danielle Bravaco** 94. **Robert Perino**, Senior Art Director, Men's Journal 95. **Linda Root**, Deputy Art Director, Sports Illustrated (Captain of the Volunteers) 96. **Andrea Nasca** 97. **Andrew Horton**, Gun for Hire 98. **Cute & Wonderful Volunteer** 99. **Simona Ternblom** 100. **Nancy Chan**, Designer, Travel+Leisure 101. **Sandra Garcia**, Senior Designer, Travel+Leisure 102. **Riny Chen** 103. **Isaac Gertman** 104. **Allison Longo**, Art Director, Diversion

The Society of Publication Designers thanks its corporate sponsors for its ongoing support.

Adobe Systems, Inc.
The New York Times Foundation
American Express Publishing

THE PUB 39 COMPETITION

Pub 39 Co-Chairs **Carla Frank**, D/D of O, the Oprah Magazine and **Luke Hayman**, D/D of New York Magazine, **Mitch Shostak**, Principal of Shostak Studios, Inc., and **Ina Saltz**, Chairperson, The Magazine of the Year Competition, wish to extend their special thanks to **Linda Root** and her corps of volunteers, the fifty judges of the Competition, Parsons School of Design and its facilities where SPD holds the competition every year. Scores of members and friends contribute long hours and hard work to this annual endeavor. On a long, cold weekend in January, the competition warms up as thousands of entries come under the critical eye of the nation's top designers and art directors. After some well deserved partying at the end of the Competition, thanks and kudos go to **Keisha Dean** and **Emily Smith** of the SPD office.

The Society's annual publication design exhibition in the Aronson Galleries of Parsons School of Design, 66 Fifth Avenue, New York, NY. will feature all of the original printed work seen in this 39th edition of the annual. The exhibit will have an Opening Reception on Wednesday, July 21, 2004 and remain on display through August 6, 2004. The Exhibition then travels to The Graphic Arts Institute of Denmark in Copenhagen as part of the Society's ongoing interchange with colleges and universities, worldwide.

THE GALA

It was back to the Library for SPD after a two year hiatus. It was "Black Tie meets Rock and Roll." Carla Frank and Luke Hayman brought over 400 rockers to their feet as the winners of the 39th Annual Design Competition came forth to collect their respective awards. The Gold, Silver and Magazine of the Year are featured in the opening pages of this annual.

Debra Bishop, the D/D of Martha Stewart Kids was named winner of the Society's Magazine of the Year Award, 2003. This award, voted on by all members of the judging teams and Captains, assure a broad range of competitive judging in this most prestigious award of the magazine industry. A finalist for MOY award for the last three years, Deb Bishop has consistently enhanced the world of kids, fashion and design in her work at Martha Stewart/Kids.
We congratulate her accomplishments and those of her extraordinary team of designers and editors.

At the Gala celebration, May 7, 2004, **George Lois**, the legendary art director, whose Esquire covers of the '60's changed the social climate of a country and invigorated a generation of designers, received the Herb Lubalin Award for Lifetime Achievement. Mr. Lois, whose career has spanned over 50 years of innovative design, was paid tribute by US Representative, **Dennis Kucinich**, Democrat of Ohio. A moving video, based on interviews with Lois, was introduced by SPD President, **Fred Woodward**. It covered his early career and most especially his years at Esquire. Woodward presented Lois with the award and acknowledged the design community's debt of gratitude to his continuing influence as well as his inspiring work. Lois accepted the award with grateful enthusiasm. It was a fitting tribute to the Master.

SPOTS

Chairperson, **Christine Curry**, Illustration Editor of The New Yorker, has consistently championed the role of illustration and the development of the SPOTS Competition.

The illustrator of this year's Call for Entries is **Marc Boutavant**/Heart Agency.
Special thanks go to **Gary Van Dis**, The New Yorker Imaging

Department, **Darrel Rees**/Heart Agency and **Robert Newman** of Fortune Magazine.

Judges for the 2003 Competition included:
Seymour Chwast, Principal, Pushpin Studios
Lara Tomlin, illustrator, Cullen & Rapp
Barry Blitt, illustrator
Amid Capeci, D/D, Rolling Stone
Kory Kennedy, A/D, Rolling Stone
Rosanne S. Guararra, Art Director, Grosset & Dunlap/Penguin Young Readers Group
Nai Lee Lum, Associate A/D, Fortune
Gibb Slife, The New Yorker
Yuko Shimizu, illustrator

The SPOTS judging took place at Parsons School of Design on May 14, 2004, and was exhibited at as part of the Society's annual publication design exhibition in the Aronson Galleries of Parsons School of Design, 66 Fifth Avenue, New York, NY.

SPD BOARD OF DIRECTORS

President
Fred Woodward, D/D, Gentlemen's Quarterly

Vice Presidents
Diana La Guardia
David Matt, D/D, Men's Journal

Board of Directors
Florian Bachleda, D/D, Vibe
Jennifer Crandall, Director of Photography, GQ
Christine Curry, Illustration Editor, The New Yorker
Arem Duplessis, A/D, The New York Times Magazine
Carla Frank, D/D, O, the Oprah Magazine
Janet Froelich, C/D, The New York Times Magazines
David Harris, D/D, Vanity Fair
Luke Hayman, D/D, New York Magazine
Melanie McLaughlin, Partner, M Studios
Linda Root, Deputy A/D, Sports Illustrated
Bruce Ramsay, D/D, Covers, Newsweek
Ina Saltz, Principal, Saltz Design
Paul Schrynemakers, C/D, ivillage.com
Mitch Shostak, Principal, Shostak Studios, Inc.

Ex Officio: **Robert Newman**, D/D, Fortune

Society of Publication Designers, Inc.
60 East 42nd Street, Suite 721
New York, New York 10165
Tel: 212-983-8585
Fax: 212-983-2308
url: www. Spd.org
email: mail@spd.org

The SPD 39th Publication Design Annual was designed and produced by **Robert Priest, Remma Shapiro** and **Ron Jones** of Priest Media Inc., 285 West Broadway, New York, NY 10013. Tel: 212-226-3225
www.priestmedia.com

First published in the United States of America by:
Rockport Publishers, Inc.
33 Commercial Street
Gloucester, MA 01930
Tel: 978-282-9590
Fax: 978-283-2742

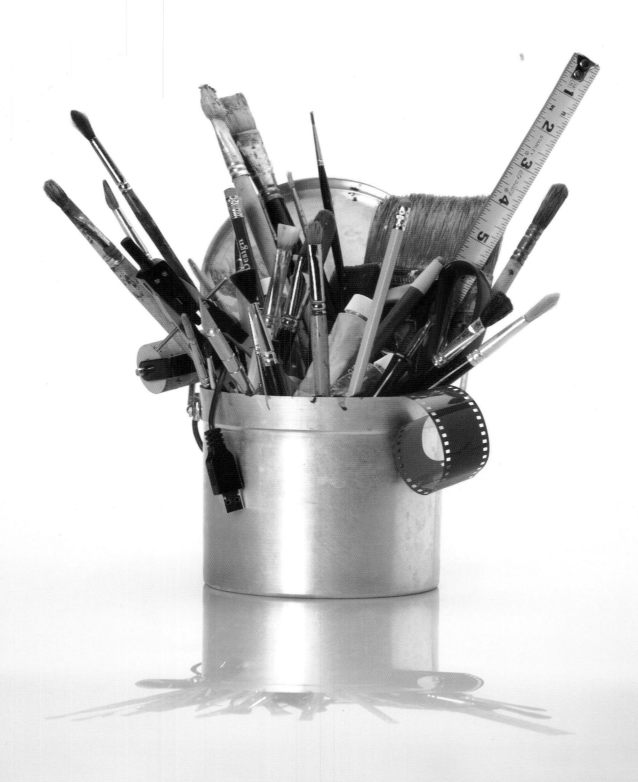

Savannah College of Art and Design

An International University for the Arts

800.869.7223 · **www.scad.edu**